A Global Pursuit

SECOND EDITION

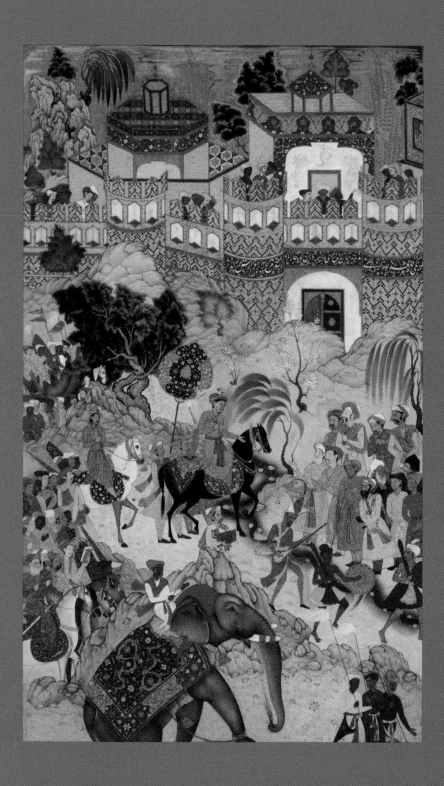

Davis Publications, Inc. Worcester, Massachusetts

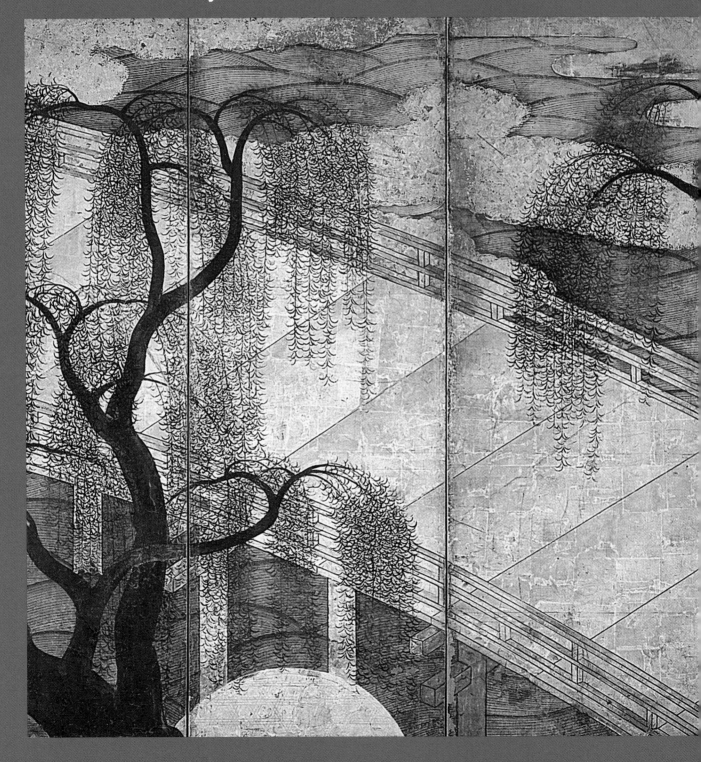

A Global Pursuit

SECOND EDITION

Marilyn G. Stewart and Eldon Katter

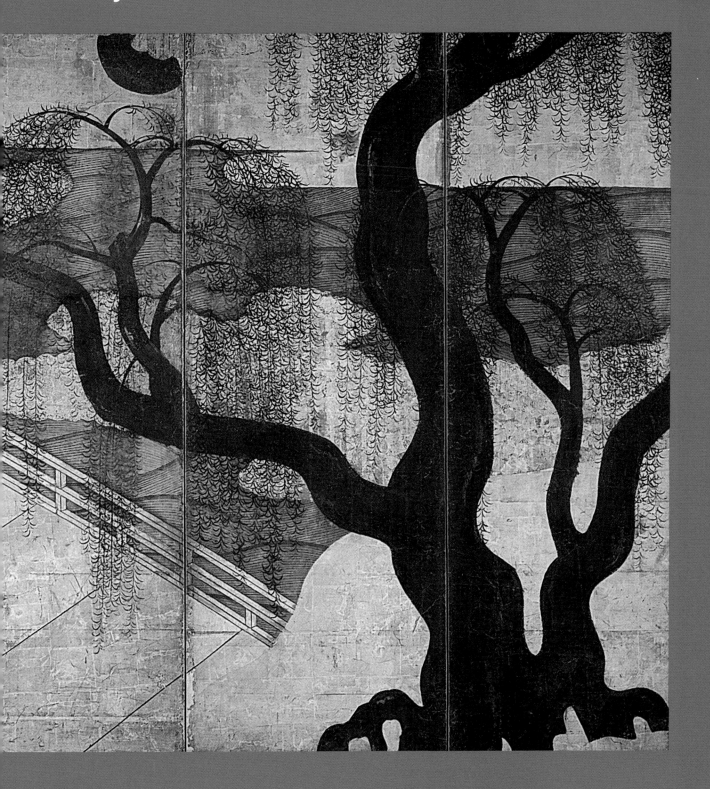

40852000285839

Library of Congress Control Number 2008931900

Printed in the United States of America

ISBN: 978-0-87192-881-8

1 2 3 4 5 6 7 8 9 RRD 15 14 13 12 11 10 09 08

Cover: Farrukh Beg, *Akbar's Entry Into Surat, Akbar-nama*, ca. 1590.
Gouache on paper, 14 ⅞" x 9 ⁹⁄₁₆" (37.9 x 24.3 cm). Trustees of the
Victoria & Albert Museum.

Title Page: Japan, *The River Bridge at Uji*, Momoyama period (1568–
1614). Ink, color, and gold on paper. Six-fold screens, 64 ½" x 133 ¼"
(171.4 x 338.4 cm). The Nelson-Atkins Museum of Art, Kansas City,
Missouri (Purchase: Nelson Trust).

A Letter from the Authors

Dear Student,

We are delighted that you'll be using *A Global Pursuit* as your art textbook this year.

Our goal in writing this book was to offer you experiences in art that will matter to you today and remain part of your thinking well into the future.

We hope this textbook will inspire you to notice the art all around you. We also hope it will help you express your own ideas and feelings through art in its many forms— drawing, painting, sculpture, photography, printmaking, fiber arts, ceramics, graphic design, and their countless combinations.

You may wonder why we chose the book's unit titles. Each unit focuses on a "big idea" such as Nature, Messages, or Daily Life. These ideas have been important to people around the world throughout history. As you learn about them, we hope you'll begin to see that ideas like these connect you to people who may live far away, people you will never meet. These are the ideas that make us all human. These are the ideas that form the basis for the art people make, no matter when or where they live.

Enjoy your artistic pursuits!

Marilyn G. Stewart is Professor of Art Education, Kutztown University of Pennsylvania. She is co-author, with Eldon Katter, of *Explorations in Art 1–5*, author of *Thinking Through Aesthetics*, co-author, with Sydney Walker, of *Rethinking Curriculum in Art*, and series editor of the Art Education in Practice series, all published by Davis Publications. Her honors and awards include 1998 Eastern Region Higher Education Art Educator of the Year, 2006 Pennsylvania Art Educator of the Year, and 1997–98 Getty Education Institute for the Arts Visiting Scholar. A frequent speaker and consultant, she has conducted more than 160 staff development institutes, seminars, or workshops in over 25 states.

Eldon Katter is Emeritus Professor of Art Education at Kutztown University. He is co-author, with Marilyn Stewart, of *Explorations in Art 1–5*, former editor of *SchoolArts*, and former president of the National Art Education Association. He has taught art in elementary schools in Illinois and Massachusetts. As a Peace Corps volunteer in the 1960s, he taught art at a teacher training school in Harar, Ethiopia. He also worked for the Teacher Education in East Africa project in Kampala, Uganda.

An Introduction to Art

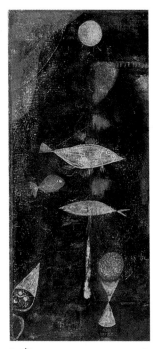

p. xix

p. xxi

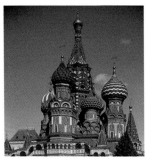

p. xxix

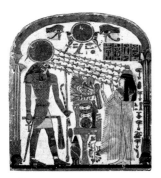

p. 2

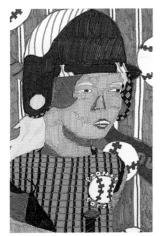

p. 15

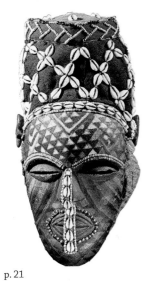

p. 21

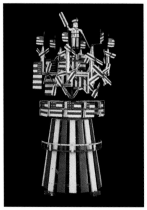

p. 36

p. 43

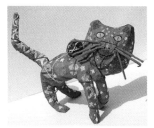

p. 53

p. 63

p. 79

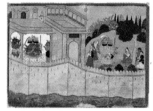

p. 82

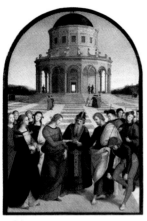

p. 94

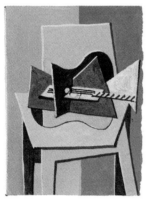

p. 103

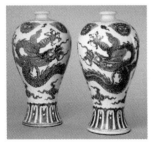

p. 111

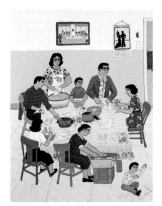

p. 126

p. 133

p. 147

p. 161

p. 163

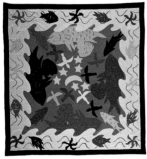

p. 175

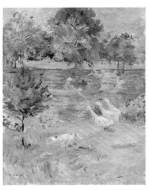
p. 182

p. 195

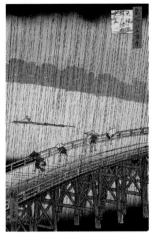
p. 202

p. 215

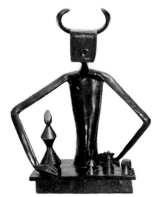

p. 227

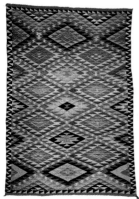

p. 213

Unit 9 Artists Explore New Territory

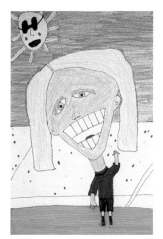

p. 251

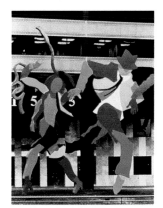

p. 253

p. 263

Student Handbook

p. 277

p. 301

Resources

An Introduction to Art

Art. It's a simple, three-letter word that you probably could spell when you were five years old. It's easy to define, too, isn't it? Art is... Well, wait a minute. What *is* art?

This section of your book has been created to introduce you to art. You may think you don't need an introduction—after all, you've probably seen a painting or two here or there over the years, and that's art, right? Right. But that's not all you need to know about art. Why do people make it? How do they use it? What about buildings or clay pots—are they artworks? What are artworks made of? What do they mean? These questions don't always have easy answers, but it's a great adventure to think about them. That's what this section—and the rest of this book—will help you do.

This section also introduces you to art's most basic building blocks—the elements of art and principles of design—through artworks that show them clearly. You'll learn about the steps to use when you look thoughtfully at a work of art. You'll also learn about the steps to use when creating your own artwork.

Come back to this section again and again, whenever you need to review art's most fundamental ideas. And keep asking yourself: What *is* art, and what is it *for*?

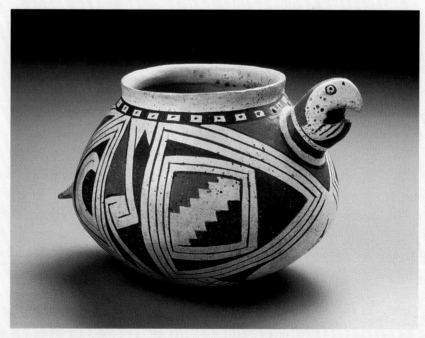

Mogollon (Casas Grandes style), *Macaw Bowl,* Tardio Period, 1300–1350.

What is art?

Architecture

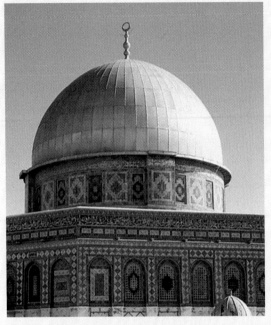

Dome of the Rock, late 7th century. Jerusalem, Israel.

Furniture

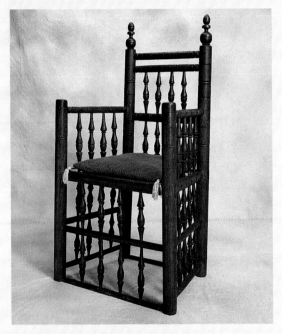

Massachusetts Bay Colony, *Bradford Chair*, 1630.

Clothing

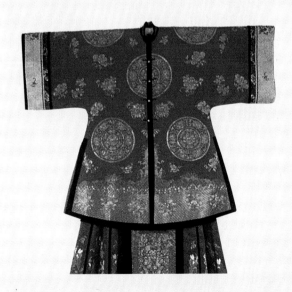

China, Qing dynasty, *Wedding Ensemble*, ca. 1860.

Photography

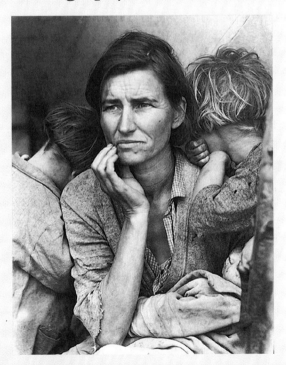

Dorothea Lange, *Migrant Mother, Nipomo, California*, 1936.

Painting

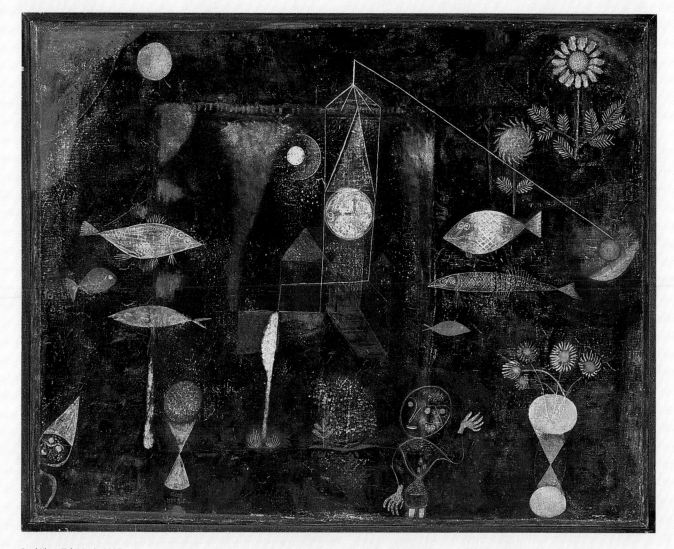

Paul Klee, *Fish Magic*, 1925.

Art can take many forms.

> **Look for examples of art in the world around you.**

Why do people make art?

To express themselves

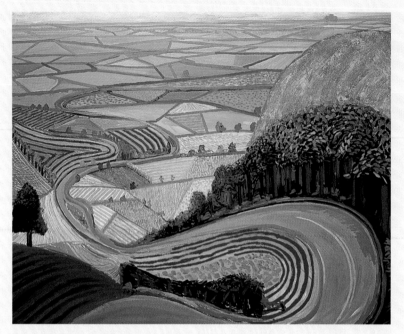

David Hockney, *Garrowby Hill*, 1998.

To tell a story

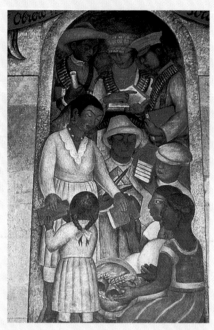

Diego Rivera, *Learning the ABC's (Alfabetizacion)*, 1923–28.

To share feelings

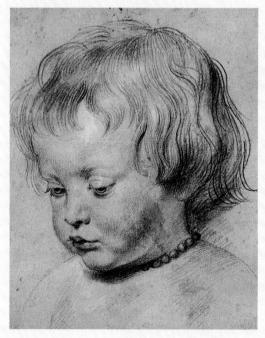

Peter Paul Rubens, *Portrait Study of His Son Nicolas*, 1621.

To make things look beautiful

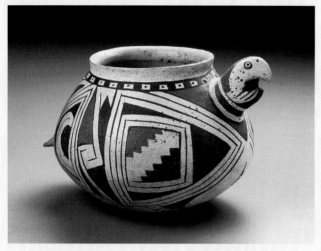

Mongollon (Casas Grandes style), *Macaw Bowl*, Tardio Period, 1300–1350.

To remember important people

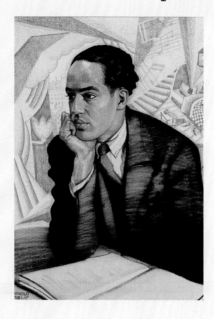

Winold Reiss, *Langston Hughes (1902–1967), Poet*, ca. 1925.

To remember special times

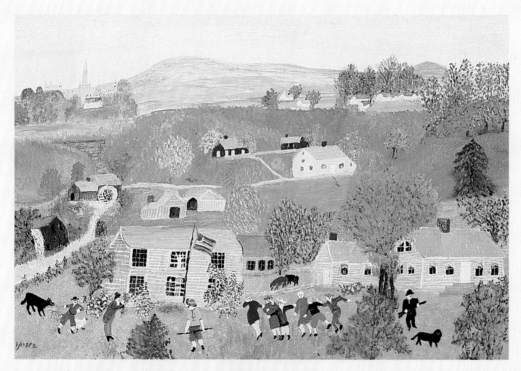

Anna Mary Robertson Moses, called Grandma Moses, *Summer Party*, 20th century.

What other reasons do people make art?

There are subjects and themes in art.

Subject: Members of the Peale family
Theme: The joy of family

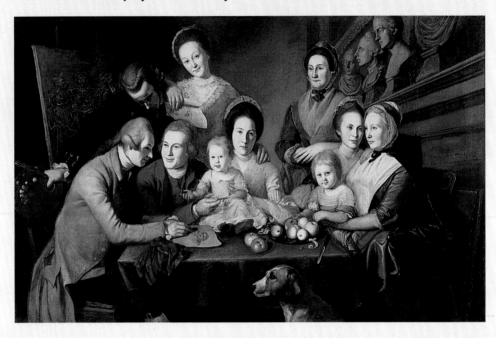

Charles Willson Peale, *The Peale Family*, ca. 1770–73 and 1880.

Subject: Lion
Theme: Strength and power

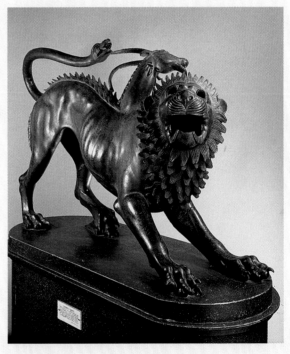

Etruscan, *Chimera of Arezzo*, 6th century BCE.

Subject: Soap box racing
Theme: Good times with friends

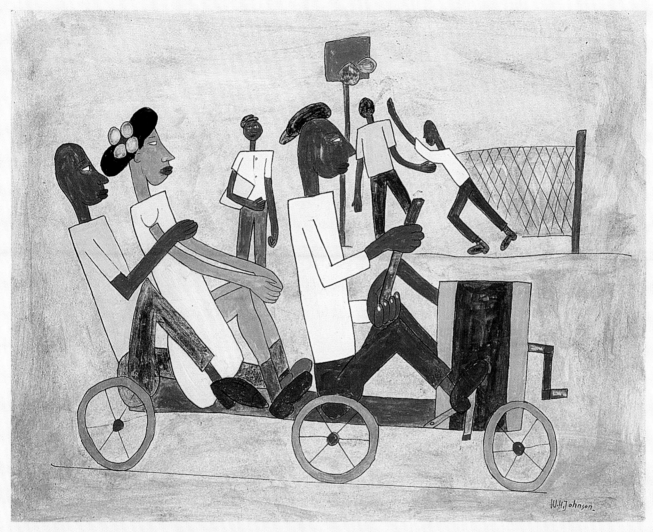

William H. Johnson, *Soap Box Racing*, ca. 1939–40.

Artists choose their art forms.

Sculpture

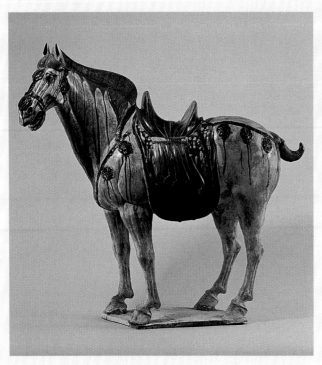

China, Tang dynasty, *Horse*, early 8th century.

Drawing

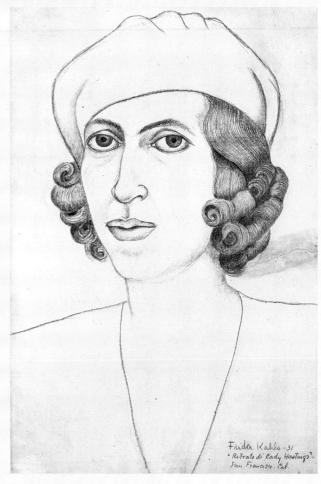

Frida Kahlo, *Portrait of Mrs. Christian Hastings*, 1931.

Collage

Warren Smith, *Cloak of Heritage*, 1991.

Photography

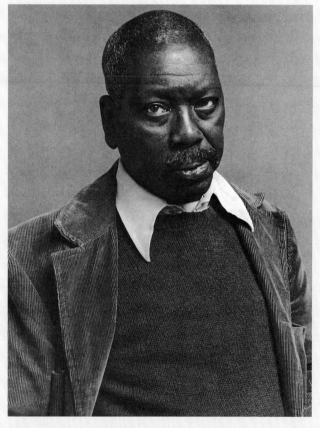

Marsha Burns, *Jacob Lawrence*.

What other art forms can you name?

Artists choose their media.

Oil Paint

Marc Chagall, *I and the Village*, 1911.

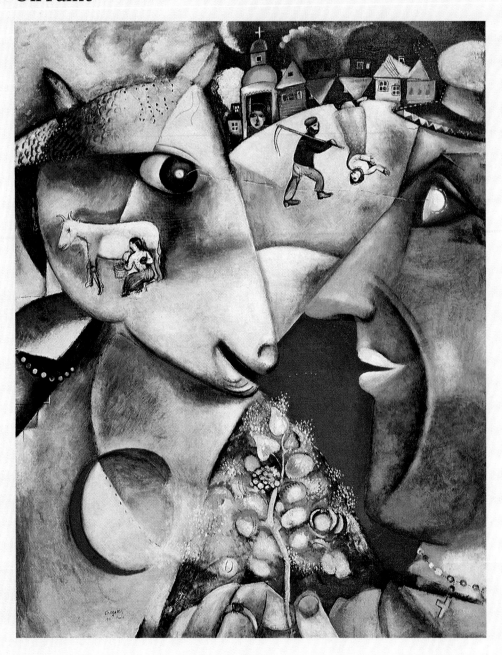

Clay

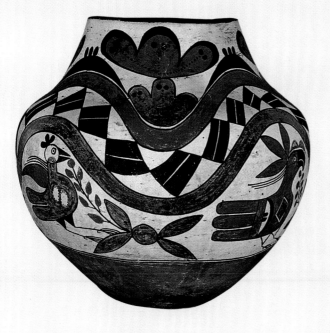

North American Indian, *Acoma Polychrome Jar.*

Glass

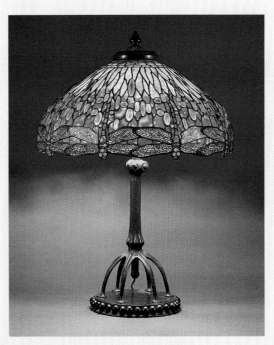

Louis Comfort Tiffany, *Dragonfly Lamp*, ca. 1900.

What other media can you name?

Art is a language.
The elements of art are the words of the language.

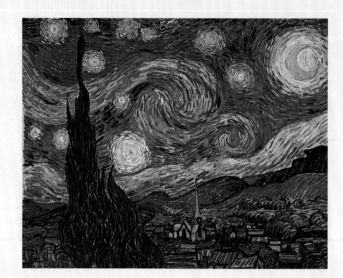

Vincent van Gogh, *The Starry Night*, 1889.

Color

Line

Shape and Space

Form

Texture

Value

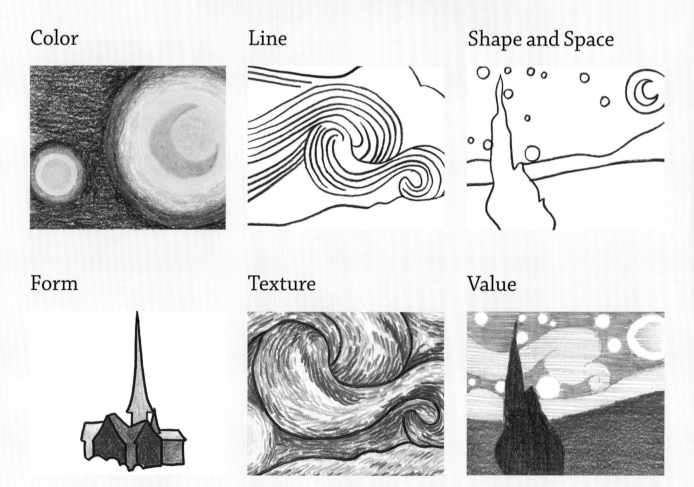

The elements of art are in everything that we see.

You can find the elements of art in all kinds of artworks.

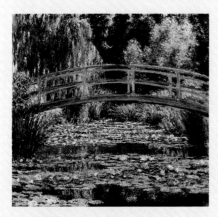

Claude Monet, *Japanese Footbridge and the Water Lily Pond, Giverny*, 1899.

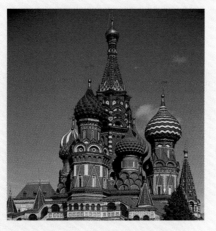

Cathedral of St. Basil, 1554–1566. Moscow.

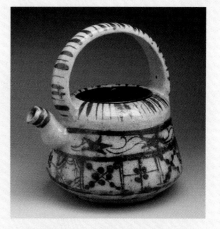

Japan, Momoyama period (1568–1615), *Ewer for Use in Tea Ceremony*, early 17th century.

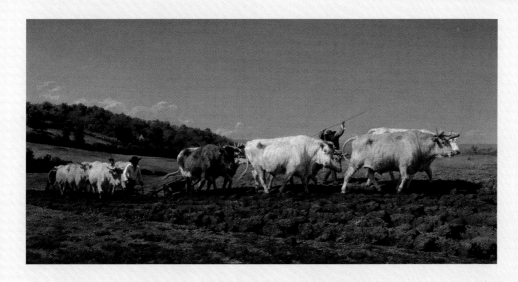

Rosa Bonheur, *Ploughing in the Nivernais*, 1849.

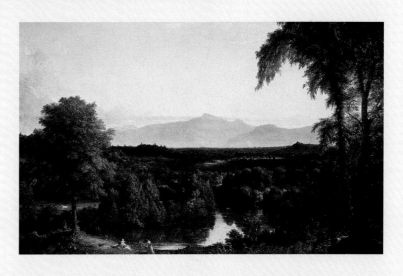

Thomas Cole, *View on the Catskill, Early Autumn*, 1837.

Artists organize these works using the principles of design.

Balance

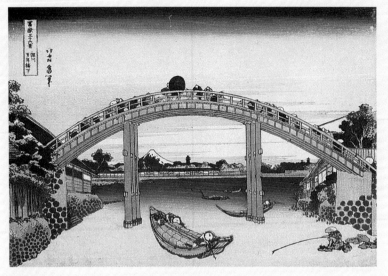

Sakino Hokusai IITSU, *Fukagawa Mannembashi*, from 36 Views of Mt. Fuji, 1830.

Pattern

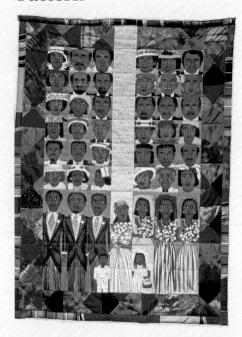

Faith Ringgold, *The Wedding Lover's Quilt No. 1*, 1986.

Proportion

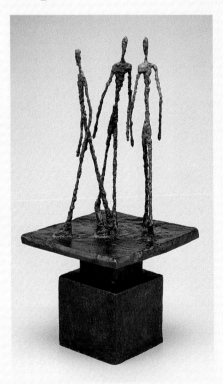

Alberto Giacometti, *Three Men Walking*, 1948–49.

Rhythm and Movement

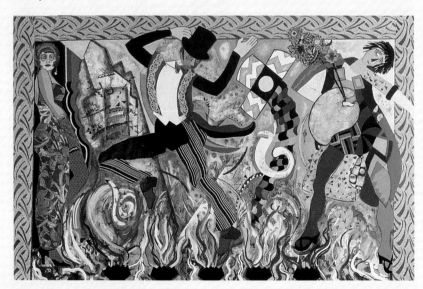

Miriam Schapiro, *Master of Ceremonies*, 1985.

Contrast

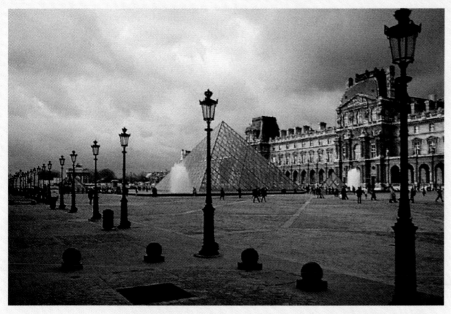

I. M. Pei, *Addition to the Louvre*, 1988.

Variety and Unity

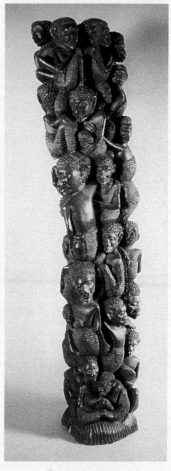

Makonde, Tanzania, *Family Group*, 20th century.

Emphasis

Anne Coe, *Migrating Mutants*, 1986.

Art Criticism

Learn to view artworks thoughtfully.

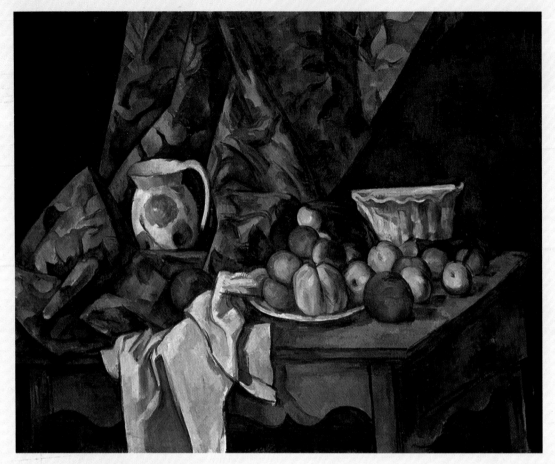

Paul Cézanne, *Still Life with Apples and Peaches*, c. 1905.

1. **Describe** what you see.
 What do you see in this painting?

2. **Analyze** the painting's organization.
 How did the artist organize the elements?
 How did Cézanne create the illusion of three dimensions?

3. **Interpret** what the artist's goals were in creating this artwork.
 What do you think Cézanne cared about in creating this painting?
 Explain your answer.

4. **Evaluate** the artwork. How effective is this painting
 in creating a balanced design?

A Five-Step Process

Keith Bush, *Deep Blue Sea*, 2000.

When you create an artwork, think about these steps.

Step 1 Plan and Practice

- What idea do you want to communicate?

- What subject and theme will you choose?

- What form and media will you use?

Step 2 Begin to Create

- Start your process.

- Be prepared to revise if necessary.

Step 3 Revise

- Do you need to change your initial plan?

- Do you need to make other adjustments?

Step 4 Add Finishing Touches

- What details will make a difference?

Step 5 Share and Reflect

- What can you learn from others?

- What did you learn about yourself as an artist?

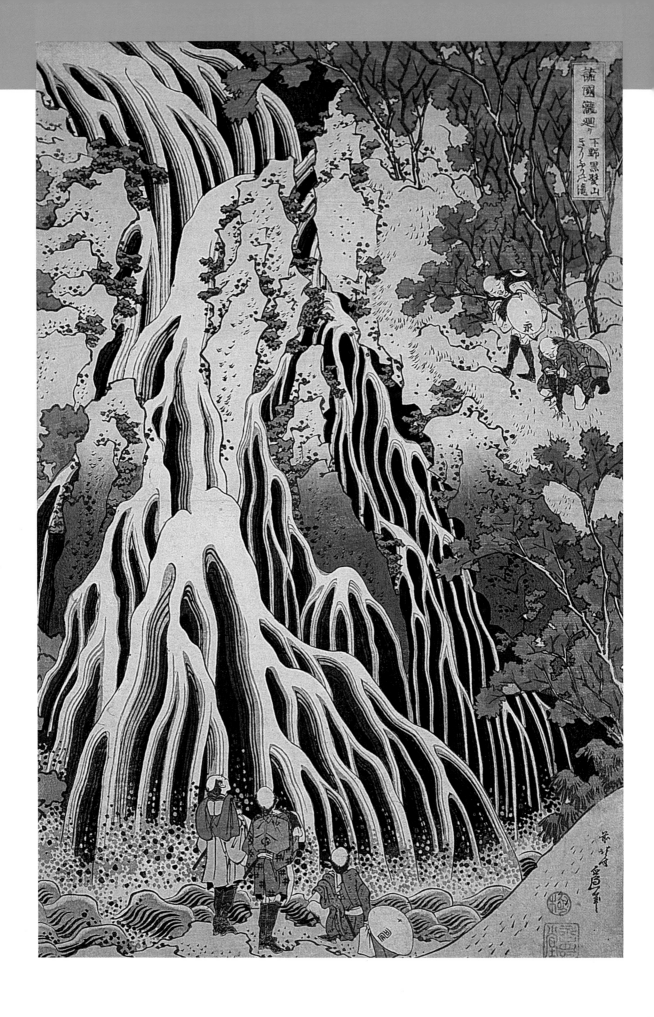

Art Is a Global Pursuit

What is a neighbor? Not long ago, your neighbors were just the people who lived next door. Today, because of improvements in communication, almost anyone can be called your neighbor. The Internet, videos, and satellite broadcasts let you see and learn about faraway people with very different beliefs and customs.

One important thing that people everywhere have in common, though, is the desire to make art. Throughout history, people have used the materials around them to make beautiful things. They have put their ideas about life into their art.

In this book, you'll explore some ideas that are shared by people all over the world. Look carefully at the artworks on these pages. Then look for some of the same ideas in the artwork around you. Can you find them? Can you see how many "neighbors" you really have?

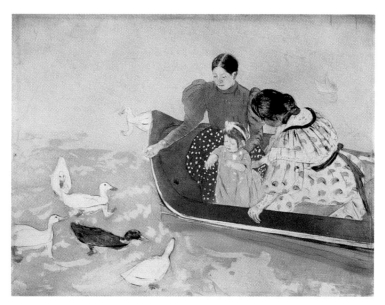

Mary Cassatt, *Feeding the Ducks*, 1895. See page 196.

Katsushika Hokusai, *Kirifuri Waterfall at Mt. Kurokami*, Shimozuke Province, Series: The Various Provinces, ca. 1831. See page 193.

Artists Send Messages

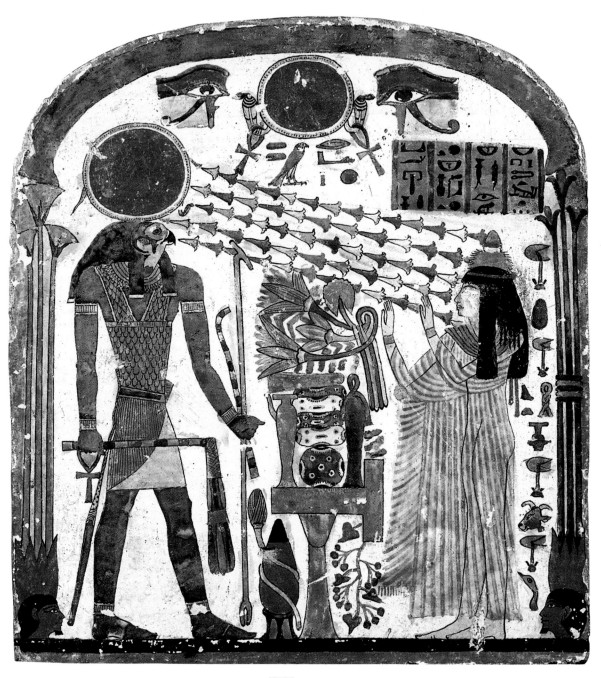

Fig. 1–1 **This carved and painted stone slab called a stele (STEE-lee) shows a woman making offerings to a sun god. Why do you think it was created?**

Lower Egypt (Lybia), 22nd dynasty (950–730 BCE.), *Lady Taperet before Re-Harakhte.* Painted stele, Louvre, Paris, France, Bridgeman-Giraudon/Art Resource, New York.

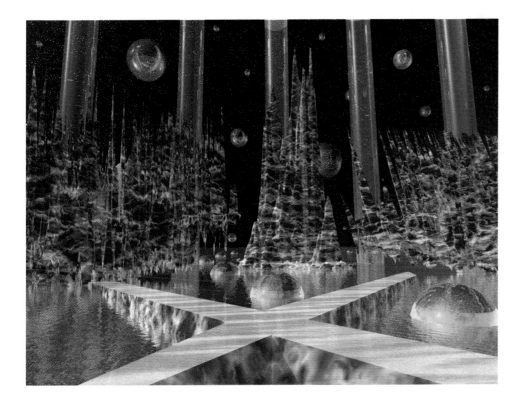

Fig. 1–2 **What message would someone hundreds of years from now think the artist is communicating in this computer-generated image?**

Kenneth B. Haas, III, *Crossroads*, 1999. Computer-generated Image, 17.7" x 13.3" @ 72 ppi. Bryce Software. Courtesy of the artist.

Have you ever looked at an artwork and asked, "What does it mean?" "What is it about?" We assume that the artist was trying to communicate something. Sometimes, the meaning is obvious. At other times, we cannot be sure what the message is.

Past artists could not have known that in the future, others would wonder about the meanings of their artworks. Although the messages were not put there for us, they still tell us something. They say, "We were here. This is what we believed in and cared about when we were alive. You can see it in our artworks."

In this unit, you will learn:

- How artists help people communicate important ideas and feelings.
- How to draw with contour lines and how to create a bas-relief sculpture with clay.
- How to look at artworks as ways for people to send messages.

Messages in Art

Sending Messages Groups of people who live together need to communicate. We communicate about topics important to our survival such as obtaining food and building shelters. But we also tell stories. We share our dreams for the future and our memories of the past. To communicate all this—to send messages—we use words, gestures, and symbols. A symbol is an image that stands for something else, such as the heart that can stand for love.

Receiving Messages Like words and gestures, artworks convey meaning and are forms of communication. We learn the meanings gradually, as we grow up. Sometimes understanding what an artwork means is easy. With other artworks, we might not be as sure about the message. For instance, we cannot fully understand messages left by prehistoric people. Prehistoric people are those who lived before the time of written records. They made drawings on cave walls and other rock surfaces. These drawings give us clues about how prehistoric people lived. For example, some rock art tells us about their early hunting methods.

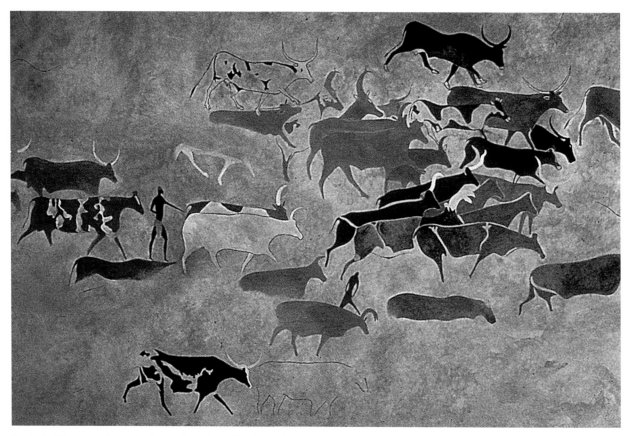

Fig. 1–3 **What can this painting tell us about life in prehistoric times?**

Saharan rock painting of Jabbaren showing early herders driving cattle, 5500 BCE–2000 BCE. Photothèque du Musée de l'homme, Paris.

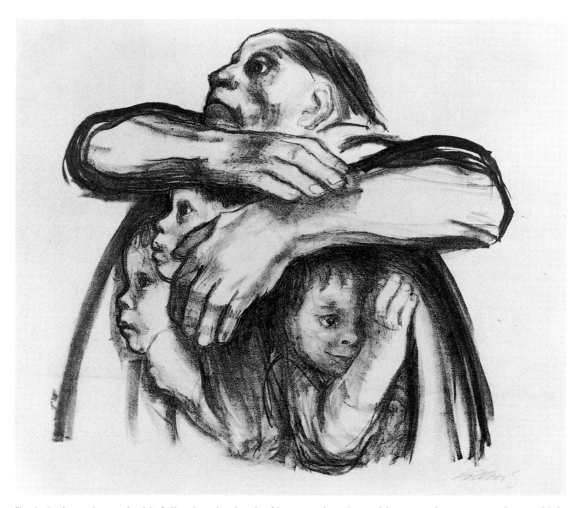

Fig. 1–4 The artist made this following the death of her grandson in World War II. What message do you think she was trying to communicate?

Käthe Kollwitz, *Seed for Sowing Shall Not Be Ground*, 1942. Lithograph on ivory paper. Private collection, Courtesy Galerie St. Etienne, New York. ©2000 Artists Rights Society (ARS). New York/VG Bild-Kunst, Bonn.

Meet Käthe Kollwitz

Käthe Kollwitz was born in Konigsberg, Russia. At age 14, she began studying painting and drawing with local artists. From 1885 to 1886, she attended the School for Women Artists in Berlin, Germany. Käthe married Dr. Karl Kollwitz when she was 24. They lived among the poor people Dr. Kollwitz helped in Berlin. During this time, Käthe observed the daily difficulties that the people in her neighborhood experienced. She wanted to share her observations so she included images of the effects of war, such as poverty and unemployment, in her art. She became known for these portrayals of suffering.

"**Everything could be so beautiful if it were not for the insanity of war.**"

— Käthe Kollwitz (1867–1945)

Messages About Our Lives People make artworks to communicate ideas and goals. Through art, we tell what is important, what we believe, and how we think people should live. Some art suggests ways to make the world a better place.

We often teach our values and beliefs through stories, legends, and myths. An artwork that suggests a story is called a narrative artwork. Not all narrative art is made to teach important lessons. Some tell stories to entertain us. Others use images to report actual events. These artworks help document history and send messages to others about who we are and how we live.

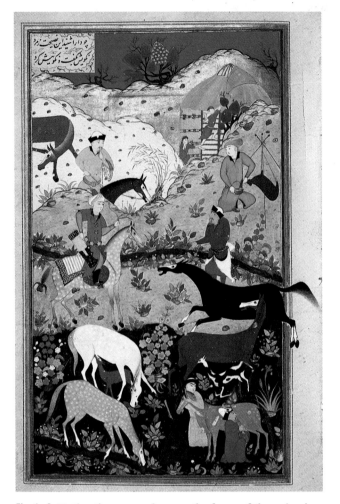

Fig. 1–6 Notice the expressions on the faces of the animals and people. What story is told in this narrative artwork?

Sa'di, Bustan *(Garden of Perfume): Darius and the Herdsmen,* Mid-16th century. Ink, colors and gold on paper, 11 ½" x 7 ¾" (29 x 20 cm). The Metropolitan Museum of Art, Frederick C. Hewitt Fund, 1911. (11.134.2) Photograph ©1978 The Metropolitan Museum of Art.

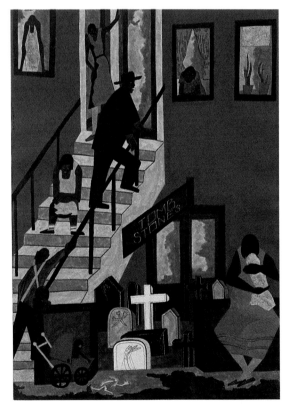

Fig. 1–5 A single image can sometimes tell a complicated story. What story do you think this artist tells in this painting?

Jacob Lawrence, *Tombstones,* 1942. Gouache on paper, 28 ¾" x 20 ½" (73 x 52.1cm). Collection of Whitney Museum of American Art, New York. Purchase 43.14. Photo by Geoffrey Clements.

Telling Who We Are Through artworks, we can communicate our dreams, visions, and fantasies. Artworks can reveal our playful side and show how we love to experiment.

We also explore techniques and processes, such as using computers to make art. As we do this, we seek new ways to send messages. We explore art's potential to communicate with others. Whether carved into stone or digitized for cyberspace, art sends messages about our lives.

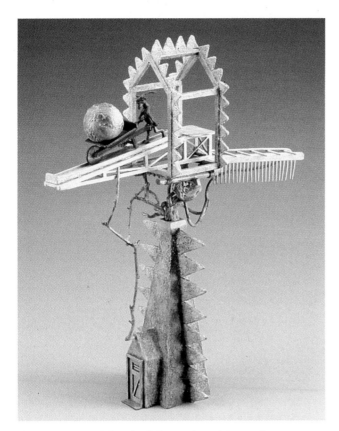

Fig. 1–7 **Rand Schiltz playfully combined forms that seem lighthearted and even silly. Often, however, humorous artworks contain serious messages. What might the message be here?**

Rand Schiltz, *Renovations, Out with the Old, In with the New*, 1991. Vacuum cast bronze and lacquer, 14" x 11" x 4" (35.5 x 28 x 10.2 cm). Courtesy of the artist. Photo by Jock McDonald.

Check Your Understanding

1. What do we mean by "narrative" art?

2. If you compared an artwork about daily life created in the 1800s to one created today, how would they be the same? How would they be different?

3. Use artworks as examples to explain the statement, "Art sends messages."

Communicating with Symbols

You can create an artwork using lines, patterns, and symbols to tell about your life.

- Start your drawing with a personal shape, such as a silhouette of your head, an outline of your hands, or a tracing of your foot.

- Fill this shape with symbols and images that represent things that are important to you or that represent important events in your life.

- Surround those symbols and images with patterns and lines to fill all the spaces within your personal shape.

- Use light pencil lines to plan your artwork. Use a fine-tip marker and colored pencils to complete the drawing.

Reflect on what the symbols and images tell about you.

Fig. 1–8
Student artwork

Using Line and Pattern

If you look carefully at artworks from the earliest times, you can see that line is the oldest and most direct form of communication. Lines are marks made by pushing, pulling, or dragging a tool across a surface. To tell about their lives, people from all cultures have used lines to decorate objects and mark surfaces. Sometimes the lines are combined with additional lines and shapes to form patterns. A pattern is a design in which lines, shapes, or colors are repeated in a planned way.

Line Drawn quickly or slowly, heavily or lightly, line can define space. It can create the illusion of volume and form. One simple line might suggest the belly of a horse, a muscle in a leg, or a fold of cloth. Artists make lines by using a variety of tools and methods. For instance, by using a light pencil line, an artist expresses a feeling different from that of a heavy, painted line.

Artists use lines to create shapes, textures, and patterns. The direction in which lines go and where they are placed can suggest various actions and moods. You can describe a line by the way it looks— straight, curved, or broken, for example. You can also describe lines as being graceful, calm, energetic, and so forth.

Fig. 1–9 **The thrills of a desert hunt are captured in this scene. Where do you see line? Where do you see pattern?**

Egypt, Thebes, *King Tutankhamen after the Hunt*, ca. 1352 BCE. Photo by Fred J. Maroon.

Observe Notice the lines in the illustration below. What words would you use to describe each line?

Tools: Twigs, feathers, cardboard edges dipped in ink, markers, brushes, crayons, charcoal, chalk, pencils of different types, and paper.

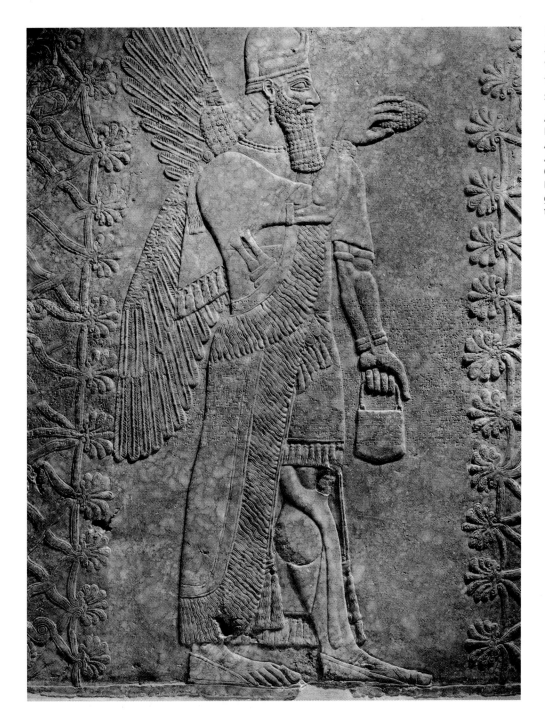

Fig. 1–10 This is an Assyrian relief of a winged genie. How did the artist use lines to suggest actions?

Assyrian, *Winged Genie*, Neo-Assyrian Period, Reign of Ashurnasirpal II, c. 883–859 BC. Alabaster, 93 1/16" x 80 13/16" (236 x 205 cm). Brooklyn Museum, Purchased with funds given by Hagop Kevorkian and the Kevorkian Foundation.

Practice: Line Experiments

- See how many different kinds of lines you can draw.
- Make a series of lines on a sheet of paper.
- Vary the tools you use as well as the thickness of the lines.

Pattern Artists create patterns by repeat-ing lines, colors, or shapes in an orderly or systematic way. Every pattern involves the repeated use of some basic element. This element can be a dot, a line, or a shape. The design that is repeated to form a pattern is called a motif. An overall pattern can help hold an artwork together visually. Small areas of pattern add interest to artwork.

Observe Egyptian artists used pattern in a variety of ways. Notice Fig. 1–11. What patterns do you see in this artwork? Are they overall patterns, or were they created in certain areas to add interest to the artwork?

Tools: Paper with grid boxes, various types of drawing tools such as pencils, pens, and charcoal, colorful markers, and crayons.

Fig. 1–11 This outer coffin is decorated with figures of the gods of the underworld. How did the artist use lines and patterns to decorate this coffin?

Thebes (Egypt), *Outer coffin of Henettawy, Chantress of Amun at Thebes*, 1085–719 BCE. Wood, painted and gessoed, length 79 ⅞" (203 cm). The Metropolitan Museum of Art, Rogers Fund, 1925. (25.3.182). Photograph ©1992 The Metropolitan Museum of Art.

Practice: Pattern Experiments

- Design a motif on grid paper.

- Fill three boxes with lines and colors, making sure each box is different from the others.

- Complete the grid by repeating the motif to form a pattern.

Check Your Understanding

1. How do lines function in artworks?

2. If you were asked to draw a line to express the emotion of love, what would it look like? How do you think it would compare to a classmate's line that expresses the same emotion? Explain.

3. What words would you use to describe the motif and pattern you created?

Studio Time

Cover Messages

You can design a book jacket for your favorite novel or a CD label for your favorite music.

- Plan your cover design and sketch ideas with light pencil lines.

- Experiment with combinations of lines and patterns to repeat as a border around your cover.

- Choose images and symbols that communicate the main theme of the book or collection of music.

- Use markers or colored pencils to finish the design.

Reflect on the line quality and your use of repeated elements to create a pattern.

Fig. 1–12 Student artwork

Create Your Own Message

Studio Background

Throughout history, artists have used lines and patterns to show how people live. What images would communicate a message about your life? Imagine that people in the future will "receive" the message you create.

In this studio exploration, you will use contour lines and pattern to communicate something about your life. Contour lines are lines that follow the edges of forms. Pattern is created by repeating lines in a planned way. Will you show a specific event or something that you do regularly, such as a hobby? Your image should show something that has helped shape the person you are today.

You Will Need

- props
- sketch paper or newsprint
- pencil
- markers
- drawing paper

Step 1 **Plan and Practice**

- Decide what visual message you want your drawing to send. For example, do you want people to know that you are a talented artist? Did you meet a person who has influenced you in some way?

- Choose an event or activity to show in a finished drawing.

- Think about the lines and patterns you will draw to best communicate your message.

Things to Remember:

- ✓ Use contour lines and pattern.
- ✓ Draw poses that will show your message.
- ✓ Include props in your drawing.

Inspiration from Our World

©Robert Maass/CORBIS

Inspiration from Art

Art provides a glimpse of life from around the world and throughout history. It communicates messages from an earlier time.

Artworks that depict people often show them performing an activity. Examine the artwork on this page. Notice how it sends a message through the use of line. The lines in the image record the edges of forms: arms and legs, clothing, musical instruments, and other objects. The artists followed these edges by moving a drawing tool. Look for differences between the length, weight, and thickness of the lines in the images.

Repeated lines can create pattern. Notice the patterns in the picture. Patterns can be simple, as in the earrings worn by the musicians, or more complex, as in the musicians' necklaces. Observe how pattern creates variety and interest in the overall composition.

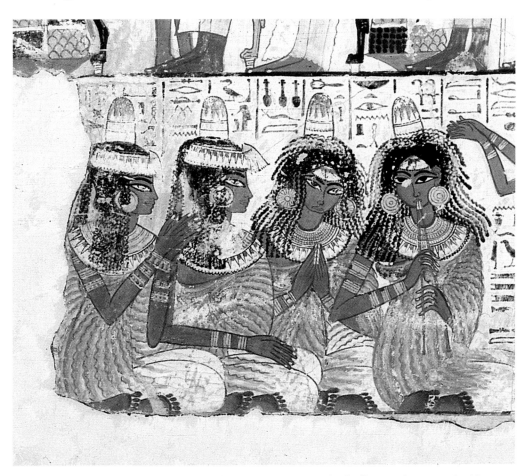

Fig. 1–13 **Contour lines show the forms of these women. How do the lines and patterns in this artwork tell you about how these women lived?**

Egypt, Thebes, 18th dynasty, *Banquet Scene*, (detail), about 1400 BCE. Wall painting. ©The British Museum.

Step 2 **Begin to Create**

- **Sketch classmates posing in different activities that you enjoy.** Practice drawing just the edges of clothing, features, and props. Notice the ripples, creases, and other features of the edges you draw. Exact detail is not important.

- After you have made several practice drawings, choose an event or activity to show in a finished drawing. What visual message do you want the drawing to send about your life?

- **Plan your drawing on a sheet of sketch paper.** How many people and poses will you include? What props will add meaning to your message?

- **Try a variety of ways to create pattern with line.**

- Use markers to make your final drawing.

Step 3 **Revise**

Did you remember to:

✓ Use contour lines and pattern?

✓ Draw poses that show your message?

✓ Include props in your drawing?

Adjust your work if necessary. In your sketchbook, make a note of your revisions and why you made them.

Step 4 **Add Finishing Touches**

- Examine your drawing closely. Add any missing details.

Step 5 **Share and Reflect**

- Share your drawing with a small group of classmates.

- Take turns describing the main features of each other's artwork. Pay attention to the way each of you used contour lines. Note where and how lines were repeated to create pattern.

- Discuss what messages about your lives would be sent if the drawings are found a hundred years from now.

- How did you arrange the parts of your drawing, including lines and patterns, to make the message clear?

- How was this drawing experience similar to or different from other drawing experiences you have had?

Fig. 1–14 Student artwork

Art Criticism

Describe What does the artist show us in this self-portrait?

Analyze Where did the artist use pattern in this self-portrait?

Interpret What does this portrait suggest about the life of middle school students today?

Evaluate What did the artist do especially well in creating this self-portrait?

Art of the Ancient World

Have you ever scratched lines into dirt with a stick or noticed scuff marks on a floor? Sometimes we make marks accidentally, but usually we make them for a purpose. We might doodle to help us think, or draw a map to show someone where we live. When early humans drew on rocks, painted on walls, or carved stones, they did so to communicate.

Prehistoric Messages Some of the oldest known images are more than 25,000 years old. They have been painted on cave walls or carved into rock on every continent. They may have been used to communicate thoughts, to record events, or to educate children.

Most rock art shows humans, animals, and symbols. People often appear as stick figures with spears. Detailed, lifelike animals are shown mostly from the side. People used materials such as chalk, burned wood, and clay, to create these images. Some artists mixed minerals with animal fat to create colored pigments. They applied these colors with their fingers, moss, fur brushes, feathers, or twigs.

Mesopotamian Messages About 7000 years ago, people began to live in Mesopotamia (present-day Iraq). They created art to tell about their powerful rulers. The artworks were made of wood, gold, silver, gemstones, shells, stone, and clay. Some tell stories of hunts, battles, and ceremonies. Some also show the rulers as animal gods.

In 3000 BCE, the Mesopotamians developed a system of writing called cuneiform. Cuneiform writing was writing made up of symbols pressed into clay tablets. It was used to keep records.

ca. 15,000 BCE
Hall of Bulls,
Lascaux

3000 BCE
Cuneiform
writing

ca. 2685 BCE
Sumerian,
Standard of Ur

ca. 1297 BCE
Ptahmoses
of Memphis

490 BCE
A messenger runs from
Marathon to Athens to
spread news of a victory.

15,000–490 BCE

4000–3500 BCE
The Egyptians discover
the use of papyrus.

3000 BCE
Egyptian priests develop
a system of writing called
hieroglyphs.

ca. 2589 BCE
Pyramid of
Cheops

1200 BCE
The Phoenicians finalize their
22-character alphabet, which
was borrowed by the Greeks.

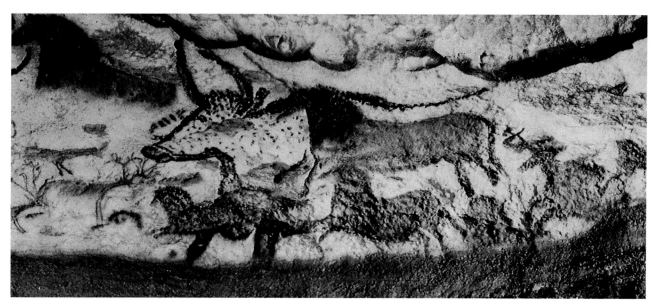

Fig. 1–15 **These cave paintings may have been created to tell stories and to educate children. What do you think the children learned from these images?**

Lascaux, *Hall of Bulls*, detail, ca. 15,000–13,000 BCE, Dordogne, France. Color photo Hans Hinz.

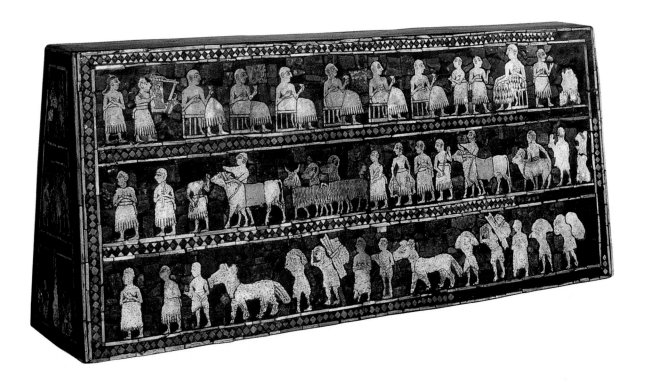

Fig. 1–16 **This panel tells a story of peace after a battle. Notice that the king is larger than everyone else. What message does this image send?**

Sumerian, *Standard of Ur: Peace*, about 2685–2645 BCE. Mosaic Panel of shell and colored stones, 19" (48cm) long. Royal Cemetery at Ur. ©The British Museum.

Ancient Egyptian Messages Powerful kings called pharaohs ruled ancient Egypt. They built royal cities and commanded artisans to create artworks. These artworks told important stories about the daily life of the pharaohs.

The earliest Egyptian stone structures, carved monuments, tomb paintings, and artifacts of daily life are almost 5000 years old. These objects are records of ancient Egyptian life and culture. Some of these objects include hieroglyphs. Hieroglyphs are an early form of picture writing.

The Egyptians believed that their pharaohs were gods who would live after death. Many pharaohs had their tombs built in the form of pyramids. Tombs were filled

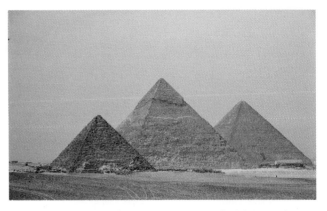

Fig. 1–18 **The pyramids were once covered with smooth stone that reflected sunlight. What message might that convey to someone looking at the pyramids from a distance?**

Giza, Egypt, *The Pyramids of Mycerinus, Chefren, and Cheops,* built between 2589 and 2350 BCE. Limestone. Erich Lessing/Art Resource, NY.

with furniture, jewelry, and other items that the rulers would need in the afterlife. Wall paintings, relief sculptures, and small models in the tombs tell stories of servants bringing gifts, harvesting crops, and fishing.

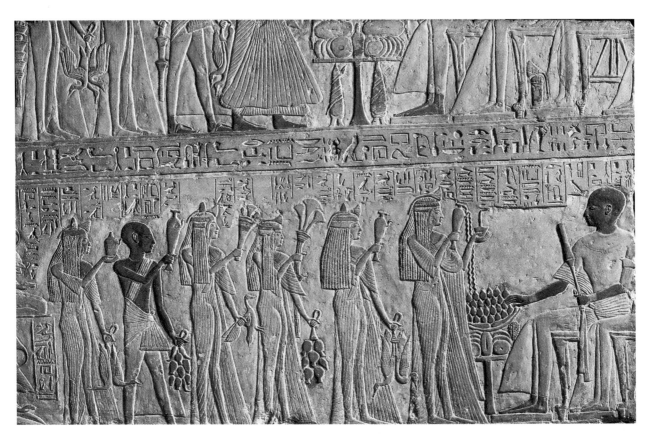

Fig. 1–17 **How does this painted relief reflect the Egyptian artistic rules for showing people?**

Egypt, *Ptahmoses, high-ranking official of Memphis receiving offerings from his children,* 19th dynasty. Painted relief. Museo Archeologico, Florence, Italy. Scala/Art Resource.

Meet Ancient Egyptian Artists

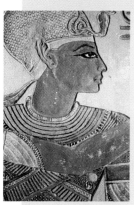

For centuries, artists in Egyptian kingdoms sent messages using a single set of artistic rules. Artists were valued for their ability to follow these rules, rather than for their originality. For example, drawings of people were always carefully measured for correct human proportions. Human proportions are the ideal relationship between various parts of the human body. Ancient Egyptian artists always outlined the human figure. They always showed the shoulders and one visible eye as though you were looking at them from the front. The head, arms, and legs were always drawn in profile, as though seen from the side.

Much of Egyptian art is considered timeless. Artists today use many of the same artistic principles that the ancient Egyptian artists used nearly 5000 years ago.

"The Egyptians...searched for the permanent essence and the typical character of an object."

— Kurt Hübner

Check Your Understanding

1. What materials did prehistoric people use to create art?

2. Prehistoric people, Mesopotamians, and ancient Egyptians all used art to communicate. How are their messages different from one another? How are they the same?

3. Why do you think Egyptian pharaohs valued artists who followed the rules?

Studio Time

Freeze the Action

As a contrast to the Egyptian style of figure drawing, try gesture drawing to record human figures in action.

- Remember that gesture drawings are made with quickly drawn lines that define the basic position and mass of a figure.

- Use quick easy strokes to capture a pose or action with just a few lines. Your drawing does not have to be realistic.

- Draw your friends or classmates quickly as they "freeze" in different action poses for a few moments.

Reflect on the line quality of your drawing. Compare the style of your drawing with the Egyptian and Assyrian artworks shown in this unit.

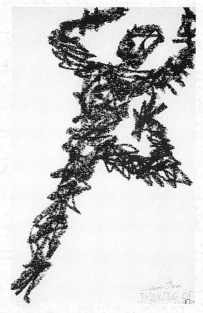

Fig. 1–19 Student artwork

Messages of African Kingdoms

Understanding Meaning People create art for special purposes, but we can't always tell what the artwork's purpose is just by looking at it. Often, we can't receive the messages the artwork sends unless we have learned the cultural meaning of its symbols. An artwork's cultural meaning is a meaning that only members of a specific culture can understand. Knowing what the artwork is used for can also help us understand its messages.

Sending Messages By looking at African objects and traditions, we can tell that much African art—both past and present—has been created to send messages to spirit worlds or community members.

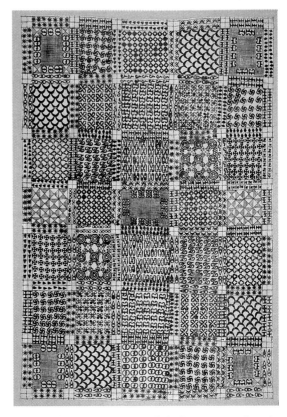

Fig. 1–20 **This hand-stamped cloth is worn at functions for departing guests and at funeral ceremonies. What message do you think the cloth communicates?**

Asante people, Ghana, *Display Cloth*, late 19th century. Cotton Cloth, natural dye, 82 ¾" x 118 ⅞" (210 x 302cm). Museum Purchase, 83-3-8. Photograph by Franko Khoury. National Museum of African Art, Smithsonian Institution, Washington, DC.

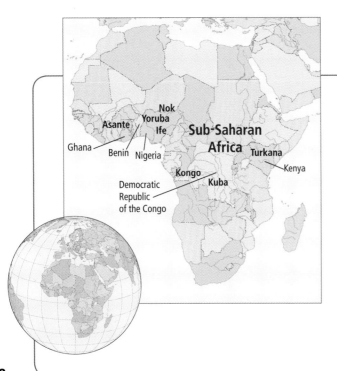

Social Studies Connection

Africa is divided almost in half by the equator. The tropical rain forest near the equator receives over 100 inches of rain every year. North of the equator is the vast Sahara desert. The desert areas in Africa receive less than one inch of rainfall each year.

Africa has many diverse cultural groups. Because of this, various creative traditions with long histories are represented in African art. Sadly, much of the early African artwork south of the equator was destroyed by hot weather and insects.

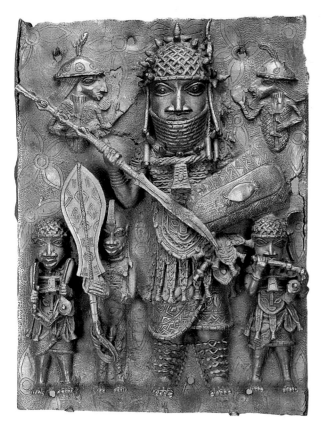

Fig. 1–21 **This bronze relief sculpture once decorated the king's palace in Benin. What does this plaque tell about royal life in Benin?**

Edo peoples, Benin Kingdom, Nigeria, *Plaque*, mid-16th–17th century. Cast copper alloy, 116.8" (46 cm). Purchased with funds provided by the Smithsonian Acquisition Program, 82-5-3. Photograph by Franko Khoury. National Museum of African Art, Smithsonian Institution , Washington, DC.

Visual Culture

In this lesson, you have learned that in some African cultures, clothing and headdresses can send messages. Consider the many different types of hats and head coverings that people wear for work, play, and special times. Think about how the colors and symbols send messages. Also consider the many different messages and designs that we see on T-shirts and jackets. What do these tell us about the people who wear them?

Artworks from the widespread African kingdoms are made in many different materials and styles. They have multiple levels of meaning and a variety of uses. Household objects such as spoons and stools, sculptures of figures and animals, jewelry, and fabrics are often used to send messages about power, status, hope, good health, and the like.

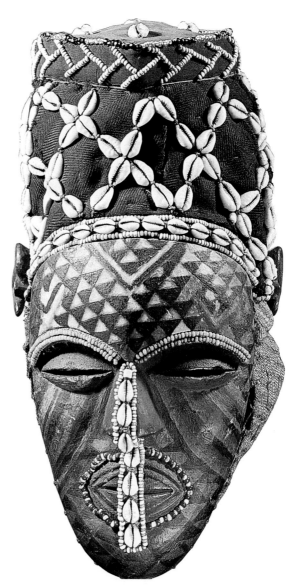

Fig. 1-22 **This mask communicates sorrow and was used in a performance that honored deceased people. What do the parallel lines under the eyes suggest to you?**

Democratic Republic of the Congo; Kongo, Kuba, *Female Mask (Ngady Mwaash)*, 19th century. Wood, cowrie shells, glass beads, paint, raffia cloth, trade cloth, height: 13 ⅜" (34cm). ©Bildarchiv Preussischer Kulturbesitz, Berlin.

Identifying Art's Function Many African artworks are used in rituals, ceremonies, and celebrations. For example, handcrafted objects and costumes might be used to communicate with spirits. Sometimes, carved wood masks are used as part of a costume. They are also used to mark the time when children become adults and when judging a person accused of a crime. Each situation has its own special ritual that makes use of certain types of art.

African Influence The arts of ancient North Africa were an early influence on Western culture. Beginning in the 1800s, African artisans began producing art objects for trade. African artworks were first displayed in Europe during the late 1800s. They were used in ritual celebrations or other ceremonies, and most of them were replicas. A replica is a copy of an item. Artworks like these influenced such Western artists as Pablo Picasso and Henri Matisse early in the 1900s. Today, many museums have collections of African art.

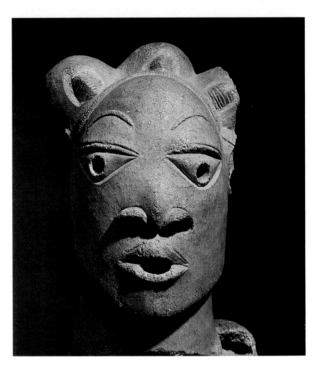

Fig. 1–23 **This Nok sculpture is about 2000 years old. It probably served a religious function. What do you think is the intended message?**

Nok culture, Nigeria. *Terra cotta head from Rafin Kura*, 500 BCE–200 CE. Frontal View. National Museum, Lagos, Nigeria. Werner Forman/Art Resource, NY.

Fig. 1–24 **This headdress is made to be worn in a dance. Such performances make comments on current events and community conditions. What message do you see?**

Yoruba people, Nigeria. *Magbo Headpiece for Oro Society*, first half of 20th century. Wood, pigment, cloth, iron, metal, foil, mastic; height: 28 5/16" (71.9cm). Indianapolis Museum of Art, Gift of Mr. and Mrs. Harrison Eiteljorg.

Check Your Understanding

1. When were Western cultures first introduced to African art?

2. Compare the African use of masks to the American use of masks. How are they used similarly? How are they used differently?

3. Why is knowledge about a culture important for understanding the meaning of its artworks?

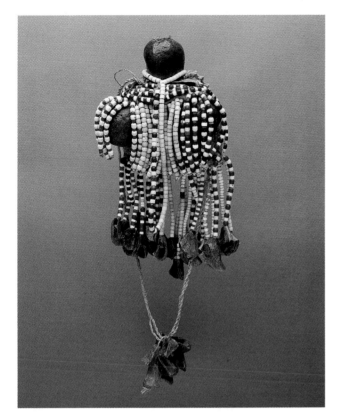

Fig. 1–25 Bead-decorated figures like this one, made from a gourd, are more than playthings. How does this figure communicate a hope to bear children?

Turkana (Kenya), *Doll*. Gourd, beads, glass, fiber, leather, horn, 10" x 2 ½" (25.4 x 6.3 cm). Seattle Art Museum, Gift of Katherine White and the Boeing Company. 81.17.1077. Photo by Paul Macapia.

Meet Yoruba Artists

The Yoruba live in Nigeria and the Republic of Benin. Their art can be traced back to before the year 1100 CE.

Yoruba artists create artworks according to customer requests, but are expected to blend their own interpretations into the pieces. Unique personal style is important to the success of Yoruba artists. One should be able to identify the creator of each specific Yoruba artwork through the individual style and message reflected in the piece.

"Our tradition is very modern."

— Yoruba expression

Sculpture with a Message

You can construct a sculpture to send a message about a social issue, an important event, or a joyous occasion.

- Plan your sculpture to be freestanding, perhaps with a flat base.

- Select materials and choose colors that will help communicate a mood and feeling.

- Carefully arrange and glue the parts of your sculpture.

- Add lines, shapes, textures, patterns, and other details to help communicate your message.

Reflect on how well your sculpture communicates the message you intended.

Fig. 1–26 Student artwork

Bas-Relief Sculpture in Clay

Studio Background

Think about a public statue or monument you have seen. How big was it? Why was it made? Who or what does it help you remember?

In this studio exploration, you will carve, model, and emboss clay to create a bas-relief sculpture. A bas-relief, or low relief, sculpture is a sculpture that is viewed only from one side, like a wall plaque. Some parts of the design stand out from the background. Your sculpture will send a message about an event in your life or an activity you enjoy.

There are several ways to create bas-relief sculpture in clay. You can scoop out unwanted clay by carving it with simple tools. You can model a clay slab by shaping it with your fingers or adding smaller pieces of clay to it. To emboss clay, you press objects into its surface to create marks. Use all three techniques in your sculpture.

You Will Need

- clay
- paper clip
- board covered with cloth
- rolling pin or dowel
- finishing materials
- wooden slats
- clay modeling tools or tongue depressor
- found objects
- finishing materials

Step 1 **Plan and Practice**

- Decide what message your sculpture will tell. What purpose will it serve?

- Plan how you will show your message. Will your sculpture be vertical or horizontal? How will it be shaped? How will you use line and pattern?

Inspiration from Our World

Things to Remember:

✓ Fill the space of the clay slab with your composition.

✓ Use all three techniques—carving, modeling, and embossing—in your sculpture.

✓ Use line and pattern to create your message.

Inspiration from Art

In ancient cultures, bas-relief sculptures were often created to help people remember a special accomplishment or dramatic story such as a military victory, the opening of a new waterway, or the completion of a large building project. The artwork shown in **Fig. 1–27** is an ancient example of a bas-relief sculpture.

Many artists also created sculptures in order to impress the general public. The people who created these kinds of sculptures were highly skilled artists. Even though the sculptures are fairly flat, they are very detailed and show a feeling of depth.

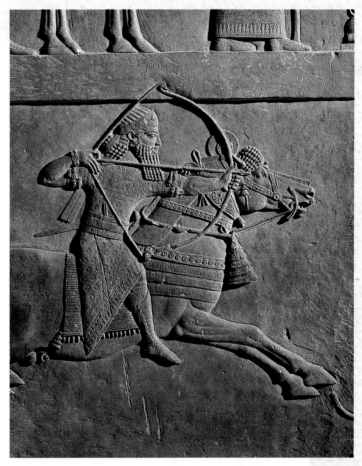

Fig. 1–27 **This relief shows a soldier in battle. How many different patterns do you see? What are they? How could you make these in clay?**

Assyrian, *Ashurbanipal in battle*, 7th century BCE. The Trustees of the British Museum.

Step 2 Begin to Create

- Begin by using a rolling pin or dowel to roll out clay into a slab about ½- to 1-inch thick.

- Cut the slab into the shape you want with a paper clip.

- **Carve the clay to create high and low relief areas.** Think about how the high and low areas of the relief will create areas of light and dark.

- **Model the clay: Pinch and pull it with your hand or attach coils, pellets, and ribbons of clay with slip.**

- **Emboss the surface by pressing objects into it to create interesting textures.**

- When you are satisfied with your work, put it aside to dry evenly and slowly. Your teacher will supervise the kiln firing when the sculptures are dry.

Step 3 Revise

Did you remember to:

✓ Fill the space of the clay slab with your composition?

✓ Use all three techniques—carving, modeling, and embossing—in your sculpture?

✓ Use line and pattern to create your message?

Adjust your work if necessary. In your sketchbook, make a note of your revisions and why you made them.

Step 4 Add Finishing Touches

Finish your work in one of the following ways:

- Rub neutral pigments or moist dirt into the embossed areas. Before the dirt or pigment dries, wipe the raised surfaces with a moistened rag. Add a protective coat of liquid wax or clear gloss polymer.

- Paint your sculpture with acrylic paint. Use only one color. After the paint is dry, stain it with diluted black acrylic or shoe polish.

Step 5 **Share and Reflect**

- Share your bas-relief sculpture with your classmates.

- Discuss the message you tried to communicate and whether or not you were successful in doing so.

- Talk about the techniques you used to create your sculpture. Explain how you used modeling, embossing, carving, lines, and patterns.

- How do you feel about the artwork you have just completed? Explain your answer.

- What have you learned about the question of why we make art?

Art Criticism

Describe Tell what you see in this tile.

Analyze How has the artist used line and pattern and arranged all the parts of this tile?

Interpret What message or story does this tile tell?

Evaluate What makes this clay tile a successful bas-relief sculpture?

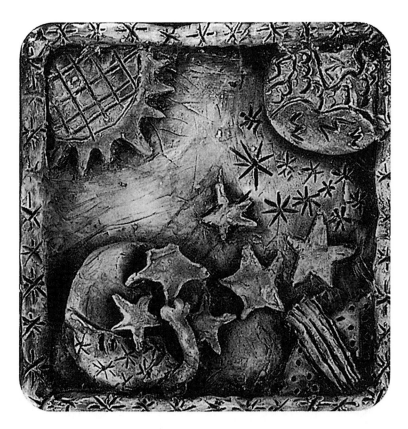

Fig. 1–28 Student artwork

Social Studies

Artworks and monuments send messages about both culture and history. Their meanings might depend on who the viewer is and where the viewer is from. Some works are widely recognized and become part of general cultural knowledge. Sometimes, artists "copy" and change such works. For example, Stonehenge is a stone structure in England that has been recreated with objects other than monumental stones, such as in **Fig. 1–29**.

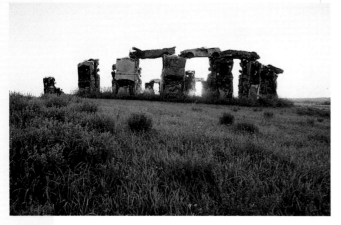

Fig. 1–29 **What does this monument tell about the artist's culture?**

William Lishman, *Autohenge*, 1986. Crushed, painted, automobiles. Blackstock, Ontario. Photo by W.M. Lishman.

Dance

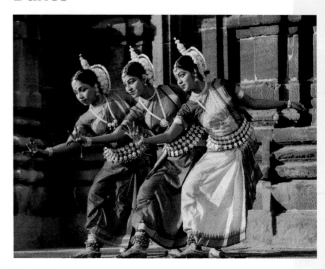

Fig. 1–30 ©Jim Zuckerman/CORBIS.

Dance communicates our questions and ideas about who we are and about our relationships to others. Think about how a work of dance communicates a mood such as danger, sadness, or love. How do the elements of the dance—such as its speed or rhythm—create this mood? What message might the dance send? How might a dance's message differ from a visual artwork's message? What might that tell you?

Careers **Archaeologists**

Archaeologists are scientists who provide us with information about how people in ancient cultures lived. Many archaeologists also have artistic skills, such as the ability to observe carefully, draw, or paint. These skills are important because archaeologists need to accurately record historic finds and help interpret messages from the past.

An archaeologist goes on field studies to search for tools, buildings, and other evidence of a culture. The archaeologist then interprets the information, giving us a picture of the past.

Fig. 1–31

Fig. 1–32 **What message do you think the artist who created this coffin was trying to send?**

Coffin of Bakenmut, detail, Egypt, late 21st–22nd dynasty. Gessoed and painted sycamore fig wood, 81 ⅞" x 172.7" (208 x 68 cm). ©The Cleveland Museum of Art, Gift of John Huntington Art and Polytechnic Trust, 1914.561.a-.b

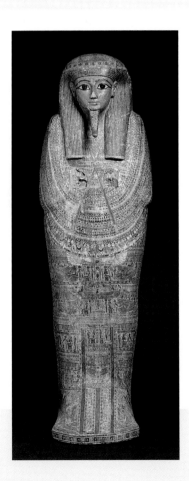

Daily Life

Whether created on stone, wood, cloth, or clay, ancient symbols of language and ideas send messages. For example, Adinkra stamps, Egyptian hieroglyphs, and cuneiform writing were once understood by people from particular cultures; however, we often do not fully understand the meaning of such ancient symbols.

Look around your environment for cultural messages. What product brands do you recognize and understand just from their symbols? What messages can you find that are meant to be seen by many people?

Vocabulary Review

Match each art term below with its definition.

lines

pattern

cuneiform

cultural meaning

contour lines

1. a design in which lines, shapes, or colors are repeated in a planned way

2. a Mesopotamian system of writing made up of symbols pressed into clay tablets

3. meaning that only members of a specific culture can understand

4. marks made by pushing, pulling, or dragging a tool across a surface

5. lines that follow the edges of forms

Aesthetic Thinking

When an artwork's meaning can be understood only by members of the artist's cultural group, or was made so long ago that the message is not certain, why exhibit it for others? Does it, then, take on new meaning?

Write About Art

Look closely at the symbols in this Inca tunic from Peru. Make a list of the symbols and the ideas that they suggest to you.

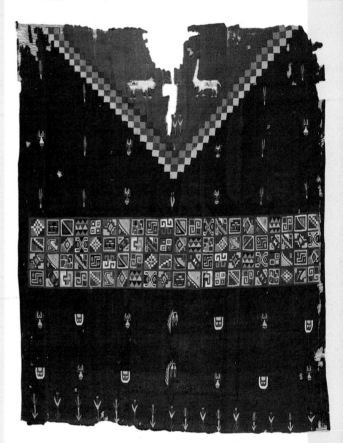

Fig. 1–33 **Artworks that show symbols can be more difficult to understand than artworks that show objects we know.**

Peru, South Coast, Inca, Early Colonial Period, *Half-Tunic*. Interlocked tapestry: cotton warps and wool wefts, 37 ½" × 28 ½" (95.3 × 72.5 cm). ©The Cleveland Museum of Art, The Norweb Collection, 1951.393.

Art Criticism

Describe What representational forms do you recognize in this sculpture?

Analyze How are the many parts and forms arranged, and what features are repeated?

Interpret Considering the title given by the artist, what might be the message of this sculpture?

Evaluate What sets this sculpture apart from others you have seen in this book?

Fig. 1–34 Rand Schiltz, *Renovations, Out with the Old, In with the New*, 1991. Vacuum cast bronze and lacquer, 14" x 11" x 4" (35.5 x 28 x 10.2 cm). Courtesy of the artist. Photo by Jock McDonald.

Meet the Artist

Rand Schiltz was born in Omaha, Nebraska. He now lives in California. Schiltz has been working as a metalsmith and jewelry designer for more than twenty-five years. He makes most of his sculpture from cast bronze. Many of Schiltz's sculptures include animal figures in architectural settings.

"Using satire and humor, I stage these animal characters to tell a story or to make a visual comment."

— Rand Schiltz (born 1950)

Detail of *Renovations, Out with the Old, In with the New.*

For Your Portfolio

Create a portfolio and add to it an artwork that you created during this unit. Choose an artwork that best sends your intended message through the use of elements and principles of design. Include your message on a self-stick note.

For Your Sketchbook

Design symbols for human emotions. For example, instead of using facial expressions for an emotion, use line and pattern to express it. Add to your sketchbook throughout the year.

Artists Show
Identity and Ideals

Fig. 2–1 The Mayan ruler represented in this sculpture wears a very complex headdress. What other details in this artwork might suggest this ruler's identity?

Mayan, *A Ruler Dressed as Chas Xib Chac and the Holmul Dancer*, ca. 600–800. Ceramic with traces of paint, 9 ⅜" (23.8 cm) high. Kimbell Art Museum, Fort Worth, TX / Art Resource, NY. Photo by Michael Bodycomb.

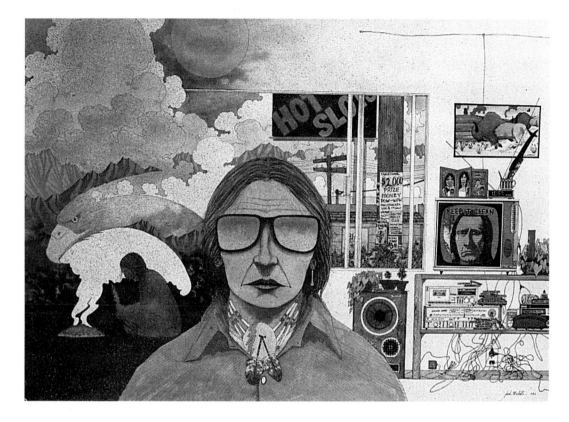

Do you usually spend your days alone or with others? Although people tend to live, work, and play together, each of us has our own identity. Identity means who we are as an individual. Much of our identity comes from the people around us and from the groups to which we belong.

Members of a group often share ideals. Ideals are views of what the group thinks a perfect world would be like. Groups are usually made up of people who have similar goals or beliefs. Throughout history, people have created art that shows and celebrates these similarities.

In this unit, you will learn:

- How artists create artworks that reflect and preserve the ideals that hold people together.

- How to use rhythm and texture in drawings, mosaics, and sculptures.

- How to look at artworks as a means by which people express individual and group identity and ideals.

Showing Shared Beliefs

Imagine a Fourth of July parade. What do members of a group marching in the parade have in common? How do they show that they are a group? Marching band members, for instance, might show their group identity by their uniforms. The uniforms are symbols. A symbol is something that stands for something else. Symbols help to represent a group and show what the members believe.

Showing Group Identity The way artworks look can tell us something about what is important to a group. For example, the ancient Greeks believed that the ideal person could control both mind and body. This ideal being was calm, strong, flexible, and well proportioned. Where can you see examples of these qualities in the sculpture in Fig. 2–3?

Some artworks are used in important ceremonies or rituals to remind the group of significant beliefs. For example, the mask in Fig. 2–4 was worn by the Native American Kwakiutl (kwah-key-OOT-ul) in ceremonies held to distribute property and to make contracts official. Notice how the eyes and eyebrows are painted a deep, striking black. This creates emphasis. In art, creating emphasis means catching a viewer's attention through changes in color, size, or shape.

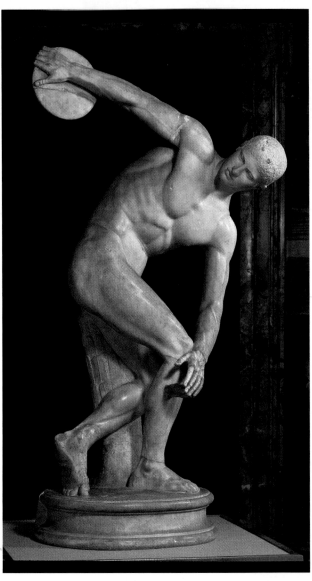

Fig. 2–3 **How has the artist shown the strength of this discus thrower?**

Myron of Athens, Discobolus (Discus Thrower), Roman copy of Greek original (ca. 450 BCE). Museo Nazionale Romano delle Terme, Rome, Italy. Scala/Art Resource, New York.

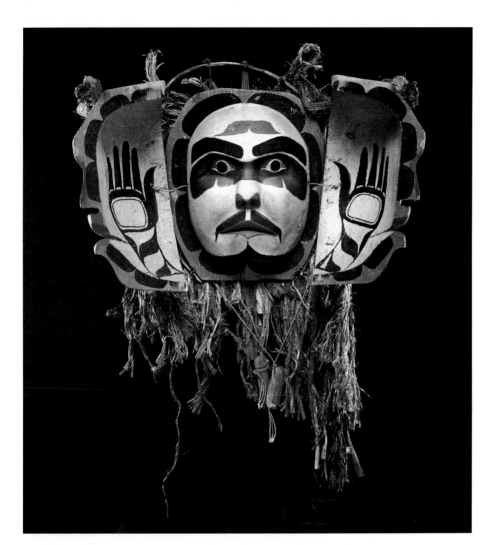

Fig. 2–4 **How might this Native American mask show that the wearer belongs to a group?**

Hopetown, *Mask of Born-to-Be-Head-of-the-World.* Wood, reed and undyed cedar bark, rope, 24 ½" x 29 ⅝" x 9 ⅛" (62 x 75 x 23 cm). No. 4577 (2). Photo by Lynton Gardiner. Courtesy Department of Library Services, American Museum of National History.

Meet the Northwest Coast Artists

The Pacific coast of Canada and northern United States is known as the Northwest Coast. Northwest Coast peoples such as the Yup'ik, Inuit, Kwakiutl, and Haida are known for artwork with simple shapes and strong outlines of human and animal forms.

Traditional Northwest Coast maskmakers usually worked alone, carving their works from red cedar wood. They mixed their own paints using natural materials. Chewed, dried salmon eggs helped hold the paint together. The masks could be simple, but some were heavy and complicated, with hinges and moving parts. Northwest Coast maskmakers are still working today, blending old ways with new.

"Throughout our history, it has been the art that has kept our spirit alive."

— Robert Davidson, Haida artist

Showing Group Ideals Through Art

People like to celebrate and display what they believe is important or ideal. United States citizens understand that the red, white, and blue flag with stars and stripes stands for their country. The flag also stands for American ideals such as democracy, freedom, responsibility, and loyalty. When artists use this powerful symbol, they expect viewers to recognize a message about American ideals.

Ideals are also often presented through a culture's customs. For example, color, style, and fabric patterns all have special meaning in China. In the past, men would wear a dragon robe like the one shown in Fig. 2–6 for official business. Historically, the dragon was usually associated with China's emperor. It is still a symbol of authority. The patterns on the robe that represent water, clouds, mountains, fire, and grain also symbolize the Chinese ideals of power and authority.

Check Your Understanding

1. Why might a group of people represent themselves with a symbol?

2. Imagine that an artist created an artwork like the one pictured in Fig. 2–5, but showed the flag of another country in place of the American flag. How would the ideals reflected in the pieces differ? How would they be the same?

3. What can the design of an artwork tell you about the identity of the people who made and used it?

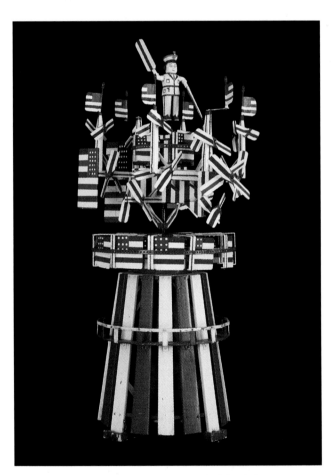

Fig. 2–5 **Why do you think the artist combined the playfulness of the whirligig with the seriousness represented by the flag?**

Frank Memkus, *Whirligig Entitled "America,"* 1938/42. Wood and metal, 80 ¾" x 29" x 40" (205 x 73.7 x 101.6 cm). Restricted gift of Marshall Field, Mr. and Mrs. Robert A. Kubiceck, Mr. James Raoul Simmons, Mrs. Esther Sparks, Mrs. Frank L. Sulzberger, and the Oak Park-River Forest Associates of the Woman's Board of The Institute of Chicago, 1980.166. Photo by Thomas Cinoman. Photograph ©1999, The Art Institute of Chicago, All Rights Reserved.

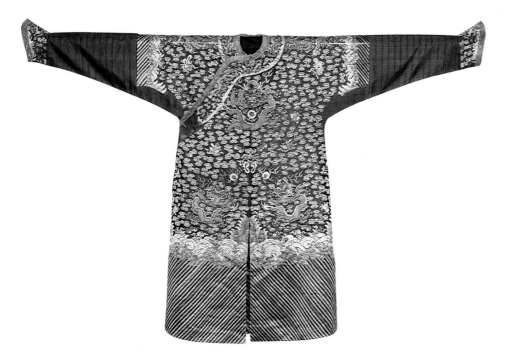

Fig. 2–6 **This robe was worn for daily official business. What kinds of people do you think might have worn it?**

China, Dragon Robe, late 19th century (Quing dynasty). Embroidery on silk gauze, 53 ½" x 84" (135.9 x 213.4 cm). Asian Art Museum, San Francisco, The Avery Brundage Collection, 1988.3.

Studio Time

Painting a Self-Portrait

Create a self-portrait with symbols to show who you are and what you care about.

- Use a mirror and refer to proportion guidelines to make sketches. Make several sketches of things, such as favorite objects, animals, or pets. How can you include these in your self-portrait?

- Use light pencil lines to plan the final drawing before adding color.

- Draw or paint background and light colors first. Work from light to dark for shading and variations in skin tones.

- If making a painting, use a fine-tip brush for details. Try to create emphasis with changes in color, size, and shape.

Fig. 2–7 Student artwork

Reflect on how the objects you have included help to identify your values and ideals.

Using Texture and Rhythm

Looking at Texture Every object has texture. Texture is how a surface feels when you touch it. In art, there are two kinds of textures. Actual textures are those you can really feel. For example, the actual texture of a stone is usually rough; glass is usually smooth. Implied textures are textures that only look like actual textures. They are seen in two-dimensional artworks such as paintings and drawings.

Examples of implied texture

Artists use different media to create textures. A glossy surface has a shiny texture because it reflects light. A rough surface absorbs light and looks dull. For example, a mosaic (Fig. 2–9) is an artwork made by fitting together small materials such as colored glass, tiles, stones, paper or other materials, a process called tesserae. The texture of a mosaic depends on the materials the artist uses.

Observe Look at the image shown in Fig. 2–8. What words might you use to describe the textures you see?

Tools: Paper, fine-tipped drawing tools, such as pencils, markers, and pen and ink.

Practice: Actual and Implied Textures

- Find some three-dimensional objects in your classroom.
- On a sheet of paper, name the objects and describe their actual textures.
- Draw the objects using implied textures.

Mimi Smith, *Steel Wool Peignoir*, 1966, 59" x 26" x 8". Spencer Museum of Art, museum purchase, Helen Foresman Spencer Art Acquisition Fund.

Fig. 2–9 **Imagine clapping out the rhythm you see in this mosaic. What would it sound like?**

Byzantine, The Court of Justinian, ca. 547. Mosaic, 8' 8" x 12' (2 .64 x 3.65 cm). S. Vitale, Ravenna, Italy. Scala/Art Resource, NY.

Looking at Rhythm Feel your heartbeat. Tap your foot to music. Rhythm is a kind of movement that is related to pattern. Artists create rhythms by repeating visual elements such as lines, shapes, and colors in an organized way. Rhythms help lead the viewer from one point to another within an artwork.

In a *regular* rhythm, one visual element, such as a circle, is repeated over and over. In an *alternating* rhythm, a set of visual elements are repeated, such as a circle and a square. In a *flowing* rhythm, there is a graceful path of repeated movements with no sudden changes.

A *progressive* rhythm has a repeated element with regular changes, such as a series of circles with each slightly bigger than the next. In a *jazzy* rhythm, the repeated elements are used in complicated and unexpected ways.

A flowing rhythm

Observe Look at the image in Fig. 2–9. Notice the vertical folds of the gowns and robes, the round heads, and the spaces between the heads. How do these repeated elements help create rhythm?

Tools: Paper, writing tools such as pencils, markers, or pen and ink.

Practice: Rhythm

- On a sheet of paper, create examples of regular, alternating, flowing, progressive, and jazzy rhythms.
- Use letters from your name as your visual elements.

Check Your Understanding

1. Explain one way that artists can create rhythm in an artwork.

2. How are actual textures and implied textures the same? How are they different?

3. Why is it important to consider texture and rhythm when creating an artwork?

Studio Time

A Paper Mosaic

Create your mosaic by using an assortment of papers cut or torn into small pieces.

- Design your mosaic to show a detail from an image that might be used as a symbol in a decorative border design. Think about which colors, types of paper, and shapes might relate to a thematic border.
- Combine materials that have different textures. For example, you might contrast a smooth, shiny material, such as foil, with a rough, dull material, such as sandpaper.
- Create rhythm in your mosaic by repeating visual elements such as lines, shapes, and colors in an organized way.

Reflect on how well your mosaic shows texture and rhythm.

Fig. 2–10 Student artwork

Sculpting Your Identity

Studio Background

You've seen that some artworks can show group identity and encourage group ideals by using symbols. Think of the groups you belong to that help make up your identity. The family is the first group to which most of us belong. You might also belong to a religious group, a sports team, or a club. What other groups do you belong to?

In this studio exploration, you will make a papier-mâché self-portrait that uses symbols to tell about who you are and what is important to you. A self-portrait is an artwork you make that shows yourself.

You Will Need

- pencil
- scrap paper
- wire or pipe cleaners
- papier-mâché paste
- tape
- newspapers
- blank newsprint paper
- paper towels or tissues
- modeling tools
- assorted found materials
- acrylic paint, varnish, and paintbrushes (optional)

Step 1 Plan and Practice

- Make a list of some groups you belong to, and a list of your ideals.
- Draw symbols to represent each item on the list.
- Sketch portrait ideas, including poses and where you could include symbols.

Things to Remember:

✓ Include symbols that represent both the identity of a group you belong to and your ideals.

✓ Pose your sculpture in a way that shows who you are.

✓ Consider and use texture and rhythm in your artwork.

Inspiration from Our World

©Dennis MacDonald / Alamy.

Inspiration from Art

Art can show what a person looks like on the surface. It can also show deeper characteristics such as what the person loves or hates and how he or she feels. A person's identity, including his or her ideals, values, and beliefs, can be shown in different ways. The artist might show the person doing something. Or the person might be shown dressed a certain way. Artists also use facial expression to show emotions.

Notice the sculptures shown in **Fig. 2–11** and **Fig. 2–12**. Both artists carefully chose the symbolic objects they included in their portrait sculptures. Notice where these objects are placed within the sculptures. What does the placement of the objects tell us about these people? How did the artists give us information about the people they sculpted? What do the materials the artists chose tell us about the people they portrayed?

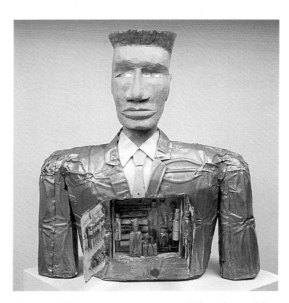

Fig. 2–12 **This contemporary portrait bust has wild orange hair and a green, formal suit. What do you think these features might symbolize?**

Alison Saar, *Medicine Man*, 1987. Wood and tin, 27" (68.6 cm) high. Phyllis Kind Gallery, NY.

Fig. 2–11 **The artist chose a symbol of this person's identity. To what group might this person belong?**

Peter Vandenberge, *Hostess*, 1998. Ceramic, stains, slips, Underglazes, 46" x 22" x 13" (116.8 x 55.9 x 33 cm). John Natsoulas Gallery, Davis, CA.

Step 2 **Begin to Create**

- Build an armature for your sculpture. An armature is a system of support, similar to a skeleton, used to make a sculpture.

- **Bend wire into the pose you desire.**

- **Wrap paper tightly on the armature.** Add rolls or wads of paper towels or tissues to build the head, hands and feet, and other special features. Tape them in place.

- **Wrap the sculpture with four or five layers of paste-soaked newspaper strips.**

- Add a final layer made from strips of blank newsprint paper.

- **When the sculpture is dry, add a face, hair, clothes, symbols, and decorations with paint, yarn, fabric, buttons, and found objects.**

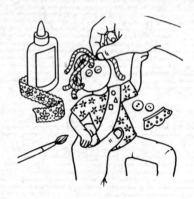

Step 3 **Revise**

Did you remember to:

✓ Include symbols that represent both the identity of a group you belong to and your ideals?

✓ Pose your sculpture in a way that shows who you are?

✓ Consider and use texture and rhythm in your artwork?

Adjust your work if necessary. In your sketchbook, make a note of your revisions and why you made them.

Step 4 **Add Finishing Touches**

- Check to make sure your sculpture is complete. Make any necessary changes or additions.

Step 5 **Share and Reflect**

- Display completed self-portraits and discuss them as a class. How does each self-portrait show identity and ideals? Discuss whether or not each artist successfully showed the group to which he or she belongs.

- How did you decide about the overall form of your sculpture?

- What advice would you give to others about making a self-portrait sculpture that shows their identity and ideals?

Art Criticism

Describe What does the artist show in this portrait sculpture?

Analyze How has the artist chosen to show the figure?

Interpret What do you think this sculpture is about?

Evaluate What do you like best about this sculpture?

Fig. 2–13 Student artwork

Art of Greece, Rome, and Byzantium

The cultural ideals held by the Greek, Roman, and Byzantine civilizations greatly influenced art in many parts of the world.

When Greek culture was at its height, Rome was just a village of huts. The Romans eventually conquered Greece and many other areas. In 330 CE, Rome's last important emperor, Constantine, moved the capital to Constantinople. Near his death, Constantine became a Christian. His new empire, called Byzantium, embraced Christianity and its ideals.

Greek Perfection Artists in ancient Greece experimented with different kinds of art, such as sculpture, painting, mosaics, and architecture. Their goal was to achieve harmony and balance. The Greek idea of beauty was based on perfect proportions and balanced forms.

Greek art reflects the culture's idea of a perfect person. Artists tried to show this perfection by not including features that make each person unique, such as wrinkles or freckles.

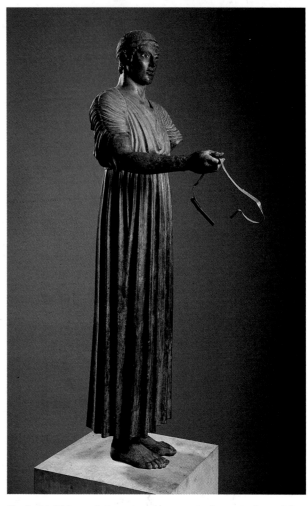

Fig. 2–14 **This sculpture was once part of a grouping with a chariot and horses. How does this sculpture reflect Greek ideals?**

Greek (Classical), *The Charioteer of Delphi* (side view). Dedicated by Polyzalos of Gela for a victory either in 478 or 474 BCE. Bronze, 71" (180 cm) high. Archaeological Museum, Delphi, Greece. Nimataliah/Art Resource, New York.

ca. 478 or 474 BCE
The Charioteer of Delphi

335 BCE
Aristotle founds a school of philosophy called the Lyceum.

72–80 CE
Colosseum begun

613 CE
Muhammad begins preaching Islam publicly.

BCE (Before Common Era)

CE (Common Era)

448–432 BCE
Parthenon begun

19 BCE
Virgil writes the *Aeneid*, an epic-length poem celebrating Roman ideals.

100s CE
Augustus of Prima Porta

1000s CE
The Archangel Michael with Sword

During the 600s BCE and 500s BCE, Greek artists created sculptures of the human figure standing in stiff poses. By the 400s BCE, the style had changed. Artists showed more natural-looking figures in realistic positions. These artworks are called classical.

The Greeks used the human body as the basis for their architecture, too. They compared the parts of a building to the parts of the human figure. They noticed the way parts relate to one another, support each other, and work together in harmony. The Greeks wanted their architecture to have perfect balance and ideal proportions, just as the figures in their sculptures and paintings did.

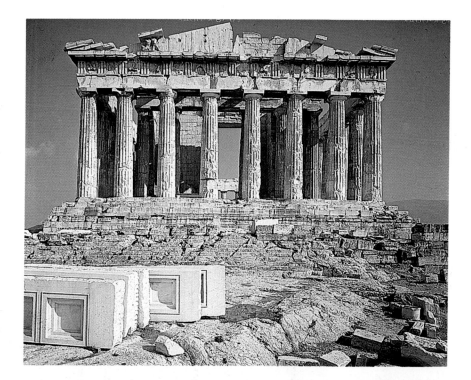

Fig. 2–15 Greek architecture reflects the ideals of balance and harmony. Imagine if these columns were not evenly spaced. How would that change this temple?

Iktinos and Kallikrates. *West façade of the Parthenon Temple*, Acropolis. Athens, Greece, 448–432 BCE. Pentelic, marble, 111' x 237' (33.8 x 72.2 m) at base. Scala/Art Resource, New York.

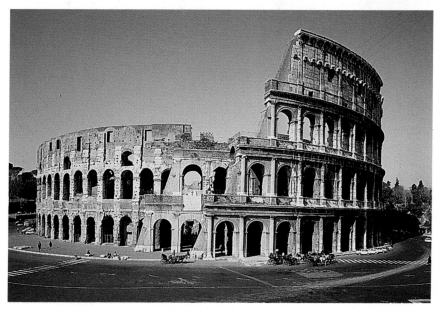

Fig. 2–16 Compare this Roman arena to the Greek temple in Fig. 2–15. How does the use of the arch make the Roman example different? What modern structure does this remind you of?

The Colosseum, exterior view, Flavian dynasty 72–80 CE. Rome, Italy. Scala/Art Resource, NY.

Roman Realism Romans copied examples of Greek art because they admired Greek ideals. However, Roman artists showed people as they really looked because they wanted them to be recognizable.

Images of rulers appeared in artworks throughout the empire. Artists sometimes made the bodies look perfect to stress the ruler's perfect qualities. But the artists showed the ruler's actual facial features so that people could recognize their ruler.

Byzantine Ideals After nearly four centuries of existence, serious problems finally appeared in the Roman Empire. The Empire was divided in two, with one capital at Rome and the other at present-day Istanbul, Turkey. Because of these problems, many people began to look to Christian teachings for new ideals.

Much Byzantine art shows these Christian ideals. Artists focused on images from holy books. Such artworks reminded people who believed in Christianity that following these new teachings was a good way to live.

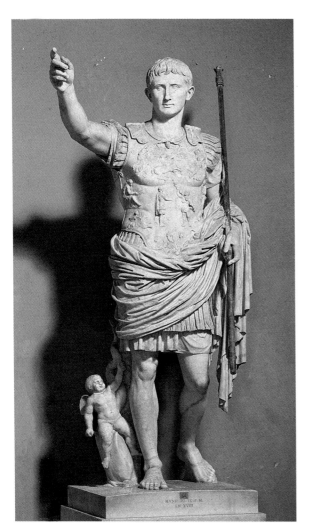

Fig. 2–17 **This is a sculpture of a Roman ruler. How does this sculpture reflect ancient Roman ideals?**

Augustus of Prima Porta, Roman Sculpture, early first century CE. Vatican Museums, Vatican State. Scala/Art Resource, New York.

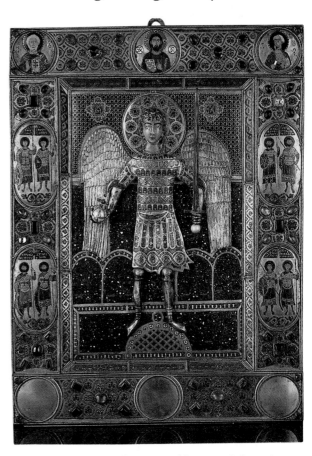

Fig. 2–18 **Compare and contrast this artwork from the Byzantine Empire with Fig. 2–17. What ideals can you identify in each?**

The Archangel Michael with Sword, Byzantine icon from Constantinople, 11th century. Gold, enamel, and precious stone. Framed icon. Tesoro, San Marco, Venice, Italy. Cameraphoto/Art Resource, New York.

Meet Byzantine Artists

In the Byzantine Empire, only clergy and wealthy people knew how to read. Since common people could not read the Bible, emperors, clergy, and members of the court decided to communicate the Christian message to the poor. They hired artists to create images of biblical figures and scenes.

Byzantine art was not as realistic as Greek or Roman art. Instead of showing realistic human forms, Byzantine artists wanted to show the glory of God. To impress people with the beauty of heaven, artists used gold, jewels, ivory, expensive stones, pearls, and rich colors in their pieces. They decorated churches with mosaics and frescoes. They made crosses, Bible covers, and icons. Icons are images of Christ, the Virgin Mary, or the saints. Byzantines believed that these images could help people connect with the holy figures that they showed.

"(T)he art of the Byzantine period can be conceived to be above all a religious art."

— Dr. Robin Cormack,
Courtauld Institute of Art

Check Your Understanding

1. Why did some people of Byzantium turn to Christianity?

2. How are ancient Greek sculptures similar to ancient Roman sculptures? How are they different?

3. How do you think the people of ancient Greece would feel about Byzantine art? Explain your answer.

Studio Time

Façade with Figures

Create a collage of your own building façade (outside front) using human figures as the architectural supports.

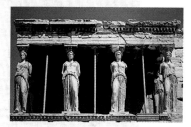

Fig. 2–19 **The Greeks sometimes used statues of male or female figures as supports for buildings.**

- The people you show in the columns should reflect the identity of the people who will use the building.

- Photocopy pictures of people. Combine them with pictures of architectural details, such as windows, a roof, or doors.

Reflect on a name for your such as *The House of the Football Players*.

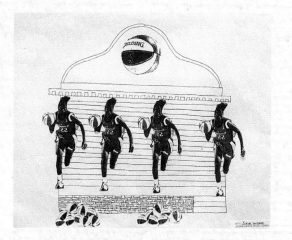

Fig. 2–20 Student artwork

Native North American Objects

Unique Group Identity Early in their settlement of North America, native peoples developed specific shapes, patterns, and designs on their artworks. For example, ancient cultures of the American Southwest such as the Ancestral Puebloans (sometimes called Anasazi) created unique black-and-white geometric designs and animal forms. Today, it is often possible to know the identity of a community by looking at its one-of-a-kind designs.

Family Identity The native peoples of the Northwest Coast value the right to display family images. One way they do this is through totems. Totems are animals or imaginary creatures that are the ancestors or special protectors of the family. Totem poles (Fig. 2–22) are tall wooden structures with totems carved into them. Each pole tells a story about the way the clan or family received its name, various properties, or rights and privileges. Animal figures on the poles stand for certain characteristics. For example, the eagle represents wisdom; the beaver, patience.

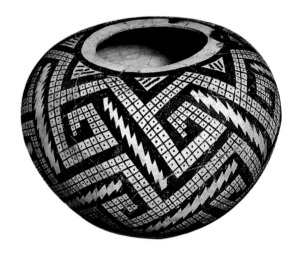

Fig. 2–21 **How would you know this is an Ancestral Puebloan jar just by looking at it?**

American, New Mexico, Anasazi people, *Seed Jar*, 1100–1300. Earthenware, black and white pigment, 10 ⅝" (27 cm) high, Diameter 14 ½" (36.9 cm). Gift of Mr. Edward Harris 175:1981. St. Louis Art Museum.

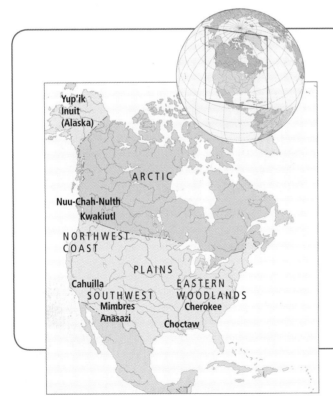

Social Studies Connection

Throughout human history, people have migrated. Migration is the movement of groups from one continent to another. Ancient and native peoples who migrated to **North America** shared their traditions and beliefs through spoken stories. Although each group has its own history, language, and beliefs, their artworks show that the groups share some common ideals and a deep respect for nature.

Today, native peoples continue to use traditional themes and techniques for inspiration. Art is the link that helps them hold on to the identity and ideals of their ancestors.

In native Northwest Coast communities, the crest is the most important way to show identity. A crest is a grouping of totems. Each family has the right to use only certain crest images in their art.

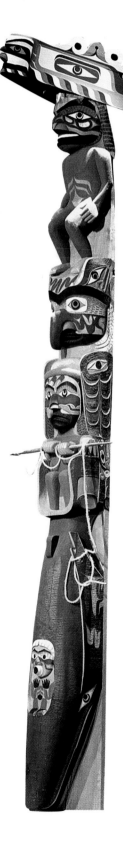

Fig. 2–22 **Look closely at this Northwest Coast totem pole. What human or animal forms can you see? What story do you think the pole tells?**

Nuu-Chah-Nulth Totem, by Tim Paul. Painted wood. Photo © Museum of Civilization, Quebec. artifact VII-F-937, image S924402.

Visual Culture

When someone says, "Let's go to the museum," what's the first thing that comes to your mind? What do you think you are going to see? Museums can be collections of all kinds of objects. The way we look at and think about objects often depends on where we encounter them, what other objects surround them, and how they are classified or labeled. If you and your classmates were responsible for a collection of objects from different time periods, from all over the world, and they ranged from paintings and sculptures to spoons and bicycles, how would you display them? What decisions would you have to make?

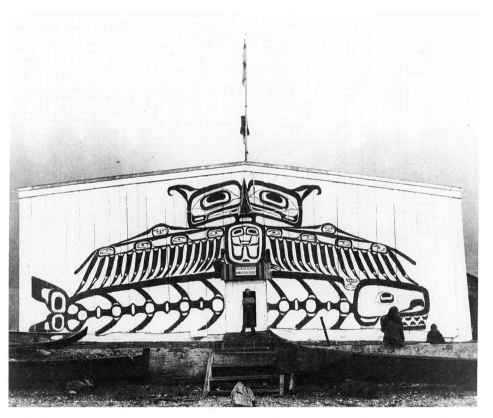

Fig. 2–23 **The crest shows a mythical bird trying to lift a whale. What effect do you think this large painted image has on visitors? Why?**

Kwakiutl Painted House. Kwakiutl, Alert Bay, British Columbia, Canada, before 1889. Courtesy of the Smithsonian Institution, National Anthropological Archives, Bureau of American Ethnology, neg. no. 49,486.

Nature's Role Much Native North American art is made of natural materials. Plants and animals are often shown in the designs. Native Americans strongly believe in forming a relationship with nature. They know they cannot live without it.

Making artworks from natural materials and using nature-related designs help native peoples form this special relationship. They believe they can receive power, strength, protection, and knowledge from the spirits that are part of all natural things.

Fig. 2–25 **Why might a Native American living in the desert choose a snake design to decorate a basket?**

Cahuilla, *Basket with rattlesnake design*, California, n.d. 6 ⅜" x 14 ⅛" (17.3 x 35.8 cm). National Museum of the American Indian, Smithsonian Institution. Photo by David Heald. 4.7735.

Preserving Group Identity After the arrival of European settlers in the 1600s, many native peoples were forced to accept new values. But some native cultures were able to hold onto their ideals. They continued to produce works using traditional techniques and styles.

Today, many artists still work with traditional techniques and designs, while others choose to work in new styles. Either way, they try to preserve a link with the past by using art to reflect their identity.

Fig. 2–24 **Traditional Yup'ik masks were worn during dances or ceremonies to connect with the spirits found in nature. What natural forms and materials can you see in the mask?**

Yup'ik, Mask of a diving loon, before 1892. Wood, paint, owl feathers, height: 31 ½" (80 cm). Sheldon Jackson Museum, Sitka, Alaska II-G-11. Photo by Barry McWayne.

Check Your Understanding

1. Why is most Native American art made of natural materials?

2. How is Native American art from the American Southwest different from Native American art from the Northwest Coast? How are they the same?

3. What animal would you use to represent your identity? Why?

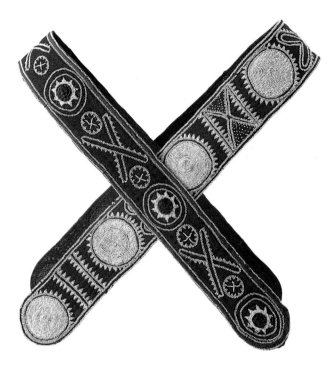

Fig. 2–26 **The arrival of European settlers also brought new materials for artworks. Why would the artist use new materials, but maintain a traditional design?**

Choctaw, Eskofatshi (beaded Bandoliers), Mississippi, ca. 1907. Wool with cloth appliqué. 46 ½" x 3 ¼" (118 x 8.1 cm); 49 ½" x 3 ½" (125.6 x 8.8 cm). National Museum of the American Indian, Smithsonian Institution. Photo by David Heald. 1 .8859 and 1.8864.

Your Animal Identity

Create a sculpture of a personal mascot or animal that you feel best symbolizes who you are, what you believe, and what you care about.

- Think about how animals are used to advertise products or to identify sports teams.

- Think about phrases such as "wise as an owl," "fast as a rabbit," "clever as a fox," and "busy as a bee." Do any of these describe you?

- Use clay, wood, wire, or cardboard to make your sculpture.

Reflect on how well your animal represents your identity.

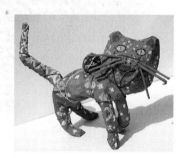

Fig. 2–27 Student artwork

Meet Choctaw Artists

Originally, Choctaws lived in Mississippi and Alabama. Women farmed, raised children, and were the heads of their families. Men were rarely home because they were hunting or fishing. Although Choctaws did not make a living as artists, they loved making artistic clothes, beadwork, and baskets.

Today, Choctaws have strong communities in Oklahoma and Mississippi and continue to make traditional artworks. They pass their knowledge down from generation to generation in order to preserve their cultural identity.

"What it means to be Choctaw is deeply rooted within each of us."

— Miko Bealsey Denson, Choctaw chief

Architecture and Meaning

Studio Background

Imagine that you are designing a sports complex for your local athletic teams. How will you visually represent the teams' identities and ideals? If you were an architect, you would probably draw an architectural floor plan. An architectural floor plan is a diagram of an interior part of a building seen from above. Or you might make an elevation drawing. An elevation drawing shows an interior or exterior side of a building.

In this studio exploration, you will create an elevation drawing of a residential or public building in your community. Architectural designs often communicate important ideas about the people who live in, or use, the building.

You Will Need

- sketchbook
- soft lead pencil (#2)
- eraser
- graph paper or drawing paper
- ruler
- fine-tip marker

Step 1 **Plan and Practice**

- Make a list of public buildings or dwellings in your community. Select one building that interests you.

- Notice clues to the building's identity. For example, what design does your school building feature? How does it reflect the school's ideals or values?

- Choose a side of the building that tells something about its identity.

Things to Remember:

✓ Include features that tell something about the building or the people who use it.

✓ Draw your building to scale.

✓ Pay attention to architectural details.

Inspiration from Our World

Inspiration from Art

You have probably seen architecture around your town that looks something like the temples and public buildings of ancient Greece and Rome. Architects who design banks, libraries, and government structures often borrow shapes and forms that were first used by Greek and Roman architects. These features reflect ancient ideas about politics and beauty. They send the message that whatever is inside the building will last forever.

Some cultures use a more personal expression of identity in their architecture. The large plank houses built by Native Americans of the Northwest Coast (**Fig. 2–23**) are an impressive example. Every plank house has an enormous totem pole. The animals and crests on the totem pole represent the family's identity and history. Other features, such as house posts and exterior walls, are also decorated with family symbols.

Fig. 2–28 **This museum structure is like that of ancient Greek temples. Why do you think the architects included Greek architectural features in the museum design?**

Philadelphia Museum of Art, 1995. Photo by Graydon Wood, 1998. (D. Winston, H. Armstrong Roberts, Inc.). Riverfront view.

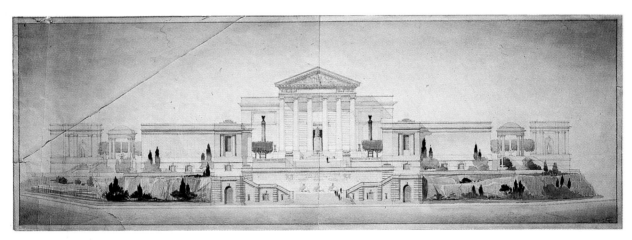

Fig. 2–29 **How might you figure out whether or not this artwork was drawn to scale?**

Borie, Trumbauer, and Zantzinger, *Philadelphia Museum of Art*, 1912. Watercolor and graphite. Philadelphia Museum of Art Archives. Photo: Graydon Wood, 1996.

Fig. 2–30 **The Greek ideals of beauty are seen in the culture's columns and capitals. How would you describe the differences between the capitals diagrammed here?**

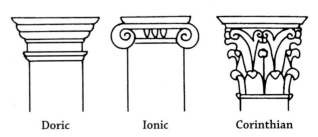

Doric Ionic Corinthian

Step 2 Begin to Create

- Make some rough pencil sketches that show the basic features of the building and how those features work together.

- **Estimate the size of the wall and its parts.**

Wall = 17'x12'
Edge to plaque = 2'
Plaque to window = 2'

- Create a scale at which you will draw the wall. A scale is the relationship between the actual size of something and the size of a drawing that represents it. For example, ½ inch on your drawing might equal 1 foot of the wall's actual length.

- **Using a ruler, draw the wall to scale on graph paper.**

- **After you draw the basic shape of the building, add simple lines that suggest details such as windows, cabinets, and decorative elements.**

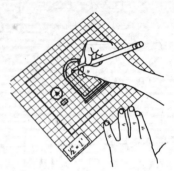

Think about how these architectural details can help show the ideals the building represents.

- When the elevation drawing is finished, trace over the pencil lines with a fine-tip marker.

Step 3 Revise

Did you remember to:

✓ Include features that tell something about the building or the people who use it?

✓ Draw your building to scale?

✓ Pay attention to architectural details?

Adjust your work if necessary. In your sketchbook, make a note of your revisions and why you made them.

Step 4 Add Finishing Touches

- Erase any visible pencil lines.

Step 5 **Share and Reflect**

- Share your work with a partner. Explain the ideals or identity you tried to show in your elevation drawing.

- As a class, display all the elevations and discuss whether or not they successfully reveal the identity of the buildings shown. Which buildings borrow architectural details from the past?

- What was the most difficult or challenging part of this project?

- What parts of your drawing were particularly successful? What would you change?

Art Criticism

Describe What does the artist show in this drawing?

Analyze How are the architectural features of this building arranged?

Interpret What impression do you think this building plan creates? How do you think the building might function?

Evaluate What do you think the artist did especially well?

Fig. 2–31 Student artwork

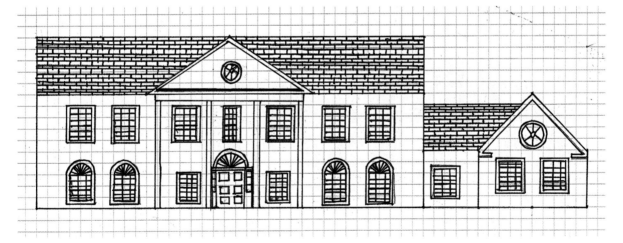

Mathematics

Ancient Roman engineers perfected the use of the round arch. A round arch is a curved architectural element that crosses over an opening. Arches open up large spaces in walls and let in light. They also decrease the amount of building material needed. The Romans made arches from wedge-shaped pieces of stone. These pieces met at an angle perpendicular to the curve of the arch. What are some examples of arches that you have seen?

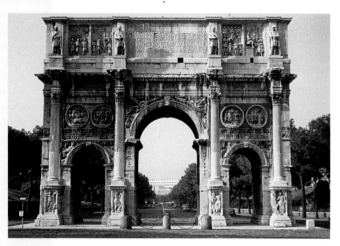

Fig. 2–32 **How is this arch similar to the arches in the Colosseum in Fig. 2–16?**

Rome, *Arch of Constantine*, 315 CE. East elevation. Courtesy of Davis Art Images.

Language Arts

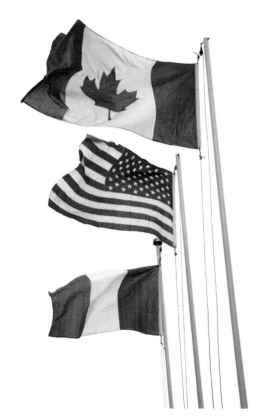

Fig. 2–33 **Flags represent different groups of people.**

Think of a story you have read that focuses on the identity and ideals of a group of people. Narrative artworks can do the same thing. Instead of words, the artists use images to tell their stories. Like written stories, narrative artworks may have characters, events, action, plot, sequence, and purpose. Choose an artwork from this book that tells a story about a group of people. How does the artwork tell about the identity or ideals of that group?

Careers **Architects**

Did you know that Thomas Jefferson was an architect?
Jefferson used classic ideals about architecture in his design for the University of Virginia. Things have changed since Jefferson was an architect. Today, the planning and making of large structures requires teams of people. Architects work with drafters, modelmakers, and illustrators. Then these people work with engineers, builders, and other designers. How do you think Jefferson would feel about modern architecture?

Fig. 2–34 **How could you figure out whether this is an elevation drawing or an architectural floor plan of the University of Virginia? Which one is it?**

Daily Life

With what groups do you identify? How do you show that you are a part of these groups? Throughout history and across cultures, clothing has expressed identity and status. How does group identity affect what you wear? For example, you may wear certain colors, hats, shoes, or uniforms. Why do you choose to wear these? What role does peer pressure have on your clothing choices? Why do you think this is?

Fig. 2–35

Vocabulary Review

Match each art term below with its definition.

identity

ideal

migration

texture

mosaic

elevation drawing

1. the distinguishing traits or personality of an individual

2. a diagram of an interior or exterior side of a building

3. an artwork made by fitting together small materials such as colored glass, tiles, stones, or paper

4. the feeling of a surface when you touch it

5. a view of what the world and people would be like if they were perfect

6. the movement of groups from one continent to another

Aesthetic Thinking

Artistic traditions help cultures maintain their identity. What are the advantages of working within traditions? What are the advantages of breaking traditions? Consider the perspective of the artists as well as viewers.

Write About Art

Imagine that you have encountered this house on a trip and that you can explore the inside and the outside. Write a postcard to a friend describing the experience.

Fig. 2–36 **What kinds of animal symbols do you see in the totem pole? What stories might they tell?**

Haida house model, late 19th century. British Columbia, Canada. Carved and painted wood, 35 ⅜" x 18 ⅞" x 16 ½" (90 x 48 x 42 cm). National Museum of the American Indian, Smithsonian Institution. Photo by David Heald. 7.3031.

Art Criticism

Describe What do you see in this sculpture?

Analyze How does the artist use texture in this artwork?

Interpret How would the meaning of this sculpture change if the doors in the man's chest were closed?

Evaluate How does the visual pun of the man's medicine "chest" add to our appreciation of this work?

Fig. 2–37 Alison Saar, *Medicine Man*, 1987. Wood and tin, 27" (68.6 cm) high. Phyllis Kind Gallery, NY.

Meet the Artist

Paul O'Connor/Courtesy LA Louver, Venice, CA.

Alison Saar was born in Laurel Canyon, California. She uses many different materials in her sculpture, including wood, metal, and found objects like bottles. Saar's art explores different aspects of identity, including race, gender, and culture.

"I think of the materials I work with as artifacts: they have spirit and wisdom."

— Alison Saar (born 1956)

For Your Portfolio

Choose one of your artworks from this unit that sends a clear message about ideals. In a few sentences, explain how the arrangement of its parts helps to send its message. Include the artwork and the explanation in your portfolio.

For Your Sketchbook

On a sketchbook page, list words about identity. You might write words that describe anyone's personality, physical appearance, or culture. Refer to this list for ideas for future artworks.

Artists Teach Lessons

Fig. 3–1 **St. Matthew is writing the stories of Christ's teachings and time on earth. How might the artist have wanted this portrait to inspire the viewer?**

German (Helmarshausen Abbey), *St. Matthew*, fol. 9v, Gospel Book, ca. 1120–40. Tempera colors, gold, and silver on parchment bound between pasteboard covered with brown calf, 9" x 6 ½" (22.8 x 16.4 cm). The J. Paul Getty Museum, Los Angeles.

What lessons have you learned from the stories you have read or heard? Maybe you know the popular book *The Little Engine That Could*, in which the author teaches the reader lessons about determination and never giving up.

Lessons for living are passed down in all cultures. Parents and other adults use stories to teach children how to live healthy, productive, and meaningful lives. Adults also need lessons for living. Sometimes these lessons are in the form of artworks rather than written stories. Artworks from around the world have been created and used for hundreds of years to teach important ideas.

Fig. 3–2 **This sculpture shows Buddha's hands in the teaching position. What lesson or lessons do you think the artist wanted to teach?**

India, *Seated Buddha Preaching in the First Sermon, Sarnath,* Gupta period, 5th century CE. Stele, sandstone, 63" (160 cm) high. Archaeological Museum, Sarnath, Uttar Pradesh, India. Borromeo/Art Resource, NY.

In this unit, you will learn:

- How artists use images, symbols, and words to teach important lessons.
- How to create triptychs and paper sculptures using shape, balance, and symbols.
- How to look at artworks to learn about important ideas.

Life's Lessons in Art

When you wonder what life is all about, who do you ask? Many of our life lessons have been passed down through the generations. Some lessons are political. They teach people how to live together peacefully. Other lessons are religious. They teach a set of beliefs. Art can help us see and understand these lessons in new ways.

Learning Through Art Artists can teach lessons through artworks with words, images, and symbols. These artworks are usually placed in public or shared spaces, such as government buildings, where people can see them and discuss them with others.

Fig. 3–3 **This mosaic from a synagogue shows images of ritual objects, such as the *menorah* and the *shofar*. The *menorah* is a seven-branched candelabra like the one that used to be in the ancient Temple in Jerusalem. The *shofar* is a ram's horn which is blown on the most important holidays. Its call is very loud.**

Detail from mosaic pavement from a synagogue at Hammat Tiberias, 4th century CE. Photograph: Zev Radovan, Jerusalem.

Religious lessons are often displayed in places of worship. The lessons might be shown in small portable paintings, altarpieces, holy books, windows, or on walls and floors. As you learn more about a religion's beliefs, the symbols you see in artworks gain more meaning. The lessons taught through images and symbols are meant to help people achieve a stronger and more lasting religious faith. For example, in a mosque, an Islamic building for worship, the walls are covered with lessons. Study the Islamic artwork in Fig. 3–4. Notice the geometric patterns, plant shapes, and Arabic writing.

Fig. 3–4 **This wall space in a mosque is called a *mihrab (MIH-râb)*. It points to a holy place called Mecca. What might this artwork inspire?**

Iranian, *Mihrab of the Medersa Imami*, Isfahan, ca.1354. Composite body, glazed, sawed to shape and assembled in Mosaic, height: 11' 3" (342.9 cm). The Metropolitan Museum of Art, Harris Brisbane Dick Fund, 1939. (39.20) Photograph ©1982. The Metropolitan Museum of Art.

Meet Islamic Artists

Images of God and people are forbidden in Islamic religious art. Pictures of people and animals are only allowed in stories about everyday life.

The Islamic religion appeared in India in the 700s. The introduction of paper to India in the 1300s opened the way for new artistic ideas that included colorful surfaces, detailed patterns, and realistic images.

Figures and scenes from stories appear in small paintings called miniatures. From the 1500s until the 1700s, Indian artists used Muslim miniature painting techniques to illustrate books and stories on paper. Until this time, most Indian paintings had been on cave walls.

Fig. 3–5 We do not know the names of the people who made this amazing artwork, but most embroidery of the time was done by women. This was probably created by artists and an historian working together. The mural is over 230 feet long and contains 626 human figures, 731 animals, 376 beasts, and 70 buildings and trees. What might they have wanted to teach?

Bayeux Tapestry, detail: William preparing his troops for combat with English Army. Musée de la Tapisserie, Bayeux, France. Bridgeman-Giraudon/Art Resource, New York.

Lessons From the Past Most people look for ways to live together peacefully. They work together to make rules about how to treat one another. They encourage one another to have pride in their history and heritage. Artworks are important sources of information about the past. For instance, the *Bayeux Tapestry* (Fig. 3–5) shows the Norman invasion of England in 1066. The events of the battle are retold in

Fig. 3–6 This mural on the side of a market in Massachusetts makes a statement about poverty. What is the artist trying to say to her community?

Lydia Stein, *Food, Water, Shelter*. Photo by Tom Fiorelli.

Rules for Living

Prepare a mixed-media image that teaches an important lesson to young children.

- In small groups, create a list of rules for living.

- Combine magazine images with drawing, using colored pencils, to illustrate one of these rules from the list.

- Possible lessons are: never tell a lie; look before you leap; plan ahead; chew with your mouth closed.

Share your artwork with the class and reflect on the responses to your message.

Fig. 3–7 Student artwork

the embroidered images. Artworks such as this teach about events that dramatically changed the lives of the people of the time.

Community Lessons Artworks can perhaps do their best teaching if they are displayed where many people can see them. Murals are large artworks usually designed for walls or ceilings. They are often used to present ideas about history and about how to live. Some city neighborhoods have murals on outdoor walls. The people who live there can see and learn from them daily.

Check Your Understanding

1. List at least three ways that artworks are used to inspire or teach others.

2. What would you show in a mural created for your community? How would it be similar to the mural shown in Fig. 3–6? How would they differ?

3. Choose one image in this lesson and tell how its parts combine to teach a lesson.

Using Shape and Balance

What Are Shapes? A line that surrounds a space or color in a drawing, painting, or other two-dimensional artwork creates a shape. Shapes have height and width but no depth. They can be defined by an outline or area of color. Many artists carefully plan their use of shape to help show a specific idea or teach a lesson. Some artists use shapes as symbols, to add meaning.

Organic shapes are irregular and often have curves. Most shapes found in nature are organic, such as feathers, leaves, and puddles. Geometric shapes are regular in outline. They may be described using mathematical formulas. For example, triangles, circles, rectangles, and squares are geometric shapes.

There is another way to describe shape. Shapes that stand out from the background are called positive shapes. The subjects of artworks, such as the person in a portrait or the objects shown, are positive shapes. The area around the positive shapes creates negative shapes. In a stained-glass window, the shapes made of colored glass are positive shapes. The black area surrounding them is the negative shape. A successful design balances the use of positive and negative shapes.

Fig. 3–8 **This artist arranged geometric shapes in an organic shape that resembles a ribbon. Why do you think the artist included both organic and geometric shapes?**

Harold Haydon, *The Path*, 1972. Stained-glass window. University of Chicago, Rockefeller Chapel.

Fig. 3–9 **What shapes do you see in this painting? Why might the artist have used these shapes?**

Arturo Herrera, *Untitled*, 2003. Enamel paint on wall, Site-specific dimensions. Courtesy of Sikkema Jenkins & Co.

Observe Study the images shown in Figs. 3–8 and 3–9. Both artists used shapes to express important ideas. Which are organic shapes and which are geometric? Where are the positive and negative shapes?

Tools: Blank paper, drawing tools such as pencils, pens, crayons, and markers.

Practice: Shapes
- Fold a sheet of paper in half.
- On one half of the paper, draw three geometric shapes. Color the positive shapes.
- On the other half of the paper, draw three organic shapes. Color the negative shapes.

Balance In Art Balance describes how parts of an artwork are arranged to create a sense of equal weight or interest. Different kinds of balance have different effects on the viewer, but every kind holds a design together.

Balance can be symmetrical or asymmetrical. A design with symmetrical balance looks the same on both sides, like a mirror image. A design with asymmetrical balance does not look the same on both sides. Instead, an area on one side of the design is balanced by a different type of area on the other side. A third kind of balance is called radial balance, in which the parts of the design seem to radiate, or spread out, from the center of the artwork.

symmetrical balance

asymmetrical balance

radial balance

Observe Look at Fig. 3–10. What kind, or kinds, of balance do you see? How can you tell?

Tools: Sheets of paper and soft pencils.

Practice: Symmetrical Balance

- Use a soft pencil to draw a design on one half of the paper.

- Fold your paper in half and rub the back to transfer the image.

- Unfold your paper. You should have a symmetrical design.

Check Your Understanding

1. What is the difference between positive and negative shapes?

2. In terms of shape and balance, how are the stained-glass works in Figs. 3–8 and 3–10 similar? How are they different?

3. What type of balance would you use to depict a wild ride at an amusement park? Why?

Fig. 3–10 **This artwork tells about religious history. How do repeated shapes and colors contribute to the sense of balance? What lesson might this artwork teach?**

North Transept Rose and Lancet Windows (Melchizedek & Nebuchadnezzar, David & Saul, St. Anne, Solomon & Herod, Aaron & Pharaoh), 13th century. Stained glass, 42' (12.8m) Diameter. Chartres Cathedral, France. Scala/Art Resource, New York.

Stained Glass Symmetry

Make your own design that resembles a symmetrically balanced stained-glass window.

- Draw the positive shapes of the design in pencil on black paper.
- Cut out these positive shapes.
- The remaining parts of the black paper will be the negative shapes. They will be unbroken and connected. Glue colored tissue pieces behind the cutouts.

Reflect on the process you used for creating symmetrical balance.

Fig. 3–11 Student artwork

A Triptych That Teaches a Lesson

Studio Background

If you were asked to teach something important, what would it be? We teach and learn lessons in a variety of ways. One important way to communicate these lessons is through art.

In this studio exploration, you will make a foldout booklet or greeting card in the form of a triptych. A triptych is an artwork with three sections. Your triptych should teach a lesson. You might make images that instruct someone about your beliefs. You could use symbols to stand for important ideas. You might teach a life lesson, such as always trying your best. You might choose to show an event that you think others can learn from.

You Will Need

- pencil
- drawing paper or light cardboard
- markers
- colored pencils
- glue
- magazine cutouts
- printouts of computer-generated designs (optional)
- gold and silver paint or markers (optional)

Step 1 **Plan and Practice**

- Decide what lesson you want to teach.
- Think about how you want to show the lesson. What pictures, words, or symbols will you use? Symbols might be simplified images of animals, birds, or plants.
- Review the information about shape and balance in lesson 2 of this unit.

Things to Remember:

✓ Make each panel rich and colorful.

✓ Use pictures and symbols to express your ideas.

✓ Use shape and balance in your triptych.

Inspiration from Our World

Inspiration from Art

A triptych is an artwork with three sections. It has a central panel and two wings, which are attached with hinges. Some triptychs have architectural elements such as columns, arches, or windows. In the Middle Ages, triptychs showed religious subjects. Some of these triptychs were small enough to be carried by their owners, like portable altars. The images told religious stories and taught key beliefs. As with much medieval art, symbols represented important ideas. They also stood for the identities of saints.

A triptych can be used to give shape to ideas about family, culture, history, or other important themes. A triptych does not require a religious focus.

Fig. 3–12 **This artist's book was designed to showcase natural materials collected on a nature walk. How is it similar to a triptych from the Middle Ages?**

Karen Stahlecker, *Golden Shrine*, 1995. Shaped book with perforated covers, artist's handmade papers, natural materials, 7 ¼" x 4 ¼" x 1 ⅓" (18.4 x 10.8 x 3.5 cm), when closed. Photo by K. Stahlecker.

Fig. 3–13 **This triptych depicts scenes from the life of Roman Emperor Constantine I. What features of the artwork suggest that Constantine was an important person?**

Mosan, *The Stavelot Triptych*, ca. 1156–1158. Gold, cloisonné Enamel, inlay, 19 ¹⁄₁₆" x 26" (48.4 x 66 cm) when open. The Pierpont Morgan Library, New York/Art Resource, New York.

Step 2 Begin to Create

- **Make two folds in a piece of paper to form a central panel and two sides that fold out. If you wish, cut the triptych into a shape that will help teach your lesson.**

- **Lightly sketch a plan for what you will show. Think about the images you will use.** What symbols will best represent your lesson? Consider presenting your lesson as a story with three scenes.

- Outline the main lines of your sketch with markers.

- Combine collage and colored-pencil techniques to make each panel rich and colorful.

Step 3 Revise

Did you remember to:

✓ Make each panel rich and colorful?

✓ Use pictures and symbols to express your ideas?

✓ Use shape and balance in your triptych?

Adjust your work if necessary. In your sketchbook, make a note of your revisions and why you made them.

Step 4 Add Finishing Touches

- Look over your triptych. Is it complete? Make any necessary additions or changes.

Step 5 Share and Reflect

- Exchange your triptych with a classmate. Each of you should guess what lesson is being taught. How did your classmate use collage and colored pencil to present powerful messages? What role do shape and balance play in your classmate's triptych? How did your classmate use symbols effectively?

- How did the requirement of having three panels affect your design?

- What do you like best about your artwork? Why?

Art Criticism

Describe What do you see in this artwork?

Analyze How did the artist organize this drawing?

Interpret The inside of this triptych teaches a lesson. What might that lesson be?

Evaluate What's special about this artwork?

Fig. 3–14
Student artwork

Art of the Medieval World

Fig. 3–15 **Gothic architecture often seems to point upward. What parts of this Gothic cathedral support that description?**

Notre Dame Cathedral, exterior, begun 1163. Paris, France. Davis Art Images.

After the decline of the Roman Empire in the 400s, people began migrating, or moving from country to country, all across Europe. This era, called the Middle Ages or Medieval period, lasted nearly 1000 years.

During this time, many people found comfort in the teachings of Christianity, Islam, and Judaism. Most Europeans could not read or write, so art continued to be an important way to communicate these lessons.

1096
The First Crusade begins. Christians attempt to recover holy lands from Muslims.

ca. 800
Book of Kells

ca. 1130
Giselbertus, *Last Judgment*

1163
Notre Dame begun

800–1300 CE

1066–1072
William the Conqueror, a duke from Normandy, France, invades and conquers England.

1098
As religious enthusiasm intensifies, a new group, the Cistercian monks, is founded.

1100s
Chartres stained-glass windows

1266
Thomas Aquinas writes *Summa Theologiae*, a book which reconciles reason and religion.

In early medieval times, art was often small and portable. People could easily carry around books and other objects. But, by the 1000s, people began to settle in permanent communities. The style of the art and architecture of this period is called Romanesque. Romanesque art and architecture uses ideas borrowed from the Romans.

Toward the end of the Middle Ages (from the 1200s through the early 1400s), churches became the center of religious and social activity. The art of this part of the Middle Ages is called Gothic. Gothic art and architecture show the energy of the growing cities of the time.

Early Medieval Art In early medieval times, books helped to preserve Christian, Jewish, and Islamic lessons. Scribes spent their lifetimes copying sacred manuscripts to preserve the lessons for future generations.

Many of these copied texts were illustrated by artists called *illuminators*. The completed pieces were called illuminated manuscripts. An illuminated manuscript is a decorated or illustrated manuscript in which the pages are often painted with silver, gold, and other rich colors. The art of manuscript illumination was practiced throughout medieval Europe and the Middle East.

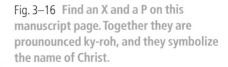

Fig. 3–16 **Find an X and a P on this manuscript page. Together they are prounounced ky-roh, and they symbolize the name of Christ.**

Chi-rho Gospel of St. Matthew, chapter 1 verse 18, Irish (vellum). *Book of Kells*, ca. 800. The Board of Trinity College, Dublin, Ireland/Bridgeman Art Library.

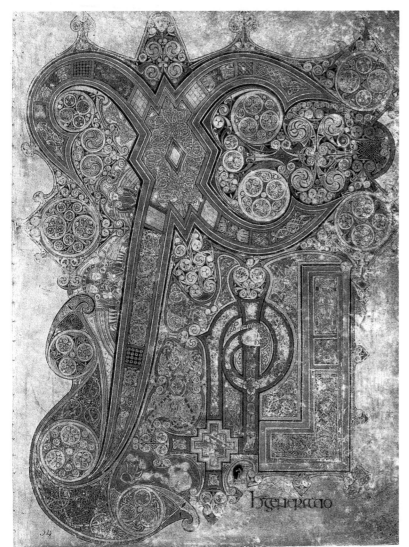

Fig. 3–17 **This doorway arch, or tympanum, shows Christ weighing people's souls to judge the way they have lived their lives. Why might this scene have been placed above a church doorway?**

Giselbertus, *The Last Judgement*, 1130–1140. West tympanium, St. Lazare. Autun, France. Davis Art Images.

Romanesque Art The wars from the 400s through the 900s destroyed many European buildings. Much re-building began in 1000. Stone churches were built in the Romanesque style. For medieval Christians, the church became the center of teaching. Lessons for good living were shown in wall images, such as Fig. 3–17, and in sculptures.

Gothic Art Church-building continued into the 1300s. Christians wanted to fill their churches with light, which symbolized the presence of God. Architects developed a new way to build taller buildings with thinner walls. These walls could have large windows to let in a lot of light.

Gothic cathedrals had stained-glass windows, which were made of small pieces of cut, colored glass held together with lead. In the windows, artists created Bible scenes to remind Christians of how to live a good life.

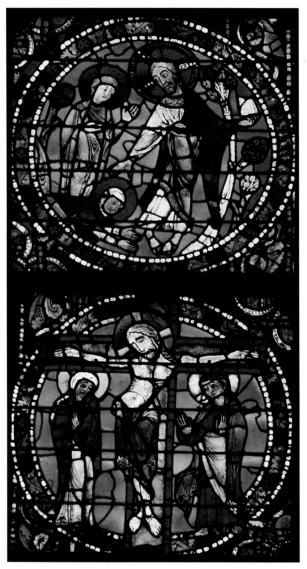

Fig. 3–18 **These two details show stories from the life of Jesus. What effect does the stained glass have on the stories?**

Noli me tangere and Crucifixion (detail), Cathedral of Chartres, 12th century. Stained glass. Photo by Edouard Fiévet.

Meet Gothic Artists

In the Middle Ages, artists did not usually sign their work as artists often do today. A Gothic artist generally belonged to a group of artists called a guild. Each guild was expert at a particular art form, and the guild kept its art-making techniques secret from members of other guilds. Because most guild members did not know how to read or write, these secret techniques were taught to young artists by older members.

Medieval guilds were made up of a master and a group of artists. The master developed ideas for a design, and the artists created it. While the master sometimes worked on the most important parts of a design, often he did not create any of the artwork at all.

"The...Gothic cathedral interior...draws the gaze to the highest point in the vault...symbolic of...a heavenly realm."

— Julien Capuis
Department of Medieval Art and The Cloisters, The Metropolitan Museum of Art

Check Your Understanding

1. What is an illuminated manuscript?

2. Both Gothic cathedrals and illuminated manuscripts teach lessons about Christianity. How are their ways of teaching similar? How are they different?

3. Why might artists have chosen to use stained glass instead of unstained glass in the church windows?

Studio Time

An Illuminated Letter

Create an illuminated manuscript page with one or more decorated capital letters.

- Think of a lesson your page might teach. Your illumination might include your initials or a poem.

- Look at books and cards with examples of historical and modern illumination and decorative borders, or study **Fig. 3–16** to help you get ideas.

- Experiment with different kinds of type: large or small, plain or fancy. Plan your composition carefully.

Reflect on your calligraphy skills.

Fig. 3–19 Student artwork

The Art of India

Buddha's Lessons Buddhism is based on the teachings of a holy man known as Buddha, or the "enlightened one." Buddhism first appeared in India in the 500s BCE.

Buddhist art and architecture are meant to help followers reach their own state of enlightenment through meditation. The earliest form of Buddhist architecture is called the *stupa* (STEW-pah). Stupas are a type of rounded burial mound built to honor the Buddha (Fig. 3–21). They serve as places for meditation and prayer.

Fig. 3–20 Vishnu, an important Hindu god, is associated with love and forgiveness. In some myths, he is a playful trickster. How does this sculpture show this?

India, late Chola period (ca. 13th century), *Narasimha: Lion Incarnation of Vishnu*. Bronze, 21 ¾" (55.2 cm) high. ©The Cleveland Museum of Art, 1999, gift of Dr. Norman Zaworski, 1973.187.

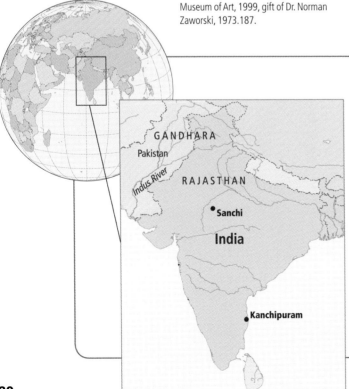

Social Studies Connection

Early peoples lived in **India** probably as far back as 30,000 BCE. Around 2700 BCE, the earliest Indian culture settled in the area of the Indus River. It is known as the Indus Valley civilization.

Throughout its long history, Indian art has reflected the teachings of its two main religions: Hinduism and Buddhism. Each religion produced its own unique style of sculpture and architecture. Each religion also used a rich variety of distinct symbols to teach followers important lessons.

At first, the Buddha was shown in artworks only by a symbol. Sometimes it was a lotus flower, the symbol of purity. Other times it was a wheel, an ancient sun symbol that represented his teachings and the cycle of life. Sometime between 1 CE and 200 CE, images of the Buddha appeared. The symbols and gestures shown in these images made the Buddha easily recognizable (Fig. 3–22).

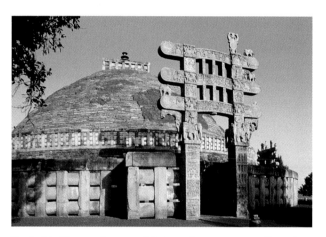

Fig. 3–21 **The carvings on this stupa's gateways tell stories from the previous lives of the Buddha. How could they help teach lessons?**

India (Sanchi), east gate, *Great Stupa*, 75–50 BCE. ©Adam Woolfitt. All Rights Reserved.

Visual Culture

In this lesson, you have learned that in some cultures around the world, architectural elements and sculptures can be used to teach important lessons and to influence behavior. Consider how images in movies, television shows and commercials, and even pictures in catalogues and magazines can influence our lives and teach lessons. What are some lessons that you have learned from images on the big screen or on TV?

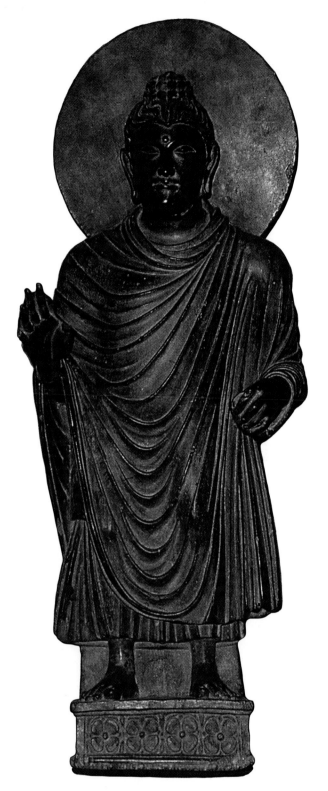

Fig. 3–22 **The Buddha makes hand gestures that are known as** *mudras*. **This mudra means "fear not." What other features of this sculpture might be symbolic?**

India (Gandhara), *Standing Buddha*, 2nd–3rd century CE (Kushan period). Phyllite, 23 ¼" x 13" (59.1 x 33 cm). Asian Art Museum of San Francisco, The Avery Brundage Collection, B60 S132+.

Hindu Lessons Hinduism is India's oldest religion. It has many gods. The three main gods are: Brahma, the Creator; Vishnu, the Preserver; and Siva, the Destroyer. Artists show these gods in animal or human form. They are shown with symbols that stand for each god's special powers.

For example, in Fig. 3–23, Siva is shown holding a drum in his back right hand to symbolize his power to create. In contrast, he holds fire in his back left hand, which represents his power to destroy. His inner right hand is raised in a gesture that means "fear not." His inner left arm points to his raised left foot that symbolizes escape from ignorance.

Architecture has also played an important role in the Hindu religion. Temples topped with towers were built as the residences of the gods. Inside, a sculpted image of the temple's god is placed in a sacred space.

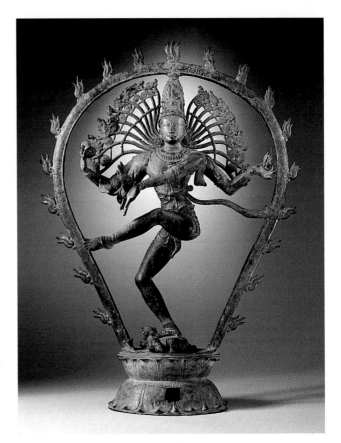

Fig. 3–23 **When the Hindu god Siva is shown dancing, he is called Nataraja, meaning "Lord of the Dance." What type of balance does this sculpture show?**

Indian (Tamil Nadu), *Siva, King of the Dancers, Performing the Nataraja*, c.950. Copper alloy, 30" x 22 ½" x 7" (76.2 x 57.1 x 17.8 cm). Los Angeles County Museum of Art, given anonymously. M.75.1.

Fig. 3–24 **This page shows a scene from the poem Ramayana. It gives information about ancient Indian values and ideals. What might one learn from this scene?**

India (Pahari, Guler School), *Sita in the Garden of Lanka, from the Ramayana, Epic of Valmaki.* Gold and color on paper, 22" x 31" (55.5 x 79 cm). The Cleveland Museum of Art, Gift of George P. Bickford, 66.143.

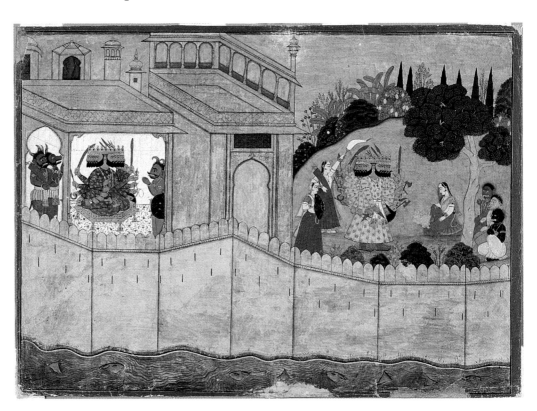

Meet Guler School Artists

The Guler School was a style of painting in northern India. It was developed in the 1600s and lasted until the end of the 1800s. Kings hired artists to paint scenes from Hindi religious books, especially scenes with the gods Krishna and Rama.

Guler artists were known for their delicate work. They painted realistic details of nature and used color to show mood in their paintings. Masters did the first sketches and assistants filled in the colors their masters chose.

"In these illustrations, the painters had the opportunity to reveal the poetic core of their feelings."

— Chandramani Singh

Check Your Understanding

1. How have the symbolic characteristics of Buddha changed over time?

2. How is Buddhist art and architecture similar to Hindu art and architecture? How are they different?

3. Why might followers of Buddhism and Hinduism view art as a way to learn?

Your Manuscript Page

Use colored and textured or patterned papers to create a collage that teaches others something about yourself.

- To plan your collage, make a list of your characteristics. What talents do you have? What are your favorite things?
- Decide how you will represent these characteristics in your collage.
- Your collage can be in the form of a manuscript page with figures and a patterned background.

Reflect on the effectiveness of the message of your collage.

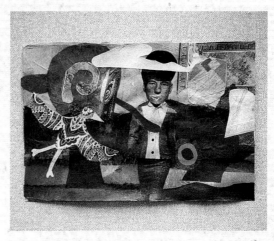

Fig. 3–25 Student artwork

A Folded Box of Lessons

Studio Background

What do an octagon, a fork and knife, and the alphabet have in common? They can all be used as symbols to express important information. For example, the red octagon of a stop sign alerts a driver that it's time to slow down. A fork and knife symbolize food. Symbols like these help us get along in life. Symbols can also remind us of traditions passed down from generation to generation. Symbols that teach lessons can be found in families, communities, and cultures all over the world.

In this studio exploration, you will fold a box and decorate it with symbols that represent meaningful things in your life. As you plan your box, think about the kinds of lessons you want to put inside.

You Will Need

- two squares of white drawing or construction paper
- newsprint paper
- pencil and eraser
- colored markers
- typewriter bond

Step 1 **Plan and Practice**

- Make a list of some meaningful things in your life.
- Decide what symbols represent these meaningful things. For example, what symbols might represent your family, your favorite pastime, a special place, or the like?
- On a sheet of newsprint paper, sketch the symbols.

Things to Remember:

✓ Fold your paper carefully and precisely to make your box even.

✓ Use large, colorful shapes for your symbols.

✓ Make your box interesting to look at from all sides.

Inspiration from Our World

Inspiration from Art

Religions all over the world share the tradition of teaching. Their artworks often tell stories or incorporate symbols that have special religious meaning. If you look closely at religious artworks, you might see symbols that stand for important lessons or ideas.

Judaism—the Jewish religion—is ancient, with beginnings nearly four thousand years ago. The customs, traditions, and laws of Jewish life influenced a wide variety of ceremonial artworks. Many of these artworks are decorated with special symbols. The Star of David, the universal symbol of Judaism today, came into popular use during the 1600s. It appears on the flag of the state of Israel, in synagogues, and on Jewish ritual objects.

Fig 3–26 **The Star of David is an ancient symbol with many different meanings. In Jewish lore, it represents the shield of King David, protecting him from his enemies. What kind of balance does the star show?**

Israel, Jerusalem, *Star of David, Lion Gate*, detail, 1st century CE. Courtesy of Davis Art Images.

Fig. 3–27 **This receptacle, called a *mezuzah*, contains a prayer written on a tiny scroll. Why might *mezuzahs* be placed at the doors of Jewish homes?**

Galicia, *Mezuzah*, ca. 1850. Carved wood, ink on parchment, 10 $^7/_{16}$ " x 2 ¼ " (26.5 x 5.7 cm). Gift of Dr. Harry G. Friedman. The Jewish Museum, NY/ Art Resource, NY.

Step 2 **Begin to Create**

- **Follow the steps illustrated on the Studio Master to construct a box and lid.** Use the smaller sheet of white paper for the bottom of the box and the larger sheet for the lid. Or, find a box that has already been made.

- **When you're happy with your sketches, choose where you want to add the symbols to the box. Carefully decorate the box with colored markers.**

- Your box can be a container for lessons or sayings that mean something to you. You may be fond of some sayings such as, "A penny saved is a penny earned." Write the sayings carefully on small pieces of paper. Place them inside your box.

Step 3 **Revise**

Did you remember to:

✓ Fold your paper carefully and precisely to make your box even?

✓ Use large, colorful shapes for your symbols?

✓ Make your box interesting to look at from all sides?

Adjust your work if necessary. In your sketchbook, make a note of your revisions and why you made them.

Step 4 **Add Finishing Touches**

- Look over your box to make sure your message is clearly communicated. Make any necessary changes.

Step 5 **Share and Reflect**

- Share your box with classmates. Discuss the important message you want your artwork to communicate. See if your classmates can identify the meaning behind the symbols you created. Ask them what they have learned about you after looking at your box and reading the sayings inside.

- In what way does your finished product show your usual quality of work?

- What new skills or abilities did you demonstrate when you made this artwork?

Art Criticism

Describe Describe the parts of this box. What do you see?

Analyze How did the artist create unity and variety in this box?

Interpret What idea does this box suggest? Why do you think this?

Evaluate What features of this box are especially pleasing to you? Why?

Fig. 3–28 Student artwork

Theater

Fig. 3–29 ©Leonhard Foeger/CORBIS.

Theater may be used to teach lessons. The ancient Greeks said that the purpose of theater was "to teach and to please." By the Middle Ages, the morality play was an example of theater that teaches. In this type of play, characters represented different weaknesses and qualities. Individual actors taught lessons through their dialogue.

The most famous morality play, *Everyman*, was written in the 1400s. It shows the character of Everyman trying to escape Death with the help of Good Deeds and Knowledge.

Science

Builders in the Middle Ages developed an important scientific advancement in Gothic architecture. Because the heavy stone walls of a cathedral could lean outward and collapse if left unsupported, architects joined stone columns to the upper walls of the exterior for more support. Gothic cathedrals were also decorated with figures of ugly beasts and humans. These figures taught lessons and served a practical purpose as waterspouts.

Fig. 3–30 **Flying buttresses are angled arches held up by pillars. On Gothic cathedrals, the flying buttresses were decorated with complex gables and sculptures.**

Notre Dame Cathedral, 1163–1250. Paris, France. Courtesy of Davis Art Images.

Careers **Stained-glass Artist**

Stained-glass artists may teach lessons with their designs. In medieval times, these artists moved through three levels of training. These levels were: apprenticeship, journeyman, and master.

Today, a stained-glass designer may have trained at an art school, a university, or a trade school. Stained-glass artists make working "cartoons," or drawings. Then they construct windows or other artworks by cutting pieces of glass and joining them with lead. Contemporary artists have many choices of glass.

Fig. 3–31 **Before electric lights, the brilliance of colors in stained-glass windows such as this was unique. How do you think such art influenced people to learn?**

Top third of window, 19th century. Swiss National Museum, Zurich. Photo: H. Ronan.

Daily Life

Art records people's lives, from everyday details to amazing events. This art may also teach us about history. Look at the *Bayeux Tapestry* shown in lesson 1 (Fig. 3–5). This tapestry is a visual record of events before, during, and after a specific battle. What kinds of contemporary events do we consider important to remember and tell? How do we honor these historic events? What major events have made an impact on your life?

Fig. 3–32 **This photo records the opening ceremony at the Olympics. Why do you think it is important to record events such as this?**

©George Tiedemann/CORBIS.

Unit 3 Vocabulary and Content Review

Vocabulary Review

Match each art term below with its definition.

organic shape

murals

asymmetrical balance

triptych

radial balance

geometric shape

1. a shape that is regular in outline
2. an artwork with three sections
3. an irregular shape that often has curves
4. the kind of balance a design has where it does not look the same on both sides
5. the kind of balance a design has where parts seem to spread out from the center
6. large artworks usually designed for walls or ceilings

For Your Sketchbook

Use some of your sketchbook ideas to develop a decorative alphabet for an alphabet book that could be used to teach others.

Aesthetic Thinking

Discuss and defend which is more effective in teaching about the horrors of war, *Bayeux Tapestry* or TV news coverage. What if artworks that taught lessons did not exist? How would this affect learning?

Write About Art

Make a list of symbols that have a special meaning for you personally. Next to each symbol, explain what it represents. For example, this star is made up of two triangles. It has different meanings in different cultures. In Jewish lore, it is called the Star of David and represents the shield of King David, a famous ruler of ancient Israel.

Fig. 3–33 Israel, Jerusalem, *Star of David, Lion Gate*, detail, 1st century AD. Courtesy of Davis Art Images.

Art Criticism

Describe What do you recognize in this artwork?

Analyze How is the artwork organized?

Interpret What do you think this painting might be about?

Evaluate What has the artist done especially well?

Fig. 3–34 David Alfaro Siqueiros, *Portrait of the Bourgeoisie: Foundry Underneath a Concrete Slab*, 1939. Mural. Sindacato Mexicano de Electricistas, Mexico City, D.F., Mexico. Photo: Schalkwijk/Art Resource, NY. ©ARS, NY.

Meet the Artist

David Alfaro Siqueiros was born in Santa Rosalía de Camargo, Mexico. He studied painting in Mexico City. Siqueiros fought in the Mexican revolution and became active in politics. Along with Diego Rivera and José Clemente Orozco, Siqueiros was one of the "Three Great" Mexican muralists. He painted large murals in public places, using his art to convey political messages.

"Art must no longer be the expression of individual satisfaction, but should aim to become a fighting, educative art for all."
— David Alfaro Siqueiros (1896–1974)

For Your Portfolio

Choose an artwork you created in this unit that you feel best teaches a lesson. Think about how you used artistic techniques such as shape and balance to successfully convey your lesson.

Artists Create
Organization and Order

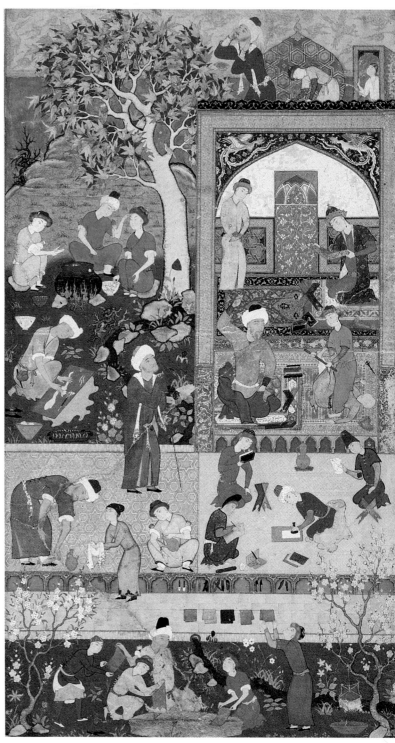

Fig. 4–1 **What makes the scenes within this artwork appear "stacked?"**

Mir Sayyid-Ali, *A School Scene*, ca. 1540. Opaque watercolor, ink, and gold on paper. Arthur M. Sackler Gallery. Smithsonian Institution, Washington, DC. S1986.211.

Do you line up your socks in the drawer according to their color? Do you have labels on your bookshelves showing where certain types of books belong? People tend to organize things. Sometimes the organizing system is obvious to others; other times it's obvious only to the person who created it. Organization makes life easier, allowing people to focus on what counts—the life that goes on around and inside all that order.

Fig. 4–2 Sculptures of dogs were common in ancient Mexico. Experts are not certain why some of them wear masks with human faces.

Mexico (Colima), *Dog Wearing a Human Face Mask*, 200 BC–AD 500. Ceramic with burnished red and orange slip, 8 ½" x 15 ½" x 7" (21.6 x 39.4 x 17.8 cm). Los Angeles County Museum of Art, The Proctor Stafford Collection, Museum Purchase with funds provided by Mr. and Mrs. Allan C. Balch. M.86.296.154.

Artists have figured out how to organize artworks so that they are easy to view and understand. The organization of an artwork allows viewers to focus on the message, meaning, and use that it can have.

In this unit, you will learn:

- How artists use various techniques to organize their artwork.

- How to use unity, variety, and perspective in your artworks.

- How to recognize and understand the ways artists organize their works.

Making Parts Work Together

European Renaissance artists were fascinated by linear perspective. **Linear perspective** is a special technique used to show three-dimensional space on a two-dimensional surface. Renaissance artists observed that objects that are far away seem smaller. They found that parallel lines seem to move away from the viewer and appear to meet at a point on the horizon. You can see this for yourself if you stand in a long hallway and look at the lines formed by the walls at the ceiling and the floor.

The point at which parallel lines seem to meet and disappear is called the **vanishing point**. As artists experimented with linear perspective, they found that they could create the illusion of depth with one, two, and even three vanishing points.

There are other ways to organize a flat surface to create the illusion of depth. One way is overlapping. **Overlapping** means covering part of one object by placing another object in front of it. Objects that overlap others seem closer than whatever is covered up. Artists also work with size, color, and placement to help suggest depth.

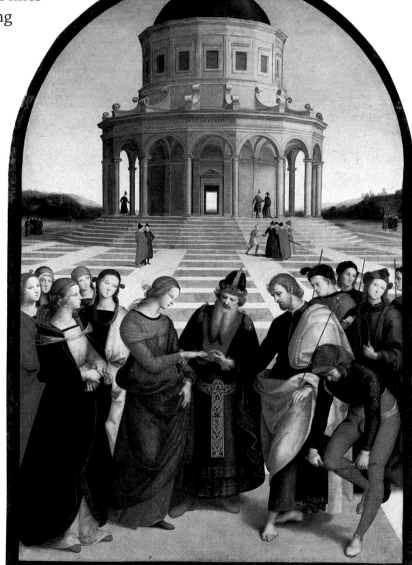

Fig. 4–3 **Notice how your eyes move toward the space in the distance, beyond the main characters in the scene. How has the artist created the illusion of depth?**

Raphael Sanzio, *Marriage of the Virgin*, 1504. Wood panel, 67" x 46" (170 x 118 cm). Pinacoteca di Brera, Milan, Italy. Scala/Art Resource, New York.

Fig. 4–4 **David Hockney creates and explores his own system for organizing space.**

David Hockney, *Merced River Yosemite Valley Sept. 1982*, 1982. Photographic collage, 52" x 61" (131.1 x 154.9 cm). ©David Hockney.

Meet David Hockney

David Hockney was born in England and studied at the Royal College of Art, London, where he won the college's gold medal for his achievements. Soon afterward he moved to California and became a full-time artist.

Hockney is well known for his paintings, photography, and computer art. He often experiments with ways of showing places and people. In the 1980s he made a series of what he called "joiners," landscapes and portraits made of many individual photographs to show more in two dimensions than photographs or paintings can usually show.

"If we are to change our world view, images have to change. The artist now has a very important job to do."

— David Hockney (born 1937)

Using Design Principles Artists in every culture organize their artworks, paying attention to how the parts add to the entire work. Within the Western tradition, artists mostly use principles of design (such as unity, pattern, and repetition) to guide their use of the elements of design (such as line, shape, and color).

Nancy Graves organized her sculpture (Fig. 4–6) by repeating similar shapes and forms. Notice how her use of color adds an element of rhythm. How do your eyes move from part to part? From color to color?

George Tooker used repeated colors, values, and shapes to help unify his painting (Fig. 4–5). Note how all but the central character are wearing drab-colored coats and have a similar form. The red dress and the wearer's worried expression add contrast to the composition. Many lines point to the woman, adding tension and interest. This painting shows how organization can help an artist hold the viewer's interest and direct their attention. With the elements and principles of design as organizational tools, an artist has the power to convey mood and meaning.

Fig. 4–5 **The artist organized the painting to create a feeling of anxiety. Lines, forms, and colors are arranged to heighten suspense. How did he use perspective?**

George Tooker, *The Subway*, 1950. Egg tempera on composition boards 26" x 44" (66 x 111.8 cm). Collection of Whiney Museum of American Art. Purchased with funds from the Juliana Force Purchase Award. 50.23. Permission of the artist, courtesy of D.C. Moore Gallery, NY. Photo by Sheldon C. Collins.

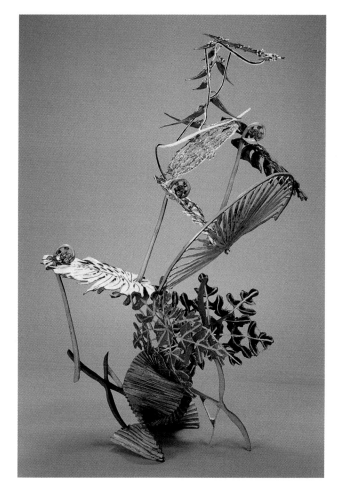

Fig. 4–6 **At first glance, this sculpture may appear so lively as to seem chaotic. How has the sculptor organized her work?**

Nancy Graves, *Zaga*, 1983. Cast bronze with polychrome Chemical patination, 72" x 49" x 32" (182.8 x 124.5 x 81.3 cm). Nelson-Atkins Museum of Art, Kansas City, Missouri (Gift of the Friends of Art). ©1999 The Nelson Gallery Foundation. All Reproduction Rights Reserved. ©Nancy Graves Foundation/ Licensed by VAGA, New York, NY.

Check Your Understanding

1. Use examples to explain two ways an artist can unify an artwork.

2. Show by example how an artist can create the illusion of depth in an artwork.

3. Which piece of art from this lesson appears the most organized to you? Explain.

Creating a System

You can create an artwork using a system for organizing its shapes, lines, and colors.

- Consider possible ways to organize a drawing with many different parts, such as perspective, overlapping, repetition, tessellation, or radial symmetry.

- Choose an organizing system and a square, rectangular, or circular format that you would like to use.

- Decide on a theme or related set of shapes. Include both large and small shapes for variety. Make several sketches to explore ways to unify the parts.

- Plan your final drawing with light pencil lines and render in colored pencil.

Reflect on the organization of your design.

Fig. 4–7 Student artwork

Using Unity and Variety

Even though consistency and change are opposites, people seem to like both. Too much order can be monotonous. Too little order may seem confusing. This is true in life and in art. By using the design principles of unity and variety, artists can express ideas and capture our interest.

Looking at Unity Unity is the sense of oneness in a work of art. You can see unity in art when parts work together in harmony.

In art, unity is often created by:
- repetition
- dominance (use of one major color, shape or element)
- harmony (a relationship among similar colors, textures, and materials).

Some artists may also show one major element in several different ways throughout the work, or carefully place shapes to lead the viewer's eye around the work.

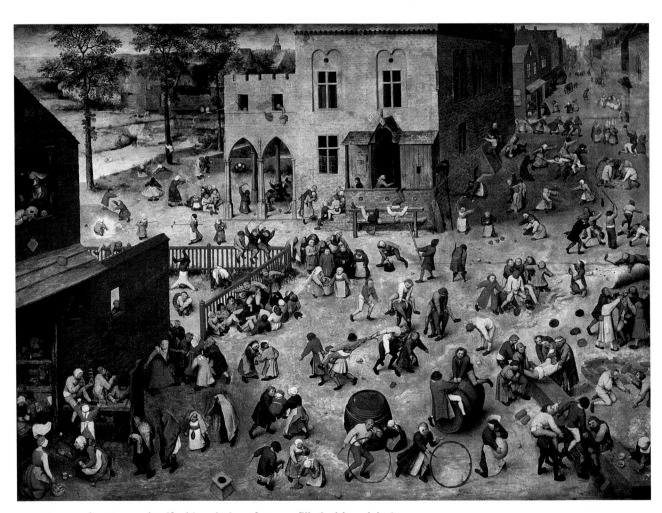

Fig. 4–8 **How does Bruegel unify this painting of a town filled with activity?**

Pieter Bruegel, *Children's Games*, 1559–60. Oil on wood, 46 ½" x 63 ½" (118 x 161 cm). Kunsthistorisches Museum, Vienna.

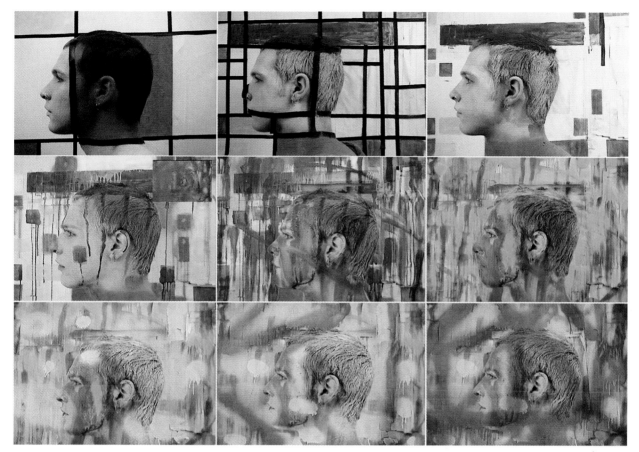

Fig. 4–9 **How does the artist use both unity and variety in this painting?**

Oliver Herring, *The Sum of Its Parts.* Courtesy the artist and Max Protetch Gallery.

Observe Notice the zigzag "path" that starts in the lower left corner of Fig. 4–8. Follow the fence and then the row of trees; next move across the top of the building and back down the open street. The path ends in the bottom right. This "path" helps create unity in they painting by pulling the work together.

Tools: Paper, pencils or other drawing tools, and colored media such as crayons, markers, or colored pencils.

Practice: Creating Unity

- Draw a simple landscape.
- Use repetition, dominance, or harmony to create unity. For example, you can create unity in the landscape by using three related colors (related colors are colors that are next to each other on the color wheel).

What unifies this illustration?

Fig. 4–10 **Sofonisba Anguissola was the first Italian female painter to become well known. How well does she achieve a balance of unity and variety in this work? Explain.**

Sofonisba Anguissola, *Three Sisters Playing Chess*, 1555. Oil on canvas, 28 ⅜" x 38 ¼" (72 x 997 cm). MNPM039. Muzeum Narodwe, Poznan, Poland. Photo by Jerzy Nowakowski.

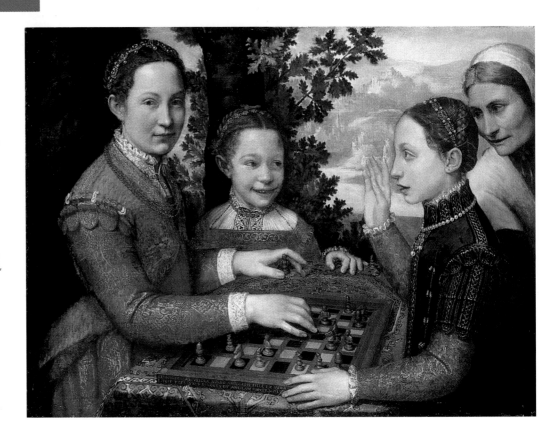

Looking at Variety Variety, unity's opposite, is the use of different or contrasting design elements to make a composition livelier. Artists try to use variety wisely so that the artwork is interesting but not confusing. Variety can be achieved through slight changes in texture or color, or by adding visual surprises, such as unexpected contrasts, exaggerations, or bright colors in a dull-colored area.

Observe Notice how the slight changes in texture and color within the dresses of the three sisters create variety (Fig. 4–10).

Tools: Pencils or other drawing tools and colored media such as crayons, markers, or colored pencils.

Practice: Creating Variety

- Refer back to your drawing of a simple landscape.

- Add contrasting colors, exaggerations, or other elements that create variety.

- Reflect: Is it possible to create too much variety?

What gives this illustration variety?

Torn-Paper Portrait

Create a portrait collage using a variety of papers.

- Look for different shapes, colors, lines and textures.

- Organize your collage to create unity through repetition and harmony.

- Use one major color, shape or other element to create dominance.

- Slightly overlap the edges as you glue your collage pieces to a background.

Reflect on the variations in colors and papers and how you created unity in your collage.

Check Your Understanding

1. Describe three ways an artist might plan for unity in an artwork.

2. Compare and contrast unity and variety. How are they different? How are they the same?

3. Why might an artist want to create disunity in a work of art? What feelings might such a work cause in its viewers?

Fig. 4–11 Student artwork

Organizing a Sculpture

Studio Background

Cubism is an art movement that began when Pablo Picasso noticed that forms could be simplified into shapes and shown from more than one point of view. Picasso first used his system in his drawings and paintings (Fig. 4–12). Then, while looking at one of his Cubist paintings, he realized it would only have to be cut up and reassembled to be sculpture. So, Picasso created a kind of sculpture (Fig. 4–13) that had never been seen before. He began cutting simple shapes out of flat pieces of metal and cardboard and assembling them.

In this studio exploration, you will experiment with Cubist ideas, first by drawing and then in a sculpture. As you work, consider how you are organizing the space in your composition. Keep in mind that your final sculpture may or may not resemble the object you begin with— that is your choice.

You Will Need

- object to draw
- sketch paper
- pencil
- posterboard
- scissors
- tape

Things to Remember:

✓ Consider the different angles of the object when you are designing your sculpture.

✓ Focus primarily on the main shapes of the object, not its details, to keep your artwork simple.

✓ Organize the shapes in a way that will interlock the best to create a three-dimensional sculpture related to your object. Your completed sculpture, however, eventually may not have any resemblance to the original object that inspired it.

Inspiration from Our World

Inspiration from Art

When Pablo Picasso was a young child in the late 1800s, people said that he could "draw like Raphael." Picasso continued to draw and explore other art media for more than seventy years. During this time, he experimented with many different ways to organize his artworks. The system for which he is most well known is called Cubism.

Like the Renaissance artists, Picasso wanted to show figures as they really exist in space. But he noted that figures in space are actually seen from many changing viewpoints. Therefore, the Cubist system broke up natural forms into tilting, shifting planes and geometric shapes.

Fig. 4–12 **Cubism is an art movement that was started by Picasso. Why is this painting a good example of Cubism?**

Pablo Picasso, *Guitar on a Table*, 1919. Gouache on paper, 4 9/16" x 3 7/16" (11.6 x 8.7 cm). Musée Picasso, Paris, Dation Picasso. ©Photo RMN. ©2000 Estate of Pablo Picasso/Artists Rights Society (ARS), New York.

Fig. 4–13 **Before Picasso created this work, all sculpture had been either carved or modeled. Why do you think this new kind of sculpture was called constructed sculpture?**

Pablo Picasso, *Guitar*, 1912–13. Construction of sheet metal and wire, 30 ½" x 13 ¾" x 7 ⅝" (77.5 x 35 x 19.3 cm). Museum of Modern Art, New York. Gift of the artist. Photograph ©2000 The Museum of Modern Art, New York. ©2000 Estate of Pablo Picasso/Artists Rights Society (ARS), New York.

Step 1 Plan and Practice

- Select an object that interests you.
- **Look at the object from many different angles.** What features of the object do you think are most important?

- **Sketch the main shapes of the object from different points of view.** Draw your object repeatedly until you feel you know it well. Which shapes will you simplify for a sculpture?

Step 2 Begin to Create

- Draw each of your shape choices separately on posterboard.
- **Cut out each shape. How will they interlock?** Cut the slots.

- Construct your sculpture. Secure the parts with tape.

Step 3 Revise

Did you remember to:

✓ Consider the different angles of the object when you are designing your sculpture?

✓ Focus primarily on the main shapes of the object, not its details, to keep your artwork simple?

✓ Organize the shapes in a way that will interlock the best to create a three-dimensional sculpture related to your object?

Adjust your work if necessary. In your sketchbook, make a note of your revisions and why you made them.

Step 4 Add Finishing Touches

- Does your sculpture resemble your object?
- Are there any details of your object that you want to add?

Step 5 Share and Reflect

- As a class, discuss each student's sculpture. How were the simplified shapes combined to provide different viewpoints? How have you organized your forms in space? What effect might the work have on the viewer?

Art Criticism

Describe How would you describe this sculpture to someone over the phone?

Interpret What comes to mind as you look at the sculpture?

Analyze How did the artist arrange the parts of this sculpture?

Evaluate What makes this artwork interesting?

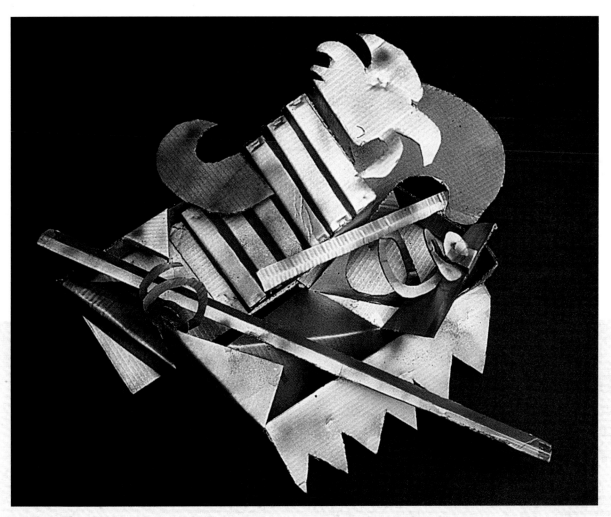

Fig. 4–14 Student artwork

The Art of the Renaissance

As the Middle Ages came to a close in the late 1300s, people in Europe were looking for ways to improve their lives. In Italy, individual participation in trade and commerce increased. Towns and cities grew. The middle and upper classes controlled the wealth and government of the cities. They also became patrons for local artists by hiring them to create special artworks for their use. A patron is a wealthy or influential person or group who supports artists.

Artists of the 1400s knew they were living in a special time. They wanted to create their own golden age of art called the Renaissance. The term renaissance means "rebirth." It refers to the return to classical ideals of ancient Greece and Rome.

Fig. 4–15 **Michelangelo designed the dome of St. Peter's Basilica, pictured here. Where else have you seen domes such as this one?**

Michelangelo Buonarroti, *Dome of St. Peter's*, 1546–64. The Vatican, Rome. Courtesy of Davis Art Images.

ca. 1427
Masaccio,
Tribute Money

1512
Juan Ponce de León discovers Florida.

1513
Da Vinci,
Staircase and Horses

1528
A manual for European nobles, *The Book of the Courtier*, is published.

1546–64
Michelangelo,
Dome of St. Peter's

1400s

1500s

1499
Michelangelo,
Pietà

1513
Machiavelli writes *The Prince*, an influential book about political power.

1514
Matsys,
Moneylender

1534
The Act of Supremacy splits the Pope and the Church of England.

1550
Giorgio Vasari writes the first book of art history and art criticism.

Art and Perspective Renaissance artists used new knowledge about the natural world. They established new theories and systems for drawing. They created special new portraits, landscapes, and religious paintings. Art criticism, art history, and new theories about architecture and linear perspective were written.

Through the use of linear perspective, Renaissance artists were able to arrange their works in an orderly way. Linear perspective helps show how the shapes of things seem to change as they recede in space. A scene painted using linear perspective appears orderly to our eyes because it shows how we see things in real life.

To make things seem very far away, artists used a technique called atmospheric perspective. Paintings with atmospheric perspective use pale colors, fuzzy outlines,

Fig. 4–17 **What type of perspective is used to create this artwork? How can you tell?**

Leonardo da Vinci, *Perspective study for the staircase and horses (for the "Adoration of the Magi")*. Photo: Alinari/Art Resource, NY.

and almost no details to show objects in the distance. Atmospheric perspective can help give order to an artwork by separating it into distinct sections. These sections are known as foreground (the area closest to you), middle ground, (the area between foreground and background), and background (the area farthest away from you).

Fig. 4–16 **Masaccio experimented with perspective. The diagonal lines of the building in this fresco show linear perspective. What elements of the painting show atmospheric perspective?**

Masaccio, *The Tribute Money*, ca. 1427. Fresco. Brancacci Chapel, S. Maria del Carmine, Florence, Italy. Scala/Art Resource, New York.

Classical Sculpture The work of Michelangelo clearly expresses the Renaissance world. Like many artists of his time, Michelangelo studied anatomy. His artworks reveal this new knowledge of the human body. Look at Michelangelo's *Pietà* (Fig. 4–19). Despite the heavy folds of clothing, Michelangelo gives us the sense of a real body underneath. This sculpture is an example of the Renaissance interest in showing the underlying structure of things.

Northern Europe's Renaissance

Like the Italians, northern Renaissance artists wanted their artworks to look real. But while Italian artists focused on the structure of things, artists of the north were more interested in showing their surface, or how they appeared. The new medium of oil paint helped them show richly colored, carefully detailed surfaces. They used size, color, and placement to draw the eye to areas they wanted to emphasize.

Fig. 4–19 **During the Renaissance, the church remained an important patron of the arts. This sculpture was commissioned by a cardinal in the Vatican.**

Michelangelo Buonarroti, *Pietà*, 1499. Marble, height: 5' 6" (1.7 cm). St. Peter's Basilica, Vatican State. Scala/Art Resource, NY.

Check Your Understanding

1. What are two ways Renaissance artists organized their paintings to create an illusion of depth?

2. Compare the way Masaccio and Matsys portrayed the people in their paintings.

3. How much influence do you think patrons had on the artworks produced by Renaissance artists? Explain.

Fig. 4–18 **How does the artist make you feel as though you're sitting across from these two people?**

Quentin Matsys, *The Moneylender and His Wife*, 1514. Oil on wood, 27 ¾" x 26 ½" (70.5 x 67 cm). Louvre, Paris, France. Erich Lessing/Art Resource, NY.

Meet Michelangelo

Today, many talented young artists go to school. But during the Renaissance, promising young boys, and a few women, studied in studios with masters. Michelangelo began his training at the young age of thirteen.

In Michelangelo's time, the Roman Catholic Church was the most powerful patron in Western Europe. The church paid great artists to produce paintings and sculptures that showed its importance as a political and spiritual leader. Michelangelo's art for the church went beyond what others had done before. He filled his figures from the Bible with deep human emotion. Look at Michelangelo's *Pietà* (Fig. 4–19). You can sense Mary's sadness as she holds her dead son. When Michelangelo completed this sculpture at the age of twenty-five, people were so impressed with his talent that he was selected for many other projects.

"What little good I have within me came from the pure air of your native Arezzo [city in Central Italy] and the chisels and hammers."

—Michelangelo (1475–1564)

Studio Time

Renaissance Portrait

Create a portrait of yourself, or someone you know, in a Renaissance setting or costume.

- Consider the following: What clothing and hairstyle will you include? What setting will you depict? How will your viewers know what century you have depicted? How will your viewers recognize the subject of your portrait? Sketch the portrait in pencil using proportion guidelines.

- Start painting with light colors. Then work toward darker shades for shadows. Create highlights with tints.

- Use a fine-tip brush for small details.

Reflect on how the costume and setting in your portrait is similar to and different from Renaissance portraits.

Fig. 4–20 Student artwork

The Art of China and Korea

The art of both China and Korea spans thousands of years. Chinese ideas and culture greatly influenced Korea, but Korean artists developed their own unique style of art. Artists from both countries have worked in varied media, perfecting their techniques over time.

Patterned Vessels Over the centuries, the Chinese have developed unique and elegant forms for their bronze and ceramic vessels. They have decorated these vessels and other objects with designs and patterns that have special meaning to them.

Fig. 4–21 **This vessel was probably used only for ceremonies. Look for images or shapes of animals in the vessel's overall form.**

China (Shang Dynasty, ca. 1600–1045 BCE). *Kuang Ceremonial Vessel*, 12th century BCE. Bronze, 9 ¼" x 12 ³⁄₁₆" (23.5 x 31.0 cm). Courtesy of the Freer Gallery of Art, Smithsonian Institution, Washington, DC.

Social Studies Connection

Often, the peoples of one country influence those of another, either by force or by example. These influences can be seen in the way people live, how they think, and the art they create.

The long histories of **China** and **Korea** are usually divided into dynasties. China has the longer history, going back some 8000 years. But Korea helped spread China's influence into other parts of East Asia, especially Japan.

Fig. 4–22 **This vase shows the Korean inlay technique. Where is the pattern on this vase?**

Korea, Koryo Dynasty (918–1392), *Meiping Vase with Crane and Cloud Design*, late 13th–early 14th century. Porcelaneous ware, celadon with inlaid design, 11 ½" (29.2 cm) high. The Metropolitan Museum of Art, Fletcher Fund, 1927 (27.119.11). Photograph ©1987 The Metropolitan Museum of Art.

Fig. 4–23 **The dragon has always been an important element in Chinese designs. During the Ming Dynasty, when this jar was made, the dragon represented the emperor.**

China, Ming Dynasty (1368–1644). *Pair of Vases,* 1426–35. Porcelain with blue underglaze decoration, 21 ¾" x 11 ½" (55.2 x 29.2 cm). The Nelson-Atkins Museum of Art, Kansas City, Missouri (Purchase: Nelson trust).

The Order of Patterns Patterns help to organize and unify the different parts of an artwork. An *allover pattern* is created when designs and patterns cover the whole surface of an object. The Chinese used this type of pattern often. Sometimes, Chinese artists only placed the designs in bands around the vessel's form, as in Fig. 4–23.

Korean ceramics (Fig. 4–22) show the influence of the Chinese. Chinese artists taught the Koreans the techniques of glazing and working with porcelain. Porcelain (POR-suh-len) is a type of fine white clay. Korean artists also used allover patterns and bands to organize surface designs. They carved a design into the main clay form and then placed black and white clays in the grooves. This technique, known as *inlay*, was much admired by the Chinese.

Visual Culture

The four treasures of Chinese artists are the ink stick, the ink stone, the bamboo brush, and the paper. They keep these treasures neatly organized in a special box. In specific order, the artist takes a small portion of the ink stick, dilutes it with water while grinding it on the ink stone, and then applies ink with a bamboo brush.

Consider how people in your home and community organize the tools and materials they work with. What rules do people follow for setting a table for dinner? How do auto mechanics, electricians, plumbers, and carpenters organize their tools? What organizational systems do librarians use? How do organizational systems affect the appearance of a home or workplace?

Painted Spaces Painting has always been an important art form in East Asia. Chinese artists had a long tradition of landscape painting, which they transferred to Korea. Korean artists treated the subject in their own way, often adding humorous elements or exaggerated parts of the landscape.

Organizing Space Chinese and Korean paintings are carefully organized. It is sometimes helpful to imagine taking a walk inside these artworks. On long horizontal paintings, called *handscrolls*, you start on the right-hand side. On long vertical paintings, called *hanging scrolls*, you start at the bottom. Look for changes in value, color, or different kinds of lines that direct your eye. Contrasts in light and dark or colored and uncolored parts can also make things stand out and draw your attention. Objects in the foreground are usually lower in the painting. Objects in the background are higher in the work.

Meet Lu Zhi

Lu Zhi lived and worked during the Ming dynasty in south central China. He was the son of a schoolteacher. Lu studied art under Wen Zhengming, a renowned painter, and after his father's death, he earned his living by selling his paintings. In China at that time, painting, calligraphy, and poetry were called the "Three Perfections." Ming dynasty paintings were usually accompanied by poems. About 1557, Lu retired to the mountains to grow chrysanthemums, write poetry, and paint.

"I feast my eye on the cold river in autumn."

— From poem inscribed on the hanging scroll *Pulling Oars Under Clearing Autumn Skies* (Fig. 4–25) by Lu Zhi (1496–1576)

Fig. 4–24 **How does the contrast between light and dark unify this work?**

Korea (Choson period, late 18th century), *Seven Jewelled Peaks Ch'ibosan*. Ten-panel screen, ink and color on cloth, 62 ¼" x 172 ½" (158.1 x 438.2 cm). ©The Cleveland Museum of Art, Mr. and Mrs. William H. Marlatt Fund, 1989.6.

Fig. 4–25 **How does the unpainted space that symbolizes a river connect the foreground to the background?**

Lu Zhi (Ming Dynasty, 1368–1644), *Pulling Oars Under Clearing Autumn Skies ("Distant Mountains"),* 1540–1550. Hanging scroll, ink and color on paper, 41 ⅝" x 12 ¼" (105.7 x 31.1 cm). W.L. Mead Fund 1953.159. Photograph ©1999, The Art Institute of Chicago. All Rights Reserved.

Studio Time

A Stroll on a Scroll

Make a scroll painting that leads your viewer on a "walk."

- Borrow the Chinese and Korean system for showing distance. Think carefully about: path of the journey, the format (vertical or horizontal), and the colors.

- Use lines or changes in value or color to direct the viewer's eyes. Use contrast (light or dark, colored or uncolored) to draw attention.

- Place the closest parts of the scene at the bottom; place the distant parts at the top.

Reflect on how you can walk into and through your painting.

Fig. 4–26 Student artwork

Check Your Understanding

1. What are some of the similarities between Chinese and Korean art?

2. Compare and contrast the way that Chinese and Korean artists represent space and distance with the way European Renaissance artists do.

3. What cultures were most directly influenced by the arts of China and Korea?

Drawing in Perspective

Studio Background

Have you ever wondered what it might be like to step into a landscape painting? Suddenly, everything in the painting would come alive. What seemed flat would have depth. Artists can create that sense of wonder when they draw or paint with linear perspective.

In this studio exploration, you will draw a scene in one-point perspective. Use one-point perspective to add a sense of real life to the picture. Think about other methods of perspective that you can use. (See Inspiration from Art.) Make your scene as inviting to viewers as you can.

You Will Need

- drawing paper
- pencil and eraser
- ruler or yardstick
- colored pencils

Step 1 **Plan and Practice**

- Find an indoor or outdoor scene that interests you. Make sure it lends itself to one-point perspective. The scene should have features with lines that clearly come together at a single vanishing point—a tree-lined road, rooftops, railroad tracks, a long hallway, or the like.

- Study the scene. Where is the horizon line? Which lines in the scene come together to a vanishing point? Sketch the scene to help you remember the linear perspective qualities and details.

Things to Remember:

- ✓ Intersect your guiding lines at a single vanishing point.
- ✓ Follow the guidelines you created to sketch your scene.
- ✓ Use other methods of perspective to enhance the illusion of space.

Inspiration from Our World

Inspiration from Art

For hundreds of years, artists practiced many methods of perspective. Until the Renaissance, the most common methods included overlap, variation of size, placement of subject matter, amount of detail, and use of color. While artists of the Renaissance knew these methods well, they wanted to paint with greater realism.

In the early 1400s, artist and architect Filippo Brunelleschi discovered linear perspective. An artist painting or drawing a scene in linear perspective creates a horizon line. A horizon line is a level line where the earth seems to end and the sky begins. The horizon line is usually located at eye level. It can be high, low, or in the middle of the artwork, depending on the point from which the artist wants you to view the scene. Vanishing points are placed on the horizon line.

From the 1400s on, artists could combine linear perspective with other methods of perspective. This helped them achieve realism.

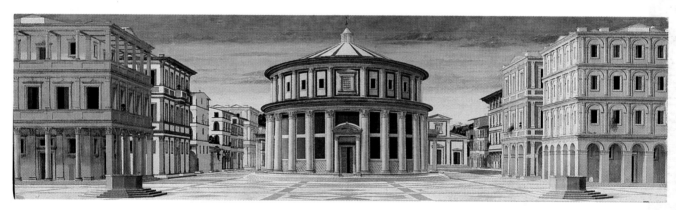

Fig. 4–27 **This cityscape is an excellent example of linear perspective. Vertical lines of windows and columns are perpendicular (at right angles) to the horizon line. Most horizontal lines are parallel to the horizon line. Notice how the roof and foundation lines, building stories, and pavement lines meet.**

Piero della Francesca, *The Ideal City*, 1480. Galleria Nazionale Della Marche, Urbino, Italy, Scala, Art Resource, NY.

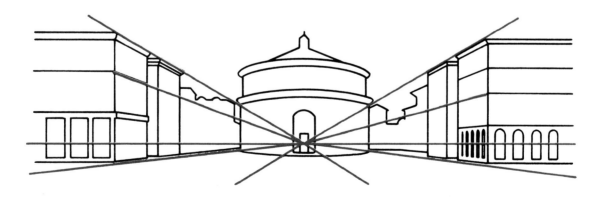

Step 2 **Begin to Create**

- Begin your drawing by first drawing a light horizon line. Will it be high, low, or in the middle of the paper? Mark a vanishing point on the horizon line.

- **Use a ruler or yardstick to add light guides for the lines that come together at the vanishing point.** When you are finished, you will have a grid that will help you organize your drawing.

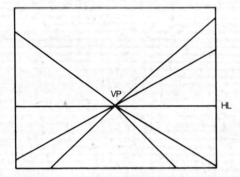

- **Lightly sketch the main features of the scene.** Follow the guidelines as needed to keep the one-point perspective.

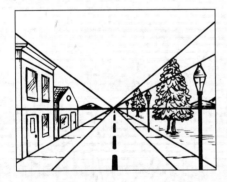

- When you are happy with your sketch, add color and the details you remember with colored pencils. You may wish to add details from your imagination.

- As you work, think about other methods of perspective that will help you create the illusion of space. Are objects in the distance smaller than those up close? Do objects overlap? Do they get lighter in color as they recede into space?

- When you finish, carefully erase any unwanted guidelines.

Step 3 **Revise**

Did you remember to:

✓ Intersect your guiding lines at a single vanishing point?

✓ Follow the guidelines you created to sketch your scene?

✓ Use other methods of perspective to enhance the illusion of space?

Adjust your work if necessary. In your sketchbook, make a note of your revisions and why you made them.

Step 4 **Add Finishing Touches**

- Do you need to add more details? More color?
- Make sure all guidelines are completely erased.

Step 5 **Share and Reflect**

- Discuss your drawing with classmates. What was the most difficult challenge you faced when drawing in one-point perspective? How did you solve the problem?
- See if your classmates can find your horizon line and vanishing point. Can they point out other methods of perspective that you used?

Art Criticism

Describe What do you see in this drawing?

Analyze How did the artist create the illusion of space in this drawing?

Interpret What mood or feeling does this drawing suggest to you?

Evaluate What makes this artwork successful?

Fig. 4–28 Student artwork

Language Arts

Until the mid-1400s, books had to be copied carefully by hand. As a result, they were rare and expensive. The invention of the printing press and movable type changed things. Around 1450, Johannes Gutenberg began to print with movable type. Cast metal letters were put together to form words. The words filled a page, and the pages made a book. Why is organization important when creating a book?

Fig. 4–29 John Amos Comenius, *Typographers (Die Buchdruckerey), Orbis Sensualium Pictus. Nuremburg,* 1658, p. 190. PML 83013 The Pierpont Morgan Library/Art Resource, NY.

Music

Fig. 4–30

In musical works, composers organize sounds to create a melody. The melody is the tune in a song that grabs your attention. The composer adds harmony to the melody. It is often played by instruments different from those playing the melody. If we compare music and art, we might say that harmony is like a painting's perspective. This is because it provides a sense of depth. In what other ways are music and art similar?

Careers **Graphic Designer**

Graphic designers bring organization to visual communication. Graphic designers are hired by services and industries. They organize and clarify information that is very important to business success. These artists use what they know about design. They create advertisements, presentations, books, and commercials. They also create displays, web pages, signs, and packaging. Some of their "building blocks" are words, company logos, photography, illustration, and digital special effects.

Fig. 4–31 **Graphic designer David Lai creates websites, writes books on design, and teaches web design. He is chief executive officer of Hello Design in California (www.hellodesign.com).**

Photo courtesy of the artist.

Daily Life

What kinds of bowls can you think of? Some may be made from a type of ceramic clay. Archaeologists have found clay containers from the earliest civilizations in China and Korea. Some are food vessels made of rough clay. Others are colorfully decorated porcelain clay pieces. Simple and organized designs are common in traditional Asian ceramics. Nature scenes are also common. What might these clay containers tell us about the earliest civilizations in China and Korea?

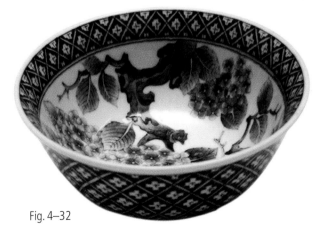

Fig. 4–32

Vocabulary Review

linear perspective

vanishing point

porcelain

atmospheric perspective

unity

variety

1. sense of oneness in artwork

2. a technique used to show three-dimensional space on a two-dimensional surface

3. a type of fine white clay

4. the use of different or contrasting design elements to make a composition livelier

5. technique that uses pale colors, fuzzy outlines, and few details to make things seem far away

6. the point at which parallel lines seem to meet and disappear

Aesthetic Thinking

What do you think makes an artist choose one way of organizing over another? Make a list of things that might influence artists' decisions and compare with classmates.

Write About Art

Look carefully at this image. Then imagine you are the artist looking at the actual scene. Describe how and why you are creating the painting. What do you see, hear, smell? What have you left out of the painting?

Fig. 4–33 Thebes, XVIIIth dynasty, *Garden with Pond*, ca. 1400 BCE. ©The Trustees of the British Museum.

Art Criticism

Describe What do you see in this wall painting?

Analyze How does the artist use repetition to unify the painting?

Interpret How does the architecture in the painting help to organize the group of figures?

Evaluate This painting, showing Greek philosophers, decorates the Pope's library in the Vatican. How does the painting help extend the space in the room where it hangs?

Fig. 4–34 **Raphael shows himself in this painting at the far right, wearing a black beret. Why do you think he is the only figure who makes eye contact with the viewer?**

Raphael Sanzio, *The School of Athens*, 1509–11. Stanza della Segnatura, Vatican Palace, Vatican State. Scala/Art Resource, NY.

Meet the Artist

Raphael Sanzio (1483–1520) was born in Urbino, Italy. He was one of the most important artists of the period known as the High Renaissance, from 1500 to 1520. Raphael painted altarpieces, portraits, and frescos. He also worked as an architect. Raphael died in Rome at the young age of thirty-seven.

For Your Portfolio

Choose one of your works that shows good organization through unity, variety, or illusion of depth. Explain why its organization works well.

For Your Sketchbook

Sketch various views through a doorway. Try different ways to organize them: create deep space in some, and shallow space in others.

Artists Respond to Daily Life

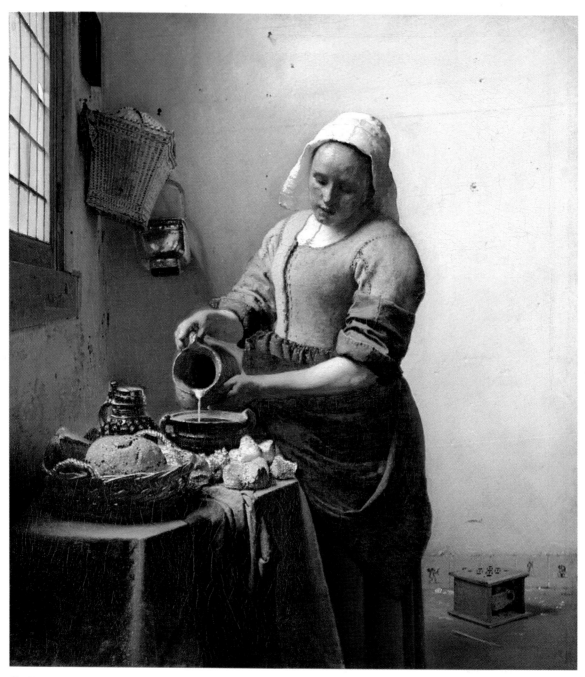

Fig. 5–1 **Vermeer shows a quiet scene from daily life. What familiar scenes can you think of that have a special beauty?**

Jan Johannes Vermeer, *The Milkmaid*, ca. 1658. Oil on canvas, 18" x 16 ⅛" (45.5 x 41 cm). Purchased from the heirs of Jonkheer P.H. Six van Vromade, Amsterdam, 1908, with aid from the Rembrandt Society. Rijksmuseum, Amsterdam.

Lots of people keep a journal or diary to record what they do each day. Do you? People have been keeping records about their daily lives for centuries. From cave drawing to diaries to cameras and videos, people record the day-to-day and special events happening around them. Keeping records in this way is important so people can share their stories, and so that the changes in daily life are captured for history.

If you were to travel around the world, you would find that people do many of the same basic things. Artists have found daily-life objects and events to be important subject matter for artworks. The way we work and play, and the things we have in our homes and workplaces, have found their way into paintings and sculptures.

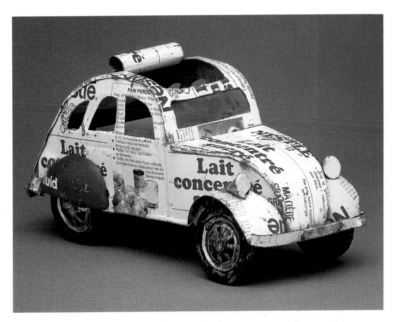

Fig. 5–2 **Everyday objects can be recycled to create new forms. Here, a milk can is turned into a toy.**

South Africa (Johannesburg), *Deux Chevaux (Toy Car)*, 1994. Johannesburg, South Africa. Nestle concentrated milk can. Collection of the International Folk Art Foundation, Museum of International Folk Art, Santa Fe. Photo: John Bigelow Taylor, NYC.

In this unit, you will learn:

- How artists show daily life and add beauty to everyday objects.
- How light, value, and contrast can add dimension to artworks.
- How to view works of art as statements about daily life.

Art and Daily Life

Artistic Objects Even when daily life is difficult, people care about having beauty around them. They carefully design objects to help them with their work and play. Crafted tools, containers for storing and serving food, and clothing and blankets for staying warm are all created with care. In cultures around the world and throughout time, functional objects for daily use have been decorated with traditional patterns and symbols.

Prehistoric people probably used oil lamps to light the caves where they created wall paintings. These early oil lamps (Fig. 5–3) were practical, but they were also decorated.

Useful objects are usually made from materials that are easy to find nearby. Have you ever made something useful from materials around you? Have you seen wind-catchers made from plastic soda containers? Can you imagine how an artist might use scraps of cloth to decorate a quilt (Fig. 5–5)?

Fig. 5–3 From the earliest times, people have decorated objects. Note the decoration on this lamp used to light caves.

Lascaux, *Decorated Lamp*, 15,000–13,000 BCE. Musée des Antiquities Nationale, St. Germaine-en-Laye, France. Photo ©RMN, Jean Schormans.

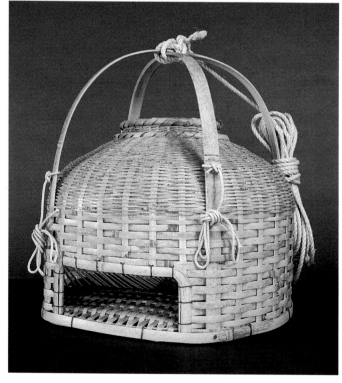

Fig. 5–4 Look closely at all the parts of this basket. How do you think it was made? Why might someone take such care to create a fish trap?

Hiroshima Kazuo, *Fishtrap Basket*, 1986. Bamboo, rope, metal wire, and synthetic string, 20 ⅛" x 20 ⅛" x 20 ⅛" (51 x 51 x 51 cm). National Museum of Natural History Collections, Smithsonian Institution.

Fig. 5–5 Mary Carpenter made the top part of this quilt when she was thirteen. Do you think her sole interest was in making something that would keep her warm?

Mary Carpenter Pickering. Quilt appliquéd with fruit and Flowers, 1850–54. Cotton fabric, 89 ⅛" x 89 ¼" (226.4 x 226.7 cm). National Museum of American History.

Meet Hiroshima Kazuo

Hiroshima Kazuo was born in rural Hinokage, Japan. He injured his hip as a child and could not do farm work or walk to school. At 17, he studied under a basketmaker for two years, then started his career. He travels around the Hinokage region, staying with families and making or repairing baskets. He makes backpack baskets for farmers to collect harvests, fishtrap baskets for fisherman, and storage baskets. He even weaves cylinder baskets that are used for making soy sauce. He is the last wandering basketmaker in his region, and is concerned that this tradition will fade away.

Photograph by Louise Allison Cort

"Making a good basket is not a process of *thinking* about what to do. It's more like a form of prayer.... I want to make something that will please the person who uses it and suits that person's needs."

— Hiroshima Kazuo (born 1915)

Daily-Life Events Lots of different events make up your daily life. You sometimes gather with friends and family. Perhaps you dance or sing. You play games. Many people also work hard every day. On your way home today, notice the people at work. What are they doing? How are they working? Are they alone or are they working with others? Do they use special equipment? Must they dress in a special way?

Artists notice how people work and play together and alone. Sometimes artists make daily life the subject matter of their artworks. For example, Carmen Lomas Garza likes to show the ways that people in families and communities get together. In her work *La Tamalada (Making Tamales)* (Fig. 5–6), we see a family working together to make tamales.

Another important part of daily life is work. Artists show people working to record their daily lives. In *The Tailor's Workshop* (Fig. 5–7), notice the poses of the people. What type of atmosphere has the artist created?

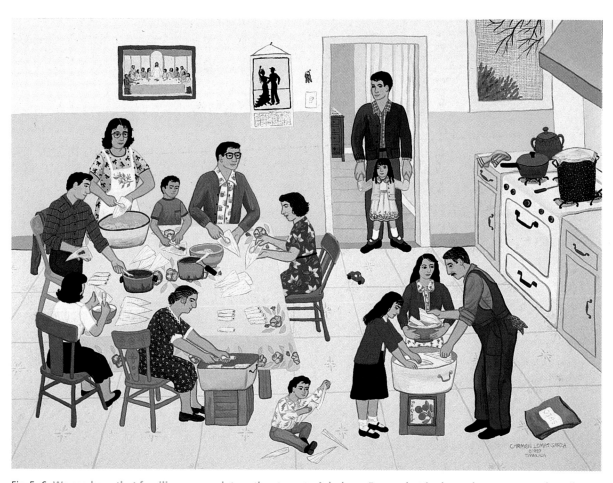

Fig. 5–6 We see here that families can work together to get a job done. From what is shown here, can you describe the process of making tamales?

Carmen Lomas Garza, *La Tamalada (Making Tamales)*, 1984. Gouache painting, 20" x 27" (50.8 x 68.6 cm). Photo: Wolfgang Dietze. Collection of Leonila Ramirez, Don Ramon's Restaurant, San Francisco, California. Courtesy of the artist.

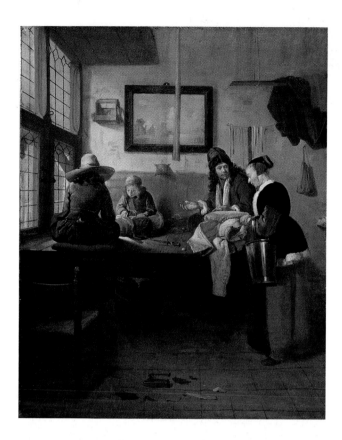

Check Your Understanding

1. What are some ways that art enters our daily lives?

2. Compare and contrast the paintings *La Tamalada* and *The Tailor's Workshop*.

3. How are artists observers of life?

Fig. 5–7 **Artists often show the many ways we spend our daily life. This painting shows people working in a tailor's shop.**

Quinringh Gerritsz van Brekelenkam, *The Tailor's Workshop*, 1661. Canvas, 26" x 20 ⅞" (66 x 53 cm). Rijksmuseum, Amsterdam.

Studio Time

Meal Time

You can create a painting that shows what happens at meal time.

- Decide on a viewpoint (from above, from the side).
- Show the objects that you use, and the food you eat.
- How are the room, the objects, and the table decorated?
- Use light pencil lines to plan your painting.
- Paint large shapes first. Then add details.

Reflect on the effectiveness of the viewpoint you chose.

Fig. 5–8 Student work

Using Light, Value, and Contrast

We need light to see what is around us. The artists of the works shown in this lesson lived in a time before the invention of the electric light bulb. They painted objects from their daily lives lit only by the sun or by lanterns. The objects in these paintings have deep shadows and strong highlights. Using the language of art, we say these paintings show contrast between dark and light values. Contrast is a great difference between two things. The artists' use of contrast helps make the items look three-dimensional, as if they exist in space.

Creating Value Value is the range of light and dark in a color. Look at the value scale. You will see that the lightest value is white. The darkest value is black. Notice the number of gray values that are between white and black. The number of values can vary from one scale to another. Artists can create a value scale for any color. The color red, for example, may have a light value of pink and a dark value of maroon. Red itself may fall somewhere in the middle of its value scale.

Shading is a gradual change in value. It is used to show the shift from dark areas to light ones. A light value of a color is called a tint. Gradual changes in value can suggest a misty atmosphere or a calm, quiet mood. More sudden changes in value create a strong contrast between very light areas and areas of deep shadow.

Observe Examine the change in value on the value scale. Then, look for the range of light and dark in one color in Chardin's painting (Fig. 5–9). How many different values of the color can you see?

Tools: Two thin pieces of paper, folded into five vertical sections, and crayons or another colored medium.

light values middle values dark values

Fig. 5–9 **How would you describe the artist's use of value in this work?**

Jean-Baptiste-Siméon Chardin, *The Silver Goblet*, ca.1760. Louvre, Paris, France, Giraudon/Art Resource, NY.

Practice: Tints and Shades

- On the first piece of paper, color all the sections white.

- Choose a color. Add increasing amounts of the color to each section to create tints. Start tinting in the second section, so that a section remains with the original white.

- On the second piece of paper, color all the sections the same shade of the color you used on the first paper.

- Add increasing amounts of black to the sections of the second piece of paper to create shades. Start shading in the second section, so the first section remains the original color.

Fig. 5–10 **People in the 1600s in the Netherlands enjoyed decorating their homes with artworks of objects and scenes they saw every day.**

Clara Peeters, *Still Life of Fruit and Flowers*, after 1620. ©Ashmolean Museum, Oxford.

Creating Contrast Contrast, as you have already learned, is a great difference between two things. A contrast in values creates a noticeable difference between light and dark in a composition. This design rule allows artists to add excitement or drama to their work. Artists also create contrast by using strong differences between colors, shapes, textures, and lines. Often, the area of an artwork with the greatest contrast captures our attention first.

Where do you see strong contrasts in this drawing?

Observe Look at the painting *Still Life of Fruit and Flowers* by Clara Peeters. Where did she use the most contrast in her work?

Tools: Paper, pencil, and fine-tip black markers.

Practice: Creating Contrasts

- Find two or more objects to draw that are very different in shape and texture, such as your shoe and a book.

- Create a series of drawings of your objects to highlight the contrast in shape, size, and texture.

- Use dots or lines to suggest values and shading. Make some areas solid black and leave other areas white to create strong value contrast.

- In some areas add lines, dots, or repeated small shapes to create the illusion of textures.

Check Your Understanding

1. What is shading used for?

2. Compare the value and contrast in Figs. 5–9 and 5–10.

3. How might the artworks in this lesson look different if a strong spotlight had been used to illuminate the objects in each?

Drawing Everyday Objects

Use pencil or charcoal to make a careful drawing of everyday objects.

- Choose objects that interest you and create an arrangement. Observe the forms and angles.

- Locate the light source. Notice where the light creates highlights and shadows on the object.

- Plan your drawing with light pencil lines. Draw large shapes first, then add details.

- Experiment with creating highlights and a range of dark and light values. Apply more pressure to create dark values. Use less pressure to create light values. You can use an eraser to create highlights.

Reflect on how clearly you have indicated a light source by your use of highlights and shadows.

Fig. 5–11 Student artwork

An Everyday View

Studio Background

A still life is an arrangement of objects that are not alive and cannot move. Since early times, artists have drawn and painted still lifes, carefully selecting objects that say something about a way of life. Almost anything can be selected for a still life, such as flowers, food, vases, and old books. The objects can be drawn literally or as symbols of something else.

In this studio exploration you will create your own still-life painting of things you see every day. Think about objects you collect or like to arrange, or a part of a room that has meaning for you. Why are these things or this spot important to you? Do they tell something about who you are? Choose objects that have special meaning to you or that might symbolize something else.

You Will Need

- paper
- pencils
- tempera paint
- brushes

Step 1 **Plan and Practice**

- Choose some objects to arrange for a still life. Think about objects that express something about your daily life.

- Experiment with arranging your objects in several different ways. Consider size and color relationships.

- If you can control the lighting, direct the light in a way that creates shadows that you like.

- Choose the arrangement you like the best.

Things to Remember:

✓ Choose objects that express something about your daily life.

✓ Pay attention to your light source and light and dark values.

✓ Use tinting and shading techniques to make objects in your painting appear three-dimensional.

Inspiration from Our World

Inspiration from Art

In the Netherlands in the 1600s, artists began to use the term *still life* for paintings in which objects were most important. Dutch artists used food, flowers, and precious objects as symbols to caution people to live good lives.

For example, because the beauty of flowers or fruit does not last long, Dutch artists used them in paintings. They wanted to remind people that their lives were also short.

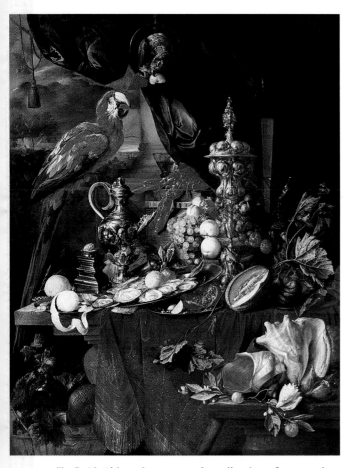

Fig. 5–12 **This artist arranged a collection of new and unusual foods and objects brought back by Dutch merchants. Can you see objects that might symbolize an idea?**

Jan Davidsz de Heem, *A Still Life with Parrots*, late 1640s. Oil on canvas, 59 ¼" x 46 ¼" (150.5 x 117.5 cm). Bequest of John Ringling. Collection of the John and Mable Ringling Museum of Art, the State Art Museum of Florida.

Fig. 5–13 **This painting by Audrey Flack was made about 300 years after the de Heem still life at left. How are the two paintings similar and different?**

Audrey Flack, *Parrots Live Forever*, 1978. Oil over acrylic on canvas, 83" x 83" (210.8 x 210.8 cm). Courtesy of the Louis K. Meisel Gallery, New York.

Step 2 Begin to Create

- **When you are happy with your arrangement and lighting, sketch your arrangement.** Draw the main forms first. Then add the smaller ones.

- Experiment with mixing colors of paint. **Add a color to white to create a tint.**

Add black to a color to create a shade.

- Paint your composition. Start with the light colors and gradually work to the dark colors.
- Mix and use tints and shades. Pay careful attention to where light and dark areas are in your arrangement.

Step 3 Revise

Did you remember to:

✓ Choose objects that express something about your daily life?

✓ Pay attention to your light source and light and dark values?

✓ Use tinting and shading techniques to make objects in your painting appear three-dimensional?

Adjust your work if necessary. In your sketchbook, make a note of your revisions and why you made them.

Step 4 Add Finishing Touches

- If you want to give special attention to part of your drawing, use additional contrast, or big differences in value, to help direct the viewer's attention.

Step 5 Share and Reflect

- Talk with your classmates about your artworks. Try to use at least five adjectives to describe the qualities of light you see in them.
- What makes each composition work well? How does the use of light make the objects look? Do they look important? Mysterious? Cheerful?
- Discuss whatever personal or symbolic meaning the objects seem to have to the artist.

Art Criticism

Describe What objects do you recognize in this painting?

Analyze What choices did the artist make to create unity and add variety to this artwork?

Interpret What mood or feeling does this artwork remind you of?

Evaluate What do you think were good decisions that the artist made?

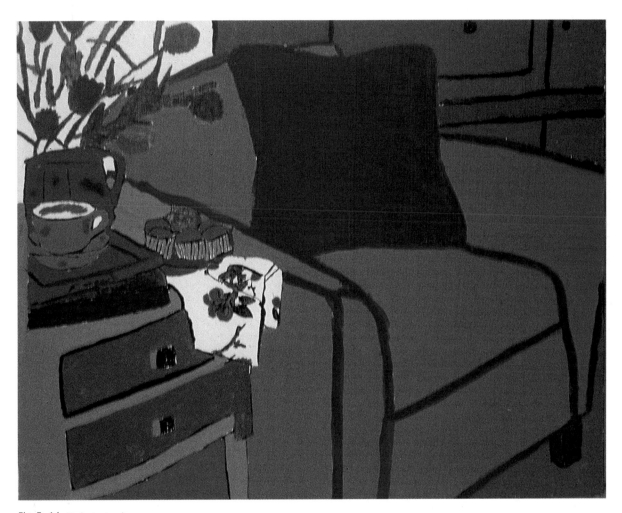

Fig. 5–14 Student artwork

European Art: 1600–1750

Around 1600, exciting changes were happening in the art world. Artists throughout Europe were competing to paint works of art for people who wanted them. To please the people who bought their artwork, artists created fancy pieces that were full of drama and energy. Artists searched for dramatic ways to show familiar subjects: portraits, still lifes, and scenes of everyday life. Tastes were changing. A bold new art style was formed.

This new art style is called Baroque. It began in Italy, but artists throughout Europe liked its power and drama. They used rich textures to add realism. Diagonal lines helped them show movement. Often, Baroque artworks are dramatically lit, like a theater stage. Bright-colored figures or objects emerge from a dim background

In the 1700s, artists in France took the grandness and drama of Baroque one step further. They developed the witty and playful Rococo style. Rococo is a style of art in which artists used contrast, texture, and movement in their art and architecture.

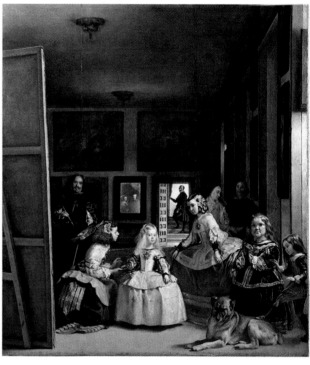

Fig. 5–15 **How does Velázquez use light to add drama and contrast to the figures?**

Diego Velázquez, *Las Meninas (The Maids of Honor)*, 1656. Oil on canvas, 10' 7 " x 9' ½" (3.23 x 2.76 m). Derechos Reservados ©Museo National Del Prado, Madrid.

Rococo artists wanted to create a light and airy feeling. Their paintings had shimmering highlights and textures. Their pastel-colored sculptures appeared delicate and fragile.

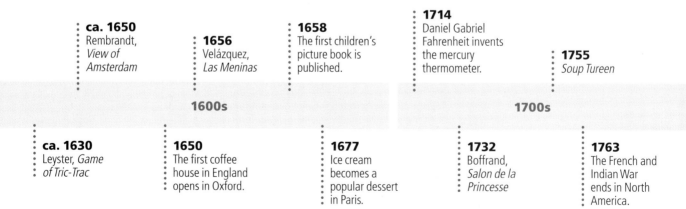

ca. 1650
Rembrandt,
*View of
Amsterdam*

1656
Velázquez,
Las Meninas

1658
The first children's
picture book is
published.

1714
Daniel Gabriel
Fahrenheit invents
the mercury
thermometer.

1755
Soup Tureen

1600s

1700s

ca. 1630
Leyster, *Game
of Tric-Trac*

1650
The first coffee
house in England
opens in Oxford.

1677
Ice cream
becomes a
popular dessert
in Paris.

1732
Boffrand,
*Salon de la
Princesse*

1763
The French and
Indian War
ends in North
America.

A Glimpse of Daily Life We know a lot about daily life in the Netherlands in the 1600s thanks to the visual record the artists and patrons have left behind. Dutch artists were experiencing an exciting time.

The middle class in the Netherlands was growing. As people became wealthier, more and more of them were able to buy artworks to decorate their homes. Art was no longer just for the rich and powerful.

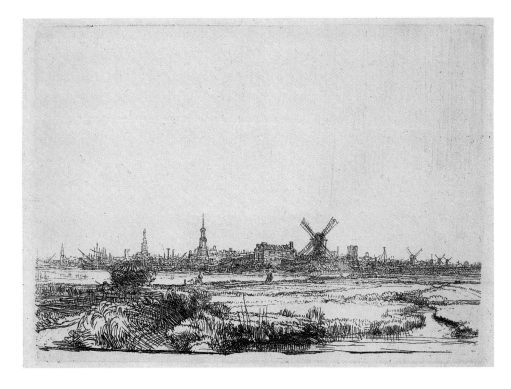

Fig. 5–16 Prints were inexpensive and very popular with the Dutch middle class. Landscape artists like Rembrandt created scenes of the towns and countryside they saw.

Rembrandt van Rijn, *View of Amsterdam*, ca. 1650. Rijksmueum, Amsterdam.

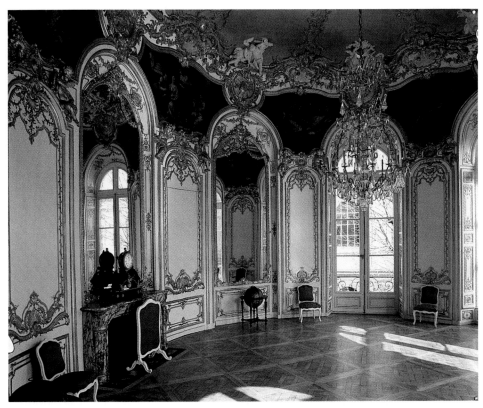

Fig. 5–17 Rococo architecture was generally lighter and more graceful than the earlier Baroque style. How does this room reflect that?

Germain Boffrand, *Salon de la Princesse*, Hôtel de Soubise, Paris, begun 1732. Scala/Art Resource, NY.

For their homes, Dutch people wanted art that reminded them of their comfortable world. Artists focused on landscapes or genre scenes as their subjects. Genre scenes are images of everyday life. Artists such as Judith Leyster (Fig. 5–19) became known for paintings of people and places in the Netherlands. These genre scenes showed ordinary people enjoying their free time. The Dutch saw themselves, their lives, and their activities reflected in these artworks.

Everyday Splendors Rococo artists took the lessons of Baroque art to new heights. They decided to trade Baroque heaviness and seriousness for wit and whimsy. Rococo art reflected the tastes of the wealthy upper class of French society, showing them enjoying leisure time. Look at the everyday object used to serve soup in Fig. 5–18. What does it tell you about life in the 1700s in France?

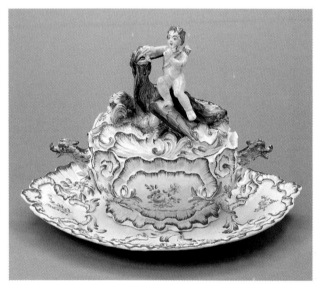

Fig. 5–18 **The Rococo style appeared in all kinds of objects. For what type of occasion do you think this soup tureen might be used?**

Soup Tureen, Cover, and Stand, ca. 1755. Faience with enamel decoration, 11 ⅞" x 14" x 17 ⅞" (30.1 x 35.5 x 45.4 cm). Sceaux Pottery and Porcelain Manufactory, France. Nelson-Atkins Museum of Art, Kansas City, Missouri (Purchase: Nelson Trust). Photography by E.G. Schempf. ©1999. Nelson Gallery Foundation. All Reproduction Rights Reserved.

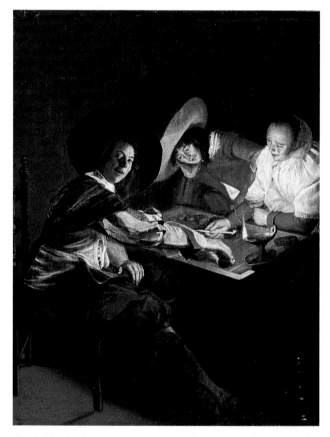

Fig. 5–19 **This interior genre scene shows an ordinary Dutch family enjoying themselves at a popular game, similar to backgammon.**

Judith Leyster, *Game of Tric-Trac.* Oil on panel, 16" x 12 ¼" (40.7 x 31.1 cm). Worcester Art Museum, Worcester, Massachusetts. Gift of Robert and Mary S. Cushman.

Meet Judith Leyster

Judith Leyster (1609–1660) was born in Haarlem, Netherlands. She may have studied with the well-known painter Frans Hals, or with his brother, Dirck Hals. Like them, she used dramatic lighting in her paintings of everyday scenes. By the age of 18, Judith was a successful painter. At 24, she became the only female member of the Haarlem painters guild, which included well-known artists like Rembrandt.

Once Judith married, she stopped creating her own paintings. After some time, she was forgotten. People assumed that her paintings were created by Frans Hals.

In 1893, the Louvre Museum bought a Hals painting and found the initials JL on it. They sent an angry letter to the seller, but soon uncovered the truth. Thanks to the Louvre, Leyster is now remembered as one of the best Dutch painters of her time.

"Leyster had a talent for painting lively scenes of people enjoying themselves in taverns, playing music, and the like."

— Website, National Museum of Women in the Arts

Check Your Understanding

1. What kind of daily life did Rococo art depict?

2. What are the main differences between Baroque and Rococo art?

3. Why might Rococo artists have used the qualities of whimsy and wit to reflect the daily lives of the French upper class?

A Collage of an Interior Scene

You can combine collage and drawing to create an interior scene from everyday life.

- Use perspective and overlapping to show foreground, middle ground, and background.
- Think about how you might use a light source, color, and value for dramatic effects.
- Consider making crayon rubbings of textured surfaces and cut shapes from these rubbings to use in your interior scene.
- Consider using magazine cutouts to add pattern and detail.
- Glue the parts of your collage carefully.

Reflect on the range of values in your collage.

Fig. 5–20 Student artwork

The Art of Latin America

Artists of Latin America have always decorated everyday objects. They often show scenes of their daily life. The art from Latin American countries is diverse, just like the countries themselves. But all these artworks provide valuable clues about the daily life of the people.

Many civilizations were flourishing in the Americas long before the arrival of Europeans. We call the art these cultures made during this period pre-Columbian art. Pre-Columbian means "before Columbus." This art was created without influences from Europe.

Fig. 5–21 **This Cuban artist painted interior scenes and still lifes of fruits. The strong black outlines and bright-colored shapes resemble stained-glass windows in Cuban homes.**

Amelia Pelaez, *Still Life*, 1942. Gouache and watercolor, 29 ⅞" x 28 ⅜" (75.7 x 72 cm). ©Christie's Images, Ltd, 1999.

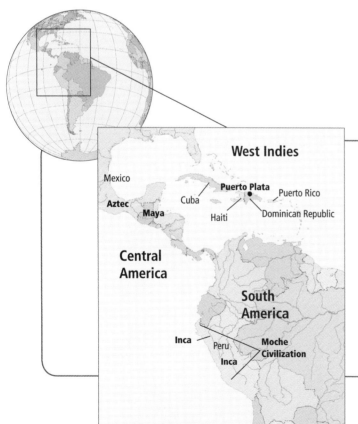

Social Studies Connection

You may be wondering: Where is Latin America? **Latin America** is really a term that groups together many different countries on two continents: Mexico, countries in South America and Central America, and the Caribbean islands. The history of each of these countries is very different. But they all share one important historical event. All these countries were taken over by European settlers in the 1500s.

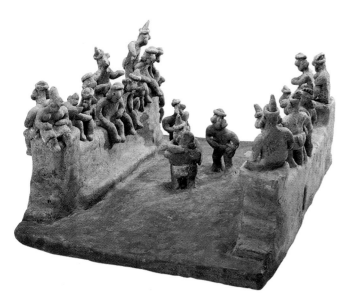

Fig. 5–22 An ancient Mayan ceremonial ball game was popular subject matter for sculptures. Why do you think the Maya made artworks showing this game?

Mayan, *Model of a Ball Game*. Pottery, 6 ½" x 14 ½" x 10 ⅝" (16.5 x 36.8 x 27 cm). Worcester Art Museum, Worcester, Massachusetts. Gift of Mr. and Mrs. Aldus Chapin Higgins. Photo © Worcester Art Museum.

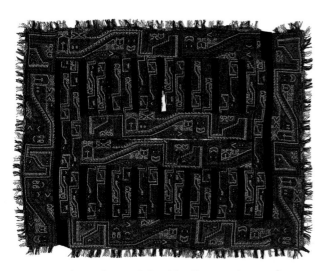

Fig. 5–23 Cultures in pre-Columbian Peru are known for their textiles. This poncho (a kind of cape) was buried in the desert and preserved in perfect condition.

Peru, Paracas, *Poncho*, 300–100 BCE. Wool embroidery on Cotton, 30" x 23 ⅝" (76 x 60 cm). 24:1956. St. Louis Art Museum.

Clues to Daily Life People of these early cultures painted pottery, carved stone calendars, and wove colorful patterned textiles. They decorated the objects they wore with human and animal designs, which reminded them of nature and their gods.

Unfortunately, when some European settlers arrived, they destroyed many objects the native cultures had produced. But many examples have now been uncovered from tombs or found in the ruins of ancient cities. These objects allow us a glimpse into daily life in these ancient cultures.

Visual Culture

Have you ever heard the expression, "It's the clothes that make the person"? What do clothes tell us about people and what they do? Where do you see people wearing uniforms or special kinds of clothing? Can you think of times when people are expected to dress in a certain way? Work with your classmates to collect pictures of people dressed for work. Consider practical reasons for wearing uniforms. Why should we care about the way people dress?

Modern Latin American Art After centuries of European rule, the countries of Latin America eventually gained their freedom. Some Latin American artists decided to return to the themes and images from their past. They wanted to show a connection with their nearly forgotten native heritage.

A Celebration of the Worker Like pre-Columbian art, modern Latin American art also gave us clues about everyday life. But modern artists seemed to be sending us a different message about the daily life around them. These artists often focused on the life of the worker, showing scenes of daily household chores or farm work.

Painter Diego Rivera showed the hard labor of people who worked the land. He pointed out how such workers helped their country prosper. Through the celebration of the worker, he and other modern Latin American artists hoped to make others aware of the often-overlooked value and dignity of work.

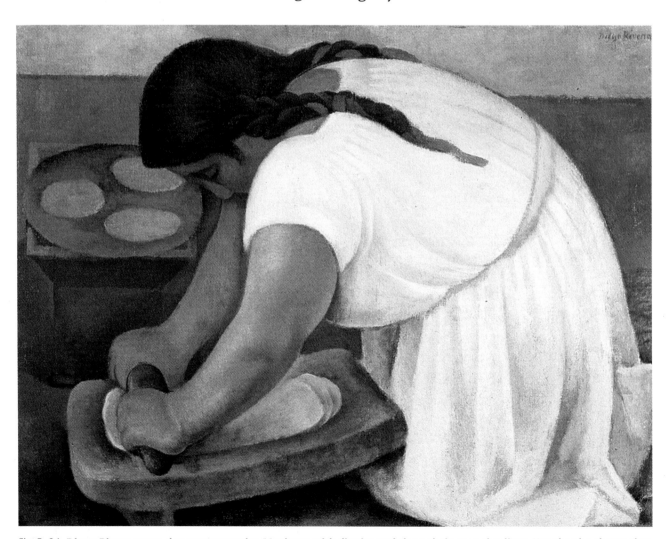

Fig. 5–24 **Diego Rivera wanted to present native Mexicans with dignity and show their everyday lives. How has he shown that grinding corn is hard work?**

Diego Rivera, *Woman Grinding Maize*, 1924. Mexico. Museo Nacional de Arte, Mexico City CNCA-INBA.

Fig. 5–25 **This painting criticizes the difficult labor many people faced in the artist's homeland of Puerto Rico. Why might he have titled it** *Our Daily Bread?*

Ramon Frade, *Our Daily Bread*, ca. 1905. Puerto Rico. Institute de Cultura Puertoriquans, Galeria Botello, Hato Ray, PR. Photo by John Betancourt.

Meet Diego Rivera

After his childhood art training in Mexico, Diego Rivera studied in Europe. When he returned to Mexico in 1921, Rivera was shocked by the political and social conditions. Rich landowners ruled without concern for the poor. Rivera vowed to use his art (Fig. 5–24) to honor those who worked hard for a living.

"Nothing can be expressed except through the force of feeling. The soul of every masterpiece is powerful emotion."

— Diego Rivera (1886–1957)

Check Your Understanding

1. What major event occurred in Latin America in the early 1500s?

2. Look at Figs. 5–24 and 5–25. Although they have different subjects, what theme do these two paintings share?

3. How might the style and content of the art of Latin American cultures have changed just after the arrival of European settlers?

Studio Time

An Ordinary Moment

Create a pastel drawing of someone engaged in a common, everyday activity.

- Think of an ordinary scene from everyday life—a favorite weekend activity, a chore you do, a game you often play, for example. What are the main elements of the scene?

- Ask a classmate to pose for you.

- Sketch some ideas. Choose your favorite sketch.

Reflect on how you used light, value, and contrast to add interest to your drawing.

Fig. 5–26 Student artwork

Rococo Container

Studio Background

Picture a favorite container that you use every day—a cup or bowl, for example. How is it decorated? Is it painted with a design? Is the form itself decorative? Now think about other things you probably see in your daily life: furniture, lamps, towels, and plates. Cultures all over the world decorate objects like these. Many objects are simply patterned, while others appear complicated and overdone. Some are not decorated at all.

In this studio exploration, you will decorate an everyday container in either the Rococo style or the style of the pre-Columbian period in Latin America. The features and decorations you add to the container should express something about your daily life.

You Will Need

- sketch paper
- pencils
- container
- cardboard
- newspaper
- scissors
- tape
- wheat paste
- paints
- brushes
- found objects
- glue

Step 1 **Plan and Practice**

- Think of an everyday container you would like to decorate.

- Look at the artworks shown in this lesson. How do the decorations reflect the ideas of each culture? How might you use features from that style to decorate your own everyday container?

- Think of the found objects that you would like to include as decoration. How will you arrange them on your container?

Things to Remember:

✓ Echo art styles of either the Rococo or the pre-Columbian period.

✓ Decorate your container in a way that expresses something about your daily life.

✓ Consider all parts of your container when decorating.

Inspiration from Our World

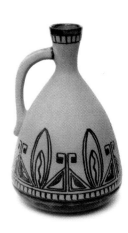

Inspiration from Art

The Rococo art style, which started in France in the 1700s, is known for its extreme amount of detail. Porcelain pieces from this period, such as **Fig. 5–28**, are highly decorated and playful. You might think that Rococo artists "went overboard" with details, but the ornate style was an expression of a new lighthearted spirit in Europe.

Vessels and sculpture from the pre-Columbian period differ from the delicate forms and pastel colors of Rococo objects. Pottery from this period (**Fig. 5–27**) is fairly plain. It is decorated with simple, often geometric, shapes that resemble symbols. Its colors are usually soft and dull. Most objects made before the time of Columbus that have lasted to the present had ceremonial uses. They generally have a more serious tone than Rococo objects.

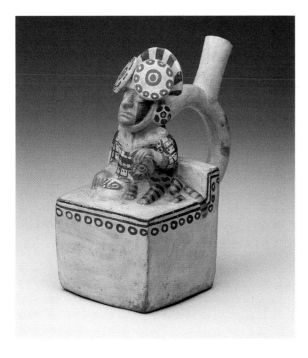

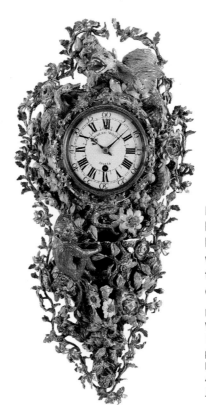

Fig. 5–27 **Many stirrup vessels take the form of an animal or human head. What might the forms on this vessel represent?**

Peru (Mochica culture), *Stirrup Vessel representing seated ruler with pampas cat*, 250–550 CE. Ceramic, 7 ⅝" x 7 ½" (19.4 x 19.1 cm). Katie S. Buckingham Endowment, 1955.2281. Photograph ©1999 The Art Institute of Chicago, All Rights Reserved.

Fig. 5–28 **This clock may have been intended to hang over a bed. How would you describe the textures you see in the clock's decoration?**

Movement made by Charles Voisin and Chantilly manufactory, *Wall Clock*, ca. 1740. Soft-paste porcelain, enameled metal, gilt-Bronze, and glass, 29 ½" x 14" x 4 ⅜" (74.9 x 35.6 x 11.1 cm). The J. Paul Getty Museum, Los Angeles.

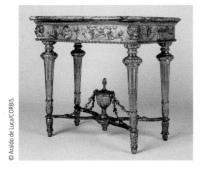

Step 2 Begin to Create

- Look at your container. Sketch your ideas about what kinds of decorative features you can add that will express something about your life.

- Using the container as your base, build a structural framework onto which you will apply papier-mâché. **To build the framework, tape features made from cutout cardboard or wads of newspaper to the container.**

- **When all the parts are in place, cover the whole form with five or six layers of papier-mâché.** Make sure that each layer is smooth and even. Let the work dry completely.

- Paint your container. Choose a color scheme that best fits your daily life. When the paint is dry, decorate the container with buttons, sequins, beads, ribbons, foil, tissue papers, or other found objects.

Step 3 Revise

Did you remember to:

✓ Echo art styles of either the Rococo or the pre-Columbian period?

✓ Decorate your container in a way that expresses something about your daily life?

✓ Consider all parts of your container when decorating?

Adjust your work if necessary. In your sketchbook, make a note of your revisions and why you made them.

Step 4 Add Finishing Touches

- Are there any other features that you would like to add to, or remove from, your container?

- When finished, be sure to sign and date your container.

Step 5 Share and Reflect

- Identify the best features of your work. What do your decorations say about your culture or your daily life?

- Why is the decorative style you chose appropriate for your container?

- Is this a container you could use every day? Why or why not?

Fig. 5–29 Student artwork

Art Criticism

Describe Tell what you see and what materials you think the artist used to make these containers.

Analyze How did the artist unify the design of these containers?

Interpret How do you think each container might be used?

Evaluate What do you think are the best features of these artworks?

Fig. 5–31 Student artwork

Fig. 5–30 Student artwork

Mathematics

We all need to keep track of time.

How do you think ancient civilizations were able to do so? The early Maya lived in what today are parts of Mexico, Honduras, Guatemala, Belize, and El Salvador. They developed sophisticated calendars and an advanced number system. They kept track of the solar and lunar years, eclipses, and the cycles of visible planets. The Maya were one of the first people to have a numerical symbol for zero. Why is knowing the time and day necessary for daily life?

Fig. 5–32 **Why do people hang calendars on their walls? Where might these stone calendars have been located?**

Pre-Columbian Maya, *Calendar disk*, ca. 200 BCE–1521 CE. Chiapas, Mexico. Courtesy of Davis Art Images.

Theater

Fig. 5–33 **Tennessee Williams uses realistic dialogue in the play** *The Glass Menagerie.*

Photo courtesy of The Southeast Institute for Education in Theatre, directed by Kim Wheetley, 1992, starring Susan Edler as Laura and Julia Martin as Amanda.

Painters sometimes use light to show their subjects in a certain way.

Playwrights do something similar with dramatic dialogue. A conversation among the characters in a play may seem very realistic. But, if you listen closely, you will hear a difference. Many real-life conversations wander off topic. Dialogue in a play usually stays focused on one topic. Also, the characters use very few words to express their ideas. Many playwrights carefully organize the dialogue to "highlight" certain ideas. In what other ways are playwrights like artists?

Careers **Product Design**

What products do you always see advertised on TV? Automobile commercials that show the latest designs are common. Automobiles are developed by industrial or product designers. Product designers work in every manufacturing industry. They must be creative and aware of their audience. They must understand style trends. Product designers might work with samplemakers to create models. They often use computer programs to make working drawings. Look around the classroom for ordinary objects. What do you see that may have been designed to be both useful and attractive?

Fig. 5–34 Offices are full of product designs, such as computers, telephones, calculators, and printers.

Fig. 5–35

Daily Life

Objects that you see and use every day are a form of art. The clothes you wear and the cell phone you use were designed to look a certain way and be useful. They were designed by fashion designers, graphic designers, and computer designers. Even your school was designed by an architect. These designs play an important part in our daily lives. What are some other examples of the role that art plays in your life?

Vocabulary Review

Match each art term below with its definition.

Baroque

Rococo

contrast

value

pre-Columbian

1. the range of light and dark in a color

2. beginning in 1600s Italy, a powerful and dramatic artistic style using rich textures

3. a word used to describe a period of Latin American culture before the arrival of European settlers

4. a great difference between two things

5. a witty and playful artistic style in 1700s France

Aesthetic Thinking

How are photographs of people and their everyday activities similar to Baroque and Rococo paintings? How do they differ? How does the accessibility of the camera change how modern life is depicted compared to life in the 1600s?

Write About Art

What do you think the woman and two men in this painting are talking about? Write a dialogue that captures some of their conversation.

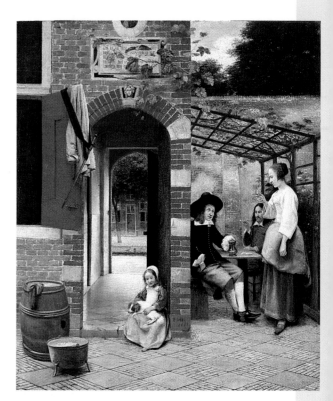

Fig. 5–36 **Dutch Baroque artists had a specific audience in mind when they created their artworks. Why do you think this painting would have appealed to the country's new middle class?**

Pieter de Hooch, *Courtyard of a House in Delft*, 1658. Canvas laid down on panel, 26 ⅝" x 22 ⅝" (67.8 x 57.5 cm). Private collection. Courtesy Noortman Ltd.

Art Criticism

Describe What is happening in this painting?

Analyze How does the artist use rhythm in this painting?

Interpret Study the musical instruments, and then find other places in the painting where their shapes are repeated.

Evaluate The instruments almost look like they are an extension of the musician's bodies. What does this suggest about the people in the painting?

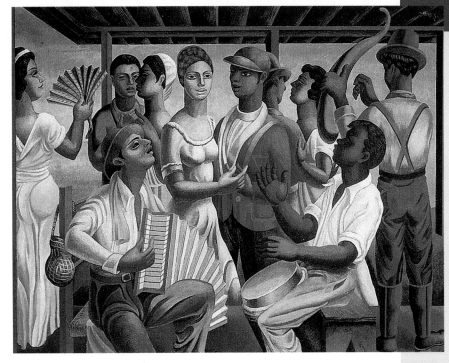

Fig. 5–37 Jaime Colson, *Merengue, 1937*. Tempera on board. Museo Juan Jose Bellapart, Santo Domingo, Dominican Republic.

Detail of *Merengue*

Meet the Artist

Jaime Colson (1901–1975) was born in Puerto Plata, Dominican Republic. He studied art in Spain and France and also spent time in Mexico. Colson worked in a variety of styles: some of his paintings are realistic, while others are abstract or even surreal. He also taught art and wrote poetry.

For Your Portfolio

Choose two of your daily life artworks from this unit to include in your portfolio. Write a brief explanation of how the unit artworks influenced these two artworks.

For Your Sketchbook

Design an attractive border on a sketchbook page where you can write your thoughts or make sketches about ways that art is part of your daily life. Add to the page from time to time, and use your ideas for future artworks.

Artists Remember Places

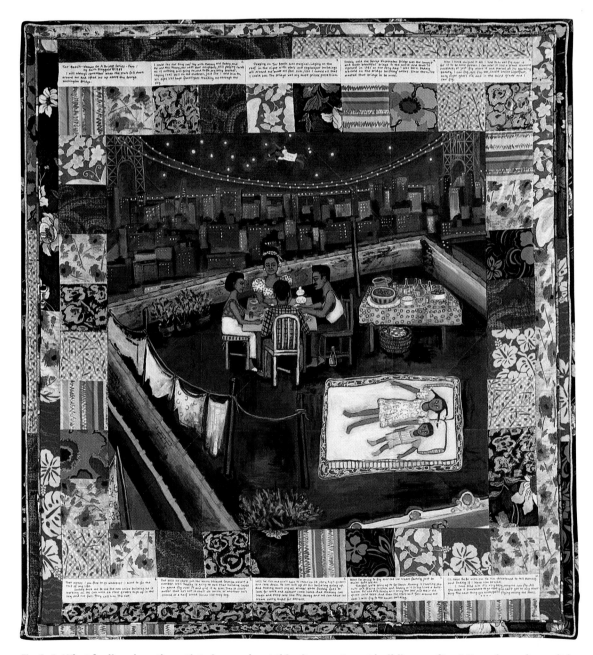

Fig. 6–1 **What feeling does the artist give us about this city apartment building rooftop? How do we know it is a special place to her?**

Faith Ringgold, *Tar Beach*, 1988. Acrylic paint on canvas bordered with printed and painted quilted and pieced cloth, 74 ⅝" x 68 ½" (189.5 x 174 cm). Solomon R. Guggenheim Museum of Art, New York. Gift, Mr. and Mrs. Gus and Judith Lieber, 1988. Photograph by David Heald ©The Solomon R. Guggenheim Foundation, New York. (FN 88.3620)

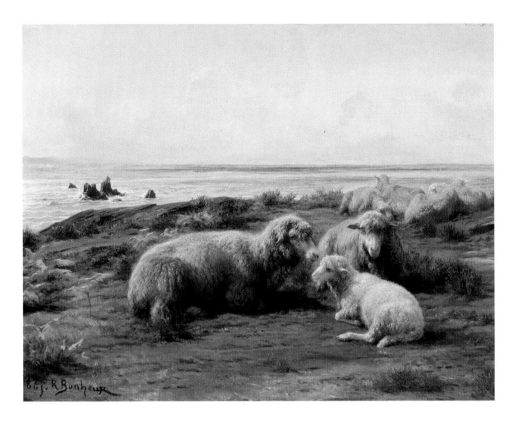

Fig. 6–2 **This artist painted a scene of sheep resting by the ocean. Why do you think she saw this ordinary setting as a special place?**

Rosa Bonheur, *Sheep by the Sea*, 1869. Oil on cradled panel, 12 ¾" x 18" (32 x 45.7 cm). Gift of Wallace and Wilhelmina Holladay. The National Museum of Women in the Arts.

Is there a place you go when you want to be alone? Is it your room? Maybe it's a special place in your neighborhood. Most of us also have places for certain activities such as playing or learning. Places are important to us. Because we can remember places, we can "return" to them in our minds. We do this especially for places that have special meaning for us. For example, we may wish to remember where an important event happened. Places are also important to groups of people. Throughout history, people have used art to show that certain places are special.

In this unit, you will learn:

- How artists call attention to the special qualities of places.
- How to create sculptures and stitched wall hangings using space and emphasis.
- How to look at artworks as records of places that have special meaning.

What Places Tell Us

When you enter a place, pay attention to its design. How does the structure remind you of what the place is used for? For example, how does the design of a building, such as a church or a monument, match its purpose?

Places to Notice Artworks are sometimes created to mark a place. Entryways, for instance, can tell visitors that they are crossing into a special place. The Maori people of New Zealand use art to add to the significance of their buildings. They carve and decorate wood poles and beams like the one shown in Fig. 6–3.

Places to Document Artists make artworks to show us places. They might illustrate places from the past that actually existed, or they might show imagined places. When you look at an artwork that shows a place, think about what the artist might have wanted you to experience. How attracted are you to the place? What realistic or unrealistic qualities does the place have? How well does the artwork document how a place looks? To document a place is to record its details carefully.

Fig. 6–3 This pole was created as a memorial to a deceased person. Why would the Maori people position it in a special place?

Niu Ailand People, Melanesia (New Ireland), *Memorial Pole*, early 20th century. Wood, fiber, operculum, vegetable paste, and paint, 98 7/16" x 9 7/8" x 5 15/16" (240 x 25 x 15 cm). Gift of Morton D. May, 60:1977. St. Louis Art Museum.

Fig. 6–4 The people of Djénné, Mali come to this mosque to worship, to shop, to learn, and to socialize. How does the design of the mosque fit its function?

Ismaila Traoré, *The weekly market at the Great Mosque of Djénné*, 1906–07. Adobe. Mali, West Africa. Photo by Rob van Wendel de Joode.

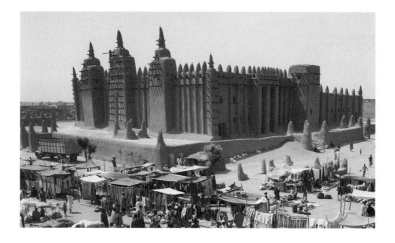

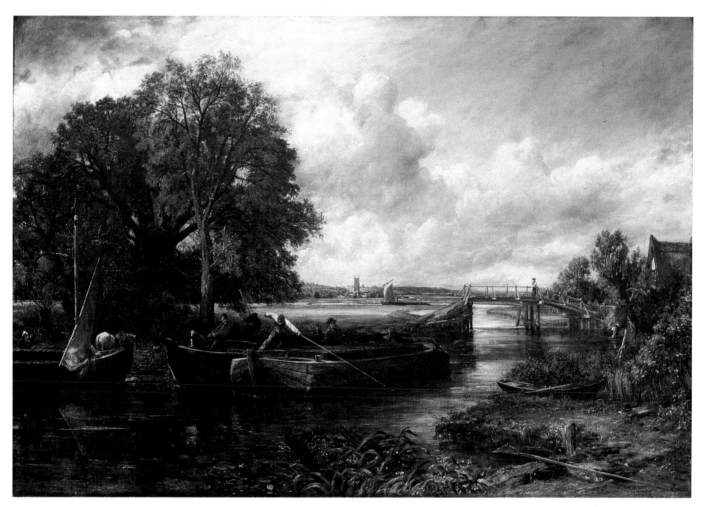

Fig. 6–5 **Constable painted a landscape in Suffolk, England. From his painting, we learn how things looked in the past. How might this view look different today?**

John Constable, *View on the Stour near Dedham*, 1822. Oil on canvas, 20 ⅛" x 29 ¼" (51ˋx 74 cm). The Huntington Library, Art Collections and Botanical Gardens, San Marino, California/ SuperStock.

Meet John Constable

John Constable was born on a farm in Suffolk, England. His parents wanted him to become a farmer. Instead, he showed his love of the land by painting it.

Most landscape artists traveled far to find stunning scenes to paint. But Constable never left England. He preferred to stay home and paint the farmland he loved, just as he saw it in real life.

He observed the moods created by light and darkness in nature, and studied changes in the sky and clouds. Because he paid close attention to the moment's light, his work later inspired the Impressionists (See lesson 7.4, page 196).

"The sound of water escaping from mill dams, willows, old rotten planks, slimy posts and brickwork, I love such things. These scenes made me a painter."

— John Constable (1776–1837)

Places to Remember Artworks can show us how things looked in the past. They can also show how a place was used. Canaletto did this in his painting of St. Mark's Plaza shown in Fig. 6–6. If we focus on how people used places in the past, we can see that some purposes haven't changed much. The shopping malls of today may look different from Italian plazas in the 1700s, but they do serve similar purposes for large groups of people.

Artworks can show us places that are important to the artist as an individual. Or, artists may show some places because the places—and the stories about them—are special to whole communities. In Fig. 6–7, Joe Nalo tells such a tale. The legend is already familiar to the people of Leip Island, but Nalo's art gives the community a new way to see the story.

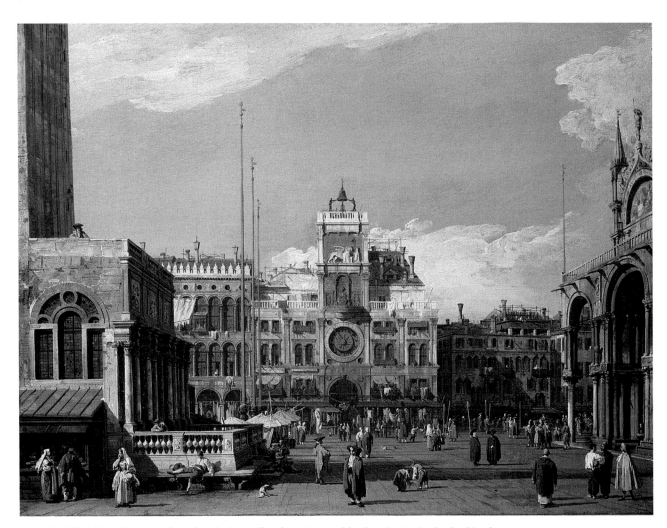

Fig. 6–6 **Which details in Canaletto's painting tell us how St. Mark's Plaza in Venice looked in the past?**

Giovanni Antonio Canale, called Canaletto, *The Clock Tower in The Piazza San Marco*, ca.1728–30. Oil on canvas, 20 ½" x 27 ⅜" (52.1 x 69.6 cm). The Nelson-Atkins Museum of Art, Kansas City, Missouri (Purchase: Nelson Trust). ©1999 The Nelson Gallery Foundation. All Rights Reserved.

Fig. 6–7 **This composition tells about Leip Island, in Papua New Guinea. Study the painting. What might be important to the people of this island?**

Joe Nalo, *The Legend of Leip Island*, 1993. Oil on canvas, 59" x 78 ¾" (150 x 200 cm). Collection: Museum für Völkerkunde, Frankfurt am Main. Photograph: Hugh Stevenson.

Studio Time

A Special Place

You can make a drawing of a place that has special meaning for you.

- Think of a place that holds good memories for you. It might be your house, a ball field, a swimming pool, or a lake.

- Sketch some ideas. Choose your best sketch to develop into a more detailed drawing.

- Draw the large shapes first, then focus on the details and where you want the emphasis to be.

- Use the point and side of your pencil lead to create a range of values from light to dark.

Reflect on what you did to call attention to the special qualities of the place you drew.

Check Your Understanding

1. Why are places important to people?

2. Imagine that you are asked to draw a futuristic illustration of a place that has special meaning to you. How would it differ from a present-day illustration of the same place? How would the illustrations be similar?

3. Why might an artist choose to depict an imaginary place?

Fig. 6–8 Student artwork

Using Space and Emphasis

Space can be three-dimensional. For example, sculptures take up space. It can also be two-dimensional. A painted canvas, for instance, can show space. You can look at any space from different places and angles, from inside or outside, in bright light and in shadow.

Regardless of your viewpoint, there will always be something that you notice first. Emphasis is an area in a work of art that tends to catch and hold your attention. It gives importance to part of a work.

Fig. 6–9 **How did the artist use emphasis in this artwork?**

Tetsumi Kudo, *Your Portrait—Chrysalis in a Cocoon*, 1967. 5' x 3' (1.610 x 0.870 m). Photo: CNAC/MNAM/Dist. Réunion des Musées Nationaux/ Art Resource, NY. ©ARS, NY.

Looking at Space Artists talk about space in many different ways. Positive space in an artwork is the space an object takes up. Negative space is the area surrounding the object. Artists make decisions about what areas in their artworks will be filled (positive space) or empty (negative space). You create space by the way you place objects or shapes.

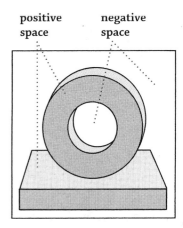

positive space negative space

In three-dimensional art, artists organize space by carefully placing solid forms. They also plan negative spaces, which are the spaces between and around the forms. In two-dimensional art, artists organize space by placing shapes carefully.

Implied space is the appearance of three-dimensional space in a two-dimensional artwork. Artists use perspective techniques to create the illusion of space on a flat surface. These techniques include overlapping, shading, placement, size, and sharpness of focus or detail. They also use linear perspective.

Fig. 6–10 German artist Caspar David Friedrich had deeply personal experiences with the sea. Where are the positive and negative spaces in this painting?

Caspar David Friedrich, *Periods of Life (Lebensstufen)*, ca. 1834. Oil on canvas, 28 ¾" x 37 ⅛" (73 x 94 cm). Museum der Bildenden Kuenste, Leipzig, Germany. Erich Lessing/ Art Resource, NY.

Observe Notice how Friedrich created the illusion of deep space in Fig. 6–10. The ships seem to get smaller as they move away from shore. There are more details in the foreground figures than in those farther away.

Tools: Paper, pencils, and straightedges.

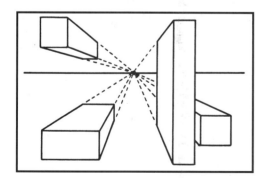

One-point perspective

Practice: Creating the Illusion of Space

- Using pencil, draw a light horizontal line on a sheet of paper.
- Draw five squares in various locations on the paper.
- Choose a vanishing point along the horizon line.
- Use a straightedge to connect the corners of the squares to the vanishing point.
- Now investigate other ways to create the illusion of space.

Looking at Emphasis You can create emphasis by planning a work so that some features are more dominant, or stronger, than others. Viewers usually notice the dominant feature first.

The repetition of a brushstroke, color, or shape can create emphasis. Other ways to create emphasis include size and placement. The subject of the work might be larger than other elements. It might be placed near the center of the work or be given a lot of space.

When an area is strongly emphasized, artists say it is the center of interest. It is not always the middle of the work. It can be anywhere the dominant element shows up.

Observe What do you notice first in Turner's painting (Fig. 6–11)? Notice how Turner repeated areas of red to draw attention to the people in his painting. How else did Turner create emphasis in this artwork?

Tools: Paper, pens or pencils, and markers or crayons.

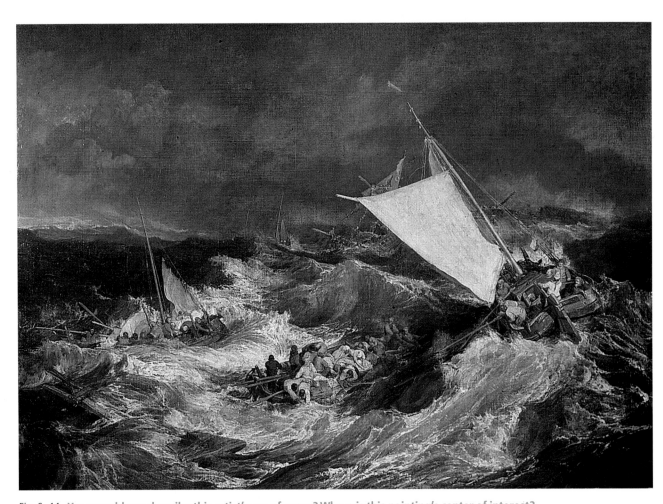

Fig. 6–11 **How would you describe this artist's use of space? Where is this painting's center of interest?**

Joseph Mallord William Turner, *The Shipwreck*, 1805. Oil on canvas, 6 ¾" x 9 ½" (17.1 x 24.2 cm). Clore Collection, The Tate Gallery, London/Art Resource, NY.

Practice: Creating Emphasis

- Divide a sheet of paper into four sections.

- Using simple shapes, create emphasis in compositions. Emphasize with color in one section, repetition in another, size in the third, and placement in the fourth.

Check Your Understanding

1. What are some ways to achieve emphasis in art?

2. How are the processes of creating space in two-dimensional and three-dimensional art similar? How are they different?

3. Why might an artist pay attention to emphasis when showing a particular place?

Studio Time

A Memorable Place

Make a watercolor painting of a place you remember or imagine.

- Decide what feature of the place you want to emphasize.

- Use emphasis to show deep space in your painting.

- Experiment with different color combinations.

Reflect on how you achieved a sense of deep space.

Fig. 6–12 Student artwork

Peaceful Places

Studio Background

Imagine a place you can go to relax and think deep thoughts. The place might be a room, a park, a garden, or a spot surrounded by trees. It can be a real or made-up place.

In this studio exploration, you will use clay to create a three-dimensional artwork of your calm, peaceful place. What would you like to show others about this place? Think about how you might use space to make the place seem more peaceful. What will you emphasize in your work?

You Will Need

- square of cloth
- work board
- clay
- slip
- paintbrush
- two sticks and a rolling pin
- clay tools or a knife and fork

Step 1 **Plan and Practice**

- Decide what place you will show in your artwork.
- Think about the best way to create your environment. How many slabs of clay will you use? Will you roll coils and balls? Will you show people?
- Think about how you could use space to make your place seem peaceful. How might you create negative space? Where might you leave open space between forms? Where might you carve holes or other shapes?

Things to Remember:

✓ Make your place look calm and peaceful.

✓ Pay attention to both positive and negative spaces.

✓ Use textures and small details to add emphasis to your work.

Inspiration from Our World

Inspiration from Art

Why do you think it is valuable to have a place to go for time alone? Most people seem to need a place like that. Gazebos, benches shaded by trees, and rock outcroppings are examples of such places. Public gardens are known as special places where people can sit quietly and enjoy their surroundings. What other special places can you think of?

Some artists show these places in their work so that we can enjoy them without actually visiting. We can imagine being there as we view the work. Traditional Chinese landscape painters were skilled at creating a visual path for viewers to follow through a beautiful natural area. Look at the works in **Figs. 6–13** and **6–14** to see how calm, peaceful places have been created by two Chinese artists.

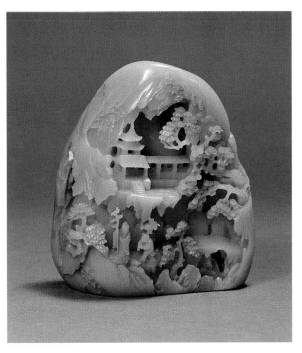

Fig. 6–13 **A Chinese artist created this place. Where are the positive and negative spaces? What areas did the artist emphasize?**

China, Qing Dynasty, Qianlong period (1736–95), *Mountain Landscape*, 18th century. Jade, 6 ⅞" (17.5 cm). ©Cleveland Museum of Art, Gift of the Misses Alice and Nellie Morris, 1941.594.

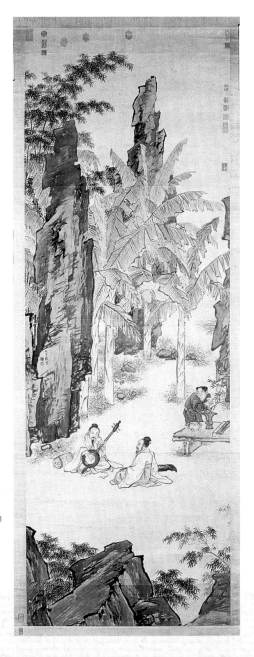

Fig. 6–14 **Where can you see negative space here? How does it help emphasize the figures?**

Ch'iu Ying, *Passing a Summer Day Beneath Banana Palms.* Section of a hanging scroll (cropped at top and bottom). Ink and Colors on paper, 39" (99 cm). National Palace Museum, Taipei, Taiwan, Republic of China.

Step 2 Begin to Create

- Start by making a clay slab for the base.
- Place a cloth flat on your work board or table.
- Put your clay on the cloth and place a flat stick on each side of the clay.
- **Press a rolling pin down on the center of the clay, letting it rest on top of the sticks.** Roll back and forth until the clay is flat.

- Use a table knife to trim the edges into the shape you want.
- **Create features of your environment to add to your slab.**

- Join the features to the slab and to each other. **Score, or scratch, the surfaces to be joined and apply slip to the scored areas.** Press the treated surfaces together firmly, but gently.

Step 3 Revise

Did you remember to:

✓ Make your place look calm and peaceful?

✓ Pay attention to both positive and negative spaces?

✓ Use textures and small details to add emphasis to your work?

Adjust your work if necessary. In your sketchbook, make a note of your revisions and why you made them.

Step 4 Add Finishing Touches

- Add any other last details to your quiet place.
- Remember that clay shrinks slightly as it dries.

Step 5 Share and Reflect

- Compare your artwork with that of your classmates. What features did you include to suggest a quiet place? What are the effects of the positive and negative spaces in everyone's work? How are parts of the peaceful places emphasized?
- In what ways is your sculpture an example of good craftsmanship?
- How can you improve your craftsmanship the next time you work with clay?

Art Criticism

Describe How would you describe this to someone who has not seen it?

Analyze How did the artist create a sense of space in this sculpture?

Interpret What does this sculpture mean to you?

Evaluate What has the artist done especially well?

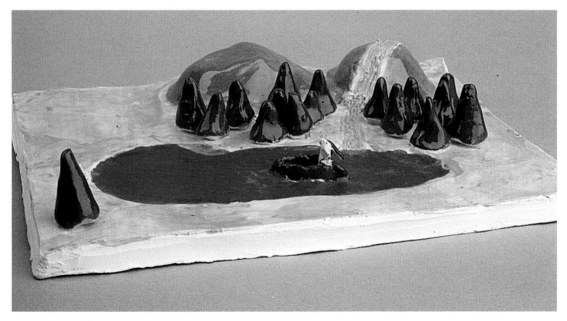

Fig. 6–15 Student artwork

European Art: 1750–1875

In the 1800s, there were many different political and social points of view in Europe. The three new, more serious art styles of this period reflected these changing views. Each style was a reaction to the one before it. Each was inspired by a different place in history and the world.

The first style was called Neoclassicism. Neoclassical artists were inspired by artworks from the classical Greek and Roman past and used them as models for their art. The Greek and Roman ideals of order and harmony were reflected in the calm, carefully organized Neoclassical artworks and architecture.

Some artists rejected the strict rules of Neoclassicism and began an art style called Romanticism. Romanticism is a style focused on dramatic action, exotic settings, adventures, imaginary events, faraway places, and strong feelings.

Toward the mid-1800s, artists of the style known as Realism did not want their artworks to show faraway places or times. Realist artists thought art should be about the places and things they saw every day.

Fig. 6–16 **David painted the story of heroism and patriotism of the Horatii brothers of ancient Rome. How does this painting reflect the style of Neoclassicism?**

Jacques-Louis David, *Oath of the Horatii*, 1784–85. Oil on canvas, 129 11/12" x 167 5/16" (330 x 425 cm). Louvre, Paris, France. Erich Lessing/Art Resource, New York.

ca. 1784
David, *Oath of the Horatii*

1787
The Constitutional Convention assembles in Philadelphia, PA to draft the U.S. Constitution.

1848
The Gold Rush begins with the discovery of gold in Coloma, CA.

ca. 1863
Daumier, *The Third Class Carriage*

1700s

1800s

1785
Kauffmann, *Pliny the Younger*

1831
James Clark Ross reaches the north magnetic pole.

1860
Delacroix, *Horses*

1861
The American Civil War begins with the battle of Fort Sumter.

1869
The first transcontinental railroad is completed; it stretches across the entire U.S.

Neoclassicism Why did artists once again become interested in the classical past? In 1738, the ancient Roman cities of Pompeii and Herculaneum were discovered. They had been destroyed by the volcano, Mount Vesuvius, in 79 CE and were perfectly preserved under volcanic ash. This new source of information on ancient Roman life inspired many artists.

Artists began to base their paintings on ancient places. They often painted scenes of Roman ruins. Some showed people from their own time in a classical setting of arches and columns. Neoclassical artists concentrated on line and careful brushwork.

Fig. 6–17 **Kauffmann painted the eruption of Mount Vesuvius. Why might the event and place shown in this painting be a popular subject for Neoclassical artworks?**

Angelica Kauffmann, *Pliny the Younger and His Mother at Misenum*, AD 70. Oil on canvas, 3' 4 ½" x 4' 2 ½" (103 x 128 cm). The Art Museum, Princeton University. Museum purchase, gift of Franklin H. Kissner. Photo Credit: Clem Fiori. ©2000 Artists Rights Society (ARS). New York/VG Bild-Kunst, Bonn.

Romanticism Romantic artists were inspired by tales of adventure. They created a style full of emotion.

These artists applied color with wild, active brushstrokes. They wanted viewers to feel the emotion of a painted scene. They chose stormy seas, faraway beaches, and dangerous battlefields as settings for their works.

Realism Realists insisted on showing only things they had seen in real life. They liked to paint scenes of people working in the countryside or going about their daily lives. Realists believed their artworks recorded simple ways of life that were disappearing as new technologies took over.

Some Realists used their art to point out the faults of modern society. In *The Third Class Carriage* (Fig. 6–18), Honoré Daumier shows viewers the poor section of a horse-drawn bus. What fault do you think he was pointing out?

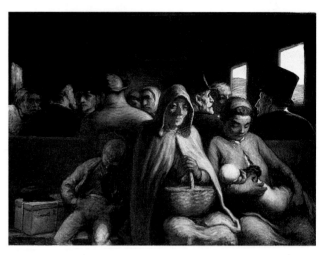

Fig. 6–18 **Notice how the poor family is separated from the wealthier passengers. What do you think Daumier was trying to say about city life in his time?**

Honoré Daumier, *The Third Class Carriage*, ca. 1863–65. Oil on canvas, 25 ¾" x 35 ½" (65.4 x 90.2 cm). National Gallery of Canada, Ottawa. Purchased 1946.

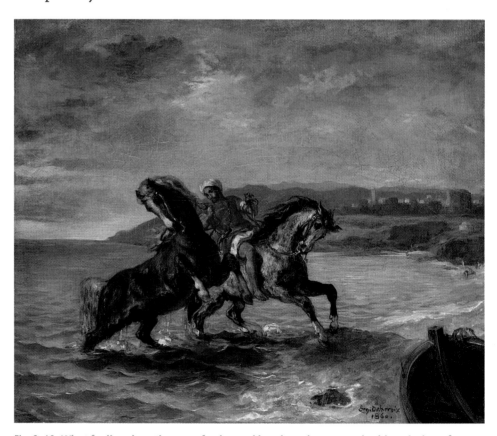

Fig. 6–19 **What feeling does the use of color and brushstrokes create in this painting of a place in northern Africa?**

Eugène Delacroix, *Horses Coming Out of the Sea*, 1860. Oil on canvas, 20 ¼" x 24 ¼" (5.4 x 61.5 cm). The Phillips Collection, Washington, DC. (0486).

Check Your Understanding

1. What inspired the style known as Romanticism?

2. Compare and contrast how Realism is different from Neoclassicism. How are they similar?

3. How might you know that the painting shown in Fig. 6–19 is Romantic just by looking at it?

Meet Honoré Daumier

Honoré Daumier (1808–1879) was born in Marseille, France. He produced about four thousand lithographs during his lifetime. He is best known for his caricatures, which show his opinions of the conditions in France around the time of the French Revolution. He criticized unfair laws and the dishonest government.

At 24, Daumier drew caricatures making fun of the French king, Louis Philippe. As punishment, he was imprisoned for six months. Afterward, he focused on criticizing rich people and showing the awful conditions of the poor. He was known as the "Michelangelo of caricature."

Daumier was also a gifted painter, but his paintings were not successful until they were finally exhibited in 1879. By this time, he had already gone blind and could not see the exhibition. His paintings show urban working-class people as they really lived. Today, Daumier is considered to be one of the founders of Realism.

"These are not portraits of particular people, but of mankind."

— Nicolas Pioch, WebMuseum, Paris

Studio Time

A Favorite Place

How can you express the idea of a secret place, an exciting place, a romantic place, or maybe even a frightening place in a scratchboard drawing?

- Decide whether to show a city place, a country place, or somewhere in between. It should be a place that is special to you.
- Draw the largest forms first.
- Think about the drawn details that will help show the mood of the place.

Reflect on how you used texture, pattern, and a variety of lines to help create a sense of place.

Fig. 6–20 Student artwork

Oceanic Art

Maintaining Traditions The Pacific Ocean forms a natural barrier around the islands of Oceania. There are people on these islands who have had very little contact with other cultures. Being isolated has allowed the people to keep their cultural and artistic traditions. Many Oceanic peoples still practice traditional ways of making art.

Materials and Designs Oceanic art is usually created to be used in everyday life or for special ceremonies. Artists use local materials such as raffia, barkcloth, shells, and feathers in their work. Some traditional art forms are wood carving, tattooing, maskmaking, and weaving.

Fig. 6–21 **This map shows how to travel to a place by tracking wave formations and patterns. What might you need to know before using it?**

Marshall Islands, Micronesia, *Stick Chart.* Wood and shell. Peabody Essex Museum, Salem, Massachusetts. Photo by Jeffrey Dykes.

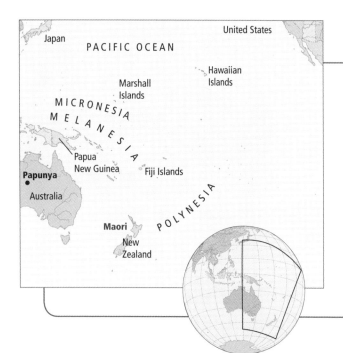

Social Studies Connection

Oceania is the name we give to a large area in the Pacific Ocean that contains thousands of islands. Many of the islands are grouped into one of three regions: Micronesia, Polynesia, or Melanesia. Within those regions are countries such as New Zealand and Papua New Guinea. The Hawaiian Islands are part of Oceania, too. The people of this huge area of islands share many similarities, even though they may be from different countries.

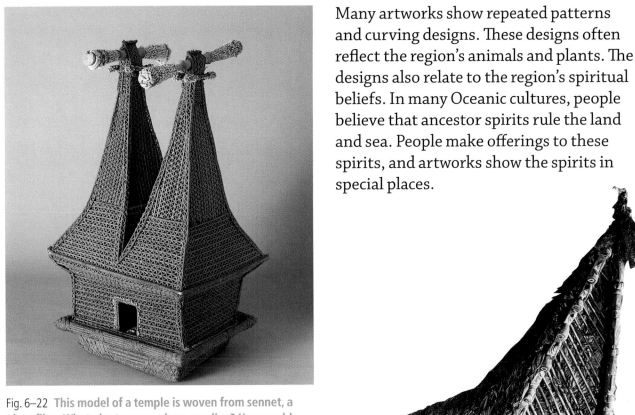

Fig. 6–22 **This model of a temple is woven from sennet, a plant fiber. What plants grow where you live? How could you weave them to make a form?**

Fiji Islands, Melanesia, *Double Spired Temple Model*. Sennet, 43 ½" (110.5 cm). Peabody Essex Museum, Salem, Massachusetts. Photo by Jeffrey Dykes.

Many artworks show repeated patterns and curving designs. These designs often reflect the region's animals and plants. The designs also relate to the region's spiritual beliefs. In many Oceanic cultures, people believe that ancestor spirits rule the land and sea. People make offerings to these spirits, and artworks show the spirits in special places.

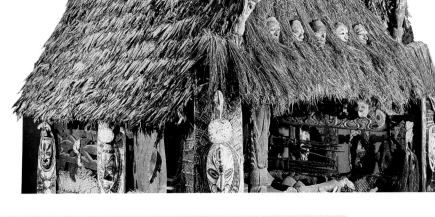

Fig. 6–23 **Some native peoples of New Guinea build highly decorated houses for ceremonies. What kinds of ceremonies might this house be used for?**

New Guinea, *Hut of Spirits*. Muscom Missionario Etnologico. Vatican Museums, Vatican State. Scala/Art Resource.

Visual Culture

Have you ever had to draw a map to explain how someone can get to your home? Drawing a map requires thinking about directions, distances, and landmarks. Think about the many kinds of maps or map-like views that people might encounter every day, such as road maps, bus or subway routes, floor plans of museums or shopping malls and the like. Consider the codes and symbols used by mapmakers.

Australia's Aborigines Much Aboriginal art is based on a belief in what is called Dreamtime. Dreamtime is thought to be a time of creation when powerful animals arose from the earth and wandered the land, shaping it as they went. These animal spirits and their journeys have inspired many customs and artworks. The works show you the special places where Dreamtime spirits have been.

Today, Aboriginal artists still stay connected with the land and the spirit world through their paintings. Traditionally, these paintings are made on barkcloth, a wood fiber that is beaten instead of woven. The artists often use bright colors and motifs, or repeated elements that create a pattern. Barkcloth paintings often seem to show a view from high up in the air. Their patterns symbolize the sacred connection between people and the land.

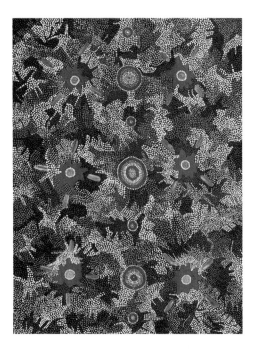

Fig. 6–24 **Watering holes are important in Australia. Where are the watering holes shown in this painting? What do you think the shapes around the watering holes might represent?**

Keith Kaapa Tjangala, *Witchetty grub dreaming*, 20th century. Acrylic on canvas. Aboriginal Artists Agency, Sydney, Australia. Jennifer Steele/Art Resource, NY.

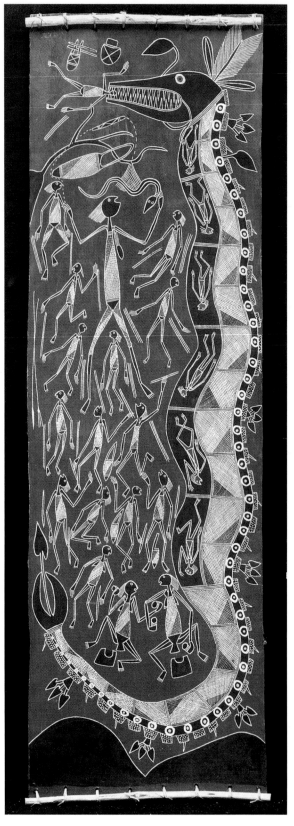

Fig. 6–25 **The serpent is shown swallowing people whom she will transform into features of the land. What do you think the water lilies on her back mean?**

Bruce Nabageyo, Ngaylod, *The Rainbow Serpent at Gabari*, 1989. Natural pigments on eucalyptus bark, 59 ⅛" x 16" (150.01 x 40.4 cm). National Gallery of Australia, Canberra.

Meet Papunya Artists

Traditional Aboriginal art was painted on dried bark, used for rituals, and then destroyed. In the 1970s, Australian Geoffrey Bardon taught elementary school at the Aboriginal settlement Papunya, in central Australia. He saw children drawing Dreamtime symbols in dirt with their fingers and encouraged them to express their traditions in art class. He also organized a group of men to paint a Dreamtime mural on the school. This public art inspired Aborigines like Keith Kaapa Tjangala to paint permanent Dreamtime scenes.

Detail of *Witchetty grub dreaming.*

"Aboriginal art is more than just ochres on bark or paper, or acrylic compositions on canvas. It represents a social history."

—Djon Mundine, Curator of the Asia Society and Museum

Studio Time

Motif Map

Use stencils or found objects to print a map of a place that is special to you.

- Choose motifs to stand for certain locations.
- Invent a way to show typical travel routes between areas within your place.
- Try different ways of repeating the basic motif. Motifs can lock together or form alternating patterns. Some motifs can be diagonally stepped (dropped) to create complex patterns in several directions.

Reflect on the map-like quality of your print.

Check Your Understanding

1. What belief is much of Australian Aboriginal art based on?

2. Compare the map in Fig. 6–21 to a map you are familiar with, such as a map in your classroom. How are they similar? How are they different?

3. Why might Oceanic artists use local materials in their artworks?

Fig. 6–26 Student artwork

Wall Hanging of a Dreamlike Place

Studio Background

If someone asked you to create an image of a magical place, what would you show? An exotic landscape? A futuristic city? What would you do if your only art materials were scraps of cloth, thread, yarn, and some buttons or beads? You would have to think like a fiber artist. A fiber artist is an artist who creates artworks with cloth, yarns, threads, and other materials. You could cut shapes from fabric and appliqué them. To appliqué fabric is to sew or glue pieces of cloth to a cloth background, just as in collage you glue paper to a background. You could create details with decorative stitches. You might sew buttons or beads onto the artwork.

In this studio exploration, you will create a stitched wall hanging that shows a dreamlike place. You might choose to show a real place with dreamlike qualities. Or you might create a dreamlike place that is imaginary.

You Will Need

- sketch paper and pencil
- sewing needle
- background fabric
- yarn and thread
- cloth scraps
- scissors
- decorative materials
- dowels
- white glue

Step 1 Plan and Practice

- Think about the place you will show in your wall hanging. Will it be real or imaginary?
- Decide if your artwork will be vertical or horizontal.
- Sketch some ideas.

Things to Remember:

✓ Keep the design simple.

✓ Use a variety of thread and yarn colors and textures.

✓ Make your place look dreamlike and inviting.

Inspiration from Our World

Inspiration from Art

When you hear the word *quilt*, you probably think of a patchwork bedspread. Its colorful fabrics and shapes add feelings of comfort and cheer to a room. However, many cultures create quilts for other reasons. They make quilts for ceremonies, for weather insulation, and for honoring people. In certain cultures, people spread them on the ground before they sit. Quilt designs can tell stories and represent ideas about marriage and freedom.

The materials used to make quilts can also go beyond what you might expect. In addition to scraps of colorful cloth, many of today's quiltmakers use threads and yarns of all textures and colors. They use ribbon, beads, paper, buttons, lace, mirrors, silk flowers—anything that can be stitched to the cloth. Artists who use such surprising materials have turned the traditional craft of quiltmaking into an expressive form of art.

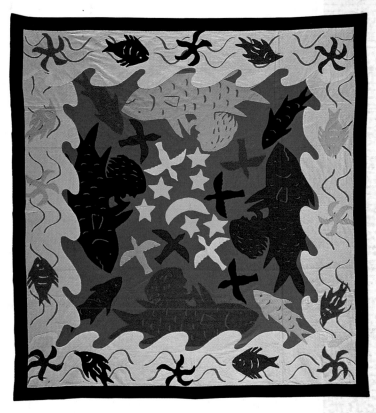

Fig. 6–27 **Women in the Cook Islands of Polynesia work together to create patchwork quilts. Does the place you see here seem realistic or dreamlike? Why?**

Maria Teokolai and others, Cook Islands, *Ina and the Shark*, ca. 1990. Tivaevae (ceremonial cloth), 101" x 97" (257 x 247 cm). Collection of the Museum of New Zealand Te Papa Tongarewa, Wellington, New Zealand, B.24769. Photo by Alan Marchant.

Step 2 **Begin to Create**

- Sketch the main shapes of your design.
- **Cut the main shapes of your design from fabric scraps, and stitch them to the background.**

- Using thread and yarn, stitch other shapes and details onto the appliquéd parts and background of the artwork. Leave some parts of the background blank.
- Sew decorations onto the artwork wherever you want them.
- When you are finished with your stitching, turn the artwork over.
- Carefully apply white glue along the length of a long dowel.
- **Lay the glued side of the dowel along the top edge of the back of the artwork. Apply another line of glue to the exposed length of dowel.**

- **Carefully roll the dowel, with background fabric attached, until the dowel is wrapped tightly with fabric.** The fabric should be glued securely to the dowel.

- Repeat the gluing process on the bottom edge of the artwork.

Step 3 **Revise**

Did you remember to:
- ✓ Keep the design simple?
- ✓ Use a variety of thread and yarn colors and textures?
- ✓ Make your place look dreamlike and inviting?

Adjust your work if necessary. In your sketchbook, make a note of your revisions and why you made them.

Step 4 **Add Finishing Touches**

- When the glue has dried, tie a yarn hanger onto the ends of the top dowel.

Step 5 **Share and Reflect**

- Discuss your artwork with classmates. How did you use stitches, shapes, colors, and decorations to make your place look dreamlike? How did you choose which materials to use?

- What challenges did you face when you designed the artwork?

- How did you come up with the idea for your place? Is it real or imaginary?

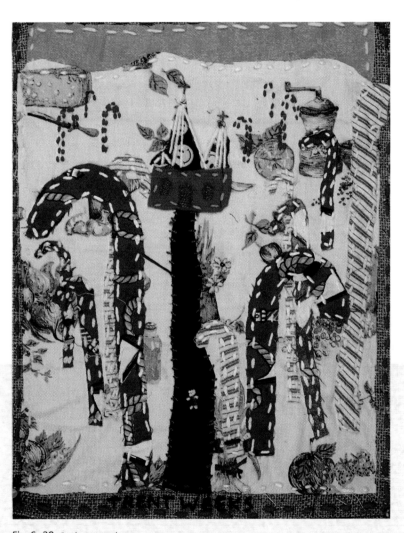

Fig. 6–28 Student artwork

Art Criticism

Describe Tell what you see in this artwork.

Analyze How did the artist create a sense of space and emphasis in this artwork?

Interpret What do you think this artwork is about? What feelings do you associate with this artwork?

Evaluate What is special about this artwork?

Science

Fig. 6–29 **Adobe forms are simple, organic, and rounded, and are often molded by hand. How are these buildings different from the ones you see every day?**

Taos Pueblo, New Mexico. Photo by H. Ronan.

Adobe structures are made from a mixture of mud and straw.
This mixture is formed into bricks or built up into solid walls. Adobe architecture was created in a desert environment like the Southwest United States and parts of Africa, India, and Saudi Arabia. Adobe buildings are simple and affordable. They are also good in hot, dry climates. Thick walls keep the indoor temperature fairly constant. What are the buildings in your community made of?

Music

If you created a "musical picture" of a favorite place, how would it sound? Would the tempo be fast or slow? Would the rhythm be smooth or bouncy? What instruments would you use? Composers sometimes write music about places they have visited or would like to visit.

After living in Paris for a few months, composer George Gershwin wrote *An American in Paris*. The music paints a picture of the city's busy sidewalks and noisy taxicabs. How many songs about places can you think of?

Fig. 6–30 **Ferde Grofé got his idea for his composition *Grand Canyon Suite* when visiting the canyon. What do you imagine it to sound like?**

Grand Canyon. Photo by H. Ronan.

Fig. 6–31 **Public artists know the strength of the materials they use. This marble elephant supports an Egyptian obelisk made of red granite.**

Gianlorenzo Bernini and Ercole Ferrata, 1667. Piazza della Minerva, Rome, Italy. Photo by H. Ronan.

Careers **Public Artist**

Public artists plan their art for display in public places, such as parks, buildings, or roadsides. What public sculptures or murals have you seen? Public artists might be sculptors who create three-dimensional forms, or they may be muralists who work with paint or mosaic tiles. They create art with a public audience in mind. Their artwork usually honors special places or people. For large public-art projects, the artists often hire assistants or apprentices.

Daily Life

We generally attach meaning, such as feeling happy or sad, to special places where we spend our time. What places are important to you? Why are these places meaningful? What public places have people remembered as special?

Today, public memorials are common. People may leave flowers, photographs, and other items to remember those who have died. What memorials are found in your community?

Fig. 6–32 **Imagine having this garden as your backyard. What would you do there? Why?**

Hampton Court, *William and Mary Gardens*. London, England. Courtesy of Davis Art Images.

Vocabulary Review

Match each art term below with its definition.

> **appliqué**
>
> **center of interest**
>
> **document**
>
> **implied space**
>
> **Neoclassicism**
>
> **fiber artist**

1. the illusion of three-dimensional space in a two-dimensional artwork

2. an artist who creates artworks with cloth, yarns, threads, and other materials

3. an area in a work of art that is strongly emphasized

4. to make or keep a record of

5. a process of stitching cloth to a background

6. a style of art based on interest in the ideals of ancient Greek and Roman art

Aesthetic Thinking

Do artists express their feelings, ideas, or beliefs about places? Is this always, sometimes, or never the case? If so, how is that possible? Choose an art example in this chapter to support your thoughts.

Write About Art

Fig. 6–33 **Barbara Watler was reluctant to go to Carlsbad Caverns because she doesn't like very small places. Finally, she gave in and loved the visit.**

Barbara W. Watler, *Cavern Gardens*, 1996. Mixed thread painting and mixed fabrics, machine stitched and appliquéd, 24" x 16" (61 x 40.6 cm). Courtesy of the artitst. Photo by Gerhard Heidersberger.

In this quilt, the artist interpreted her trip to Carlsbad Caverns, a National Park in New Mexico that features a series of caves. Which parts of this image do you think the artist actually saw, and which do you think she imagined? Write an explanation of your answer.

Art Criticism

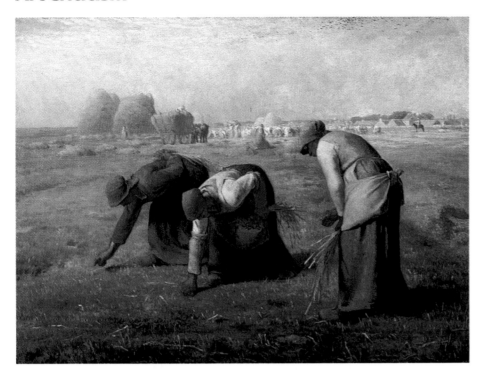

Fig. 6–34 Jean-François Millett, *The Gleaners*, 1857. Oil on canvas, 33" x 44" (83.8 x 111.8 cm). Musée d'Orsay ©Photo RMN.

Describe What do you see in this painting?

Analyze How does the artist create unity in this painting?

Interpret What makes this painting an example of Realism?

Evaluate Why do you think that people considered this painting scandalous when it was first exhibited?

Meet the Artist

Jean-François Millet (1814–1875) was born in Gruchy, France. He studied to be a portrait painter, though he later became known for his scenes of peasants at work. Millet usually made many sketches and drawings to work out his ideas before creating the final painting.

For Your Portfolio

Choose an artwork from your portfolio that you think best shows your use of space and emphasis. Reflect on what you did well and what you might need to work on.

For Your Sketchbook

Do a series of sketches of the same place, changing the center of interest in each view.

Artists Reveal Nature

Fig. 7–1 **How does this artwork encourage the viewer to feel close to nature?**

Berthe Morisot, *Girl in a Boat with Geese*, ca. 1889. Oil on canvas 25 ¾" x 21 ½" (65 x 54.6 cm). Ailsa Mellon Bruce Collection, Photograph ©1999 Board of Trustees, National Gallery of Art, Washington, DC.

182

How does nature affect your life? Do you notice it only when it keeps you from doing something you enjoy—like when a storm knocks out the electricity and you can't watch TV? Or do you look at the sky and see shapes in the clouds?

Our lives have always been linked to nature. So has our art. Artists depend on nature to provide the materials for art. They also study natural patterns and scenes to use as subject matter. The history of art-making is full of examples of how humans observe and interpret the natural world.

In this unit, you will learn:

- How artists show nature, and use natural materials in their works.
- How to use color, shape, and form to help express ideas about nature in sculpture and printmaking.
- How to see and interpret artists' artworks about nature.

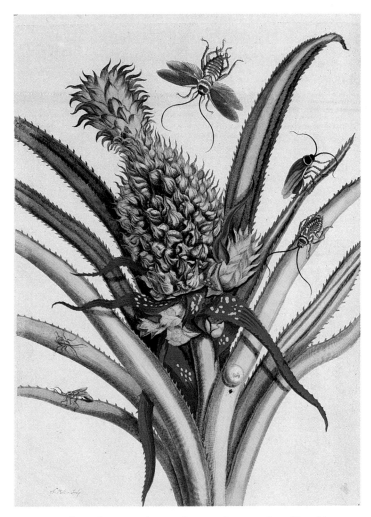

Fig. 7–2 Before photography was invented, engravings like this one showed people what plants and insects looked like. Who might have been most interested in artwork like this?

Maria Sibylla Merian, *Plate 2 from Dissertation in Insect Generations and Metamorphosis in Surinam*, second edition, 1719. Hand-colored engraving, approximately 12 ¾ " x 9 ¾ " (32.4 x 24.8 cm). The National Museum of Women in the Arts.

Seeing Nature in Art

Inspired by the Natural World Have you ever collected seashells, rocks, fossils, or leaves? Artists are attracted to these natural forms. Sometimes, they make these natural forms part of larger compositions. Other times, the forms serve as the main subject of an artwork. Before photography was invented, people relied on artists to record the details of plants, animals, and natural features throughout the world.

Artists are not always interested in showing all of nature's details. Sometimes they choose instead to show the feelings or moods that natural scenes inspire. They use color and other elements to show nature's expressions. Their artworks may appear close up, showing carefully studied details, or at a distance, as if the artist is standing back in awe (Fig. 7–3).

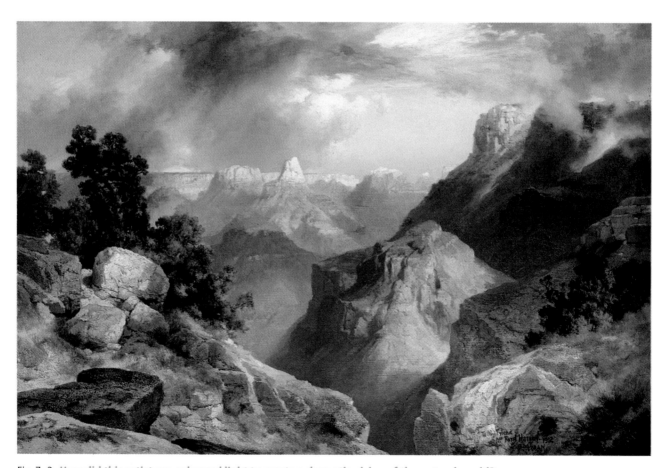

Fig. 7–3 How did this artist use color and light to create a dramatic vision of the natural world?

Thomas Moran, *Grand Canyon*, 1912. Oil on artist's composition board. 15 $^{15}/_{16}$" x 23 $^{15}/_{16}$" (40.4 x 60.8 cm). The Nelson-Atkins Museum of Art, Kansas City, Missouri (Bequest of Katherine Harvery). Photography by Robert Newcombe. ©1999 The Nelson Gallery Foundation. All Reproduction Rights Reserved.

Look around your home. Can you find shapes or items that are borrowed from nature? Look for plant shapes in fabric or on china patterns. Furniture and architectural designs in many cultures worldwide make use of simplified plant, animal, and insect shapes (Fig. 7–4). Simplified shapes are shapes that are not as detailed as the actual object.

Meet Zuni Pueblo Artists

The Zunis live in the southwestern United States. They may have lived there for over 1,300 years. Today, many Zunis earn their living by making and selling traditional Zuni pottery, jewelry, clothing, baskets, and carved figures called Kachina dolls. In a population of less than 12,000, more than 1,000 Zunis are artists.

Zuni potters traditionally were women, but over the past 50 years men have begun to make and fire pottery as well. Much of the clay they use is still dug by hand. Zuni pottery tells stories with symbols. For instance, the deer in a house (Fig. 7–4) is believed to give men good luck when hunting.

"I consider my people truly great artists, because each and every family in Zuni is very talented. This is how the Zuni people make a living."

— Veronica Poblano, Zuni carver and jeweler

Art Materials from Nature People have always created artworks from materials such as clay, wood, and fiber. It is sometimes hard to tell if an artwork is made of natural materials, however. When you look at a ceramic vase, for example, you might not believe that it began as a lump of clay in the earth. In other artworks, such as a marble sculpture, the natural materials are easier to recognize.

Artists might shape natural objects to create small works, as when they use plant reeds to make a basket. Or they might shape nature on a large scale, as in the design and creation of a public garden (Fig. 7–5).

Fig. 7–5 **Artists carefully arranged rocks and sand to create this peaceful garden.**

Soami, *Zen Stone Garden*, symbolizing sea and islands. Muromachi period (founded 1473). Ryoan-Ji Temple, Kyoto, Japan. SEF/Art Resource, NY.

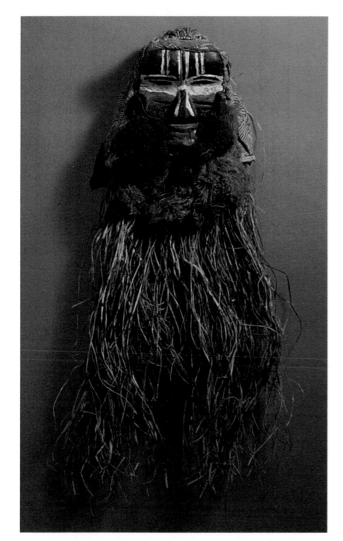

Fig. 7–6 **The geometric design painted on the face, known as the leopard pattern, was inspired by nature. What else is natural about this mask?**

Kran culture (Liberia), *Dance Mask*, 20th century. Painted wood, raffia, and fabric, 12" x 8" (30.5 x 20.3 cm). Collection of the University of Central Florida Art Gallery, Orlando, Florida.

Check Your Understanding

1. Name two ways that artists can include objects from nature in their work.

2. When might careful drawings from nature be more helpful than photographs?

3. How might an artist convey moods or feelings in an image of nature?

Studio Time

Natural Shapes

You can explore simplifying natural shapes in a cardboard relief print.

- First, draw the natural shape you see—leaf, shell, tree, animal.

- Draw the shape again, but omit some details. Try drawing the shape with straight lines only.

- Draw your shapes on lightweight cardboard and cut them out.

- Glue to a cardboard base. Apply ink with a brayer and pull your print.

Reflect on the process of simplifying natural shapes.

Fig. 7–7 Student artwork

Using Color

The world is filled with color. Everywhere you look you can see bright colors, dull colors, dark and light colors—more colors than you can name.

Color and Light Color is a feature of light. When white light is separated into its colors by a prism, or even by a drop of water, a rainbow, or spectrum, is created. The spectrum is the entire range of colors produced from white light. When white light strikes an object, some of its colors

are absorbed by the object and some of its colors are reflected. The object then appears to have color.

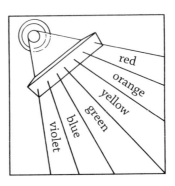

The spectrum

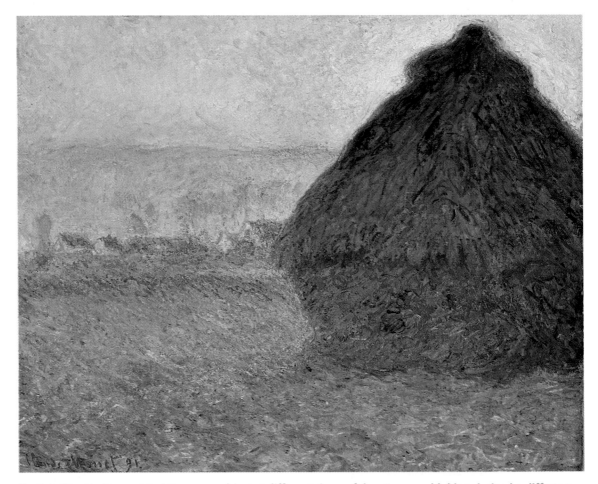

Fig. 7–8 **Monet often painted the same subject at different times of day. How would this painting be different if it had been painted in the early morning?**

Claude Monet, *Grainstack (Sunset)*, 1891. Oil on canvas, 28 ⅞" x 36 ½" (73.3 x 92.6 cm). Juliana Cheney Edwards Collection. Courtesy of the Museum of Fine Arts, Boston.

The Color Wheel A *color wheel* is a circular chart made up of *primary*, *secondary*, and *intermediate* colors. Red, yellow, and blue are the primary colors or hues. If you mix any two primary colors, you will produce one of three secondary colors—violet, orange, and green. Mixing a primary color with a neighboring secondary color produces the six intermediate colors. Complementary colors are colors that are across from each other on the color wheel.

Color in Nature You have probably noticed that the colors of objects in nature can change in the light of different times of day. Some artists are interested in showing atmospheric color in their paintings of nature. Atmospheric color is color that changes according to changes in the environment. Artists can reproduce colors they see by using and mixing paints, dyes, and other pigments. They can use the three primary colors plus black and white to create nearly every other color.

Observe Notice the many tints Monet uses in Fig. 7–8. How many varieties of yellow can you find? What about blue? What secondary colors can you identify in the painting?

Tools: Oil pastels or tempera paints.

Practice: Mixing Light Colors

- Make five circles of white paint or oil pastel on a sheet of paper.
- In the first circle, make the lightest tint of a color that you're able to.
- In the next four circles, make each tint slightly darker than the one before it.
- How many more tints of that one color can you make?

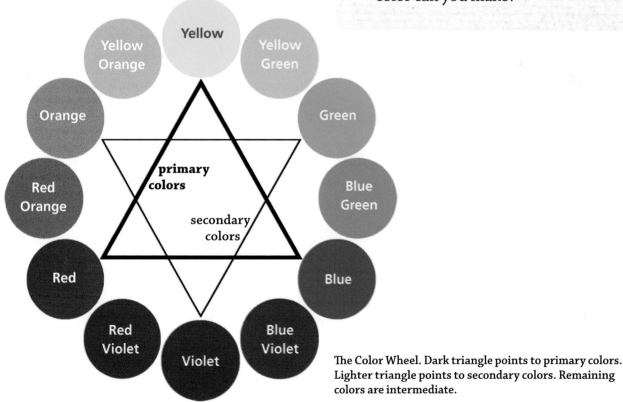

The Color Wheel. Dark triangle points to primary colors. Lighter triangle points to secondary colors. Remaining colors are intermediate.

Color Schemes When artists create a painting or drawing, they choose a color scheme. A color scheme is a plan for selecting colors. Color schemes can help artists express mood. A bright color scheme can suggest a cheerful or overwhelming mood. An earth color scheme might suggest a quite different mood. Warm colors and cool colors also help express mood.

Observe Look at the painting by Paul Gauguin (Fig. 7–9). Gauguin chose mostly dark colors for his painting. How would you describe the mood that he creates?

Tools: Oil pastels or tempera paints.

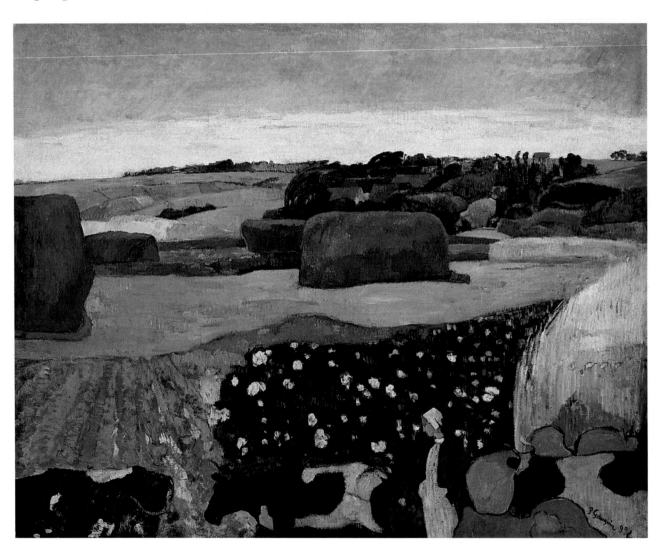

Fig. 7–9 How would you describe the color scheme in this painting? Do you see mostly warm colors or mostly cool colors? What mood is suggested?

Paul Gauguin, *Haystacks in Brittany*, 1890. Oil on canvas, 29 ¼ " x 36 ⅞" (74 x 93.7 cm). Gift of the W. Averell Harriman Foundation in memory of Marie N. Harriman. Photograph ©1999 Board of Trustees, National Gallery of Art, Washington, DC.

Practice: Mixing Colors to Create Moods

- Using red, yellow, blue, black, and white, experiment with mixing colors that suggest moods. Make at least nine different colors.

- What colors would you mix for a stormy mood? A festive mood? A bleak or sad mood?

- Try mixing a color with its complement. What happens?

Check Your Understanding

1. Why does the color of an object change throughout the day?

2. Compare a two-dimensional and three-dimensional artwork from this unit. Explain how the artists' use of color affects the moods of the artworks.

3. Why do artists use color schemes in their work?

Studio Time

Colors of Nature

Many artists use color to create moods in their artworks about nature. You can use oil pastels to create a drawing of flowers.

- Bring in real or artificial flowers.

- Use light pencil lines to plan your composition.

- Choose a color scheme that best illustrates the mood you would like to create.

- Layer and blend colors to create tints and shades.

Reflect on how your color scheme suggests a mood.

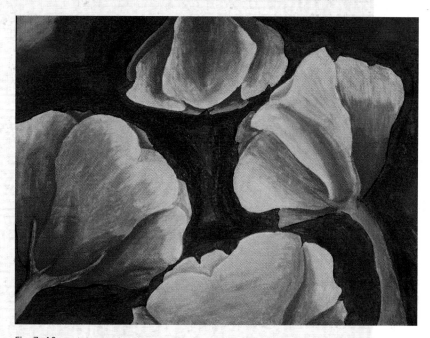

Fig. 7–10 Student artwork

Nature Relief Print

Studio Background

Where do you see shapes in nature? Do you notice the shapes of leaves or branches against the sky? Animal prints in snow or sand?

Printmaking is the process of transferring an image from one surface to another. **In this studio exploration, you will make a two-color relief print of a subject from the natural world.** A relief print is a print made by inking the raised surface of a block or plate. You might show a natural object or an entire nature scene. Whatever you choose, you may simplify the shapes.

You Will Need

- sketch paper
- pencil
- linoleum block
- linoleum cutting tools
- bench hook
- carbon paper
- printing ink, two colors
- brayer
- drawing paper

Step 1 **Plan and Practice**

- Choose a plant, animal, or scene from nature to be the subject of your print.
- Think of ways to simplify the shapes of your subject, such as leaving out some lines in detailed areas, drawing shapes with straight lines only, and thickening main lines.
- Sketch your design. Mark areas that will be printed in each of the two colors.

Things to Remember:

✓ Simplify the shapes of your natural subject.

✓ Make sure your entire design transfers to the block when tracing.

✓ Apply a thin, even coat of color to the raised areas of your design.

Inspiration from Our World

Inspiration from Art

A relief print is made from a raised surface that receives ink. The Japanese woodcut you see here is an example of a relief print.

Japanese woodcut printing was first developed in 1744. The artist, engraver, and printer usually worked together on the process. First, the artist created a brush drawing on transparent paper. The engraver then pasted the drawing to a block of wood and carved the outlines of the drawing. He or she made as many prints of the block as the number of colors chosen for the final print. For example, if the print was to be made with three colors, the engraver printed the block three times.

On each copy of the print, the engraver marked areas that would appear in one of the colors. Then he or she cut one block per color. Finally, the printer applied an ink color to each of the blocks and pulled the print one color at a time.

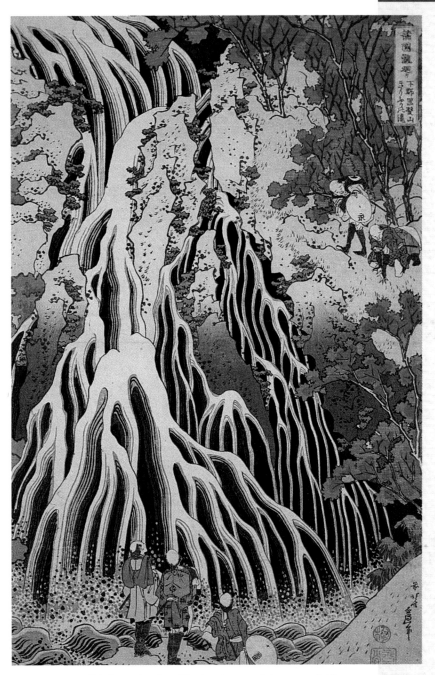

Fig. 7–11 **How did the artist simplify the shapes of the trees, falling water, and rock formations?**

Katsushika Hokusai, *Kirifuri Waterfall at Mt. Kurokami*, Shimozuke Province, Series: The Various Provinces, ca. 1831. Color woodblock print, 14 ⅝" x 9 ⅝" (37.2 x 24.5 cm). Nelson-Atkins Museum of Art, Kansas City, Missouri (Purchase: Nelson Trust). © 1999 The Nelson Gallery Foundation. All Reproduction Rights Reserved.

Safety Note To avoid cuts, use extreme care when using linoleum tools!

Step 2 **Begin to Create**

- **Use carbon paper to transfer your design onto the linoleum block.**

- With your pencil, lightly fill in areas on the block that you want to print in color.

- **Cut away the areas you do not want to print.** These areas will be the color of the paper used for printing.

- Ink the block. **Using the brayer, apply a thin, even coat of color to the raised areas of your design.** Make sure the ink does not fill in small cut areas.

- Carefully place your printing paper on the block. Press or rub the paper with your hand. Begin at the center and work toward the edges, rubbing the whole surface gently but firmly.

- **Pull the print by slowly peeling it away from the block.**

- Once you print in one color, carve away more of the block and print with a second color.

Step 3 **Revise**

Did you remember to:

✓ Simplify the shapes of your natural subject?

✓ Make sure your entire design transfers to the block when tracing?

✓ Apply a thin, even coat of color to the raised areas of your design?

Adjust your work if necessary. In your sketchbook, make a note of your revisions and why you made them.

Step 4 **Add Finishing Touches**

• Sign and date your print when it is dry.

Step 5 **Share and Reflect**

• Examine your completed artwork, along with your classmates' works. Are shapes, lines, and other elements clearly defined?

• Discuss the ways that nature is shown in the artworks. Do any show nature in a dramatic or expressive way?

Art Criticism

Describe What does the artist show in this print?

Analyze What kind of lines, shapes, and colors did the artist use?

Interpret What moods or feelings do you associate with this artwork?

Evaluate What did the artist do especially well?

Fig. 7–12 Student artwork

European Art :1875–1900

Fig. 7–13 **Many Impressionist artists were inspired by the new medium of photography. How does this print resemble a snapshot?**

Mary Cassatt, *Feeding the Ducks*, 1895. Drypoint, soft ground etching, and aquatint printed in colors, 11 11/16" x 15 ¾" (29.7 x 40 cm). The Metropolitan Museum of Art, Bequest of Mrs. H. O. Havemeyer, 1929. The H. O. Havemeyer Collection (29.107.100). Photograph ©1980 The Metropolitan Museum of Art.

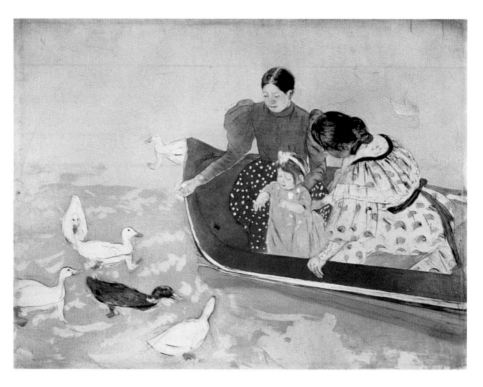

In the second half of the 1800s, the Industrial Revolution was changing societies. Cities were growing. Exciting inventions and new technologies were altering the way people lived and worked.

In this time of great social and technological change, there were also revolutions in art. French artists created two new art styles: Impressionism and Post-Impressionism. Impressionism is a style, especially of painting, that emphasizes views at a particular moment, and the effects of sunlight on color. Post-Impressionism, which means "after Impressionism," is a style that emphasizes organization, and using color to express feelings and create the illusion of form.

1874
The first zoo in the United States opens in Philadelphia, PA.

1880
John Milne invents the first seismograph, a machine that measures the nature and intensity of earthquakes.

1889
van Gogh, *Irises*

1895
Cassatt, *Feeding the Ducks*

1800s

1900s

1876
Renoir, *Garden in the Rue Cortot*

1885
Seurat, *Le Bec du Hoc*

1888
The first issue of National Geographic is published.

ca. 1890
Degas, *Horse Rearing*

1903
Pelican Island, Florida becomes the first wildlife refuge in the United States.

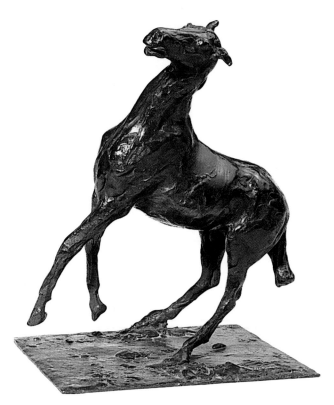

Fig. 7–14 **In addition to painting and printmaking, Edgar Degas also made models for sculptures. How does this bronze cast capture the movement of the horse?**

Edgar Degas, *Horse Rearing*, ca. 1890. Bronze. Musée d'Orsay ©Photo RMN.

Like many artists throughout history, the Impressionists and Post-Impressionists were inspired by nature and the world around them. They were also learning about exciting new influences and technologies. It was no longer enough to make things look real on a flat canvas. Instead, they were interested in color and the way it affects how we see and feel about things.

Impressionism The Impressionists hoped their artworks would give an impression of what a natural scene looked like at one moment in time. They wanted to capture a split second, when you look at something quickly and then it changes.

The Colors of Nature Look at the painting by Renoir in Fig. 7–15. Renoir and the other Impressionists used short, fast brushstrokes to record colors and light, leaving out details as they raced to capture a scene before it changed. As you look closely at Impressionist artworks, you will see brushstrokes of different colors placed next to each other. In the shadows, you will notice many different colors—purples and dark blues. In sunlight you will see the brightest colors—yellows, greens, and reds. The Impressionists knew that, at a distance, people's eyes mix the colors.

Fig. 7–15 **What details do you think Renoir left out of this scene?**

Pierre-Auguste Renoir, *The Garden in the Rue Cortot, Montmarte,* 1876. Oil on canvas, 59 ¾" x 38 ⅜" (151.8 x 97.5 cm). Carnegie Museum of Art, Pittsburgh. Acquired through the generosity of Mrs. Alan M. Scaif, 65.35. Photography by Peter Harholdt.

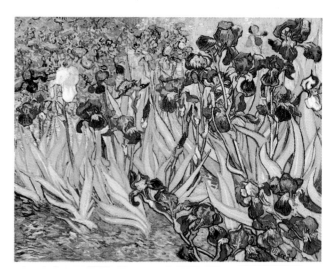

Post-Impressionism Not all artists agreed with the Impressionists' ideas about painting. The Post-Impressionists were a group of artists who felt that Impressionist artworks were too unplanned. They were not interested in trying to capture the momentary effects of light on objects. Instead, they focused on arranging objects into an organized composition. They wanted their artworks to have a strong sense of design.

Color and Composition The Post-Impressionists used color to help give order to their paintings of nature. Each artist in the group developed a unique way of working with color. For example, Georges Seurat (Fig. 7–16) placed thousands of small dots of color very close together to create the sky, water, and cliff. Edges— although not sharp—are clearly defined.

Fig. 7–17 **What do these brushstrokes and colors tell you about van Gogh's feelings toward nature and the iris?**

Vincent van Gogh, *Irises*, 1889. Oil on canvas, 28" x 36 ⅝" (71 x 93 cm). The J. Paul Getty Museum, Los Angeles.

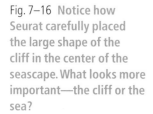

Fig. 7–16 **Notice how Seurat carefully placed the large shape of the cliff in the center of the seascape. What looks more important—the cliff or the sea?**

Georges Seurat, *Le Bec du Hoc at Grand Champ*, 1885. Oil on canvas, 25" x 32" (64 x 81 cm). The Tate Gallery, London. Photo by John Webb. Art Resource, NY.

Meet Vincent van Gogh

Vincent van Gogh was born in the Netherlands. At the age of 27, van Gogh decided to become an artist and began to teach himself how to paint. He learned by copying other people's artworks and reading books.

His early paintings were very dark until he saw Impressionist and Post-Impressionist artworks for the first time. Inspired by artists like Georges Seurat, he began using bold colors and highly visible brushstrokes to express his feelings about nature. He also used symbols in his artworks. For example, he painted brightly colored oleander flowers as a symbol of joy.

Van Gogh made almost 900 paintings in the ten years before his death. His greatness was not recognized during his lifetime, but today his work is well known and has inspired many other artists.

"Color in a picture is like enthusiasm in life."

— Vincent van Gogh (1853–1890)

Check Your Understanding

1. What interested and inspired Impressionist painters?

2. Compare and contrast the paintings of gardens in this lesson. Which painting is Impressionist? Which is Post-Impressionist?

3. Choose a Post-Impressionist or Impressionist artwork. Explain how the artwork displays the characteristics of this style.

Studio Time

Nature Close-Up

Create a painting of a close-up scene from nature.

- Use various brushstrokes within your painting. You might choose fast, short strokes, carefully placed dots of color, flat patches of color, or swirling strokes.

- Note that short or swirling brushstrokes might suggest motion; dots of color can create a shimmering effect. Plan where and why you will use different brushstrokes.

Reflect on how your color choices suggest the kind of weather and type of light for the season shown in your painting.

Fig. 7–18 Student artwork

The Art of Japan

Natural Subjects Nature and the environment are very important in Japanese art. Landscapes, plants, and animals are often used as subject matter. Japanese architects plan not only buildings, but also the natural landscape and gardens around the buildings. Look, for example, at the *Golden Pavilion* (Fig. 7–19). What makes this tea ceremony pavilion seem so settled into its surroundings?

Many Japanese artists are skilled at simplifying natural forms. Look closely at the folding screen (Fig. 7–20). What natural features have been simplified? Compare the screen with the netsuke sculpture of quail (Fig. 7–21). How have the forms of the birds been simplified?

Fig. 7–19 **How does this building blend harmoniously with its environment?**

Golden Pavillion (Kinkaku-ji). Kyoto, 1398. Photo by W. Wade.

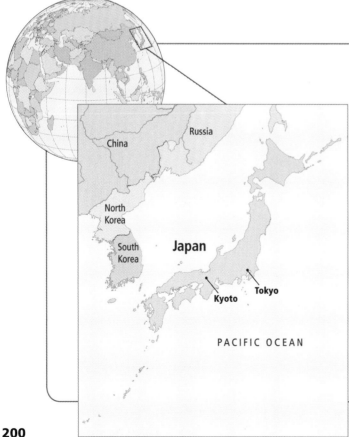

Social Studies Connection

Japan is a mountainous nation in East Asia made up of over 3,000 islands. Shinto and Buddhism are the country's two major religions. The Japanese worshiped nature gods at Shinto shrines long before Buddhism was introduced to their culture in the 500s CE. Shinto and Buddhist beliefs exist peacefully side-by-side. Shinto shrines and Buddhist temples and monasteries are found throughout Japan.

The Buddhist religion inspired many traditional arts, such as the tea ceremony, ink painting and calligraphy, and garden design. Many people study these art forms for private reflection or meditation. They think about the natural world as they improve their artistic skills.

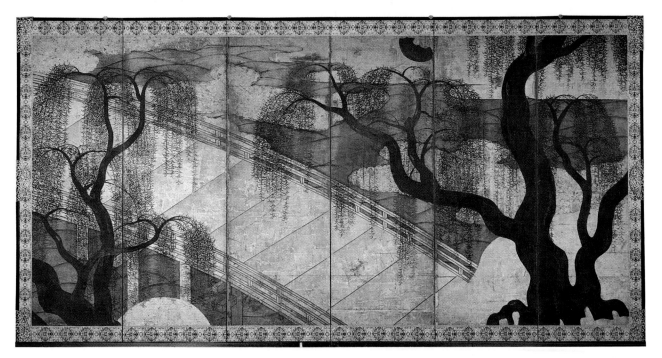

Fig. 7–20 Japanese paintings were usually done on scrolls or screens. They often were made with calligraphic brushstrokes. How has this artist combined elegance and simplicity to show a scene from nature?

Japan, *The River Bridge at Uji*, Momoyama Period (1568–1614). Ink, color, and gold on paper. Six-fold screens, 64 ½" x 133 ¼" (171.4 x 338.4 cm). The Nelson-Atkins Museum of Art, Kansas City, Missouri (Purchase: Nelson Trust).

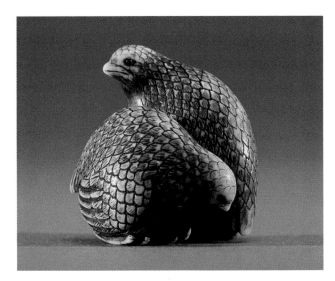

Fig. 7–21 Netsuke are small carved objects used to fasten a pouch or purse to one's kimono sash. How do you think this artist felt about nature?

Okakoto, *Two Quail*, late 18th–early 19th century. Ivory, 1 ⅜" (3.2 cm) wide. Los Angeles County Museum of Art, Gift of Mrs. G.W. Mead. M.59.35.24

Visual Culture

Have you ever noticed how many objects are decorated with images from nature?

Work with your classmates to create a display of "decoration inspired by nature." Look for examples in your home as well as in catalogues and magazines. Consider paper plates, cups, coffee mugs, napkins, and the like. Consider the ways plants and animals are used in the design of packages for food and household products such as cereal boxes, shampoo, or bars of soap. How are the plants or animals represented?

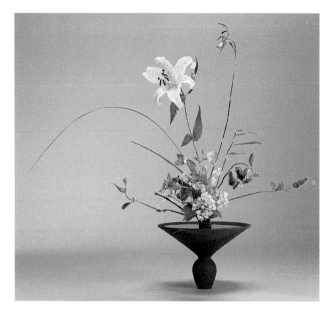

Fig. 7–22 **For hundreds of years, only Buddhist priests, royalty, and samurai were taught ikebana. Now anyone can be taught this art.**

Sen'ei Ikenobo, 45th generation Ikenobo Headmaster, *Rikka style Ikebana arrangement*, 1999. Lily, oncidium orchid, miscanthus grass, willow leaf spirea, Japanese balloon flower, and hydrangea. Courtesy of Ikenobo Society of Floral Art, Japan.

Natural Materials Japanese artists have traditionally used natural materials. The beauty of the material becomes part of the design. For example, wooden sculptures or structures are often unpainted. Garden designs may include trees or other plants, water, sand, stones, a wooden teahouse, shrine, or bridge. See Fig. 7–5 (page 186) for an example of a Japanese garden.

Ceramic arts in Japan have traditionally been an important focus. Special handmade bowls are needed for the tea ceremony, and vases are required for *ikebana*—the art of flower arranging (Fig. 7–22). Influenced by early Korean ceramic arts, the Japanese designs are usually inspired by nature.

In the 1700s, multicolored woodcuts became a very popular art form in Japan. Hundreds of prints, showing scenes from nature and everyday life, were made from the inked blocks. Hiroshige (Fig. 7–23), Hokusai, Utamaro, and Harunobu are among the masters of multicolor woodcut printing.

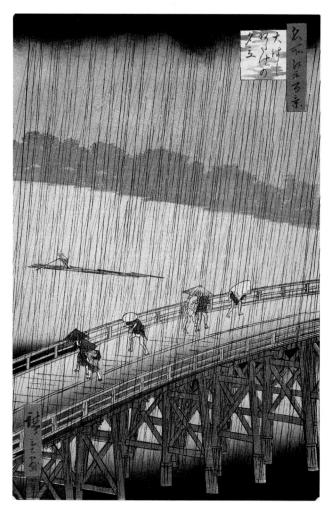

Fig. 7–23 **What scene is Hiroshige illustrating in this woodcut print? What details does he include to create this scene?**

Ando Hiroshige, *Evening Shower at Atake with the Great Bridge*, 1857, from the series *One Hundred Famous Views of Edo*. Color woodcut print, 14" x 9" (36 x 23 cm). Collection of Scott Archive.

Meet Utagawa Hiroshige

©Peter Harholdt/CORBIS.

Utagawa Hiroshige was the son of a firefighter in Edo, now Tokyo. Orphaned when he was 12, he learned the art of printmaking when he was 14, during an apprenticeship. He sold his artwork to add to his fireman's salary. In Edo in the early 1800s, artwork focused on people enjoying themselves. Artists liked to show actors and city people. Japan's most well-known landscapes were always depicted in the same ways. Artists could paint them without even seeing them. But Hiroshige traveled across Japan, making sketches of what he saw. He became known for the beauty and accuracy of his landscapes.

"(A)s much as possible I made the compositions true to life. For those who can take long trips, please bring this book along and compare my scenes to the actual scenes."

— Utagawa Hiroshige (1797–1858)

Check Your Understanding

1. What kinds of Japanese art traditions are inspired by Buddhism?

2. Compare the Japanese artworks in this lesson. What do they all have in common?

3. How do Japanese artists take advantage of the qualities of natural materials in their work?

A Natural Vessel

Create a ceramic vessel based on close observation of a natural form.

- Use the pinch pot method to create a basic vessel.

- Examine a natural form, such as an artichoke, seashell, or water lily.

- Focus on the details of your selected object as you add details and finish your vessel.

- Coils, thin slabs, and small balls of clay can be pressed on to the basic vessel for petals, leaves, or vines.

Reflect on how well your vessel captures the details of a natural form.

Fig. 7–24 Student artwork

Nature in Paper

Studio Background

When was the last time you made a newspaper hat? A house of cards? Or a paper airplane? When you made these things, you probably didn't realize that you were practicing some paper-sculpture techniques. Curling, folding, crumpling, and slitting are just some of the ways to turn ordinary paper into a jungle of wild animals or a garden paradise. Sculptors who work with paper make amazing and beautiful three-dimensional forms. When they put the forms together, they can create fantastic artworks!

In this studio exploration, you will create three-dimensional forms from paper. You will assemble the forms to make a relief sculpture. Choose any object or scene from nature for your subject.

You Will Need

- sketch paper and pencil
- colored construction paper
- lightweight cardboard
- scissors
- tools for scoring
- white glue
- paper clips or removable tape

Step 1 **Plan and Practice**

- Choose a subject from nature that interests you. You might consider animals, trees, flowers, the ocean, or mountains. How might you create a paper relief sculpture of your subject?

- Sketch your ideas. Simplify the shapes and forms of your subject. Will you use geometric shapes and forms, or organic shapes and forms?

Things to Remember:

✓ Vary your paper-sculpture techniques to make your sculpture more interesting.

✓ Use colors that create the effect you want.

✓ Arrange your paper forms so that your subject is recognizable.

Inspiration from Our World

Inspiration from Art

Paper is all around us. We use it to write on and to wrap things. We feel its many textures and thicknesses in books and magazines. It fills our homes, schools, and offices. For thousands of years, paper has been an important part of daily life. It has also made its mark in the world of art.

Since its invention, paper has provided artists with a surface for drawing, painting, and printing pictures. In the early 1900s, paper's role in art expanded into collage and sculpture. Artists invented new ways to express themselves with paper. Many were inspired by the traditional paper-folding and paper-cutting techniques they saw in Europe and Asia. Today, artists create exciting sculptural forms just by cutting, folding, scratching, tearing, piercing, bending, punching, rumpling, gluing, and decorating paper.

Fig. 7–25 **How has this artist created texture? Is it real texture or implied texture?**

Denise Ortakales, *Peacock*, 1998. Paper sculpture, 10" x 35" x 4" (25.4 x 89 x 10 cm). Courtesy of the artist.

Step 2 Begin to Create

- **Practice the paper-sculpture techniques shown in the diagrams.** Try scoring and bending straight and curved lines. Compare the results. Experiment with other techniques, such as tearing and twisting paper. Come up with ideas of your own. Which techniques will work best for your sculpture? Think about the colors and forms that will create the effect you want.

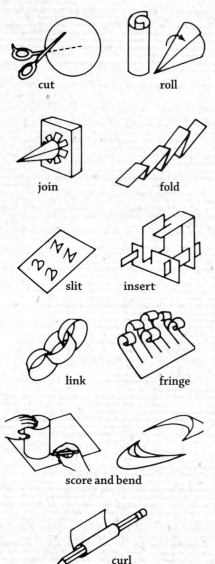

cut roll

join fold

slit insert

link fringe

score and bend

curl

- **After shaping the forms for your sculpture, carefully arrange the parts on a piece of lightweight cardboard.** Change and rearrange the forms so all parts fit together well.

- When you are happy with your arrangement, glue the forms in place. Use paper clips to hold the forms in place until the glue dries.

Step 3 Revise

Did you remember to:

✓ Vary your paper-sculpture techniques to make your sculpture more interesting?

✓ Use colors that create the effect you want?

✓ Arrange your paper forms so that your subject is recognizable?

Adjust your work if necessary. In your sketchbook, make a note of your revisions and why you made them.

Step 4 **Add Finishing Touches**

- Add any other needed touches to your sculpture, such as additional small details.
- Make sure no glue is visible on your sculpture.

Step 5 **Share and Reflect**

- Explain to classmates why the forms you chose work best for your subject.
- How many different paper-sculpture techniques did you use to create the forms?
- How clearly does your sculpture represent nature?

Art Criticism

Describe What did the artist choose to show in this paper sculpture?

Analyze How did the artist use paper to show the variety of the natural world?

Interpret What does this artwork suggest to you about the natural world?

Evaluate What makes this artwork special?

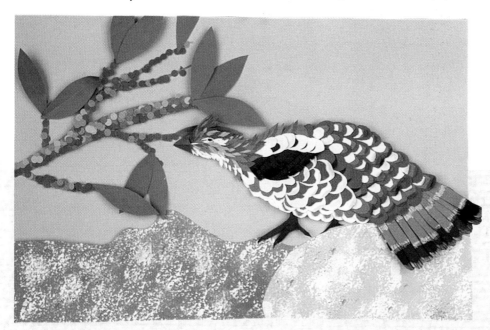

Fig. 7–26 Student artwork

Language Arts

An important form of traditional Japanese poetry is linked to nature. Haiku are thoughtful, unrhymed poems about the natural world. Some haiku contrast things such as movement and stillness. Haiku are usually about a specific season. They focus on appreciating the things that surround us. Haiku have seventeen syllables in three short lines. How could you learn to write haiku? What natural subjects would you choose to write about in your haiku?

Fig. 7–27 **Calligraphic brushstrokes tell the words of a poem while also literally forming the landscape in this work about nature. What lines and shapes in this work remind you of nature?**

Tawaraya Sotatsu and Hon'ami Koetsu, *Poem-card (Shikishi)*, 1606 Gold, silver, and ink on paper, 52" x 17" (132.1 x 43.2 cm). ©The Cleveland Museum of Art, John L. Severence Fund, 1987.60.

Music

Fig. 7–28

The natural world is a common subject in musical works. Music that has sounds similar to those found in nature is known as imitation. Listen to three compositions that imitate storms. First, listen to the storm section from Rossini's *William Tell Overture*. Then, listen to the fourth movement of Beethoven's *Sixth Symphony*. Finally, listen to "Cloudburst" from Grofé's *Grand Canyon Suite*. How are these pieces similar in the way they represent storms? How are they different? Explain which piece you think sounds the most like a storm.

Careers **Scientific Illustrator**

In a science textbook, you can find illustrations that show natural objects. You may also find drawings that show scientific ideas and living things. These images are created by science illustrators. Science illustrators have special skills in one or more areas of science. They have a strong interest in art and knowledge in a specific area of science. For example, an artist who specializes in life science might create medical illustrations. Science illustrators use a variety of media to create detailed drawings.

Fig. 7–29 **Why do you think scientific illustrations are used instead of photographs?**

Basil Besler, *Crocus Sativa, Bulbosa Flora Luteo, Lilium Bizantinum Serot,* 1613. Colored engraving, 18 ⅞" x 15 ¾" (47.9 x 40 cm). Philadelphia Museum of Art, purchased: Harrison Fund.

Daily Life

How do you enjoy nature in your everyday life? Would you rather stay inside watching TV or spend time outside? We depend on the natural environment to live. Unfortunately, we sometimes forget to make nature a part of our daily life. Look at Thomas Moran's *Grand Canyon* painting in Fig. 7–3, on page 184. This painting helped convince the United States Congress to create and save our national parks. What are some ways to encourage people to appreciate and enjoy the natural world?

Fig. 7–30 © Atlantide Phototravel/Corbis

Vocabulary Review

Match each art term below with its definition.

Impressionism

Post-Impressionism

atmospheric color

complementary colors

color wheel

simplified shapes

1. contrasting colors opposite from each other on the color wheel

2. a style of art that stresses the arrangement of objects into organized compositions

3. colors that are changeable due to light

4. shapes that are not as detailed as the actual object

5. a style of art that emphasizes views of a particular moment

6. a circular chart made up of primary, secondary, and intermediate colors

Aesthetic Thinking

What are the advantages and disadvantages of using artificial reproductions of natural materials, such as silk flowers?

Write About Art

In the 1930s, the Kaufmann family —who owned a department store in Pittsburgh, Pennsylvania—hired Frank Lloyd Wright to build a house near the waterfall on their property in the country. Imagine you are Wright and compose a letter that explains to the Kaufmanns why you propose an unusual design that places the house *on top of* the waterfall.

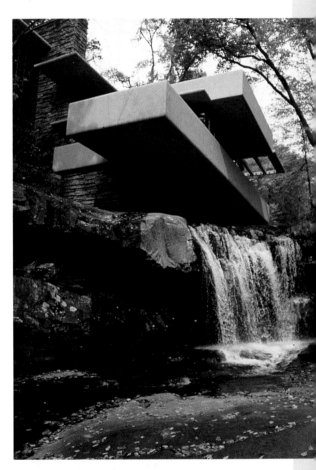

Fig. 7–31 **In this architectural work, which materials are provided by nature? Which are human-made?**

Frank Lloyd Wright, *Fallingwater (Kaufmann House),* 1936. Bear Run, Pennsylvania. Ezra Stoller ©Esto. All Rights Reserved.

Art Criticism

Describe How would you describe the bowl that you see here?

Analyze How does the artist use pattern to enliven this bowl?

Interpret Why do you think the artist chose to decorate both the inside and the outside of the bowl?

Evaluate What tells us that this bowl might have been used for a special purpose?

Fig. 7–32 Nin'ami Dohachi, *Footed Bowl*, Edo Period (1615–1867). Kyoto ware, porcelaneous stoneware, with underglaze iron-oxide and overglaze enamel decoration, 3 ⅝" x 6 ½" (9.2 x 16.5 cm) diameter. The Nelson-Atkins Museum of Art, Kansas City, Missouri (Gift of Mr. W. M. Ittmann Jr. in honor of Mrs. George H. Bunting Jr.).

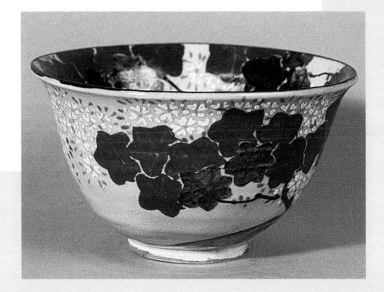

Detail from *Footed Bowl*

Meet the Artist

Nin'ami Dohachi (1783–1855) was born Takahaski Dohachi in Kyoto. He learned how to make ceramics from his father, who was also a well-known ceramic artist. Dohachi is considered one of the greatest ceramic artists from Kyoto. He made many objects that were used in the tea ceremony, and was famous for his blue and white ceramics. Dohachi was given the art name Nin'ami when he became a monk in 1812. After his death, his family continued to make ceramics for generations.

For Your Portfolio

Choose an artwork from this unit based on the theme of nature. Exchange it with a peer, and critique each other's work. Describe the work, and interpret its message about nature. Explain how the artwork is successful, and offer suggestions for improvement.

For Your Sketchbook

Select one object from nature. Draw the object in several different ways, with various media and colors, from different views, and in different light.

Artists Celebrate

Continuity and Change

Fig. 8–1 **Before 1930, most bronze portrait sculptures showed royalty or wealthy people. How is this sculpture a change from that tradition?**

Augusta Savage, *Gamin,* ca. 1930. Painted plaster, 9" x 5 ⅝" x 4 ¼" (22.9 x 14.3 x 10.8 cm). Gift of Benjamin and Olya Margolin. Smithsonian American Art Museum, Washington, DC/Art Resource, NY.

Do you celebrate a certain holiday or special date year after year? How do you celebrate? Perhaps you visit the same family members and friends or eat the same foods. These repeated traditions represent *continuity*, which means staying the same or being consistent.

Now think about how your celebration differs each year. Perhaps a baby was born or a friend cooked a new food. So while there is continuity, there is also change.

Artists also carry on traditions. For centuries, artists may sculpt or weave using certain materials or showing certain subjects. But artistic traditions can change. Artists find new ways of expressing themselves or discover new materials. Art is constantly redefining itself.

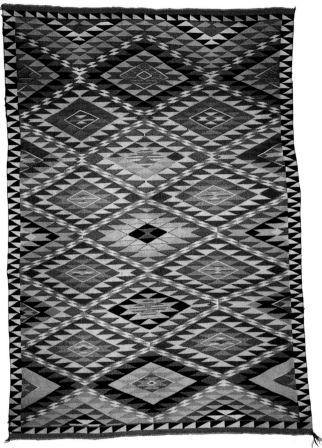

Fig. 8–2 **A Navajo artist made this rug using new colors and yarn that traders brought from Germantown, Pennsylvania. How might this yarn have changed the Navajo weaving tradition?**

Navajo, *Germantown "eye-dazzler" rug*, ca. 1880–90. Extremely rare split yarn, two, three, and four ply, 72" x 50" (182.9 x 127 cm). Courtesy of Museum of Northern Arizona Photo Archives, E3176.

In this unit, you will learn:
- How artists both honor tradition and sometimes break from it.
- How to use shape and form in assemblage and montage.
- How to perceive elements of tradition and change in artwork.

Responding to Traditions

Some art traditions are shared by most cultures around the world. For example, most cultures decorate everyday objects. But cultural groups also have their own special artistic traditions. Here's one that you may know about: skateboard decoration. Many skateboarders decorate the bottoms of their skateboards. Each skateboard has a similar design. But the artwork on each skateboard is unique.

Types of Traditions Art has a variety of traditions. For instance, the subject matter of art can be traditional. As you have already seen, nature is a traditional subject in Japanese art. In classical Greek art, beauty is a traditional subject.

The media used for artworks are another type of tradition. Art media are the materials artists use to make their works. *Media* is the plural of *medium*. For example, oil paint is a medium traditionally used on canvas. African artists typically use wood from trees grown near their villages for their sculptures. Wood is one of their media.

Certain art forms are considered traditional. Drawing, painting, and sculpture are old traditions in art. Carved-wood sculpture is a common art form in Africa (Fig. 8–3). As in many cultures around the world, older sculptors teach it to younger apprentices.

Fig. 8–3 **Carving sculpture from wood is one of the oldest artistic traditions in Africa. What sculpture traditions have you been taught?**

Yaure peoples, Ivory Coast, *Mask*, early 20th century. Wood and pigment, 14 ¾" (37.5 cm). Museum purchase, 91-21-1. National Museum of African Art, Smithsonian Institution, Washington, DC.

Fig. 8–4 **Flowers are traditional subjects for art. What is not traditional about this flower painting?**

Georgia O'Keeffe, *Oriental Poppies*, 1928. Oil on canvas, 30" x 40 ⅛" (76.2 x 101.9 cm). Collection Frederick R. Weisman Art Museum at the University of Minnesota, Museum purchase. ©2000 The Georgia O'Keeffe Foundation/Artists Rights Society (ARS), New York.

Meet Georgia O'Keeffe

Born in Wisconsin, Georgia O'Keeffe loved art from a young age. She studied at two art schools that taught students to create accurate paintings of real-world objects. This style did not inspire O'Keeffe, so she stopped making art.

Years later, she began to believe that art should show the artist's feelings and ideas. O'Keeffe experimented with abstract charcoal drawings. She later began painting large close-ups of flowers. Her emphasis on shape makes the flowers appear abstract, though they are based on what she observed in nature. O'Keeffe is best known for exploring this new view of a traditional subject.

"I have things in my head that are not like what anyone has taught me... shapes and ideas so near to me."

— Georgia O'Keeffe (1887–1986)

Breaking, Borrowing, Building

Traditions in art change over time. Artists develop new interests. They learn new ideas. They come upon new technologies. Let's look at three ways that change occurs in art.

Artists sometimes decide to break with tradition. Constantin Brancusi (Fig. 8–5) made marble sculptures, an ancient tradition. Yet he broke with tradition by not sculpting realistic portraits out of the marble.

Change also occurs when artists borrow traditions. The *Ennis-Brown House* in Fig. 8–6 shows a style borrowed from a Mayan architectural tradition.

Fig. 8–6 Frank Lloyd Wright, an American architect, borrowed from the Mayan tradition to design this house. How did Wright break from the traditional design of American houses?

Frank Lloyd Wright, *Ennis-Brown House*, 1924. Photo by H. Ronan.

Fig. 8–5 For more than twenty years, Brancusi explored the egg-shaped form shown here in his sculptures. How else might the tradition of marble sculpture be changed?

Constantin Brancusi, *Mlle. Pogany (III)*, 1931. White marble, base of limestone and oak, 17" x 7 ½" x 10 ½" (43.3 x 19 x 26.6 cm). Philadelphia Museum of Art: The Louise and Walter Arensberg Collection, 1950. Photo: Graydon Wood, 1994. ©2000 Artists Rights Society (ARS), New York/ADAGP, Paris.

In addition to breaking or borrowing traditions, artists might build on traditions. Since the 1600s, Navajo weavers made blankets to be worn while traveling. Then, in the late 1800s, traders who came to the Southwest found they could sell the blankets as rugs. The Navajo weavers built on their tradition because of a change in their world (Fig. 8–2).

When you study an artwork, think about what traditions might be part of it. Does the artwork break with, borrow from, or build on a tradition? How else might art traditions change?

Check Your Understanding

1. Explain what artistic tradition means.

2. Compare and contrast what happens when artists break from tradition with what happens when artists build on tradition. How are the changes similar? How are they different?

3. The Internet enables people to communicate with and learn about people around the world. How might the Internet affect artistic tradition?

Miniature Sculptures

You can break with tradition and create a miniature sculpture by assembling an assortment of interesting, small objects.

- Collect a variety of found materials, such as buttons, beads, wires, stones, plastic bottle caps, and the like.

- Try grouping these forms on your desk and make sketches of different arrangements.

- Think about how the different combinations can make you see objects, not for what they really are, but as something completely different.

- Choose your best sketch and arrangement and use a good, clear bonding glue to attach the parts together.

Reflect on the unified look of your sculpture and how well you can focus on the whole rather than the individual parts.

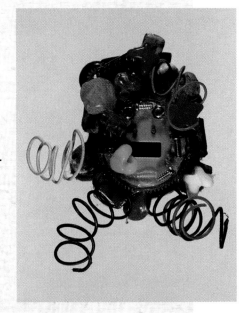

Fig. 8–7 Student artwork

Using Shape and Form

If someone asked you to draw a shape, what would you draw? A square? A circle? Or would you draw an irregular shape? Artists can use geometric shapes and organic shapes in their compositions. They can also use positive shapes and negative shapes.

Can you think of ways to show a shape without drawing a line around it? In *Sorrows of the King* (Fig. 8–8), Matisse has used color, value, and texture to make shapes.

Form If you add depth to a shape, you have a form. A form is a three-dimensional object that has height, width, and depth. It can be simple or complex. A pear has a simple form. The form of a tree is complex and made up of many parts. Just as shapes can be geometric or organic, forms can also be geometric or organic. And just as shapes can be positive and negative, so can forms.

Fig. 8–8 Matisse painted sheets of paper and then cut them into shapes for his collages. How would you describe the shapes and colors Matisse used?

Matisse, *Sorrows of the King*, 1952. Collections Mnam/Cci-Centre Georges Pompidou. Photo: Phototheque des collections du Mnam/Cci. ©2000 Succession H. Matisse, Paris/Artists Rights Society (ARS), New York.

Barbara Hepworth's sculpture (Fig. 8–9) is made up of two main forms. You can see smaller forms in each of the forms. Are the forms organic or geometric? Hepworth changed a sculptural tradition. She was one of the first artists to explore positive and negative forms in Abstract sculpture.

Observe Look at the shapes in the illustrations. Which shapes are geometric? Which are organic? Identify the positive and negative shapes.

Tools: Paints, paintbrushes, and drawing tools, such as markers, crayons, pencils, and pens.

Practice: Shapes

- On a sheet of paper, create your own artwork made up of shapes.
- Draw or paint geometric and organic shapes.
- Try using color, value, and texture to create positive and negative shapes. Make sure that your negative shapes are as interesting as the positive shapes.

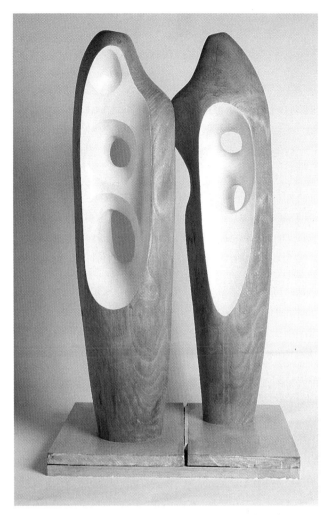

Fig. 8–9 Which parts of this sculpture are positive forms? Which parts are negative forms? What might these side-by-side forms symbolize?

Barbara Hepworth, *Two Figures*, 1947–48. Elm wood with white paint, 40" x 23" x 23" (101.6 x 58 x 58 cm). Collection Frederick R. Weisman Art Museum at the University of Minnesota, Minneapolis. The John Rood Sculpture Collection.

Showing Forms in Two Dimensions In a two-dimensional artwork, an artist may simply wish to show the shapes of objects. Or the artist may wish to create the illusion of three-dimensional form. If you were asked to draw or paint a cube on a flat piece of paper, how would you do it? Would you use perspective lines? If you didn't want to use lines, would you change the flat shapes by shading them?

Perspective and other devices can give the illusion of depth to artwork that is two-dimensional. The illusion of depth can also be created by adding shading to the flat shape of an object.

Look at Fig. 8–10, *Metamorphosis*. It is a two-dimensional artwork. Yet, we can easily see the geometric shapes as three-dimensional forms. That is because of the shading on each form. What other techniques does this artist use to create the illusion of depth?

Observe Look again at how the artist uses shading in Fig. 8–10. What direction is the light coming from to create these shadows?

Tools: Paper and pencil.

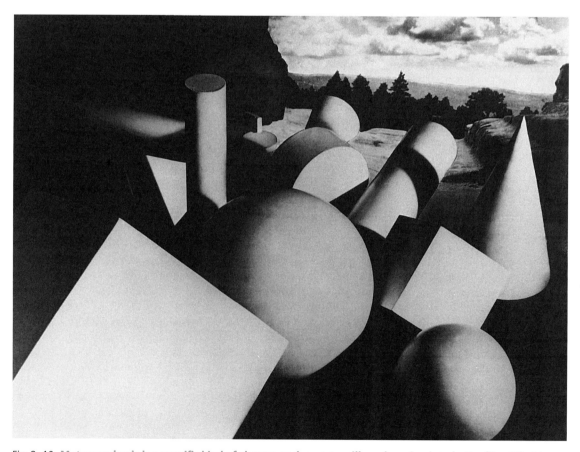

Fig. 8–10 **Metamorphosis is a specific kind of change, such as caterpillars changing into butterflies. What in this artwork seems traditional? What might the artist be saying about continuity and change?**

Herbert Bayer, *Metamorphosis*, 1936. Gelatin silver print, 9 ¹³/₁₆" x 13 ½" (24.9 x 34 cm). Courtesy of Herbert Bayer Collection and Archive, Denver Art Museum. ©2000 Artists Rights Society (ARS), New York/UG Bild-Kunst, Bonn.

Practice: Shading to Create Form

- On a sheet of paper, draw several geometric shapes, such as a circle, a cylinder, or a cone.

- Imagine light shining on the shapes from above or from one side.

- Add shading to the shapes to give the illusion of form. Think about how light would hit the shapes and how shadows would be created.

Check Your Understanding

1. Choose a three-dimensional artwork from this unit and describe its forms as simple or complex, geometric or organic.

2. Compare and contrast two two-dimensional artworks from this unit. How have the artists used shapes in similar ways? In different ways?

3. Why might it be helpful for an architect or sculptor to know how to create the illusion of three-dimensional form in two-dimensional artwork?

Shapes into Forms

You can use paper sculpture methods to change flat shapes into a three-dimensional, free-standing sculpture that can be seen from all sides.

- Choose a subject and make some sketches for a sculpture.

- Simplify the shapes and forms.

- Experiment with some of the paper sculpture techniques you learned about in unit 7, lesson 6. Which techniques will work best for your sculpture?

- Start with a basic cone, cylinder, or box form and add smaller forms and shapes of paper to complete the sculpture.

Reflect on the processes you used to turn flat pieces of paper into three-dimensional forms.

Fig. 8–11
Student artwork

Fig. 8–12
Student artwork

Found Object Assemblage

Studio Background

Sculptors may use all kinds of materials—from wood and marble to tires and toy cars—to create new sculptures. Imagine that you were asked to build a sculpture out of objects around your house. What would you make?

In this studio exploration, you will build on a tradition to make a different kind of sculpture. An assemblage is a combination of found objects that form a sculpted artwork. Assemblages are also called "junk sculptures." You may choose either a traditional *subject* (such as a person or a group of animals) or a traditional *purpose* (such as to honor a person or show humor) for your sculpture.

You Will Need

- sketch paper
- pencil
- found objects
- bonding materials (glue, nails, screws, bolts, wire)
- tempera paint
- paintbrush
- tools (hammer, screwdriver, wire cutters, wrench)

Step 1 **Plan and Practice**

- Collect your materials. Any object you are able to combine by gluing, tying, or otherwise joining could be part of your assemblage.
- Think about the possible meanings of the objects you have collected.
- Decide whether your sculpture will have a traditional purpose or show a traditional subject.

Things to Remember:

- ✓ Try several positions for each object before you attach it.
- ✓ Look at the arrangement from several angles.
- ✓ Add details that help express your traditional subject or purpose.

Inspiration from Our World

Inspiration from Art

Assemblage sculpture is an additive process. An additive process is a process in which materials are added or built up to create a form. Assemblages were made popular by artists such as Louise Nevelson (Fig. 8–14) in the 1900s. They are usually organized around a theme or idea. Often, the materials themselves suggest the idea. Sometimes, the artist joins the same kind of objects—such as wooden chair legs. Other times, a combination of objects is used—such as chair legs and plastic sunglasses.

An assemblage might be made of ordinary materials—scraps of cardboard, wood, metal, or plastic— that are also in the form of objects, such as tubes, old machine parts, or foam plastic egg cartons.

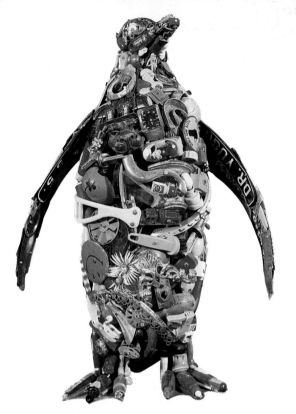

Fig. 8–13 **How do the objects used to make this sculpture change its meaning? How is it different from a traditionally carved or modeled penguin?**

Leo Sewell, *Penguin*, 1979. Assemblage-reclaimed objects, 31" x 20" x 9" (79 x 51 x 23 cm). Courtesy of the artist.

Fig. 8–14 **This assemblage is made of pieces of furniture and wood from old buildings. How does the artist make the pieces look like a unified form?**

Louise Nevelson, *Sky Cathedral*, 1958. Wood, painted black, 101 ½" x 133 ½" x 20" (260 x 339.1 x 50.8 cm). George B. and Jenny Mathews Fund, 1970:1. Albright Knox Gallery, Buffalo, New York: ©2000 Estate of Louise Nevelson/Artists Rights Society (ARS), New York.

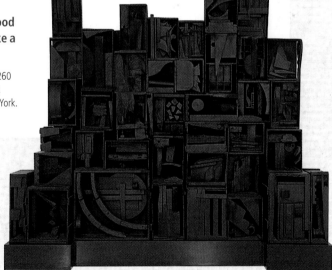

Step 2 **Begin to Create**

- **Start by sketching some ideas of what your assemblage will look like.** Show the largest forms and leave out details.

- **When you have a plan that you like, arrange your collected objects.** Move the objects around to get the effect you want.

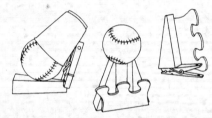

- **Start attaching the pieces together.** Begin with the larger objects and attach the smaller objects to them.

- How will you attach each object? Will you glue them, tie them, or use another method?

- Think about the kinds of details you could add. How will they contribute to your traditional subject or purpose? Will you paint these details or create them with additional materials? If you wish to paint your assemblage, allow any glue to dry first.

Step 3 **Revise**

Did you remember to:

✓ Try several positions for each object?

✓ Look at the arrangement from several angles?

✓ Add details that help express your traditional subject or purpose?

Adjust your work if necessary. In your sketchbook, make a note of your revisions and why you made them.

Step 4 **Add Finishing Touches**

- Examine your sculpture closely. Be sure all objects are securely attached.

Step 5 **Share and Reflect**

- Share your sculpture with a group of classmates.
- Talk about the similarities and differences between the sculptures.
- Discuss how the objects help show each sculpture's overall purpose.

- In what way is your sculpture traditional? In what way is it nontraditional?
- How do the objects you used express your purpose or subject?

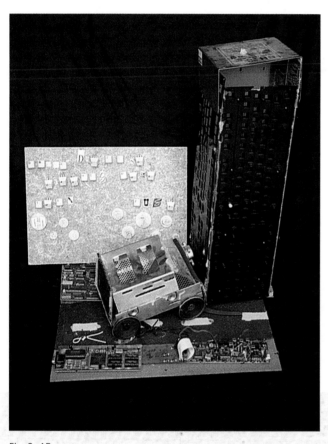

Fig. 8–15 Student artwork

Art Criticism

Describe What found objects and other materials do you recognize in this assemblage?

Analyze How did the artist unify the many different kinds of parts into one form?

Interpret What are some possible titles for this sculpture?

Evaluate What do you think makes this artwork successful?

European Art: 1900–1950

The early 1900s were a time of rapid change. There were great inventions and great changes in business and industry.

Art was also changing rapidly. Artists were trying to create their own styles. Some artists built on earlier styles. Others experimented with traditional materials and subjects.

Fig. 8–16 What mood do the unusual colors in this work create?

André Derain, *Turning Road, L'Estaque*, 1906. Oil on canvas, 51" x 76 ¾" (129.5 x 195 cm). Museum of Fine Arts, Houston; Gift of Audrey Jones Beck. ©2000 Artists Rights Society (ARS), New York/ADAGP, Paris.

1901
Atget, *Lampshade Vendor*

1908
Picasso, *House in a Garden*

1914
Delaunay, *Electric Prisms*

1930
The first soccer World Cup is held in Uruguay.

1944
Ernst, *The King Playing with the Queen*

1800s

1900s

1896
Henry Ford makes his first car, the Quadricycle.

1906
Derain, *Turning Road L'Estaque*

1910
President Taft throws the first ceremonial starting pitch at a baseball game.

1917
The United States enters World War I.

1931
Dalí, *The Persistence of Memory*

1939
Germany invades Poland, beginning World War II.

Still others tried to break completely with the past. The artworks from 1900 to 1950 on these pages show the continuity of traditions as well as the changes taking place in the art world.

Expressionism Expressionism is a style of art that began in the early 1900s. Expressionist artists used color and line with great feeling. Their goal was to show joy, sorrow, or other feelings in their artworks.

One group of Expressionist artists was known as the Fauves *(fohvs)*. *Fauve* is a French word that means "wild beast." These artists got their name from the wild, intense colors they chose.

The Fauves, such as André Derain, liked how the Impressionists broke down natural forms into different colored brushstrokes. They admired the Post-Impressionists' expressive use of color and line. In Fig. 8–16, Derain borrowed from both of these traditions.

Fig. 8–18 **Notice how this artist has broken down the parts of the figures into distinct geometric forms. Where do you see exaggeration in this artwork?**

Max Ernst, *The King Playing with the Queen*, 1944. Bronze (cast 1954, from original plaster), height: 38 ½ " (97.8 cm), at base 18 ¾ " x 20 ½ " (47.7 x 52.1 cm). The Museum of Modern Art, New York. Gift of D. and J. de Menil. Photograph ©2000 The Museum of Modern Art, New York. ©2000 Artists Rights Society (ARS), New York/ADAGP, Paris.

Surrealism Many artists from the early 1900s looked for new ways to show traditional subjects. One such group of artists were called Surrealists. Surrealist painters turned to dreams and imagination for inspiration. They created fantastic compositions of things that don't seem to go together. In Fig. 8–18, Surrealist Max Ernst used bronze to create a sculpture of large chess pieces. Bronze was usually used to create portraits. By choosing surprising subject matter, Ernst made people think about the question, "What is art?"

Fig. 8–17 **Dalí made objects look real. But he upset tradition by showing objects that are not from real life. What message about time was Dalí sending?**

Salvador Dalí, *The Persistence of Memory*, 1931. Oil on canvas, 9 ½ " x 13 " (24.1 x 33 cm). The Museum of Modern Art, New York. Given anonymously. Photograph ©2000 The Museum of Modern Art, New York. ©2000 Artists Rights Society (ARS), New York.

A New Tradition: Cubism

Artists from the early 1900s invented Abstract art. These artists built on traditions, but also made an important break with the past. Abstract art is art that is based on a recognizable subject, but the artist changes some elements so you may not recognize them.

Early Abstract artists were influenced by Post-Impressionist Paul Cézanne and his idea that everything can be broken down into three geometric forms: the cylinder, sphere, and cone. Cubism was an Abstract art style that developed from this idea. The Cubists broke down objects into shapes.

Fig. 8–20 **Photography became an exciting new art form in the early 1900s. What geometric forms do you see in this photograph?**

Eugène Atget, *Marchand Abat-Jours*, 1901. Albumen silver, 8 ¾" x 7" (22.2 x 17.8 cm). Anonymous gift, the J. Paul Getty Museum, Los Angeles.

They then rearranged the shapes. The new composition sometimes makes it hard to recognize the original subject.

Some Cubist artists created nonobjective art. Nonobjective art is art with no recognizable subject matter. In Fig. 8–21, Sonia Terk Delaunay chose colorful disks as her subject.

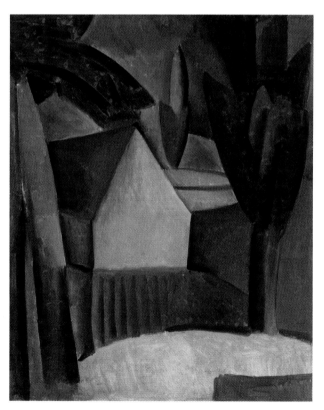

Fig. 8–19 **How has this artist used colorful, simplified shapes to show landscape elements?**

Pablo Picasso, *House in a Garden*, 1908. Oil on canvas, 29" x 24 ¹³/₁₆" (73.6 x 60.5 cm). Photograph ©The State Hermitage Museum, St. Petersburg.

Meet Sonia Terk Delaunay

Sonia Terk Delaunay was born in Ukraine but spent most of her life in Paris. She was inspired by Cubism and the colors in the paintings of Paul Gauguin and Vincent van Gogh. In her own paintings, she used bright colors and patterns similar to those used in Russian folk art. She wanted to create a sense of rhythm and movement with her shapes and colors. She also designed costumes and sets for theater and became a successful fashion designer.

"(W)e are only at the beginning of the discovery of these new color relationships, still full of mystery to unravel, which are the base of modern vision....There is no going back to the past."

— Sonia Terk Delaunay (1885–1979)

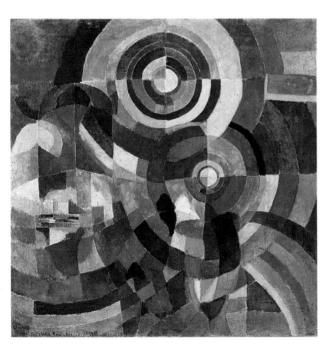

Fig. 8–21 **Notice the variety of shapes and colors used in this painting. What do you think this artwork is about?**

Sonia Terk Delaunay, *Electric Prisms*, 1914. Oil on canvas, 93 ¾" x 98 ¾" (238 x 251 cm). Collections Mnam/Cci-Centre Georges Pompidou. ©L & M Services B.V. Amsterdam 9911.6. Photo: Phototheque des collections du Mnam/Cci.

Unplanned Painting

You can create an unplanned painting using monoprint techniques.

- Choose a color scheme (warm, cool, or analogous). Mix several colors of tempera or acrylic paint.

- Using a spoon, stick, or brush, place a small amount of each color on two sheets of damp paper.

- Place the painted side of each sheet face-to-face. Lightly press and rub several areas, then slowly pull the papers apart.

- Use a brush to change each painting slightly.

Reflect on the random shapes and colors that remain.

Fig. 8–22 Student artwork

Check Your Understanding

1. What were some influences on art of the early 1900s?

2. Compare and contrast *Turning Road, L'Estaque* and *Electric Prisms*.

3. Use examples to support or reject the statement, "Artists of the early 1900s didn't pay attention to the art of the past."

Unit 8 Artists Celebrate Continuity and Change 229

The Art of Southeast Asia

Similar to other Asian countries you've read about, Southeast Asian countries have been influenced by the people and cultures around them. Artists have used such influences to create a unique kind of art in Southeast Asia.

Religious Impact Religious sculpture and architecture became important art forms in Southeast Asia. The sculptures, made of bronze or stone, often showed Buddhist and Hindu gods. They were kept in religious shrines (sacred places). In 1150, a king who ruled Cambodia began building a national shrine called Angkor Wat (Fig. 8–23).

Fig. 8–23 **The buildings of this shrine are covered with carved decorations showing figures and animals.**

Cambodia, *Angkor Wat*, 12th century. ©Leo Touchet. All Rights Reserved.

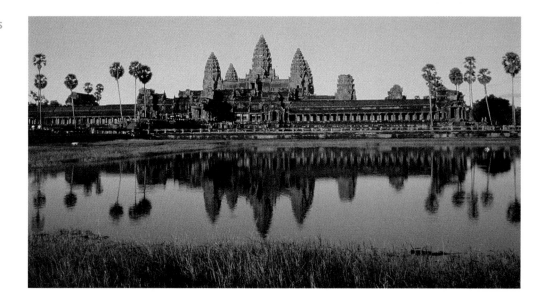

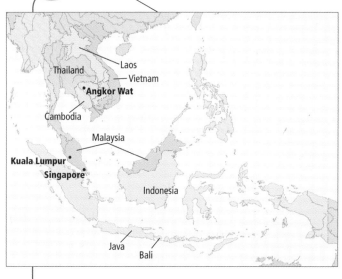

Social Studies Connection

Southeast Asia is made up of many countries and islands. Some countries, such as Thailand, are on the continent of Asia. Indonesia, another part of Southeast Asia, includes thousands of islands that stretch from Asia almost to Australia.

Southeast Asia was most influenced by India and China. Southeast Asians borrowed and changed many Indian and Chinese ideas to fit their ways of life. Southeast Asian artists used Indian and Chinese styles to create unique art traditions that continue today.

Fig. 8–24 **This jar was made in Thailand. Look at the Chinese vases, Fig. 4–23 on page 111. How are Southeast Asian and Chinese pottery similar?**

Si Satchanalai, *Coconut Oil Jar*, 14th–mid-16th century. Stoneware, height: 5 ⁹⁄₁₆" (14.2 cm), diameter: 6 ⁷⁄₈" (17.5 cm). Asian Art Museum of San Francisco, The Avery Brundage Collection. The James and Elaine Connell Collection of Thai Ceramics, 1989.34.69.

Indonesian Tradition Indonesians have developed a technique called *batik* to decorate paper or cloth. To create a batik (Fig. 8–25), artists use melted wax to paint a design onto paper or cloth. Then they dip it into colored dye. The wax protects the paper or cloth from the dye so the waxed design stands out against the colored background. Many batiks have traditional designs or special meanings.

Visual Culture

In this lesson you have learned about the tradition of using melted wax and dye to adorn fabric. While you can buy shirts and dresses made from real batik fabric, many of the patterned fabrics in stores today are imitations or designs that are printed to look like batik. This is also true of many other products that we use in our homes. Consider plastic products that have surfaces that look like wood, metal, woven fabric, or leather.

Compare these surfaces with products made from the real materials. Consider what the use of fake fur or leather in clothing and the imitation of natural surfaces in building materials suggests about our culture.

Fig. 8–25 **This is called a Javanese fairy tale batik. It tells the story of Cinderella. How did the artist tell the story without using words?**

L. Metzelaar, *Woman's Sarong in batik canting technique*, early 20th century. Cotton, 41" x 86 ⁵⁄₈" (104 x 220 cm). Tropenmuseum, Amsterdam.

Lasting Art Forms Making puppets has been popular on the Indonesian island of Java for at least 1000 years. The puppet shown in Fig. 8–26 is a Javanese shadow puppet. It is flat and has moveable arms. In a show with shadow puppets, the audience is in front of a screen. Behind the screen, a puppeteer uses rods to move the puppet in front of a light. The audience sees only the puppet's shadow.

Fig. 8–26 Notice the cutout and painted parts on this puppet. Why would an artist add such details to something that is seen only in shadow?

Java, Indonesia, *Wajang purwa shadow puppet: Bima, the Brave Giant*, late 19th–early 20th century. Painted and gilded leather, 27 ⅜" x 14 ¼" (69.5 x 36 cm). Gift of the museum in 1947 by Mr. G. Tillman Jr. London. Tropenmuseum, Amsterdam.

Changes in Modern Times Southeast Asian artists have been exposed to European art styles since the 1600s. But for centuries, traditional techniques and art forms remained the most important.

In the 1900s, some Southeast Asian artists began to experiment with modern European art trends. Many studied in European art schools. Modern art styles have changed the way some Southeast Asian artworks look. But many Southeast Asian artists have tried to maintain their own special art by showing traditional subjects and themes.

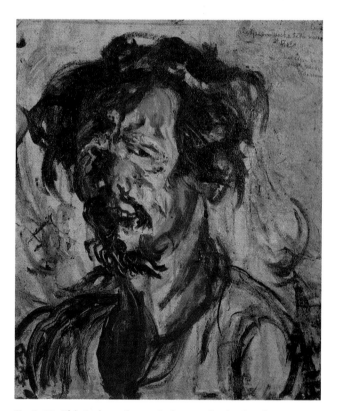

Fig. 8–27 This Indonesian artist's use of color has been compared to the Fauves. How would you describe his brushstrokes?

Affandi, *Self-portrait*, 1948. Oil on canvas, 24 ¼" x 21" (61.5 x 53.5 cm). Tropenmuseum, Amsterdam.

Fig. 8–28 **Many contemporary artists show the unique environment of Southeast Asia. What types of details did the artist include to help show her special surroundings?**

Georgette Chen, *Mosque in Kuala Lumpur,* 1957. Oil on canvas, 28 ¾" x 36 ¼" (73 x 92 cm). Singapore. Collection of the Singapore Art Museum.

Collection of the Singapore Art Museum.

Meet Georgette Chen

Georgette Chen (1906–1993) is known as Singapore's most important woman pioneer artist. A businessman's daughter, she studied art in Paris and New York.

Chen was known as a calm, rational person. She painted still lifes, landscapes, and portraits. Her early still lifes show the influence of French Post-Impressionist painter Paul Cézanne. Later, she taught at the Nanyang Academy of Fine Art in Singapore. She was one of the founders of the Nanyang painting style, which combines Asian and European artistic ideas.

"...Her hope was that they [her students] would not be confined by what they learnt from the past, but would be able to break new ground and create their own expressions."

— Liu Kang (Chinese artist, 1911–2004)

Patterned Batik

Design a paper or cloth batik with a continuous, overall pattern.

- Select a simple motif to repeat, making slight changes in each motif as it is repeated.

- Apply heavy crayon or melted wax over the sketched lines. You may use more than one color.

- Apply a dark watercolor or thin tempera paint wash. You may use more than one color of wash.

Reflect on the design and meaning of your batik.

Fig. 8–29 Student artwork

Check Your Understanding

1. Describe the method of decorating cloth that developed in Indonesia.

2. Compare and contrast the artists' techniques in Fig. 8–27 and Fig. 8–28.

3. How has art in Southeast Asia borrowed traditions from other places? Use examples to support your answer.

Traditions in Montage

Studio Background

When you see a large photograph in a newspaper, magazine, or someone's photo album, do you take a closer look? Photographs—especially photographs of people—can have a powerful effect. They capture a real moment in time, which can make them especially moving or emotional. Think about photographs you've seen of people involved in a natural disaster or a celebration. How did they make you feel?

Artists know that photographs can affect the way people feel. Some artists use photographs to create a montage. A montage is a collage that combines photographs or parts of them with other flat materials. Montages often express ideas about life. **In this studio exploration, you will create a montage that shows continuity and change in a family or cultural tradition.** You will find photographs that relate to your life in newspapers and magazines, and use them in your work.

You Will Need

- photographs
- scissors
- gift wrap
- construction paper
- wallpaper samples
- tagboard
- glue

Step 1 **Plan and Practice**

- Decide what tradition or traditions you will show to express continuity. Think of traditions that are still practiced today.

- Determine ways to express change. What ideas break away from the tradition?

- Think about how to express your feelings about the tradition and its changes.

Things to Remember:

✓ Keep a specific tradition and its changes in mind.

✓ Use photographs that illustrate the ideas and feelings you've identified.

✓ Try different arrangements of your photographs.

Inspiration from Our World

Inspiration from Art

In the early 1900s, collage was a new form of expression. Artists could create exciting images by tearing, cutting, and pasting different papers and fabrics onto a flat background. Collage also added a new element to paintings. As artists experimented with collage materials, many began to use photographs. Montage became a popular technique that remains popular today.

Through their artworks, montage artists often make statements about current events, politics, or their society. People feel they can understand these artworks because they include photographs from the everyday world. As a result, montage artworks can sometimes make a stronger impression on people than paintings.

Fig. 8–30 **This artist mixed images of politics and women. Curves add grace. Light and dark contrasts create a sense of power. What might her message be?**

Hannah Höch, *Priestess*, ca. 1920. Collage on cardboard, 13" x 9" (33 x 22.9 cm). ©Christie's Images, Ltd, 1999. ©2000 Artists Rights Society (ARS), New York/VG Bild-Kunst, Bonn.

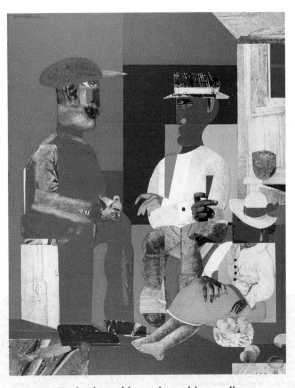

Fig. 8–31 **Notice how this work combines collage with painted areas. How do you think the artist decided where to use photographs and where to use paint?**

Romare Bearden, *Eastern Barn*, 1968. Collage of glue, lacquer, oil, and paper, 55 ½" x 44" (141 x 112 cm). Collection of Whitney Museum of American Art. Purchase. Photo by Peter Accettola, NY. Art ©Romare Bearden Foundation/Licensed by VAGA, New York, NY.

Step 2 **Begin to Create**

- **Choose photographs that illustrate the main ideas of your montage.**

- **Create background shapes and details with assorted colored and patterned papers.** Cut or tear the papers into various shapes. Try mixing cut and torn shapes in a way that fits your idea.

- **Arrange the pieces on tagboard.** Try several arrangements to express continuity and change in the tradition you have chosen.

- **When you are happy with the composition, glue the pieces in place.**

Step 3 **Revise**

Did you remember to:

✓ Keep a specific tradition and its changes in mind?

✓ Use photographs that illustrate your ideas and feelings?

✓ Try different arrangements of your photographs?

Adjust your work if necessary. In your sketchbook, make a note of your revisions and why you made them.

Step 4 **Add Finishing Touches**

- Examine your montage and be sure all photographs and papers are securely glued.

- Create a title for your montage.

Step 5 **Share and Reflect**

- Share your montage with a partner.
- Take turns describing the feelings or ideas that are shown in each montage.
- Discuss how you have expressed the theme of continuity and change.

- How does your choice of arrangement contribute to your expression of continuity and change in the tradition?
- How do you think the title helps others to understand the meaning of your artwork?

Art Criticism

Describe What does the artist show in this montage?

Analyze How did the artist arrange the parts of this montage?

Interpret What do you think this montage says about continuity and change?

Evaluate What do you think makes this a successful artwork?

Fig. 8–32 Student artwork

Social Studies

Fig. 8–33 Why is artificial lighting important in the lives of artists or photographers?

Charles Christian Nahl, *Saturday Night at the Mines* (detail), 1856. Oil on canvas, 120" x 192" (345.5 x 530.9 cm). Iris & B. Gerald Cantor Center of Visual Arts at Stanford University, Palo Alto, CA, Stanford Family Collections, 12083.

Technological advances create significant cultural change. Think about life before the development of oil, gas, and electric lamps. The only light available at night came from candles and indoor fires. As a result, people would go to sleep at nightfall and wake at sunrise. The incandescent lamp was developed in the late 1800s. With artificial lighting, people could now create light similar to natural daylight. How would your life be different if there were no electric lights?

Music

Like artworks, musical compositions can show continuity and change. Some remain popular over time and represent tradition. Others show change. To hear how music can change over time, listen to an original musical piece and to a newer version of it. In the newer version, you'll hear how the original piece was changed to sound more contemporary. Listen to both versions of "A Boy Like That" from *West Side Story*. How are the pieces alike? How are they different? What makes one piece sound more contemporary than the other?

Fig. 8–34

©Robbie Jack/CORBIS.

Fig. 8–35 "I am a creative director…I mostly do the drawings and design the digital sets, then give those designs to the animators to build digitally…" —Kent Mikalsen.

Kent Mikalsen. Digital Image courtesy of the artist.

Careers **Animator**

Changes in animated films have created a need for new skills from animators. What was the first animated movie you ever saw? In the beginning, all animated films were made from individually painted "cells." These cells showed action when put together (similar to making a "flip" book). Technological advances have created a need for animation artists with originality, artistic talent, and computer skills. If you are interested in a career in animation, you can find schools in cities including Los Angeles and New York.

Daily Life

How often do you take pictures of family and friends? What kind of camera do you use? How do you display your photographs? The way photographs are processed has changed over time. Early processes were too expensive for daily use. Some people were photographed only a few times in their life. Advances in photography now allow us to take many pictures. We can even print photographs on objects such as T-shirts. What advances in photography do you think might occur in your lifetime?

Fig. 8–36

Vocabulary Review

Match each art term below with its definition.

abstract art

assemblage

nonobjective art

form

montage

1. a three-dimensional object that has height, width, and depth

2. a combination of found objects that form a sculpted artwork

3. art with no recognizable subject

4. art based on a recognizable subject with changes to some elements so the subject may not be recognizable

5. a collage that combines photographs or parts of them with other flat material

Aesthetic Thinking

What role do artists play in establishing and changing traditions? First, make a list of different kinds of artists and consider their impact on how society looks and functions. Then decide if, and how, they have an influence on society. Discuss in groups and share with the class.

Write About Art

Select one of the elements of art visible in this work: perhaps you're drawn to its color, its repeated pattern, or the dynamic movement. Make a list of the adjectives that come to mind when you study this element. Then use those adjectives as the basis for a short poem about the rug.

Fig. 8–37

Art Criticism

Describe What do you see in this painting?

Analyze How does the artist create a sense of movement in this work?

Interpret How does the title *Stirring Still* act as a play on words?

Evaluate Describe what makes these cups look almost human.

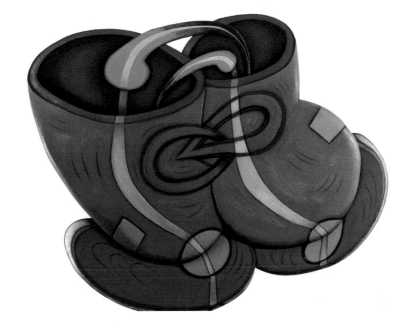

Fig. 8–38 Elizabeth Murray, *Stirring Still*, 1997. Oil on canvas on wood, 92" x 115" x 7" (234 x 292 x 18 cm). Chrysler Museum of Art. Museum purchase and gift of Mr. and Mrs. Arnold B. McKinnon, Mr. and Mrs. Richard M. Waitzer, Mr. and Mrs. Paul O. Hirschbiel, Mr. and Mrs. Norman C. Willcox, Mr. and Mrs. Harry T. Lester, Mr. and Mrs. Alfred F. Ritter, Jr., Mr. Thomas J. Brockenbrough, Mr. and Mrs. Charles R. Dalton, Mr. and Mrs. George M. Kaufman, David and Susan Goode, Henry and Angelica Light and Norfolk Southern Corporation, Shelley and Jeffrey Weisberg, and the Walter P. Chrysler, Jr., Art Purchase Fund. ©Elizabeth Murray/PaceWildenstein 99.26.

Meet the Artist

Elizabeth Murray was born in Chicago. She pioneered the idea of the three-dimensional canvas in which parts of the painting jut out from the wall. Murray's work uses almost cartoon-like imagery and bold color to bring focus to everyday objects.

"I paint about things that surround me—things that I pick up and handle every day. That's what art is. Art is an epiphany in a coffee cup."

— Elizabeth Murray (1940–2007)

For Your Portfolio

Keep your portfolio organized. Be sure each entry has your name, date, and title of work. Protect each entry with newsprint or tissue paper.

For Your Sketchbook

Create a series of sketches that show how an object changes from something traditional to something different. For example, the stages of a caterpillar turning into a butterfly.

Artists Explore
New Territory

Fig. 9–1 After many years of negotiations, Christo and Jeanne-Claude achieved their dream of wrapping the Reichstag building. How is this artwork like the Parthenon (Fig. 2–13)? How is it different?

Christo and Jeanne-Claude, *Wrapped Reichstag*, Berlin, 1971–95. Silver polypropylene fabric, blue polypropylene rope. ©Christo 1995. Photo: Wolfgang Volz.

Fig. 9–2 Paul Wallot, architect, *Reichstag (Parliament),* 1884–94. From the West. Burned 1933, destroyed 1945, restored 1958–72. Photo: Oliver Radford, 1991.

Fig. 9–3 How does Bartlett's work push the boundaries of what we traditionally consider a painting?

Jennifer Bartlett, *Sea Wall* (detail), 1985. Oil on 3 canvases, 84" x 369" (213.4 x 937.3 cm); houses and boats: wood and paint; sea wall: poured concrete and CorTen steel. Collection of the artist.

Have you ever done something that you thought was impossible?
Perhaps you hit a home run or sang a solo. We often amaze ourselves with the things we can do. Most of our accomplishments begin with a simple question: "Is this possible?"

Artists have also asked this question. People who made images on cave walls or built cathedrals wondered whether they could do what they dreamed of doing. Contemporary artists have explored more possibilities than ever before. The artists of Fig. 9–1 used industrial fabrics and ropes to wrap the Reichstag building, the home of Germany's parliament. In what ways does the artists' work change people's ideas about art?

In this unit, you will learn:
- How artists combine traditional art forms to expand the definition of art.
- How to use proportion and scale in two- and three-dimensional art.
- How to see and appreciate new ways of thinking in artists' works.

Expanding Possibilities

"What is art?" From the 1950s to today, artists have explored new ways to answer this question. They have experimented with subject matter, media, point of view, size, location, and other traditionally defined art concepts.

A Twist on the Traditional How could art change? There were many different art forms and media to use. Artists began to see vast possibilities for moving beyond familiar traditions. Painters changed the shape and size of their canvases. They poured, dripped, and sprayed paint. Sculptors assembled different objects such as televisions, automobiles, and furniture. They used unusual materials such as industrial steel, plastic, and neon lights. Artists then asked, "What else is possible?"

Fig. 9–4 **This artist used computer technology to create a condor moving on-screen. If you take a closer look, you'll see how each feather is a smaller version of the larger bird!**

J. Michael James, *Infinite Condors*, 1994. Digital Image, still frame animation of 3-D Computer graphic sculpture. Courtesy of the 911 Gallery, Newtonville, Massachusetts.

New Approaches, New Materials

Advances in electronic media led artists to use video, lasers, and computer technology in their art. Instead of making traditionally silent, motionless art, artists used high-tech features such as sound, light, movement, and interactive components. Some contemporary artists used computers to create new and unusual artworks (Fig. 9–4).

Meet Ursula von Rydingsvard

Ursula von Rydingsvard did not have an ordinary childhood. Born during World War II in Germany, she spent her early years with her parents and six siblings in post-war refugee camps. The family finally sailed to the United States in 1950. Von Rydingsvard arrived in Plainville, Connecticut, where she grew up, not knowing what an artist was.

Von Rydingsvard's memories of simple objects—cups, spoons, bonnets—began to inspire her. She went on to years of study at art schools. Her work, which is mostly in cedar wood, is known for its massive size and puzzle-like qualities.

"I strongly believe in the potential of the creative process."

— Ursula von Rydingsvard (born 1942)

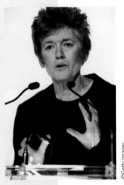

©Getty Images

New Audiences Besides asking, "What is art?" and "How can art change?" artists also ask: "Who is art created for?" They look beyond the traditional art market toward a broader audience for their work. Some want the viewer to be part of the artwork.

New Art for Sites, New Sites for Art
Technology-based methods of creating art have resulted in new places for art. Art created for a specific site is called installation art. Installation art often requires a large display space, such as a converted factory. It might include sounds or projected images. Viewers might be asked to participate. For example, the viewers of Fig. 9–7 were given play money to "bid" for sections of the island. When an installation is removed, only photographs or videos remain to show us what it looked like.

Other artists have created art that celebrates the environment. Artworks designed for particular outdoor places in nature are called earthworks. Once outdoors, artists need to consider the way an artwork will respond to or fit in with the natural elements. Like installation art, some earthworks depend on photographs or videos to allow audiences to view them.

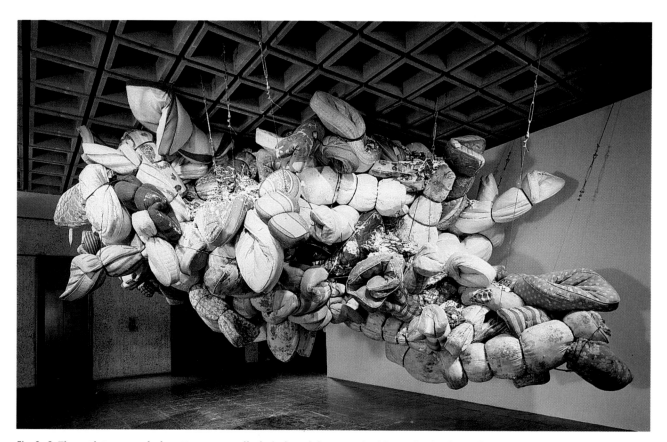

Fig. 9–6 **The artist suspended mattresses—rolled, tied, and decorated with mashed cakes—from the ceiling. Why might some people think that her work is about the lack of permanence in our society?**

Nancy Rubins, *Mattresses and Cakes*, 1993. 250 mattresses and cakes. Paul Kasmin Gallery, NY, New York.

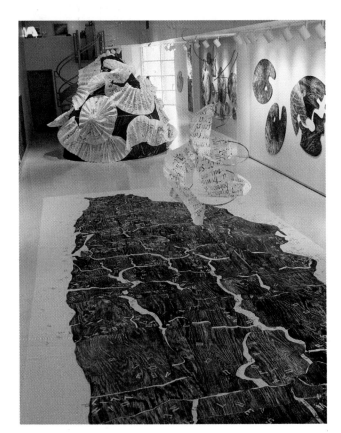

Fig. 9–7 **This installation combines various art forms and media. It deals with political and personal identity issues of Caribbean island cultures.**

Antonio Martorell, *Blanca Snow in Puerto Rico,* 1997. 15' x 12' (4.6 x 3.7m). Courtesy Hostos Center for the Arts & Culture. Photo by Frank Gimpaya.

Check Your Understanding

1. In what ways do contemporary artists explore new possibilities in art?

2. Compare and contrast earthworks and installation art.

3. How do new materials help artists to move beyond familiar traditions?

Blurring the Boundaries

Plan and create an artwork that blurs the boundaries between two art forms.

- Consider printmaking and weaving, or sculpture and jewelry-making, or graphic design and painting.

- Think about traditions and innovations in your two chosen forms as you experiment with ways to combine techniques and processes.

- Explore the possibilities.

Reflect on your choices of art forms and the decisions you made as you blurred boundaries.

Fig. 9–8 Student artwork

Using Proportion and Scale

The question "What is possible in art?" can be answered in many ways. Artists in the past one hundred years have tried to answer this question by inventing ways to transform our relationship with space.

Some artists asked, "What if I make a huge monument out of an ordinary object?" Artists such as Nek Chand (Fig. 9–9) and Red Grooms (Fig. 9–10) seem to be asking, "How can I create humor or surprise with unexpected scale and proportion?"

Using the language of art, we can talk about proportion and scale. We say artworks are life-size, monumental (much larger than life-size), or miniature (very small).

Looking at Proportion Proportion is the relationship between a part of something and the whole. It compares the size of the part to the size of the whole. Our sense of proportion in art comes from the human body. Proportions can be normal and reflect what we see around us. They can also be exaggerated and distorted.

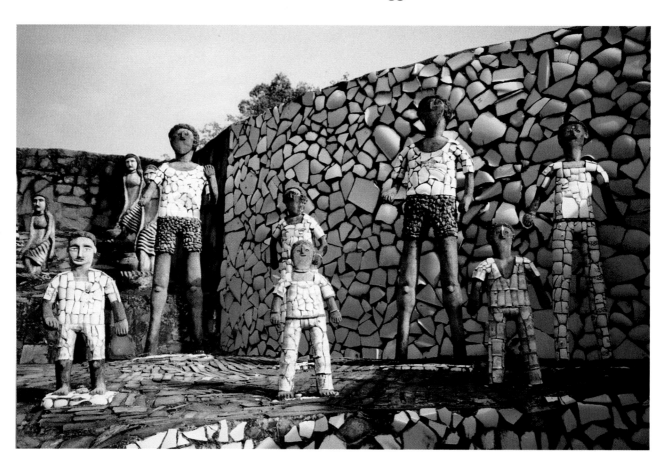

Fig. 9–9 These figures are one small part of a sculpted environment that occupies more than twenty-five acres. Nek Chand created his artworks from stones and discarded industrial materials. Would you describe the proportions of these figures as realistic or exaggerated?

Nek Chand, *Rock Garden at Chandigarh*, 1983–95. Concrete, Broken tile and other items, stone, and brick. Photo by Carl Lindquist.

Observe Look at the illustration of the sheep. Notice how the sheep's body is large, but its head is small. You might expect a sheep that large to have a bigger head.

Tools: Sketch paper, pencils, and a mirror.

Practice: Proportion

People differ in many ways, but all people are surprisingly alike in their proportions. Try drawing a self-portrait using these general guidelines for the proportions of the face:

- The eyes are about halfway between the top of the head and the chin.

- The bottom of the nose is halfway between the eyes and chin.

- The ears are about parallel to the eyebrows and bottom of the nose.

- The neck flows down from the jaw below the ears.

- The mouth is slightly higher than halfway between the chin and nose.

- The space between the eyes is about the same as the width of an eye.

- The mouth extends to a line directly under each eye.

- The iris of the eye is partly covered by the eyelid.

Looking at Scale Scale is the size of one thing compared to the size of something else, or the size of an object compared to what you expect it to be. You do not expect to see a toothbrush bigger than a bed. Artists can use changes in scale to add humor or to make you think. They also might change the normal size, scale, or proportion of things to show their importance.

In *The Woolworth Building* from *Ruckus Manhattan* (Fig. 9–10), Red Grooms has presented the building's entrance in monumental scale as compared to its surroundings.

Observe Look at the difference in scale shown in this picture of an ant in a landscape. Notice how the artist drew the ant larger than the houses and trees. Scale may be used to exaggerate an object and surprise viewers.

Tools: Sketch paper and pencils.

Fig. 9–10 **This scene is part of a large work about New York City. How does the artist's choice of sizes affect your sense of scale? What are some clues to its humorous intent?**

Red Grooms, *The Woolworth Building* from *Ruckus Manhattan* (detail), 1975–76. Mixed media, 17' x 14' x 15' (5.2 x 4.3 x 4.6 cm). Courtesy of the Marlborough Gallery, New York. Photograph by Richard L. Plaut, Jr. ©2000 Red Grooms/Artists Rights Society (ARS), New York.

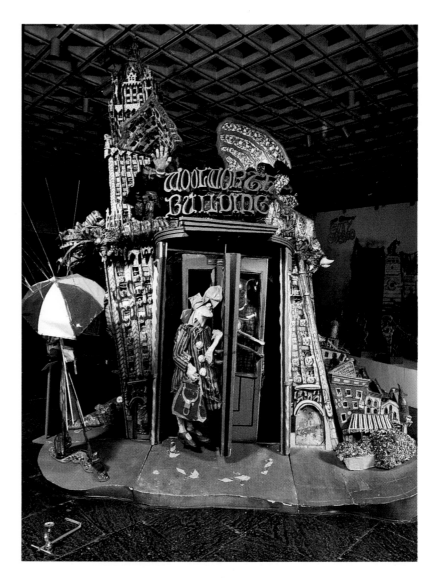

Practice: Proportion

- Imagine a playground with an ordinary object made larger than life.
- Make sketches of a playground based on the theme of oversized and undersized objects.
- Emphasize or minimize objects by altering their scale.

Check Your Understanding

1. What is proportion?

2. Compare and contrast the use of scale and proportion in Figs. 9–9 and 9–10. What is similar between the two artworks? What is different?

3. Why might you want to change the scale of an object in an artwork of your own?

Studio Time

Draw a Caricature

A caricature is an exaggerated portrait of a person, animal, or object. Draw a portrait caricature of yourself or a famous person.

- First exaggerate the proportions of the whole shape of head and hair.
- Then draw the most prominent feature or features, exaggerating the proportions. If the eyes look small in reality, make them very small in the caricature. If the chin is wide, make it very wide.

Reflect on the process of drawing a caricature and the features you chose to exaggerate.

Fig. 9–11 Student artwork

Sculptural Painting

Studio Background

Have you ever dreamed about having a car that can fly or a television that can make popcorn? If you have thought about these things, you have wanted to join two different objects. Contemporary artists have thought about the possibilities of combining art forms. Both Frank Stella and Miriam Schapiro (Figs. 9–12 and 9–13) pushed the boundaries of traditional painting into different directions. Each artist also blurred the line between sculpture and painting by making their canvases into forms.

In this studio exploration, you will use cardboard and paint to make an artwork that explores the boundaries between sculpture and painting. You may choose to create an artwork that sends a message about a social issue or only focus on shape and form. Think about how you can use proportion and scale to make your artwork humorous or surprising. Should you create parts that are larger than others? Should your artwork appear larger or smaller than viewers might expect?

You Will Need

- sketch paper and pencil
- cardboard or foam core
- scissors or X-Acto™ knife
- glue and tape
- found objects
- tempera paints and brushes

Step 1 **Plan and Practice**

- Decide what you want to explore with your artwork. Will you focus on shape and form? Will you use your work to send a message?
- Think about proportion and scale. How do they relate to what you want to do with your artwork?

Things to Remember:

✓ Combine the elements of sculpture and painting.

✓ Use scale and proportion to create surprise, add humor, or make a point.

✓ Connect all pieces securely.

Inspiration from Our World

©Richard Nebesky/Robert Harding World Imagery/CORBIS.

©moodboard/CORBIS.

Inspiration from Art

In the late 1950s, Abstract artist Frank Stella painted huge canvases with simple shapes, colors, and lines. In the 1970s, he began to "explode" his paintings into three dimensions. He used aluminum and Fiberglas™ to make multilayered organic forms. We usually think of Stella's works as paintings. But because they stick out from the wall or stand on the floor, we may also think of them as sculpture.

Miriam Schapiro shaped her paintings into recognizable forms such as hearts, fans, and houses. Throughout her career, she explored the roles, artistic work, and symbols associated with women. She put doilies, handkerchiefs, and quilt pieces traditionally made by women into her paintings. Simple human figures, often posed for dancing, also appeared. Her artwork *Anna and David* (**Fig. 9–13**) looks like a huge colored-paper cutout. Unlike Stella's forms, which move into and through space, this sculptural form is flat—very much like a painting.

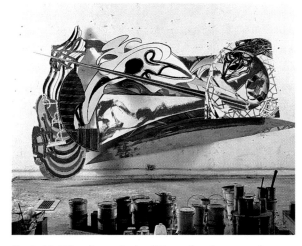

Fig. 9–12 **What is a painting? Describe the ways that this artwork fits your definition of a painting.**

Frank Stella, *The Chase, Second Day*, 1989. Mixed media, 101" x 229" x 50" (256.5 x 581.6 x 127 cm). Photograph by Steven Sloman. ©2000 Frank Stella/Artist Rights Society (ARS), New York.

Fig. 9–13 **Why would passersby consider this artwork a sculpture? What might cause them to think of it as a painting?**

Miriam Schapiro, *Anna and David*, 1987. Stainless steel and aluminum, 35" x 39" x 9" (88.9 x 78.7 x 22.9 cm). Courtesy Bernice Steinbaum Gallery, Miami, Florida.

Safety Note

Use knives and other sharp tools with extreme care to avoid cuts and other accidents.

Step 2 Begin to Create

- Sketch your ideas. **Decide what forms you will use.** Will you make a painting that also seems to be a sculpture? Or a sculpture that seems to be a painting?

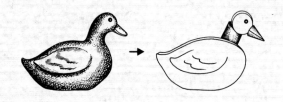

- **Cut and join your forms.** Will you use slots and tabs to connect various pieces? Or will you use tape and glue?

Step 3 Revise

Did you remember to:

✓ Combine the elements of sculpture and painting?

✓ Use scale and proportion to create surprise, add humor, or make a point?

✓ Connect all pieces securely?

Adjust your work if necessary. In your sketchbook, make a note of your revisions and why you made them.

Step 4 Add Finishing Touches

- Paint your artwork when you are sure it is stable.

- If you wish, add found objects or other materials to help show your meaning.

Step 5 Share and Reflect

- Arrange the artworks most like sculptures in one area and those most like paintings in another area.

- Discuss the artworks with your classmates.

- Decide which ones are mostly about form and which ones represent an idea or message.

Art Criticism

Describe What colors, textures, patterns, and forms do you see?

Analyze In what ways is this painted sculpture an open form?

Interpret What mood or feeling words can you connect with this sculpture?

Evaluate What did the artist do especially well?

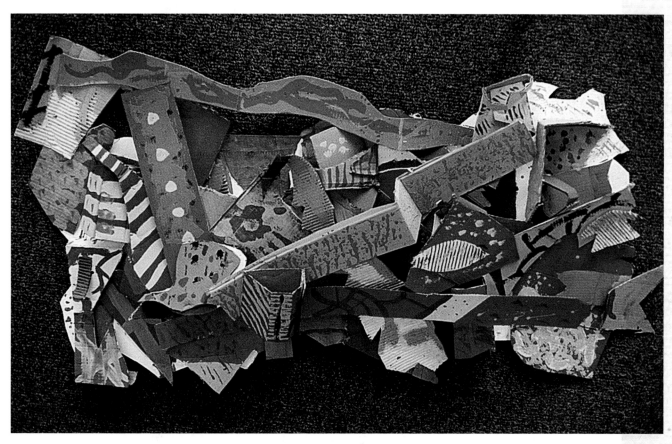

Fig. 9–14 Student artwork

Art Since 1950

In the 1950s, New York became the new art center of the Western world. Art styles began in the United States and spread widely.

American artists brought new possibilities to their artworks. Many created new art forms. Some artists experimented with exciting materials that no one had used before. Other artists used traditional materials in new ways.

Today, artists continue to challenge what is possible in art. They search for ways to change people's ideas about art. Their explorations create new kinds of art and make us wonder, "What's next?"

Fig. 9–15 **This is an Abstract Expressionist work. Why do you think Abstract Expressionism was also called "action painting?"**

Lee Krasner, *The Bull*, 1959. Oil on canvas, 77" x 70" (195.6 x 177.8 cm). Photograph courtesy of the Robert Miller Gallery, New York. ©2000 Pollack-Krasner Foundation/Artists Rights Society (ARS), New York.

1959
Krasner,
The Bull

1962
Frankenthaler,
Rock Pond

1965
Lichtenstein,
Little Big Painting

1985
Scharf,
Opulado Teeveona

1997
D.A.S.T.,
Desert Breath

Mid-to-late 1900s　　　　　　　　　　　　　　　**2000s**

1959
The newly invented hovercraft makes its maiden voyage across the English Channel.

1962
John Glenn becomes the first American to orbit the Earth.

1968
Neil Armstrong and Buzz Aldrin become the first people to walk on the Moon.

1992
The Treaty of Maastricht is signed, creating the European Union.

2004
Dancer,
Sky Grizzly

New Possibilities in Painting By the 1950s, artists were asking themselves, "What new things are possible in creating a painting?" Painters no longer had to show realistic scenes. They looked for ways to change what people thought of as a "painting."

Abstract Expressionist artists tried different ways of painting. Their work was known as "action painting." Some dripped, poured, or splashed paint on a canvas. Many focused on creating brushstrokes in their art. Look at Fig. 9–15 on the previous page. This painting is over six feet tall! The Color Field painters were another group of artists who created new ways of painting. They allowed paint to soak into the canvas.

Fig. 9–17 This artist lets paint soak into the canvas. What kind of shapes has she created with this technique?

Helen Frankenthaler, *Rock Pond*, 1962. Acrylic on canvas, 80" x 82" (203 x 208 cm). The Edwin and Virginia Irwin Memorial. ©Cincinnati Art Museum. ©2000 Helen Frankenthaler.

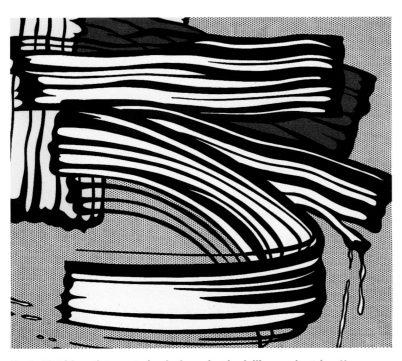

Fig. 9–16 This artist created paintings that look like comic strips. How have Pop artists, such as this one, opened up the possibilities for what a painting can be?

Roy Lichtenstein, *Little Big Painting*, 1965. Oil and magna on canvas, 68" x 80" (172.7 x 203 cm). Whitney Museum of American Art, New York. Purchased with funds from the friends of the Whitney Museum of American Art. ©Estate of Roy Lichenstein.

In Fig. 9–17, the artist poured paint onto the canvas and created fields of color. Fields are large areas or shapes.

Some artists wanted to change what artworks could show. Some of their subjects were soup cans, soda bottles, or other everyday objects. Because their subjects came from popular ("pop") culture, this style of art was called Pop Art.

New Possibilities in Sculpture Since 1950, sculptors have also explored the possibilities of new techniques, materials, and places for their works. They have taken sculpture in new directions.

Some sculptors use traditional materials in new ways. Other artists use many materials in one sculpture.

In Fig. 9–18, the artist used a TV set, toys, and jewelry to make a sculpture. At first, a sculpture made of television sets was new and shocking. Today, many artists use them in their work. Why do you think they have become a common art material? What do you think are possible materials for future artworks?

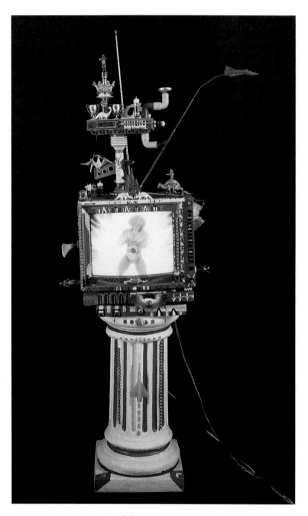

Fig. 9–18 **Kenny Scharf feels art should be fun. What other materials could he have used to make a "fun" sculpture?**

Kenny Scharf, *Opulado Teeveona*, 1985. Acrylic, jewels, toys on Sony Trinitron TV with plastic pedestal, 56" x 17" x 16" (142 x 43.2 x 40.6 cm). Courtesy Tony Shafrazi Gallery, New York. Photo by Ivan Dalla Tana. Copyright Kenny Scharf. ©2000 Kenny Scharf/Artists Rights Society (ARS), New York.

Fig. 9–19 **Look quickly at this photograph and you may see a bear drawn on a grass plain. Look closer and you will notice that people make up each part.**

Daniel Dancer, *The Sky Grizzly*. Daniel Dancer/artforthesky.com.

Check Your Understanding

1. How did many painters after 1950 try to change what people thought of as "painting"?

2. Compare and contrast three important art movements after 1950. How are these movements similar? How are they different?

3. Why do you think there have been so many styles of art since 1950?

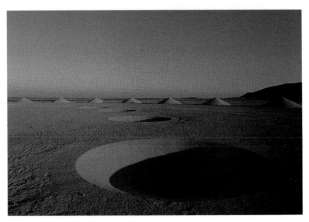

Fig. 9–20 **What does this artwork's title make you think of? What happens when you blow on a pile of sand?**

D.A.ST. Arteam (Danae Stratou, Alexandra Stratou, and Stella Constantinides), *Desert Breath*, 1997. Sand and water, 1,214' (370 m) diameter. Located: Red Sea, Egypt. Courtesy D.A.S.T. Arteam.

Meet D.A.ST.

Three Greek women make up the artists' team D.A.ST.: Stella Constandinidis and sisters Danae and Alexandra Stratou. In 1997 they created *Desert Breath*, an enormous "earthwork," or an artwork made outdoors of natural materials. D.A.ST. Arteam constructed the sculpture in the Sahara Desert near the Red Sea, using sand as the medium. *Desert Breath* included two spirals of cones, some rising from the sand and others sunk beneath it. Like many earthworks, *Desert Breath* was not intended to be permanent. When they created it, the artists knew that natural forces like wind would change the sculpture and eventually erase it.

Courtesy of Danae Stratou and the D.A.S.T. Arteam

Plan a Public Sculpture

When artists submit ideas for a possible sculpture, they usually create a maquette. A maquette is a small-scale model of what their final sculpture will look like. Create a maquette of your sculpture designed for a public place.

- Imagine that you are a sculptor hoping to win a competition for a work that reflects new directions in sculpture.

- You can make your maquette out of any material that resembles the final material you would want to use. For example, you could make your maquette out of cardboard if you were planning a sculpture with metal sheets.

Reflect on how well your maquette resembles a large public sculpture.

Fig. 9–21
Student artwork

Possibilities from Around the World

Global Challenges You have probably heard the phrase, "The possibilities are endless." This is particularly true in today's world. Lots of possibilities can be a good thing. You can make any kind of art and use many different materials. But sometimes, you might feel that there are too many possibilities. You might wonder where to begin, where to look for inspiration, or what materials to use.

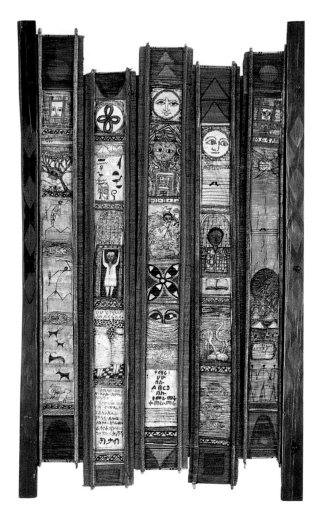

Fig. 9–22 **What patterns and images do you see in this artwork? Do you see similar images in the artworks on these pages?**

Zerihun Yetmgeta, *Scale of Civilization*, Ethiopia, 1988. Mixed media on wooden looms, 39 ⅜" x 24 ⅜" (100 x 30 cm). Inv. 90-312 959, Staatliches Museum für Völkerkunde, Munich.

Social Studies Connection

Sometimes artists overcome the challenge of endless possibilities by using their own heritage in their artworks. For example, *Tree of Life* (Fig. 9–23) relates to Native American culture. The canvas is covered with images related to Native peoples and nature. The environment is important to Native peoples, who traditionally hold the land and its creatures in great respect. The artist is of Salish, French-Cree, and Shoshone descent. Heritage is an important theme in most of the artworks in this lesson.

Fig. 9–23 This artist calls her paintings "landscapes of the mind." How is she exploring new possibilities for showing a landscape?

Jaune Quick-to-See Smith, *Tree of Life*, 1994. Oil, collage, mixed media, 60" x 100" (152 x 254 cm). Courtesy of the artist and the Jan Cicero Gallery.

Artists throughout the world have also been faced with these challenges. As you have learned in this book, artists look for ways to send messages, communicate ideas, teach lessons, and connect with nature. Sometimes, their artworks show a link with the past; other times, they break free from it. But each time, artists explore new possibilities for creating art that is meaningful to their lives and to ours.

Visual Culture

In this lesson you have learned that artists around the world today are being influenced by the art and traditions of other cultures. This is also true for the products we use and the clothing we wear every day. For example, pajamas originated in India, and flip-flops probably originated in China. Work with your classmates to research the history and multicultural origins of the many things you wear or use. Also look at the labels on the clothes in your closet or in clothing stores to see where they are made.

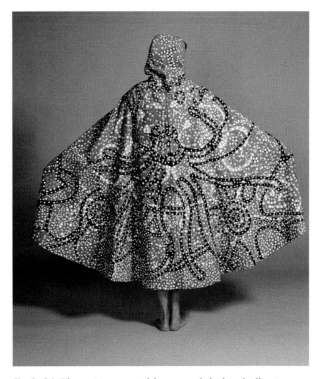

Fig. 9–24 The patterns on this cape might be similar to some of the Oceanic art in Unit 6. What message do you think this artist was trying to send?

Bronwyn Bancroft, *Cycle of Life Cape*, 1987. Australian Museum/Nature Focus. Photo by Carol Bento.

Notice the variety of artworks by living artists from around the world on these pages. As you look at the artworks, think of what you have learned about art so far. How do some of these artists connect to past art traditions? What new techniques have they used? What possibilities do you think they are exploring?

Meet Shahzia Sikander

Shahzia Sikander is a Muslim born in Pakistan. As a child, she was quiet and liked to make portraits of people. In a Pakistani art school, she learned the Hindu tradition of miniature painting, which was not popular among Muslim Pakistanis. Miniature paintings are usually scenes of Indian royal courts or Hindu gods. Shahzia learned the tradition's rules and conventions, and experimented with them, adding modern, personal, and Muslim themes. She now works as an artist in the United States.

"Whatever I create, whether it's miniature or something else, it has to be rooted in a personal connection to art and communication with others."

— Shahzia Sikander (born 1969)

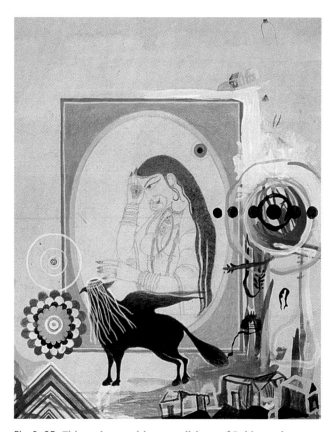

Fig. 9–25 **This artist combines traditions of Pakistan, her native country, with ideas about life in America. What symbols do you notice?**

Shahzia Sikander, *Ready to Leave Series II*, 1997. Vegetable and Watercolors on handmade paper, 7 ¾" x 6 ¼" (19.7 x 15.9 cm). Collection of Richard and Lois Plehn, New York. Courtesy of Hosfelt Gallery and the artist.

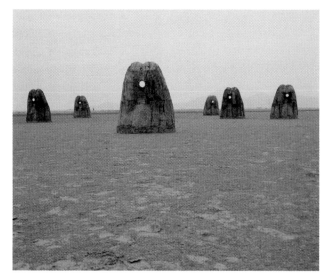

Fig. 9–26 **How has this artist explored the possibilities of new spaces for artworks? How does his choice of a site help him communicate something about place?**

Jae Hyun Park, *Toward Unknown Energy*, 1998. Resin, hempen cloth, and pigments, 85" x 66" x 27" (215.9 x 167.6 x 68.6 cm). Represented by CS Fine Art, Montrose, CA.

Fig. 9–27 The artist wanted this painting to look like an old book. She placed horses and text in the right margin to give the words a sense of movement.

Shahzia Sikander, *Writing the Written*, 2000. Vegetable color, dry pigment, watercolor, tea, on Wasli paper, 5.5" x 8" (14 x 20.3 cm) Courtesy of Sikkema Jenkins & Co.

Check Your Understanding

1. What big issues do artists all over the world seem to be concerned with?

2. Compare and contrast the symbols and patterns in Fig. 9–23 with those used in Fig. 9–24.

3. Why is preservation of artistic heritage important?

Studio Time

A New Look at Heritage

Create a work of art in any medium you have already worked with in this book. Explore new possibilities.

- Try to express something about your cultural heritage. Research the artistic traditions of your cultural heritage.

- Use traditional themes to create something new.

Reflect on how well your artwork expresses your heritage.

Fig. 9–28 Student artwork

A New Kind of Book

Studio Background

When you hear the word "book," what do you think of? You probably think of the kind that's bound with front and back covers. But imagine seeing a book that unrolls as one sheet of paper. Or one that opens like an accordion or a hand-held fan. Or one that is designed as sculpture, painting, or collage. All these can be thought of as books, too.

In this studio exploration, you will create your own book. You will see several ways to make a book. Then you will choose a way and create a book of your own. You may choose to make a scroll, concertina, or fan. Think like an artist and design something exciting!

You Will Need

- papers and fabrics
- art media and tools
- crafts materials
- small found objects
- binding materials and tools
- scissors
- glue
- tape
- stapler

Step 1 **Plan and Practice**

- List possible subjects for your book. You can make a book about nature, history, fantasy, alphabets, numbers, a story, dreams, poetry, photographs, religion, culture—anything you want.

- Sketch your ideas. Think of your book as an artwork. How big or small will it be? Will it be tall and thin or short and wide? How will the pages be shaped? What will you show on each page?

- Think about materials. What kind, color, and texture of paper will you use? Will it be the same on every page or different? Will you tear or cut the pages?

Things to Remember:

✓ Choose the type of book that will show your subject the best.

✓ Use colors, shapes, materials, and images that will add meaning to your design.

✓ Be creative and make your design surprising to your audience.

Inspiration from Our World

Inspiration from Art

While the kind of book you're familiar with is seen most often on library shelves, there are other, older forms of books that are still in use today.

A scroll is a long strip of paper or other material that can be written or drawn on and then rolled up. A rod attached to one or both ends of the scroll makes use and storage easy.

A fan is made like a hand-held fan. Its pages—usually strips of paper—are loosely bound at one end. With a fan, you can see any of the pages or a combination of them at one time. The order of the pages is not important.

A simple concertina can also be made from a long strip of paper. Only this time, the paper is folded accordion-style to create the pages. Because the concertina is a continuous strip, you can show a single, continuous idea on all of the pages or individual ideas on single pages.

Fig. 9–29 **Each of these fan books has a distinct theme. Will your fan book have a theme? Or will it break the bounds of theme?**

Jean Kropper. 1999. Left: *Faces of the World*; Right: *Go Fish*. Left: Collage and beads, 6 ¼" x 2 ¾" (15.9 x 7 cm). Right: Collage, paint chip samples, and beads, 4 ¾" x 1 ¾" (10.8 x 4.5 cm). Courtesy of the artist.

Fig. 9–30 **In this scroll, the artist shows us the history and rituals from an imaginary world. Notice how it appears to lack words. What art techniques has the artist used to create the images?**

Inga Hunter, *Imperium Scroll*, 1994. Collage on canvas with a case; etching, woodblock, and linoleum prints; paint and mixed media, 5 ⅛" x 39 ⅛" (13 x 100 cm). Courtesy of the artist.

Step 2 Begin to Create

- **Choose a format for your book. It can be a scroll, concertina, or fan.** Which format will show your subject the best? How can you break the bounds of the format? What will your book cover or scroll container look like?

scroll

concertina

fan

- Carefully create each page or scroll section.

If you are making a **scroll**, consider the following steps:

- You can create a handscroll which can be unrolled and viewed a little at a time. You can also create a hanging scroll to be viewed all at once.

- Wrap the ends of the scroll around sticks or twigs, dowels, spools, crayons, straws, or other rod-shaped objects.

If you are making a **fan**, consider the following steps:

- Make each page a different shape.

- Add different borders to each page.

- Try making a hole in the middle of the pages for a double fan.

- Create an irregular fan shape by making a hole a little higher on each page than the previous page.

If you are making a **concertina**, consider the following steps:

- Glue several folded sheets together end-to-end for a long concertina.

- Add pockets to the page panels and fill them with pictures, leaves, secret messages, or whatever you can think of.

- Write special words on the panels.

- Gather together several sheets of paper and fold them in half. Stitch the little "booklets" into the concertina folds.

Step 3 Revise

Did you remember to:

✓ Choose the type of book that will show your subject the best?

✓ Use colors, shapes, materials, and images that will add meaning to your design?

✓ Be creative and make your design surprising to your audience?

Adjust your work if necessary. In your sketchbook, make a note of your revisions and why you made them.

Step 4 **Add Finishing Touches**

- Design a cover or container that fits the subject.

- You can tie a rolled-up scroll with a cord. Or create a container for it from a film canister, cardboard tube, bottle, or empty flashlight.

- You can bind the pages of your fan together with a nut and bolt, a colored ribbon, a pipe cleaner, a key ring, or some other imaginative object.

Step 5 **Share and Reflect**

- Exchange books with a few classmates and spend some time looking through them.

- Talk about each book separately. How do the subject and design surprise the reader?

- What do you want people to do with your finished artwork? How would you like them to respond to it?

- How does your artwork go beyond the boundaries of ordinary books?

Art Criticism

Describe How would you describe this book to someone who has not seen it?

Analyze What decisions did the artist make in planning this book?

Interpret What are some initial responses to this book?

Evaluate What makes this artwork unique and special?

Fig. 9–31 Student artwork

Theater

Fig. 9–32 ©Tom Stewart/Corbis

Theater artists explore possibilities by asking "What if...?" A playwright might ask "What if the guests disappeared from the party?" An actor might ask "What if my character sneezed all the time?"

Choose a scene in a play. Create and write three possible story lines by asking a "What if..." question. Working with a small group, choose a story line, and create a scene based on that idea. Perform the scene, and ask classmates to answer the original "What if..." question.

Science

Science has endless possibilities.
Science has caused people to think about nutrition and overall health. With improvements in health care, more people live longer today than they did in the past. What developments do you think will increase life expectancy? The maximum life expectancy for humans is between 100 and 110 years. Medical advancements may be able to extend the human life span. How do you feel about this possibility?

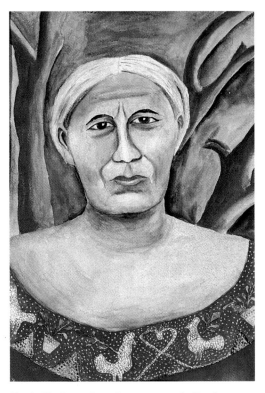

Fig. 9–33 **Even though more people live longer lives, the maximum life expectancy now is the same as it was 1000 years ago.**

Maria Izquierdo, *Retrato de Mujer*, 1944. Watercolor on paper, 20" x 14" (50.7 x 35.5 cm). ©Christie's Images, Ltd, 1999.

Advancements in computer technology have created new possibilities for museum curators. In general, curators are art historians. They also make recommendations for the purchase of artworks and develop traveling art shows.

Advancements in technology have made it necessary for curators to apply their skills to the Internet. What specific skills do you think museum curators need to keep up with technology?

Fig. 9–34
©Franz-Marc Frei/CORBIS

Daily Life

What was your first experience with a computer? There have been a lot of technological advances in your lifetime. Make a list of the computer devices you see or use each day. Since computers are such a big part of our lives, you might be surprised by what you find. Some of these may include cell phones, remote controls, MP3 players, and clocks. Of the devices you found, which ones do you need the most? What do you think computers will make possible in the future?

Fig. 9–35

Vocabulary Review

Match each art term below with its definition.

scroll

concertina

fan

earthworks

installation art

1. a strip of paper or other material that can be written or drawn on and then rolled up

2. artworks designed for particular outdoor places in nature

3. artworks created for a particular site, which often require a large display place

4. an object with loosely bound pages that is similar to a hand-held cooling device

5. a long strip of paper folded back and forth to create separate pages

Aesthetic Thinking

How should an artwork be judged? Is a judgement the same as an opinion? If not, how are they different? How are they similar? Choose an art example from this chapter to explain your answer.

Write About Art

Imagine that officials in your city or town plan to display this sculpture made entirely of dog tags, the term used for metal identification pendants that soldiers wear around their necks, as a tribute to local soldiers and veterans. Write a letter to the editor of the newspaper expressing whether you agree or disagree with this plan.

Fig. 9–36 **In what way does this sculpture communicate a message?**

Do-Ho Suh, *Some/One*, 2004 Stainless steel military dog tags, steel structure, fiberglass resin, fabric, 75" x 114" x 132" (190 x 289.5 x 335 cm). Gift of Marti and Tony Oppenheimer and the Oppenheimer Brothers Foundation, collection Nerman Museum of Contemporary Art, Johnson County Community College, Overland Park, Kansas. Photo: Bret Gustafson.

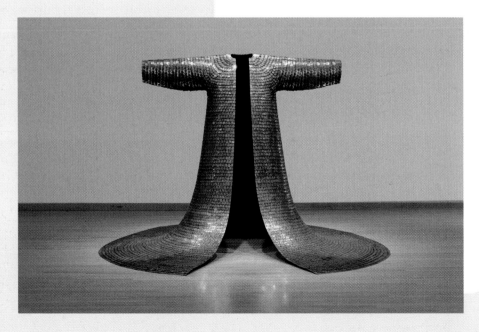

Art Criticism

Describe What do you see in this work on paper?

Analyze How does the artist use variety in this work?

Interpret How does reading the title add to our appreciation or understanding of this work?

Evaluate Stockholder has said: "When I work on flat things, bringing in a photograph is very helpful. The photograph is crisp and has all kinds of scale and information that aren't about my hand." How has she used the photograph to create contrast?

Fig. 9–37 Jessica Stockholder, *Blue Fence*, 2004. Pigmented abaca base sheet with pulp painting and archival inkjet print, 22" x 30" (56 x 76 cm). Photography by James Dee, courtesy Dieu Donné.

Courtesy of the artist & MitchellInnes & Nash Gallery

Meet the Artist

Jessica Stockholder was born in Seattle, Washington. In addition to two-dimensional works, Stockholder creates room-size installations that use traditional art materials as well as objects like refrigerators and light bulbs. These installations have been called "paintings in space." She teaches sculpture at Yale University.

"My work is about this possibility for some world other than the one we experience. It's like going into a mundane closet and disappearing into something that's extraordinary and full of fantasy."

— Jessica Stockholder (born 1959)

For Your Portfolio

Choose four portfolio artworks from units 1–9 to see your improvement in presenting meaningful themes. For each piece, write a paragraph that explains why the piece is a good example of a focus on a theme.

For Your Sketchbook

Study the artworks in each chapter's Global View lesson. On a page in your sketchbook, draw a simple object, such as an apple, in the style of each global area.

Student Handbook Contents

Studio Safety

Stay safe when you create! No matter what art materials you use, developing safe habits is important. Read labels, follow common safety procedures, and always wash your hands thoroughly after working with art materials.

Avoid breathing dust.

Why? Chalk, pastel, charcoal, and plaster dust can harm your lungs and might trigger an allergic reaction.

What to do? Wear a mask over your nose and mouth if necessary. When carving plaster, keep your work damp and place it in a shallow tray lined with damp newspapers.

Keep art materials away from your eyes.

Why? Chemicals in paints, solvents, and photo developing solutions can irritate your eyes and skin. Chemicals can also be absorbed through your skin.

What to do? Keep your hands away from your face when you work with art materials. Wear disposable latex or rubber gloves.

Do not breathe sprays or vapors.

Why? Permanent markers, some paints, some solvents, photo developing solutions, and spray fixatives all give off fumes that can be harmful.

What to do? Do not use permanent markers for any art activity. Use sprays and other chemicals only in areas with active ventilation.

Read labels carefully.

Why? Be sure labels say the materials are *nontoxic*, which means they are *not* poisonous. The word *toxic* or a picture of a small skull and crossbones means the material is poisonous.

What to do? Ask your teacher how to handle the material. Be sure to wash your hands thoroughly after use.

Point scissors and sharp tools away from you.

Why? Scissors, knives, wood or linoleum block cutting tools, clay tools, needles, pins, and tacks are sharp and if mishandled can cause injury.

What to do? Always direct a sharp edge or point away from you and others. When you use the tools, hold your work securely or use a vise. Wear safety goggles. Work slowly.

Do not eat or drink in the artroom.

Why? Chemicals from art materials may get into your food or drink. Foods that are part of an edible creation can also become contaminated.

What to do? Always leave the artroom when you want to eat or drink. Create edible artwork in the kitchen using only food preparation tools and materials.

Clean up spills immediately and keep the floor clear of objects.

Why? Liquids are slippery. Liquids and clutter on the floor can cause falls.

What to do? Clean up spills immediately, following your teacher's directions. Keep backpacks, books, and materials in or under your worktable.

Elements of Art

The *Elements of Art* are the basic building blocks that an artist uses when creating a work of art. Understanding the elements of art can also help you appreciate the artworks of others.

Line

- A mark that has length and direction.
- Outlines shapes and forms or suggests movement.
- *Implied* line is not actually drawn, but suggested by part of an image, such as a path of footprints.
- Line affects the mood of artworks. Thick zigzag lines will give a different "feel" from light, curved lines.

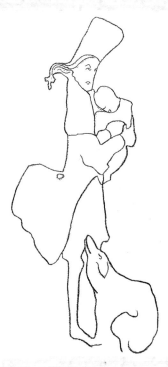

Even a simple outline can convey much information.
Romaine Brooks, *The Soldier at Home*, 1930.

Shape and Form

Shape

- Created when a line encloses a space or color.
- Flat and two-dimensional (2-D).
- Examples: circle, square.
- *Positive* shapes are the main shapes in an artwork.
- *Negative* shapes are the shapes that surround the positive shapes.
- Artists often plan their work so that the viewer's eyes move back and forth between positive and negative shapes.

Form

- Has height, width, and depth.
- Is three-dimensional (3-D).
- Examples: sphere, cube.

Shapes and Forms

- Can be *organic*, meaning irregular, such as leaves or shells.
- Can be *geometric*, meaning precise and regular, such as circles, spheres, triangles, and pyramids.

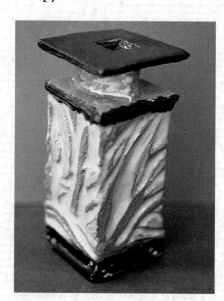

This ceramic work contains geometric shapes and forms.
Student artwork.

Space

- In three-dimensional work, artists use actual space.
- In two-dimensional work, artists create the illusion of space.
- *Positive* space is the space filled by a work.
- *Negative* space is the space that surrounds the work.
- Ways to create the illusion of space or depth include:
 - making closer objects larger, farther objects smaller
 - overlapping objects
 - placing distant objects higher in the picture
 - *linear perspective*, a special technique in which lines meet at a specific point in the picture.

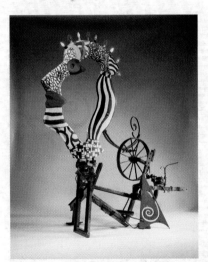

You can see negative space through the open parts of this sculpture.
Nikki de Saint Phalle and Jean Tinguely, *Illumination*, 1988.

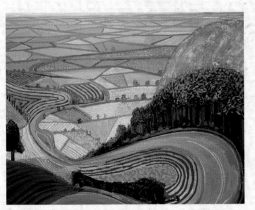

Smaller and smaller fields help create the illusion of space in this painting.
David Hockney, *Garrowby Hill*, 1998.

Texture

- The way a surface feels or seems to feel, such as rough, sticky, prickly.
- *Real* textures are those you can actually feel.
- *Implied* textures are textures that do not feel the way they look, such as soft fur created by painting many fine lines.

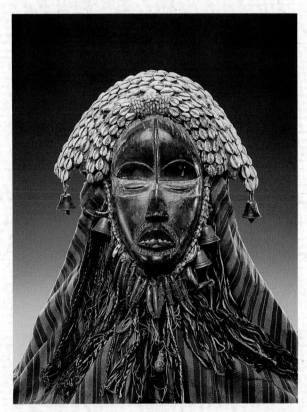

The textures in this mask are real—you could feel them if you touched it.
Africa, Dan Culture (Liberia, Ivory Coast), *Ga-Wree-Wre-Mask*, 20th century.

Color

- The *color spectrum* is created when light passes through a prism.

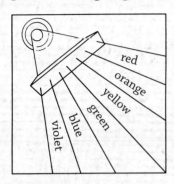

The Spectrum

- Colors of the spectrum are red, orange, yellow, green, blue, indigo, and violet.

- The *primary hues* or colors are red, yellow, and blue. Primary colors cannot be created by mixing other colors.

- The *secondary* colors are orange, green, and violet. Mix two primary colors to create a secondary color.

- To create an *intermediate* color, mix a primary color with the secondary color next to it on the color wheel.

- Use the primary colors, plus black and white, to mix almost every other imaginable color.

- *Intensity* is the brightness or dullness of a color.

- To create dull colors, mix complementary colors, those that are opposite each other on the color wheel.

- A *color scheme* is a specific group of colors an artist works with to create an artwork.

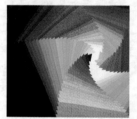

Caryl Bryer Fallert, *Refraction #4–#7*

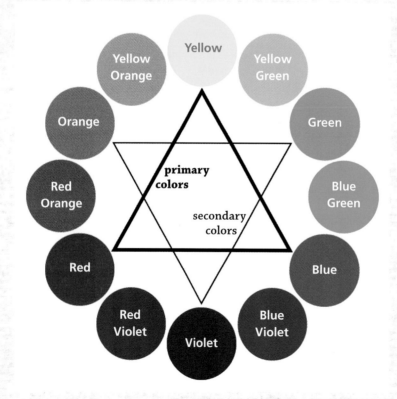

The Color Wheel

Common Color Schemes

- *Warm:* colors that remind people of warm places, things, and feelings.

- *Cool:* colors that remind people of cool places, things, and feelings.

- *Neutral:* colors that are not associated with the spectrum.

- *Monochromatic:* the range of values of one color (*monochromatic* means "one color").

- *Analogous:* colors that are next to each other on the color wheel and share a common hue.

- *Split complement:* a color and the two colors on each side of its complement.

- *Triad:* any three colors spaced at an equal distance on the color wheel, such as the primary colors or the secondary colors.

Value

- The lightness or darkness of a color.

- Create a *tint,* or lighter value, by adding a color to white.

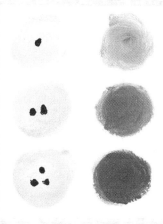

- Create a *shade,* or darker value, by adding black to a color.

Principles of Design

The principles of design are guidelines that help artists plan relationships among visual elements. These guidelines include balance, emphasis, unity, variety, pattern, proportion, movement and rhythm, and contrast.

Balance

Artists use balance to give the parts of an artwork equal "visual weight" or interest. The three basic types of visual balance are symmetrical, asymmetrical, and radial.

- In **symmetrical balance**, the halves of a design are mirror images of each other, which creates a look of stability and quiet.

- In **asymmetrical balance**, the halves of a design are visually equal, yet not exactly the same.

- In **radial balance**, the parts of a design seem to "radiate" from a central point, like the petals of a flower. Designs that show radial balance are often symmetrical.

Emphasis

When artists design an artwork, they use emphasis to call attention to the main subject. Emphasis makes objects, shapes, or even white space more noticeable than other elements.

- The **size** of the subject and **where it is placed** are two key factors of emphasis.

- Create emphasis by arranging other elements in the artwork to **lead the viewer's eyes** to the important subject.

- **Group certain objects together** in a design and **use contrasting elements** to create emphasis.

Making the apple unusually large calls your attention to it.
René Magritte, *The Listening Room*, 1958.

Unity

Unity is the feeling that all parts of a design belong together or work as a team. Here are several ways that artists can create unity:

- **repetition:** the use of a shape, color, or other visual element over and over
- **dominance:** the use of a single shape, color, or other visual element as a major part of the design
- **harmony:** the combination of colors, textures, or materials that are similar or related

Repeated shapes give this work unity.
Student artwork.

Variety

Variety adds visual interest to a work of art. Artists create variety by combining elements that contrast or are different from one another.

- A painter might draw **varying sizes** of shapes and paint them in contrasting colors.

- A sculptor might **combine media** or **vary the texture** of one material.
- Architects create variety when they **use different materials**, such as stone, glass, and concrete, together in one building.

This artist used many different materials to create variety.
Frances Hare, *Sixteen Feet of Dance: A Celebration, A Self-Portrait*, 1996.

Pattern

Artists create pattern by repeating lines, shapes, or colors in a design. Patterns help organize designs and create visual interest. Patterns are either *planned* or *random*.

- In a **planned** pattern, the element repeats in a regular or expected way.

- In a **random** pattern, elements appear scattered throughout the design. Random patterns are usually more exciting than planned ones.

Planned Random

This planned pattern is formed by the color, shape, and position of paper shapes.

Student artwork.

Proportion and Scale

Proportion is the relationship of size, location, or amount of one thing to another.

- In art, **proportion** is mainly associated with the human body. Cartoonists exaggerate human proportions for humorous purposes.

- **Scale** is the size of one object compared to the size of something else.

- Artists sometimes exaggerate the scale of objects in an artwork.

- Drawing an object on a larger scale can make it seem more important or allow the artist to use it in an unexpected way.

Here, the scale of the sink is greatly enlarged.

Doug Webb, *Kitchenetic Energy*, 1979.

Movement and Rhythm

Artists often use movement to create excitement and energy in their artwork. Rhythm, which is related to both movement and pattern, is created by repeating elements in a particular order.

- Kinetic art, such as mobiles, actually moves, while other forms of art only record the movement of their subjects.

Even simple lines can show rhythmic movement.

- Sometimes movement is added to an artwork to lead the eye to a center of interest or add to a mood.

- Rhythm may be simple and predictable, such as the lines in a sidewalk, or it may be complex and unexpected.

- Artists use rhythm, like pattern, to help organize a design or add visual interest.

Showing a figure with both feet off the ground helps suggest movement.
Omri Amrany and Julie Rotblatt-Amrany, *The Spirit, Michael Jordan*, 1994.

Contrast

Contrast is a difference between two things. The greater the difference, the greater the contrast.

- The area of greatest contrast captures your attention first.

- Value is one element artists contrast in their work. Contrast in values creates a noticeable difference between light and dark. It adds excitement or drama.

- Artists also create contrast through the use of strong differences in colors, shapes, textures, and lines.

- Some artists use contrast to create a particular mood or feeling.

Contrast between bright and dark areas adds drama to this painting.
Clara Peeters, *Still Life with Fruit and Flowers*, after 1620.

New Directions in Design

Design is the act of making a plan for a specific outcome such as a website, an appliance, a building, or a video game. Unlike fine artists, who create for self-expression, designers plan products, structures, and systems for people to use. Designers consider questions such as *How can this object best serve its user? How can its appearance match the way it functions? How can this object use specific materials or the environment for maximum efficiency?*

Information Design

- Information designers and graphic designers consider the different ways to communicate information.

- *Graphic design* is the use of visual art to communicate information.

- Graphic designers use typography (fonts), images, and page layout as part of their overall design.

- They are responsible for creating advertisements, animation, logos, road signs, diagrams in textbooks, book layouts, and websites.

Graphic designers use words and images together to send their messages.

Marvin Mattelson (illustrator), *Subway Poster for School of Visual Arts.*

Object Design

- Object designers create new designs for everyday objects such as automobiles, clothing, furniture, and appliances.

- Many of these objects are intended for mass production. The design of mass-produced consumer products is called *industrial design.*

- Industrial designers are often trained as architects or as visual arts professionals. Many work with a larger creative team to create products that work well, look attractive, and will sell well in a competitive market.

These utensils and plates were designed and then mass-produced.

"Tableware," Bloomimage/Corbis.

Space and Place Design

- Space and place designers plan and determine how a structure—including its interior—interacts with space, objects, and the environment.

- *Architects* design buildings and other structures. They consider the function their structure will serve, how stable and durable it will be, and how its form will communicate ideas.

- *Interior designers* focus on the smaller, more intimate spaces within a building and use a mix of space and objects to create certain moods.

- *Urban planners* work with much larger spaces, so they have much to consider as they design. They focus on how society uses structures and space and the impact society has on both. They also plan the development of open land and the renewal of existing parts of cities.

A city's buildings are usually designed by many different architects at various times in history.

Art on File/Corbis.

Experience Design

- Experience designers plan products, processes, services, events, and environments with which people can interact. The results of these designs provide experiences for people.

- Computer-human interface (CHI) designers create products that allow people to physically interact with computers. The computer mouse, the touch screen, and pull-down menus are examples of CHI technology.

- The video games, theme parks, toys, and games you enjoy were all created by experience designers.

Products that interface with computers should be designed for ease of use.

Brand X/Corbis.

Major Western Art Styles and Movements

For thousands of years, people all over the world have created art. In the following pages, you can observe how artists in western Europe and North America have expressed themselves and how art styles have developed and changed over time.

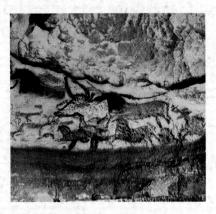

Hall of Bulls, detail, Lascaux, c.15,000–13,000 BC.

Stone Age Art 30,000–2000 BCE

- The earliest known artworks are paintings discovered in caves in Spain, France, and Africa.
- Animals in cave paintings are usually shown in profile with lifelike proportions, details, and actions. People are shown as stick figures with spears.
- Cave paintings may have been used to communicate hope for a successful hunt, to record events, or to educate children.

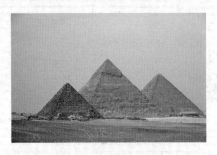

Giza, Egypt, *The Pyramids of Mycerinus, Chefren, and Cheops*, built between 2589 and 2350 BC.

Ancient Egyptian Art 3000–500 BCE

- Pharaohs built pyramid-shaped tombs filled with furniture and jewelry to take with them in the afterlife.
- Wall paintings, relief sculptures, and small models were common art forms.
- Artists worked according to strict rules: head, arms, and lower body in profile, eye and upper torso in front view.

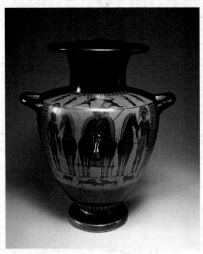

Ancient Greece, Athens, (attributed to the Antimenes painter), *Hydria*, c. 530–510 BC.

Ancient Greek Art 600–150 BCE

- Known for its elegant proportions and perfection of form.
- Mosaic murals were created in many buildings.
- Sculptures were often decorated with paint, gold, and colorful stones.
- Athletes, heroes, myths, and important events were common art subjects.
- Architecture, especially temples and outdoor theaters, featured carved columns and new building techniques.

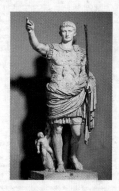

Augustus of Prima Porta, Roman Sculpture, Early first century AD.

Ancient Roman Art 753 BCE–476 CE

- Reflects ideas from Greece, but with a greater interest in naturalistic details

- Emphasized realistic features, showing rulers, ancestors, and peers as they looked in real life.

- Used for practical and political purposes. Exact facial features let people in any part of the vast Roman Empire know what their ruler looked like.

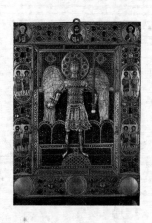

The Archangel Michael with Sword, Byzantine, 11th century.

Byzantine Art 300–1500

- Developed in eastern Roman Empire as a response to the rise of Christianity.

- Rejected Greek and Roman ideals of the perfect human being, physical beauty, and strength.

- Focused on religious themes, using symbols and icons to tell stories about how to live a Christian life.

- Artworks feature a rich use of color and flat, stiff figures.

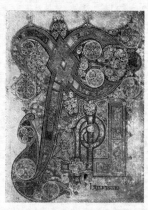

Chi-rho Gospel of St. Matthew, chapter 1 verse 18, Irish (vellum). *Book of Kells*, c. 800.

Medieval Art 400–1400

- Heavily influenced by Christianity, Judaism, and Islam.

- Because many people could not read, art was used to communicate important religious lessons.

- Illustrated scriptures show scenes painted with complex geometric patterns, figures, and fantastic animals. Often, a layer of gold is used to emphasize parts of an image.

- Artworks, in the forms of books and objects of adornment, were small and could be carried easily.

Bayeux Tapestry, 1100 CE.

Romanesque Art 1000–1200

- Developed in western Europe during the Middle Ages.

- Brought back the Greek and Roman tradition of carving large-scale sculptures.

- Cathedrals have thick walls, rounded arches, and sculpted religious scenes.

- Items created for use in worship were often decorated with gold, silver, pearls, and gemstones.

Gothic Art 1000–1200

- French style that was adopted in parts of Europe and England.

- Art and architecture characterized as vertical, open, delicate, and light.

- Churches used stained-glass windows to let in light.

- Biblical scenes in windows taught churchgoers lessons.

 Artists: Giotto di Bondone, Cenni di Pepi Cimabue, Ambrogio Lorenzetti, Simone Martini, Gentile da Fabriano, The Limbourg Brothers (Paul, Jean, and Herman) (painters); Nicola Pisano, Sabina von Steinbach, Claus Sluter (sculptors)

Michelangelo Buonarroti, *Pietà,* 1499.

Renaissance Art 1400–1600

- Began in Italy and gradually spread to the rest of Europe.

- Paintings show realistic textures such as metal, wood, and skin.

- The invention of oil paint allowed artworks to have smooth, glowing surfaces and clear colors.

- Artists focused on light and perspective, and used new techniques to show order, depth, and graceful movements.

 Artists: Fra Angelico (painter), Giovanni Bellini (painter), Filippo Brunelleschi (architect), Michelangelo Buonarroti (sculptor), Donatello (sculptor), Jan Van Eyck (painter), Leonardo da Vinci (painter)

Judith Leyster, *Game of Tric-Trac,* ca. 1630.

Baroque Art 1600–1700

- Lively motion, dramatic contrasts in light and shade, and asymmetrical design are typical.

- Artists used rich colors and textures and swirling curves.

- Still lifes, everyday objects and events, portraits, and landscapes were popular subjects.

- Artists shaped metal and stone into fluid forms.

 Artists: Michelangelo da Carravaggio, Artemisia Gentileschi, Francisco de Zurbarãn, Bartolomé Murillo, Diego Velásquez, Peter Paul Rubens, Anthony van Dyck, Nicholas Poussin, Claude Lorraine, Frans Hals, Judith Leyster, Jan Vermeer, Jacob van Ruisdael, Clara Peeters, Racel Ruysch, Sibylla Maria Merian (painters); Francesco Borromini, Guarino Guarini, Jakob Prandtauer, Christopher Wren (architects)

Movement made by Charles Voisin and Chantilly manufactory, *Wall Clock*, c. 1740.

Rococo Art 1700–1800

- Whimsical, decorative variation of Baroque art created for aristocrats in France, Spain, England, and Italy.
- Delicate colors, playful use of lines, and graceful movement show aristocrats at carefree leisure.
- Ordinary household items showed the elegance and charm favored by the upper class.

 Artists: Rosalba Carriera, Jean-Baptiste Chardin, William Hogarth, Benjamin West, (painters)

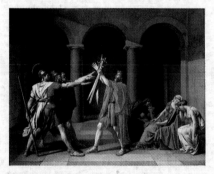

Jacques-Louis David, *Oath of the Horatii*, 1784–1785.

Neoclassicism 1750–1875

- Unearthed classical art at ancient Roman cities Pompeii and Herculaneum inspired the movement.
- Greek and Roman ideals of beauty, courage, sacrifice, and patriotism applied to artworks.
- Formal lines, shapes, proportions, and simple orientation are features of this style.
- In architecture, renewed emphasis on classical arches and columns.

 Artists: Antonio Canova (sculptor), Jacques-Louis David (painter), Thomas Jefferson (architect), John Trumbull (painter), Elizabeth Vigée-Librun (painter), Thomas Walter (architect)

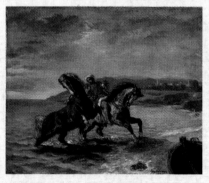

Eugène Delacroix, *Horses Coming Out of the Sea*, 1860.

Romanticism 1815–1875

- Rejected the ordered style of Neoclassical art.
- To show emotion, artists applied color with wild, active brushstrokes.
- Themes included dramatic action, exotic settings, imaginary events, faraway places, or strong feelings.

 Artists: Thomas Cole (painter), John Constable (painter), Eugène Delacroix (painter), Sophia Hayden (architect), H.H. Richardson (architect), François Rude (sculptor)

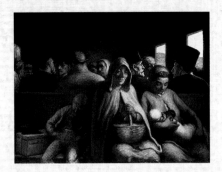

Honoré Daumier, *The Third Class Carriage*, ca. 1863–65.

Realism 1850–

- Rejected Neoclassicism and Romantic styles.
- As subjects, artists chose scenes from real life—rural and city life, people at work, the poor, and political strife
- Realists believed their art recorded simple ways of life that were being destroyed by new technologies.
- Buildings' designs matched their functions.

Artists: Rosa Bonheur (painter/sculptor), Honoré Daumier (painter), Gustave Eiffel (architect), Jean-François Millet (painter), Edouard Manet (painter), Joseph Paxton (architect), John Singer Sargent (painter)

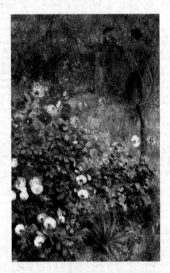

Pierre-Auguste Renoir, *The Garden in the Rue Cortot, Montmarte*, 1876.

Impressionism 1875–

- Began in France; artists created an "impression," capturing a brief moment in time.
- Space and form are suggested by varying the intensity of light and color.
- Paintings are created using short, quick brushstrokes, which cause shapes to merge together.
- Small strokes of color make artworks shimmer and sparkle.

Artists: Daniel Burnham (architect), Mary Cassatt (painter), Edgar Degas (painter/sculptor), Claude Monet (painter), Berthe Morisot (painter), Auguste Rodin (sculptor), Georges Seurat (painter)

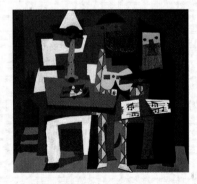

Pablo Picasso, *Three Musicians*, 1921.

Cubism 1907–

- Based on an interest in showing multiple and partial views of objects on the flat surface of a page or canvas.
- Artworks have an abstract, often puzzle-like design with features broken into pieces.
- Another characteristic of this style is the use of hard-edged, geometric forms.

Artists: Georges Braque (painter), Sonia Terk Delaunay (painter), Jacques Lipchitz (sculptor), Georgia O'Keeffe (painter), Pablo Picasso (painter/sculptor)

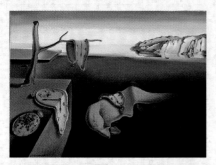

Salvador Dali, *The Persistence of Memory,* 1931.

Surrealism 1924–

- Artists emphasized dream worlds and the subconscious.
- Unrelated objects are often shown realistically in an illogical or unnatural setting.
- Artworks often include visual surprises.

 Artists: Marc Chagall, Salvador Dali, René Magritte, Joan Miró, Meret Oppenheim, Henri Rousseau, Kay Sage Tanguy, (painters)

Jackson Pollack, *Blue Poles,* 1952.

Abstract Expressionism 1945–

- Refers to large paintings that are meant to suggest feelings or ideas.
- Artworks are based on emotion and feeling, with little or no recognizable subject matter.
- Artists explore ways of painting. They drip, pour, or splash paint on the canvas.

 Artists: Hans Hofmann, Jackson Pollack, Arshile Gorky, Hale Woodruff, Mark Tobey (painters); Louise Nevelson, Nancy Graves, David Smith (sculptors)

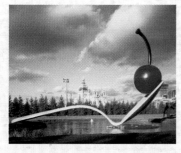

Claes Oldenburg and Coosje van Bruggen, *Spoonbridge and Cherry,* 1988.

Pop Art 1950–

- Everyday objects are used as subject matter.
- Artists draw their ideas from popular and consumer culture: comic strips, hot dogs, movie stars, and so on.
- Artworks often show wit, satire, or humor.

 Artists: Roy Lichtenstein, Jasper Johns, Andy Warhol, David Hockney (painters); Claes Oldenburg, George Segal, Duane Hanson (sculptors)

Andy Goldsworthy, *The coldest I have ever known in Britain,* 1995.

Environmental Art/Earthworks 1960–

- Artworks draw attention to environmental issues.
- Movement celebrates the environment.
- Artists often use earth, wind, and water as sculptural media.
- Artworks are often impermanent.

 Artists: Robert Smithson, Mary Miss, Christo/Jeanne-Claude, Andy Goldsworthy

Techniques

The following basic art techniques can be used as a guide while drawing and painting.

Contour Drawing

Studio Background

A contour drawing is a drawing that describes the overall shape of an object or figure. It may include some interior details. Contour drawings are usually done slowly.

There are different kinds of contour drawings. In **blind contour drawing** you do not look at the paper while you are drawing.

Blind contour drawing

In **modified contour drawing** you use the same technique as blind contour drawing, but you may pause at times to check the position of your drawing tool.

Modified contour drawing

Making a Contour Drawing

- Look only at the object you are drawing, not at your paper.
- First practice drawing the object's outline without letting your drawing tool touch the paper.

Look only at the object.

- Begin to draw, using a continuous line. Draw slowly.
- Follow the contours of the object, including its wrinkles and folds.
- Do not lift your pencil from the paper until you have finished.

Don't lift your pencil from the paper until you are finished.

Gesture Drawing

Studio Background

Use gesture drawing as a way to quickly capture the main parts of a subject before something moves or changes. When doing a gesture drawing, focus on the action lines of the subject. Most gesture drawings are sketches rather than finished drawings and are completed in a minute or two. Use them to help you plan a painting, sculpture, print, or other work of art.

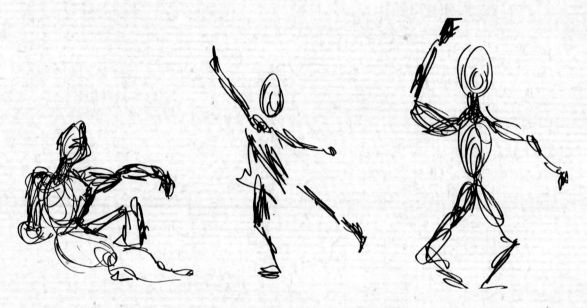

Making a Gesture Drawing

- Practice making gesture drawings using a wide, soft pencil, crayon, or piece of chalk.

- Ask a classmate to strike and hold an action pose, such as dancing, jumping up to catch a ball, or running.

- Take in the overall action of the scene and position of your subject.

- Make a gesture drawing that captures the form of the pose, but not the details. Draw quickly. You can add details later if you want. Use large, swift strokes to help you capture shapes, angles, and positions.

Have a classmate hold a pose.

Capture form, not details.

Shading Techniques

Studio Background

Shading is a gradual change in value or tones of color. Drawing techniques such as hatching, stippling, and blending let artists show gradual changes between light and dark areas. In many artworks, the light source determines where an artist places values in an artwork. Artists use shading techniques to create highlights and cast shadows that give clues to the location of the light source.

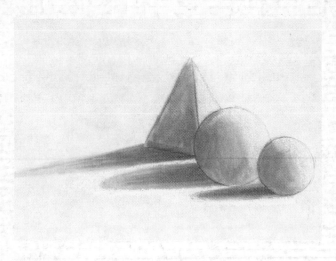

Hatching and Crosshatching

- **Hatched lines** go in one direction and are parallel to one another. Close placement creates dark areas. Use a fine-tipped drawing tool.

- When **crosshatching**, you start by creating hatched lines and then cross them with another set of lines.

Stippling

- Stippling is the process of making tiny dots. The closer together the dots are, the darker the tone. Use a fine-tipped drawing tool.

Blending

- For blending, use a soft drawing tool. Draw on paper and then smudge or blend the area with your fingers, a tissue, or a cotton swab.

Perspective

Studio Background

Artists use an assortment of techniques to create **perspective**. These techniques include overlapping, shading and shadow, placement, size, and focus. Some artists invent ways to combine these techniques.

Basic Perspective Techniques

Overlapping

Shading and shadow

Placement: Objects near top seem more distant

Size: Smaller objects seem more distant

Focus: Sharp detail suggests nearness

Using Linear Perspective

Linear perspective is a system of lines used to create the illusion of three-dimensional space.

One-Point Perspective

- Use a yardstick or ruler to lightly draw a horizon line (HL) across the paper.
- Mark a vanishing point (VP) at the center of your horizon line. Add diagonal guides that recede to the vanishing point.

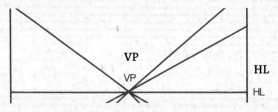

- Draw buildings, houses, or other box-like objects that recede as they approach the vanishing point.
- Vertical lines should be parallel to the side of the paper; horizontal lines should be parallel to the top and bottom of the paper.

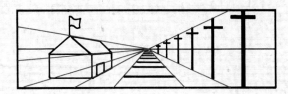

Two-Point Perspective

- Begin your drawing with two vanishing points (VP) on the horizon about the same distance from the edges of the paper.

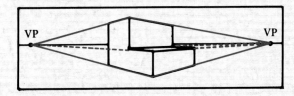

Drawing with Chalk, Crayon, and Pen and Ink

Studio Background

Before they draw, artists think about the medium they will use. Pencils, charcoal, pastels, and crayons are **dry media**. Inks, applied with a pen or brush, arc **wet media**. The effects of drawing media can change depending on whether they are used on wet or dry paper. Once artists choose their medium, they experiment with it to find the techniques they like best.

Drawing with Chalk and Crayons

- Colored chalk, or pastels, can be used on wet or dry paper.
- Practice using the tip of the chalk to make solid and dashed lines.

Practice making many kinds of lines.

- To make clean, sharp lines, dip the chalk into water or liquid starch.
- Use the side of the chalk to make wide lines.
- Press harder to make the line darker and more solid. Use less pressure for a lighter, less solid line.

Press hard to make dark lines.

- To mix colors, apply one on top of the other. Use a tissue to blend the colors together.

- Use a kneaded eraser, or putty rubber, to add highlights or small corrections.

Add highlights with an eraser.

- Practice with crayons in the same way as chalk, but on dry paper only.

Drawing with Pen and Ink

- Ink can be applied with a variety of tools—natural pens like quills, ballpoint pens, nibs, twigs, cotton swabs, or small sponges.

Try a variety of tools.

- Pen and ink can be used on wet or dry paper, but smooth paper gives a more pleasing result.
- Draw your design in pencil first.
- Go over the lines with a pen. Work from one side of the paper to the other so you do not smear the ink.

Brushstrokes

Studio Background

The type of brush and paint you choose, and the brushstrokes you use in your artwork, affect the way your paintings look. The brushstroke techniques below work well with tempera paints, watercolors and thinned acrylic paint.

Making Brushstrokes

- Try different kinds of brushes. Feel how their bristles differ from one another. Certain brushes work best with specific types of paint.

Stiff bristle brush for thick paint

Soft hair-type brush for washes and details

Stiff bristle brush for stencil work

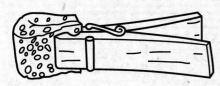

Simple sponge brush

- Choose a soft-hair brush for watercolors or thinner paints. Hold the brush with the bristles pointing down.

- Press hard for a wide brushstroke. Lift the brush up for a thin stroke. Use one stroke for a shape.

- Practice strokes using different amounts of water in your brush and different amounts of pressure. Observe how the lines change.

- Wash, wipe, and blot your brush before putting it away.

Art Forms and Media

The materials an artist uses to create an artwork are called **media**. Watercolors, pen and ink, pencil, clay, and digital cameras are different kinds of media.

Digital Photography

Studio Background

Instead of using film, digital cameras capture images and movies by changing them into thousands of **pixels**, tiny squares or dots of color, and storing them in the camera's memory. A screen allows you to preview, plan, or review images, hundreds of which can be stored in the camera's memory. You can then either delete these images or download them to a computer to be saved or printed.

Using a Digital Camera

Digital cameras are easy to use. Follow these steps to take pictures and store them in your computer.

Paul Hardy/CORBIS.

Taking a Picture

- Turn the camera on.
- Your digital camera should be in automatic mode. In this mode, the camera selects all settings.
- To view your subject, look through the viewfinder. If your digital camera does not have one, look at the screen.
- Focus on your subject. Then press the shutter button to take the picture.
- Review the image when it appears on the screen. You may delete it or save it to your camera's memory.

Saving Pictures to Your Computer

- Make sure your camera's software is installed on your computer.
- Connect your camera to the computer using a USB cable.
- Turn the camera on.
- The camera's software should open on your computer.
- Select the images from the camera that you want downloaded to your computer.
- Save or print the images.

Keep In Mind

- Make sure your digital camera has enough power by inserting or replacing the batteries. Keep extra batteries on hand. Digital cameras require a lot of power, so you may need to change the batteries again during use.
- Check that your digital camera has enough memory to record your images and movies. You can either delete images stored in the memory to free up space, or you can use memory cards with higher capacities for image storage.

- Images can be stored in different file formats. The most common file format is JPEG, which does not take up much room in the camera's memory and is processed faster than other file formats. TIFF files use more space in the memory, but they are higher-quality images. RAW files are the least common format and are used mostly by professional photographers because they have editing options.

Multimedia Presentations

Studio Background

A **multimedia presentation** uses a variety of media—text, video, slides, photographs, art, music, and charts—to communicate information about a subject. Presentation software allows you to combine these media to deliver a successful and effective multimedia presentation.

Making a Multimedia Presentation

Gather Your Media

- First, decide what you want to present. If you plan to present your portfolio, gather your artworks. If you plan to present a topic, such as an artist or an art movement, research and record information on that topic.

- Once you know what you will present, think about the kinds of media that you will include. Choose specific artworks from your portfolio. Search your local library or the Internet for audio and video clips, music, or art.

Prepare Your Media

- Scan your artworks so that you can view them on your computer. Save all other media files you might have to your computer.

- Presentation software uses *slides*—individual screens that can contain images, text, sound or animation files—to show information. Use slides to organize your media and information.

Peter Finger/CORBIS.

Prepare Your Presentation

- Consider *slide transitions*, the movement of one slide to the next. You can choose transitions in which your slides dissolve into each other, push each other off the screen, or open up like blinds. Using many different transitions can be distracting for your audience, so use only one or two kinds of transition throughout your presentation.

- Consider the layout of your slide. Make sure it is readable and visually pleasing. Put the title at the top and important information below it. To keep all your slide layouts consistent, use a *design template*, a model into which you insert your text and files.

Keep In Mind

- The amount of time a slide appears on the screen is very important. Do not change the slides quickly, because your viewers will not get a chance to read or look closely at your artwork or information. Do not keep your slides up for too long, or your viewers may lose interest.

- Electronic media require additional equipment such as projectors that you or your school must provide. If you plan to use your school's equipment, alert your teacher in advance so the equipment will be available on the day of your presentation.

Watercolors

Studio Background

Watercolor paints are transparent, and come in tubes or pans. Start with just a few basic colors, and then mix them to create a wider range.

Notice how you can see one color through another in this watercolor painting.
Emile Nolde, *Summer Flowers*, 1930.

Using Watercolors

- To create **sharp edges**, apply wet paint to dry paper.
- To create **soft edges**, apply wet paint to damp paper.
- Paint light colors first, darkest colors last.
- To create a **light value** of a hue, dilute the paint with plenty of water.
- To create a **darker value**, use more pigment and less water.

A dark value of blue

- A wash is a thin layer of paint spread over a large area.

A green wash

- You can let a wash dry and then paint over it.
- You can paint over a wash before it has dried.
- To make a white area, do not apply paint. Let the white paper show through.

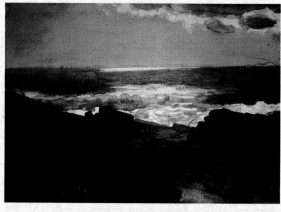

This artist let the white paper show in some areas to create highlights.
Winslow Homer, *Sunshine and Shadow, Prout's Neck*, 1984.

Tempera Paints

Studio Background

Tempera paints come in both liquid and powder form and in brilliant hues. They dry quickly, developing a dull, chalky appearance when dry. They can be layered to produce intense color.

Using Tempera Paints

- Use a stiff bristle brush and short, swift brushstrokes to paint large areas of color first.

Paint large areas first.

- Allow area to dry before adding small details. Brushing large areas of wet paint over dry paint will cause the paint to run.

Add small details after the paint dries.

- To mix a **tint**, add small dots of colored paint to white paint.

- To mix a **shade**, add small amounts of black to a color.

- To mix a new color, add small amounts of a different color to the original color.

- When you change colors, wash, wipe, and blot the brush. Do not dip the brush directly into the bottle.

- Once a bottle is opened, use it as quickly as possible. Keep bottles tightly closed. Do not return unused paint to the bottles.

Oil Pastels

Studio Background

Oil pastels are pigments mixed with oil and wax. Unlike chalk pastels, they do not make dust when you use them, but they never dry completely. This means your works will not crack, but they will smudge unless you frame them and cover them with glass or plastic.

Using Oil Pastels

- Use oil pastels to sketch the main shapes and colors.

- Press heavily for a brilliant-colored line. Press lightly to create a fuzzy line.

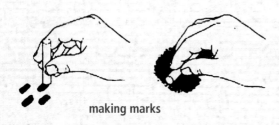

making marks

- Blend colors together using your fingers, a tissue, or cotton swab.

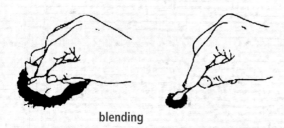

blending

- With your fingers or blending tool, add small swirls or strokes that mimic the details of your subject.

- Change colors of details by blending a new color with the base pastel. Use white or black to make a tint or shade of a color.

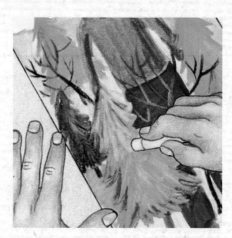

Add one color over another.

- If you are using colored paper or trying a new technique, apply a layer of white first. Scrape away the result if you do not like it, and begin again.

Monoprinting

Studio Background

A monoprint is an edition of only one print. In other forms of printmaking, you can make many prints from the same plate. When you create a monoprint, you can prepare the plate in several ways, but usually the preparations do not survive after the first print.

Making a Monoprint

Method 1

- Roll out a thin, even layer of ink on a smooth, nonabsorbent surface.

- Draw directly into the ink with a tool such as a toothpick, pencil eraser, cotton swab, facial tissue, or old comb.

- Place a sheet of paper over the design, and rub it evenly but lightly with your hand.
- Pull the print by lifting the paper away from the surface.

Method 2

- Working quickly, paint an image with tempera paint on a smooth, non-absorbent surface.

- Place a sheet of paper over the painted image, and rub it evenly but lightly with your hand.

- Pull the print by lifting the paper away from the surface.

Method 3

- Roll out a thin, even layer of ink on a smooth, non-absorbent surface. Place a sheet of paper over the inked surface, but do not rub it.

- Using a pencil, draw an image on the paper.

- Pull the print by lifting the paper away from the surface.

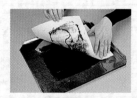

Relief Printmaking

Studio Background

Relief printmaking is one of several basic printmaking processes. A **relief print** is made from a design that is raised from a flat background, usually a wood or linoleum block. Ink is applied to the raised surfaces and then paper or another material is pressed down on the print to leave an image. Printmakers can make many identical prints using this method.

Making a Relief Print

- Create a design on paper.
- Place your design and carbon paper on top of a wood or linoleum block. Alternatively, you can use a dark pencil to black the back of your design.
- Trace over your design to transfer the image to the printing block.

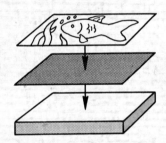

- Use wood-carving or linoleum gouges to carve out areas of your design. These areas will not print.
- Be sure to cut away from your fingers.

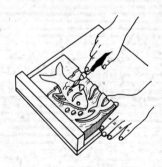

- To keep your block firmly in place, secure it with a bench hook.
- Roll printing ink on a flat surface until it is tacky.
- Roll ink on the printing block surface.
- Place a sheet of paper over your inked block.

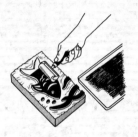

- Rub the back of the paper gently and evenly to transfer ink to the paper.
- Carefully pull the printed paper away.

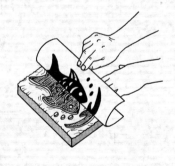

Clay

Studio Background

Clay is earth mixed with oil or water. Oil-based clay is reusable, so it is good to use for planning your artwork or to make molds. Water-based clays harden and your artwork will become permanent when you fire it in a kiln.

Getting Ready to Use Clay

- Protect your desk or work area with a plastic mat or canvas.

- Prepare a *slip*, or liquid clay, to join pieces of clay together. Slip is a creamy mixture of water, clay, and a few drops of vinegar.

- Keep your fingers moist when working with clay. Dip your fingers into water and then spread the water over your palms with your fingers.

- Press or knead the air bubbles out of your clay.

Making a Clay Figure

- Create a five-point star with a ball of clay by pulling out a point for the head, each arm, and each leg.

- To shape, pinch and pull the points. Think about the pose of your figure. Twist or bend the shape as needed.

- Add details, such as facial features, hair, and clothing patterns. Press tiny coils or bits of clay into the figure, or press textures onto the surfaces.

Making a Pinch Pot

- Press your thumb into a ball of clay.
- Slowly turn the pot as you pinch the clay between your thumb and fingers.

- Continue turning and pinching the pot until the walls are an even thickness all around. Smooth the inside and outside of the pot with a scraper.

Making Clay Coils

- Roll clay coils to about the thickness of your thumb.

- Form a flat base. Score the edge with a plastic fork. Add slip.

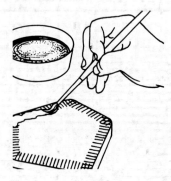

- Bend and press coil to base. Add more coils. Score each new layer and add slip.

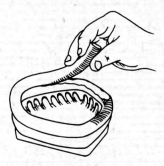

- Smooth coils together with your fingers or a clay tool.

Making a Slab Form

- With a rolling pin, roll clay flat between two sticks of the same thickness.

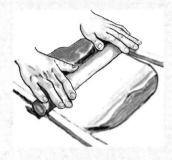

- Cut the slab into shapes that can be joined into a container. Use a plastic fork to score the edges.

- Use your fingers to apply slip to the edges and join the shapes. Reinforce the inside of the joints with coils.

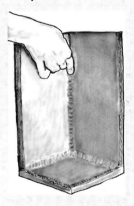

- Pinch the outside edges together and smooth.

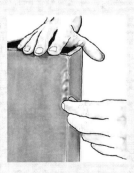

Making a Clay Object With a Press Mold

- Find an appealing form: seashell, plastic bowl, cooking utensil, and so on.
- Roll out a thin, clay slab on a piece of canvas.
- Grasping the edges of the canvas, pick up the slab and invert the clay over the mold.

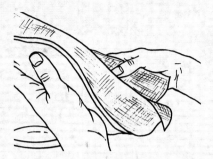

- Using your fingers, gently press the clay into the mold.

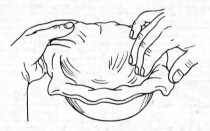

- Smooth surface with a rib tool, and let stiffen till leather-hard.

- Turn mold upside down and ease clay out. If clay sticks, let it dry some more.
- Decorate your clay piece.

Papier-Mâché

Studio Background

Papier-mâché comes from French words meaning "chewed paper." This lightweight sculpture material is made from a soupy mixture of wheat paste and paper. The paste-soaked paper is generally applied over an armature, or support. Then the sculpture becomes hard when it dries. When dry, hardened papier-mâché can be painted to be realistic or fantastic.

Using Papier-Mâché

- Begin with an armature, or support, made of wire, folded paper or foil, or recycled objects.

- Add paper with tape to fill out your sculpture's form.

- Tear newspaper or paper towels into strips at least 1" wide.

- Dip the strips into papier-mâché paste. Remove extra paste from the strips with your fingers.

- Place the strips in layers over the support. Use wide strips for large shapes, and thinner strips for smaller shapes. Apply at least two layers.

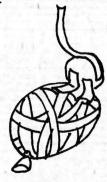

- Use paint and other materials to decorate your dried sculpture.

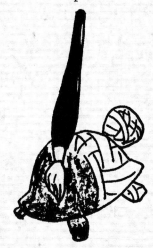

Relief Sculpture

Studio Background

A relief sculpture projects from a background surface. It is not freestanding. Depending on how far the sculpture projects from its background, it can be either *low relief* or *high relief*.

Making Relief Sculptures

Use oil-based or water-based clay to form a slab. Use any of the following techniques to create relief and texture in your sculpture.

- Use clay tools to carve away areas of the clay slab.

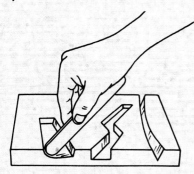

- Press and pull clay to mold lower and higher areas.

- Press textured objects (seashells, spools, rope, leaves, etc.) into the clay slab.

- Attach small coils and clay balls, or scratch lines into the surface to create a variety of textures.

Paper Sculpture

Studio Background

Paper has many purposes in art. Artists draw on paper, of course, but they also use it to create sculptures. The many colors and varieties of paper, as well as paper's ability to be bent, torn, and shaped into forms, make it an exciting medium.

Paper Sculpture Techniques

Gather a variety of paper samples—heavy or light, smooth or rough—and experiment with the techniques shown here. The forms you make can be used to create paper sculptures, or can be added to papier-mâché or other sculptural forms.

1. Make a cut partway across circle; overlap and glue to form a cone.

2. Cut tabs at bottom of cone and glue to surface to make it stand or project.

3. Accordion fold, or make folds progressively smaller.

4. Cut triangular or half-circular notches in paper; bend cut pieces upward.

5. Make slots in paper or light cardboard; join pieces by slotting together.

6. Join paper loops by gluing.

7. Slide scissors blade along strips to form curls.

8. Roll paper around pencil to form large curls.

9. Cut crescent shapes; score between points; bend to make forms.

Basic Skills

Whether drawing, painting, making a collage, or sculpting, there are some basic skills that every artist should learn.

Brush Cleaning

Regular and proper brush cleaning is key to ensuring that your brushes last a long time.

- Immediately clean your brush when you change a color or finish a painting. If the brush dries before cleaning, the paint will be difficult to remove and may stain the bristles.

- Most brushes can be cleaned with warm water.

- Try to use most of the paint on the brush before cleaning. Then, wash the brush, wipe excess water on the side of the container, and dry the brush.

Making a Viewfinder

When drawing or painting, a viewfinder can help focus your vision by isolating parts of an artwork or scene.

- You can make a viewfinder by cutting a square or rectangle in a sheet of paper. Use the viewfinder to plan your artwork.

- Look at a scene or subject through a viewfinder to notice shapes formed by the edge of the viewfinder and subject, and to determine which parts of a subject are most interesting.

- You can also construct a viewfinder with two L-shaped pieces of paper or cardboard. By sliding these L shapes together or moving them apart, you can see the shape and proportion of the area around your subject.

Mixing Paint

- Use tempera paint to mix colors.
- Select a disposable palette.
- Mix colors on a large sheet of paper.
- Clean your brush after each use.

Mixing Primary Colors

Mix Red and Blue

- Paint three circles of red.
- Add one drop of blue paint to the first circle. Use your brush to mix. Add two drops of blue paint to the second circle, and mix. Then add three drops of blue paint to the third circle, and mix.

Mix Yellow and Red

- Paint three circles of yellow. Add drops of red, and mix.

Mix Yellow and Blue

- Paint three more circles of yellow. Add drops of blue, and mix.

Mixing Tints

- Paint three circles of white. Add drops of a color, and mix.

Mixing Shades

- Paint three circles of one color. Add drops of black, and mix.

Changing Intensity

- Paint three circles of one color. Leave the first circle alone. Add one drop of the color's complement to the second circle, and mix. Add two drops of the color's complement to the third circle, and mix. Compare intensities.

Making a Grid

Grids are networks of squares formed by horizontal and vertical lines. They can be used to recreate or enlarge an existing artwork. The grid lines help transfer the proportions of the original artwork to the copy or enlargement.

- Use a yardstick or ruler to draw horizontal and vertical lines over your artwork.

- Draw a second grid on another sheet of paper.

- If you are enlarging the artwork, use a larger sheet of paper for the second grid, and make the squares on this grid proportionally larger than the first grid.

- Carefully copy the contents of each square on the first grid into the corresponding squares on the second grid.

Mounting

Any drawings, prints, photos, or paintings you plan to exhibit should be mounted and accompanied with a label that identifies your work. Follow these steps to mount your work:

- Choose a piece of heavy paper or board that is larger than the artwork you will exhibit. Select a color for your mount that will enhance or match the colors in your artwork.

- Center your artwork on the mount.

- Measure the borders to check that they are even.

- Use a pencil to lightly trace the corners of your artwork.

- Apply glue or double-sided tape to the back of your artwork.

- Position your artwork inside the corner marks.

- Press your artwork onto the mount.

- Print a label that includes your name and other information about the artwork, such as title, date, medium, your grade, and the name of your teacher and school.

Making a Mat

A **mat** is a colored piece of board or paper that frames an artwork. The purpose of a mat is to enhance and protect an artwork. You can make a mat for an artwork that you want to display in your home or in your school.

- Choose a colored piece of poster or mat board. Be sure to select a color for your mat that will match the colors in your artwork or make the existing colors stand out.

- On the back of your artwork, draw in light pencil a line ¼" from the edges.

- Find the center point of your art. Lightly draw lines dividing your paper into four equal parts.

- Cut poster or mat board 6" longer and 6" wider than your artwork.

- To find the center of your mat, on the back, draw a vertical line down the middle of the mat. Then draw a horizontal line across the middle. Where the lines intersect is the center.

- Place your artwork face down on the back of the mat board. Line up the pencil lines.

- Attach your art to the mat using several small pieces of tape.

- Trace the corners of your artwork.

- Locate the four points on your artwork where the ¼" guidelines cross. At each point, press a pin through your artwork, into the mat board, and through to the front of the mat to make pinholes in the mat board. Remove the pins and your artwork.

- Place the mat face up on a sheet of cardboard.

- Lay a metal ruler or yardstick between two pinholes and parallel to the mat edge.

- Cut along the edge of the ruler with a sharp mat knife. Repeat, cutting between the other pinholes to create the mat "window."

- Remove the window.

- Place your artwork on the back of the mat over the opening.

- Secure the artwork to the mat with tape. Check that the artwork is straight. Add more tape if necessary.

Photographic Credits

An Introduction to Art

Page xviii

Dome of the Rock, late 7th century. Jerusalem, Israel.

Massachusetts Bay Colony, *Bradford Chair*, 1630. Black ash, seat: wood, 46" x 24" x 19" (116.8 x 61 x 48.3 cm). Pilgrim Society, Pilgrim Hall Museum, Plymouth, MA.

China, Qing dynasty, *Wedding Ensemble*, ca. 1860. Silk with embroidery and couched gold threads; robe: 43" x 38" (109 x 97 cm); skirt: 39" x 46" (99 x 117 cm). Pacific Asia Museum Collection, Gift of Dr. and Mrs. Milton Rubini 80.86.1AB. ©Pacific Asia Museum.

Dorothea Lange, *Migrant Mother, Nipomo, California*, 1936. Gelatin silver print. Reproduced from the Collections of the Library of Congress.

Page xix

Paul Klee, *Fish Magic*, 1925. Oil on canvas, mounted on board, 30 ⅜" x 38 ½" (77.3 x 97.8 cm). Philadelphia Museum of Art, The Louise and Walter Arensberg Collection. Photo by Graydon Wood, 1994 Acc # '50-134-112 © 2000 Artists Right Society (ARS), New York / VG Bild- Kunst, Bonn.

Page xx

David Hockney, *Garrowby Hill*, 1998. Oil on canvas, 60" x 72" (152.4 x 182.9 xm). David Hockney No. 1 Trust.

Diego Rivera, *Learning the ABC's (Alfabetizacion)*, 1923–28. Mural, 6 ¾' x 4 ⁹⁄₅' (2.06 x 1.33 m). Court of Fiestas, Level 3, West Wall. Secretaria de Educacion Publica, Mexico City, D.F., Mexico Photo Credit: Schalkwijk / Art Resource, NY.

Peter Paul Rubens, *Portrait Study of His Son Nicolas*, 1621. Black, red, and white chalk, 25.2 x 20.3 cm. Inv. 17.650. Graphishe Sammlung Albertina, Vienna, Austria. Erich Lessing / Art Resource, NY.

Page xxi

Mongolian (Casas Grandes style), *Macaw Bowl*, Tardio Period, 1300–1350. Earthenware with polychrome slip painting, 5 ¼" x 8" x 6 ¼" (13.3 x 20.3 15.9 cm). Museum of Fine Arts, Houston (Gift of Miss Ima Hogg).

Winold Reiss, *Langston Hughes (1902–1967), Poet*, ca. 1925. Pastel on artist board, 76.3 x 54.9 cm. Gift of W. Tjark Reiss in memory of his father, Winold Reiss. National Portrait Gallery, Smithsonian Institution, Washington, DC / Art Resource, NY.

Anna Mary Robertson Moses, called Grandma Moses, *Summer Party*, 20th century. Oil on masonite, 23 ⁹⁄₁₆" x 15 ¾" (59.9 x 40 cm). The Museum of Fine Arts, Houston; Wintermann Collection of American Art, gift of Mr. and Mrs. David R. Wintermann.

Page xxii

Charles Willson Peale, *The Peale Family*, ca. 1770–73 and 1808. Oil on canvas, 56 ½" x 89 ½" (143.5 x 227.3 cm) Collection of the New York Historical Society (1867.298).

Etruscan, *Chimera of Arezzo*, 6th century BCE. Bronze. Museo Archeologico, Florence, Italy. Scala / Art Resource, New York.

Page xxiii

William H. Johnson, *Soap Box Racing,* ca. 1939–40. Tempera, pen and ink on paper mounted on paperboard, 14 ⅛" x 17 ⅞" (35.9 x 45.5 cm). National Museum of American Art, Smithsonian Institution, Washington, DC / Art Resource, NY.

Page xxiv

China, Tang dynasty, *Tomb Figure of a Saddle Horse*, early 8th century. Earthenware, three- color lead glazes, length: 31 ½" (80.5 cm). Victoria & Albert Museum, London / Art Resource, New York.

Frida Kahlo, *Portrait of Mrs. Christian Hastings*, 1931. Drawing. Fundacion Dolores Olmedo, Mexico City, D. F., Mexico. Photo credit: Schalkwijk/ Art Resource, New York. © Banco de Mexico Trust.

Page xxv

Warren Smith, *Cloak of Heritage*, 1991. Acrylic and collage on canvas, 24" x 36" (61 x 91.4 cm). © 1991 Kevin Warren Smith.

Marsha Burns, *Jacob Lawrence*. Photograph.

Page xxvi

Marc Chagall, *I and the Village*, 1911. Oil on canvas, 75 ⅝" x 5 ⅝". (192 x 151 cm). The Museum of Modern Art, New York/Art Resource, NY. © The Museum of Modern Art/Licensed by SCALA/Art Resource, NY/ARS NY/ADAGP, Paris.

Page xxvii

North American Indian, *Acoma Polychrome Jar.* Museum of Indian Arts and Culture/ Laboratory of Anthropology, Museum of New Mexico. Photograph by Douglas Kahn. (18947/ 12).

Louis Comfort Tiffany, *Dragonfly Lamp*, ca. 1900. Bronze base with color favrile glass, 28" x 22" (71.2 x 55.9 cm). Collection of the New York Historical Society (N84.113).

Page xxviii

Vincent van Gogh, *The Starry Night,* 1889. Oil on canvas, 29" x 36 ¼" (73.7 x 92.1 cm). Acquired through the Lillie P. Bliss Bequest. Museum of Modern Art, New York. © The Museum of Modern Art/Licensed by SCALA /Art Resource, NY.

Page xxix

Claude Monet, *Japanese Footbridge and the Water Lily Pond, Giverny*, 1899. Oil on canvas, 35 ⅛" x 36 ¾" (89.2 x 93.3 cm). Philadelphia Museum of Art: The Mr. and Mrs. Carroll S. Tyson, Jr. Collection.

Cathedral of St. Basil, 1554–1566. Moscow.

Japan, Momoyama period (1568–1615), *Ewer for Use in Tea Ceremony*, early 17th century. Shino-Oribe ware. Stoneware with overglaze enamels, 7 ¾". (19.7 cm) high. The Metropolitan Museum of Art, Purchase, Friends of Asian Art Gifts, 1988 (1988.156ab). Photograph © 2001 The Metropolitan Museum of Art.

Rosa Bonheur, *Ploughing in the Nivernais,* 1849. Oil on canvas, 52 ½" x 102" (133.4 x 259.1 cm). Musee d'Orsay, Paris, France. Photo Credit: Réunion des Musées Nationaux / Art Resource, NY

Thomas Cole, *View on the Catskill, Early Autumn*, 1837. Oil on canvas, 39" x 63" (99 x 160 cm). The Metropolitan Museum of Art, New York, gift in memory of Jonathan Sturges by his children, 1895.

Page xxx

Sakino Hokusai IITSU, *Fukagawa Mannembashi*, from *36 Views of Mt. Fuji*, 1830. Multiple block wood blockprint, 10 ¼" x 15" (26 x 38 cm). Courtesy The Japan Ukiyo-e Museum.

Faith Ringgold, *The Wedding Lover's Quilt No. 1*, 1986. Acrylic on canvas, quilted with pieced border, 77 ½" x 58" (196.9 x 147.3 cm). Private collection. © Faith Ringgold, 1986.

Miriam Schapiro, *Master of Ceremonies*, 1985. Acrylic on fabric on canvas, 90" x 144" (228.6 x 365.8 cm). Collection of Elaine and Stephen Wynn. Courtesy of the Steinbaum Krauss Gallery, New York, New York.

Alberto Giacometti, *Three Men Walking*, 1948–49. Bronze, height: 29 ½" (74.9 cm). Edward E. Ayer Endowment in memory of Charles L. Hutchinson, 1951.256. Photograph courtesy The Art Institute of Chicago. © 2000 Artist Rights Society (ARS), New York/ ADAGP, Paris.

Page xxxi

I. M. Pei, *Addition to the Louvre*, 1988. Glass, steel rods, and cable, I. M. Pei, Paris, France.

Makonde, Tanzania, *Family Group*, 20th century. Wood, 31" (78.7 cm). Gift of Nancy Gray, Collection Bayly Art Museum of the University of Virginia, Charlottesville. (1981.94.75)

Anne Coe, *Migrating Mutants*, 1986. Acrylic on canvas, 61" x 61" (154.9 x 154.9 cm). Horwitch Newman Gallery, Scottsdale, Arizona. Courtesy of the artist.

Page xxxii

Paul Cézanne, S*till Life with Apples and Peaches*, ca. 1905. Oil on canvas, 31 ⅞" x 39 ½" (81 x 100.5 cm). © National Gallery of Art, Washington, Gift of Eugene and Agnes Meyer.

Page xxxiii

Student artwork.

Student Handbook

Page 276

Romaine Brooks, *The Soldier at Home*, 1930. Pencil on paper, 9 ⁹⁄₁₆" x 7 ⅛" (24 x 18 cm). Gift of Romaine Brooks. Smithsonian American Art Museum, Washington, DC/Art Resource, NY.

Page 277

Niki de Saint Phalle and Jean Tinguely, *Illumination*, 1988. Mobile sculpture, mixed media, height: 9' (2.75 m). Courtesy Galerie Bonnier, Genevia. © 2001 Artists Rights Society (ARS), New York/ADAGP, Paris.

David Hockney, *Garrowby Hill*, 1998. Oil on canvas, 60" x 72" (152.4 x 182.9 cm). David Hockney No. 1 Trust.

Page 277

Africa, Dan Culture (Liberia, Ivory Coast), *Ga-Wree-Wre-Mask*, 20th century. Wood, metal, fiber, cowrie shells, glass beads, brass, bone, hand-woven cloth, 47" x 16" x 22" (119.4 x 40.6 x 55.9 cm). Virginia Museum of Fine Arts, Richmond. The Adolph D. and Wilkins C. Williams Fund. Photo: Katherine Wetzel. © Virginia Museum of Fine Arts.

Page 278

Caryl Bryer Fallert, *Refraction #4–#7*. Hand-dyed cotton fabric, machine pieced and quilted, 88" x 88" (224 x 224 cm). Courtesy of the artist.

Page 280

René Magritte, *The Listening Room,* ca. 1958. Oil on canvas 15" x 18" (38 x 46 cm). Kunsthaus, Zürich, donated by Walter Haefner. Photo AKG London. ©2001 C. Herscovici, Brussels/Artists Rights Society (ARS), New York.

Page 281

Frances Hare, *Sixteen Feet of Dance: A Celebration, A Self-Portrait,* 1996. Cotton fabrics, beads, braided cloth, 69" x 56" (175.2 x 152.2 cm). Courtesy the artist.

Page 282

Doug Webb, *Kitchenetic Energy,* 1979. Acrylic on linen, 30" x 40" (76.2 x 101.6 cm). Courtesy of the artist.

Page 283

Omri Amrany & Julie Rotblatt-Amrany, *The Spirit, Michael Jordan,* 1994. Bronze, height (including base): 16' (5 m) United Center, Chicago, Illinois.

Clara Peeters, *Still Life of Fruit and Flowers,* after 1620. ©Ashmolean Museum, University of Oxford.

Page 284

Marvin Mattelson (illustrator), *Subway Poster for School of Visual Arts.* Art Director: Silas H. Rhodes; Designer: William J. Kobasz; Copywriter: Dee Ito.

"*Tableware*", Bloomimage/CORBIS

Page 285

Art on File/CORBIS

Brand X/CORBIS

Page 286

Lascaux, *Hall of Bulls,* detail, c. 15,000–13,000 BC, Dordogne, France. Color photo Hans Hinz.

Giza, Egypt, *The Pyramids of Mycerinus, Chefren, and Cheops,* built between 2589 and 2350 BC. Limestone. Erich Lessing/Art Resource, NY.

Ancient Greece, Athens (attributed to the Antimenes painter), *Hydria,* c. 530–510 BC. Black-figure earthenware, height: 16 5/8" (42.2 cm). Cleveland Museum of Art. Purchase from the J. H. Wade Fund. 1975.1.

Page 287

Augustus of Prima Porta, Roman Sculpture, Early first century AD. Vatican Museums, Vatican State. Scala/Art Resource, New York.

The Archangel Michael with Sword, Byzantine, 11th century. Gold, enamel, and precious stone. Framed icon. Tesoro San Marco, Venice. Cameraphoto/Art Resource, New York.

Chi-rho Gospel of St. Matthews, chapter 1, verse 18, Irish (vellum). *Book of Kells,* c. 800. The Board of Trinity College, Dublin, Ireland/Bridgeman Art Library.

Bayeux Tapestry, William preparing his troops for combat with English Army. Musée de la Tapisserie, Bayeux, France. Giraudon/Art Resource, New York.

Page 288

North Transept Rose and Lancet Windows (Melchizedek & Nebuchadnezzar, David & Saul, St. Anne, Solomon & Herod, Aaron & Pharaoh), 13th century. Stained glass, 42' (12.8 m) Diameter. Chartres Cathedral, France. Scala/Art Resource, New York.

Michelangelo Buonarroti, *Pietà,* 1499. Marble, height: 5' 6" (1.7 cm). St. Peter's Basilica, Vatican State. Scala/Art Resource, New York.

Judith Leyster, *Game of Tric-Trac,* c. 1630. Oil on panel, 16" x 12 1/4" (40.7 x 31.1 cm). Worcester Art Museum, Worcester, Massachusetts. Gift of Robert and Mary S. Cushman.

Page 289

Movement made by Charles Voisin and Chantilly manufactory, *Wall Clock,* c. 1740. Soft-paste porcelain, enameled metal, gilt-bronze, and glass, 29 1/2" x 14" x 4 3/8" (74.9 x 35.6 x 11.1 cm). The J. Paul Getty Museum, Los Angeles.

Jacques-Louis David, *Oath of the Horatii,* 1784–85. Oil on canvas, 129 11/12" x 167 5/16" (330 x 425 cm). Louvre, Paris, France. Erich Lessing/Art Resource, New York.

Eugène Delacroix, *Horses Coming Out of the Sea,* 1860. Oil on canvas, 20 1/4" x 24 1/4" (5.4 x 61.5 cm). The Phillips Collection, Washington, DC. (0486).

Page 290

Honoré Daumier, *The Third Class Carriage,* ca. 1863–65. Oil on canvas, 25 3/4" x 35 1/2" (65.4 x 90.2 cm). National Gallery of Canada, Ottawa. Purchased 1946.

Pierre-Auguste Renoir, *The Garden in the Rue Cortot, Montmarte,* 1876. Oil on canvas, 59 3/4" x 38 3/8" (151.8 x 97.5 cm). Carnegie Museum of Art, Pittsburgh. Acquired through the generosity of Mrs. Alan M. Scaif, 65.35. Photography by Peter Harholdt.

Pablo Picasso, *Three Muscians,* Fontainebleu, summer 1921. Oil on canvas, 6' 7" x 7' 3 3/4" (22.07 x 222.9 cm). The Museum of Modern Art, New York. Mrs. Simon Guggenheim Fund. Photograph ©2000 The Museum of Modern Art, New York. ©2000 Estate of Pablo Picasso/Artists Rights Society (ARS), New York.

Page 291

Salvador Dalì, *The Persistence of Memory,* 1931. Oil on canvas, 9 1/2" x 13" (24.1 x 33 cm). The Museum of Modern Art, New York. Given anonymously. Photograph ©2000 The Museum of Modern Art, New York. ©2000 Artists Rights Society (ARS), New York.

Jackson Pollock, *Blue Poles,* 1952. Enamel and aluminum paint with glass on canvas. 6' 10 7/8" x 15' 11 5/8" (212.09 x 488.95 cm). Collection: National Gallery of Australia, Canberra (NGA Acc. No. 74.264). © The Pollock-Krasner Foundation/Artists Rights Society (ARS), New York.

Claes Oldenburg and Coosje van Bruggen, *Spoonbridge and Cherry,* 1988. Aluminum painted with polyurethane enamel and stainless steel, 29'6" x 51'6" x 13'6" (9 x 15.7 x 4.1 m). Minneapolis Sculpture Garden, Walker Art Center, Minneapolis, Photography by Attilio Maranzano. Courtesy of the artists.

Andy Goldsworthy, *The coldest I have ever known in Britain/as early/worked all day/reconstructed icicles around a tree/finished late afternoon/catching sunlight, Glenn Marlin Falls, Dumfriesshire, 28 december 1995,* 1995. Cibachrome print, 23" x 19" (58 x 48.3 cm) square. Galerie Lelong, New York, New York. Courtesy of Private Collector, New York.

Page 300

Emile Nolde, *Summer Flowers,* 1930. Watercolor painting.

Winslow Homer, *Sunshine and Shadow, Prout's Neck,* 1984. Watercolor painting.

Artist Guide

Affandi (ah-FAHN-dee) Indonesia, 1907–1991, p. 232

Anasazi artists (ah-nah-SAH-zee), also called Ancestral Puebloan, Southwestern US, 100–1600 CE, p. 50

Ancient Egyptian artists Egypt, 3000–500 BCE, pp. 2, 8, 10, 13, 18–19, 29

Ancient Greek artists, Greece, 600–150 BCE, pp. 46–47, 55

Ancient Roman artists Roman Empire, 753 BCE–476 CE, pp. 47–48, 58

Anguissola, Sofonisba (ahng-gwee-SOH-lah, soh-fahn-EEZ-bah) Italy, 1527–1625, p. 100

Asante artists (ah-SAHN-tee) Ghana, p. 20

Assyrian (uh-SEER-ee-an) Mesopotamia, 1365–609 BCE, pp. 9, 25

Atget, Eugène (ah-zhay, ooh-zhen) France, 1857–1927, p. 228

Bancroft, Bronwyn (BAN-kroft, BRON-win) Australia, b. 1958, p. 261

Bartlett, Jennifer US, 1941, p. 243

Bayer, Herbert (BAY-uhr) Austria, 1900–1985, p. 220

Bearden, Romare (BEER-den, roh-MAIR) US, 1912–1988, p. 235

Bernini, Gianlorenzo (bair-NEE-nee, jahn-low-RENS-oh) Italy, 1598–1680, p. 179

Besler, Basil (BEZ-luhr, BAH-seel) Germany, 1561–1629, p. 209

Boffrand, Germain (buh-fron, zhair-mah) France, 1667–1754, p. 137

Bonheur, Rosa (bon-ERR) France, 1822–1899, p. 153

Brancusi, Constantin (bran-COO-zee, CON-stan-tin) Romania, 1876–1956, p. 216

Bruegel, Pieter (BRUE-gl, PEE-ter) Flanders, ca. 1525–1569, p. 98

Buonarroti, Michelangelo (bwone-uh-RAH-tee, my-kell-ANN-jell-oh) Italy, 1475–1564, pp. 106, 108–109

Byzantine artists (BIZ-ann-teen) Southern Europe, Northern Africa, Asia Minor, 474–1453, pp. 40, 48–49

Cahuilla artists (kuh-WEELAH) Native American, California, US, p. 52

Canale, Giovanni Antonio (can-AHL-lay, joe-VAH-nee ann-TOE-nee-oh) Italy, 1697–1768, p. 156

Cassatt, Mary (cah-SAHT) US, 1844–1926, p. 196

Chand, Nek India, active 2000s, p. 249

Chardin, Jean-Baptiste Siméon (shar-DA, zhahn bah-TEEST-see-may-ON) France, 1699–1779, p. 129

Chen, Georgette (chenn, gyor-gyett) Singapore, 1906–1993, p. 233

Choctaw artists (TCHOK-taw) US, p. 53

Choson period Korea, 1700s, p. 112

Christo and Jeanne-Claude (kriss-toe, zhahn-klawd) Bulgaria and Morocco, both b. 1935, p. 242

Colima artists (ko-LEE-ma) Mexico, 200 BCE–500 CE, p. 93

Colson, Jaime (COAL-sun, JAY-mee) Dominican Republic, 1901–1975, p. 151

Constable, John England, 1776–1837, p. 155

D.A.ST. Arteam (Stella Constandinidis, Danae and Alexandra Stratou) Greece, active late 1900s–present, p. 259

da Vinci, Leonardo (dah VIN-chee, lay-oh-NAR-doh) Italy, 1452–1519, p. 107

Dalí, Salvador (DAH-lee, SAHL-vah-door) Spain, 1904–1989, p. 227

Dancer, Daniel US, b. ca. 1945, p. 259

Daumier, Honoré (doe-mee-ay, on-noh-ray) France, 1808–1879, pp. 168–169

David, Jacques-Louis (dah-veed, zjahk-loo-ee) France, 1748–1825, p. 166

de Heem, Davidsz Jan (duh HAYM, dah-VIDS yahn) Netherlands 1606–1684, p. 133

de Hooch, Pieter (duh-HOKE, PEET-ur) Netherlands, 1629–1684, p. 150

Degas, Edgar (day-GAH, ed-GAHR) France, 1834–1917, p. 197

Delacroix, Eugène (dul-la-kwah, oo-zhen) France, 1798–1860, p. 168

Delaunay, Sonia Terk (duh-lawn-ay, sohn-yah turk) France, 1885–1979, p. 229

della Francesca, Piero (deh-lah-frahn-CHESS-kah, PYAIR-oh) Italy, ca. 1410–1492, p. 115

Merian, Maria Sibylla (MAIR-ee-an, mah-REE-ah sih-BILL-ah) Germany, 1647–1717, p. 183

Metzelaar, L. (MEH-tzeh-lahr) Indonesia, 1900s, p. 231

Millet, Jean-François (mee-LAY, zhahn fran-SWAH) France, 1814–1875, p. 181

Ming Dynasty China, 1368–1644, pp. 111–112

Mochica (Moche) (moh-CHEEK-ah) Coastal Peru, 250–550 CE, p. 145

Monet, Claude (moh-nay, kload) France, 1840–1926, p. 188

Moran, Thomas US, 1837–1926, p. 184

Morisot, Berthe (moh-ree-ZOH, bairt) France, 1841–1895, p. 182

Mosan School Europe, 1000s–1100s, p. 73

Murray, Elizabeth US, 1940–2007, p. 241

Myron Greece, 400s BCE, p. 34

Nabageyo, Bruce (nah-bah GAY-oh) Australia, b. 1949, p. 172

Nahl, Charles Christian US, 1818–1878, p. 238

Nalo, Joe (NAH-loh) Papua New Guinea, active 2000s, p. 157

Navajo artists (NAH-vah-ho) Southwestern US, pp. 213, 217, 240

Nevelson, Louise (NEHV-ell-sun) Russia, 1899–1988, p. 223

Niu Ailand People (nee-yew EYE-land) New Ireland (Papua New Guinea), p. 154

Nok artists Nigeria, p. 22

Nuu-Chah-Nulth artists (noo-CHA-nuhl) Canada, p. 51

O'Keeffe, Georgia (oh-KEEF) US 1887–1986, p. 215

Okakoto (oh-kah-koh-toh) Japan, early 1800s, p. 201

Ortakales, Denise (or-TAH-kah-leez) US, b. 1958, p. 205

Papunya (pah-POON-ya) Australia, Aboriginal, 1971–present, p. 173

Paracas (pah-ROCK-us) Peru, 900 BCE–400 CE, p. 141

Park, Jae Hyun (pahrk, jah-ee yuhn) Korea, b. 1960, p. 262

Peeters, Clara Flanders, 1594–1657, p. 130

Peláez, Amelia (pay-LAH-ess) Cuba, 1897–1968, p. 140

Picasso, Pablo (pee-KAHS-oh, PAH-blo) Spain, 1881–1973, pp. 102–103, 228

Pickering, Mary Carpenter US, 1831–1900, p. 125

Qing Dynasty (ching) China, 1800s, pp. 37, 163

Quick-to-See Smith, Jaune (zhon) US, b. 1940, p. 261

Renoir, Pierre-Auguste (ren-wahr, pee-air oh-goost) France, 1841–1919, p. 197

Ringgold, Faith US, b. 1934, p. 152

Rivera, Diego (ree-VAY-rah, de-AY-goh) Mexico, 1886–1957, pp. 142–143

Romanesque Europe, 900s–1100s, p. 78

Rubins, Nancy US, b. 1950, p. 246

Saar, Alison (SAHR) US, b. 1956, pp. 43, 61

Sa'di (SAH-dee) Persia, 1213–1291, p. 6

Sanzio, Raphael (SAHN-zee-oh, RAH-fie-ell) Italy, 1483–1520, pp. 94, 121

Savage, Augusta US, 1892–1962, p. 212

Sayyid-Ali, Mir (sigh-ID ah-LEE, meer) Persia, active ca. 1525–1543, p. 92

Schapiro, Miriam (shah-PEER-roh, MEER-ee-ahm) US/Canada, b. 1923, p. 253

Scharf, Kenny (shahrf) US, b. 1958, p. 258

Schiltz, Rand (shilts) US, b. 1950, pp. 7, 31

Seurat, Georges (suh-rah, zjorzj) France, 1859–1891, p. 198

Sewell, Leo (sue-ell) US, b. 1945, p. 223

Shang Dynasty China, ca. 1600–1045 BCE, p. 110

Sikander, Shahzia (see-KAN-der, shaw-zee-aah) Pakistan, b. 1969, pp. 262–263

Siqueiros, David Alfaro (see-KAYR-ohss, DAY-vid al-FAR-oh) Mexico, 1896–1974, p. 91

Smith, Mimi US, b. 1942, p. 39

Soami (soh-ah-mee) Japan, 1472–1525, p. 186

Sotatsu, Tawaraya (soh-aht-soo, tah-wah-rah-yah) Japan, active 1620s–1640s, p. 208

Stahlecker, Karen (STAH-leck-ur) US, b. 1954, p. 73

Stein, Lydia US, b. ca. 1988, p. 66

Stella, Frank US, b. 1936, p. 253

Stockholder, Jessica US, b. 1959, p. 271

Suh, Do-Ho (sue, doh-hoh) South Korea, b. 1962, p. 271

Sumerian artists (soo-MARE-ee-an) Mesopotamia, 3500–2000 BCE, p. 17

Glossary

abstract art Art that is based on a subject you can recognize, but the artist simplifies, leaves out, or rearranges some elements so that you may not recognize them. (*arte abstracto*)

actual texture The way a surface feels to the sense of touch. Textures are described by words such as rough, silky, pebbly. (*textura táctil*)

additive process Sculptural process in which material (clay, for example) is added to create form. In a subtractive process, material is carved away. (*proceso aditivo*)

appliqué (*ah-plee-kay*) A process of stitching and/or gluing cloth to a background, similar to collage. (*aplicación*)

architectural floor plan A diagram of a building, or group of buildings, seen from above. (*diagrama de planta arquitectónica*)

armature A system of support, similar to a skeleton, used to make a sculpture. (*armadura*)

assemblage (*ah-SEM-blij*) A three-dimensional work of art consisting of many pieces joined together. A sculpture made by joining many objects together. (*ensamblaje*)

asymmetrical (*ay-sim-MET-tri-kal*) A type of visual balance in which the two sides of the composition are different yet balanced; visually equal without being identical. Also called informal balance. (*asimétrico*)

atmospheric color (*at-mos-FER-ik*) Colors in nature that seem to change as natural light changes. (*color atmosférico*)

atmospheric perspective (*at-mos-FER-ik per-SPEK-tiv*) A way to create the illusion of space in an artwork, based on the observation that objects look more muted and less clear the farther they are from the viewer. (*perspectiva atmosférica*)

background Parts of artwork that appear to be in the distance or behind the objects in the foreground or front. (*fondo*)

balance A principle of design that describes how parts of an artwork are arranged to create a sense of equal weight or interest. An artwork that is balanced seems to have equal visual weight or interest

in all areas. Types of balance are symmetrical, asymmetrical, and radial. *(equilibrio)*

Baroque *(bah-ROKE)* 1600–1700. An art history term for a style marked by swirling curves, many ornate elements, and dramatic contrasts of light and shade. Artists used these effects to express energy and strong emotions. *(barroco)*

bas-relief *(bah ree-LEEF)* Also called low relief. A form of sculpture in which portions of the design stand out slightly from a flat background. *(bajorrelieve)*

caricature *(cah-ri-CAH-chur)* A picture in which a person's or an animal's features, such as nose, ears, or mouth, are different, bigger, or smaller than they really are. Caricatures can be funny or critical and are often use in political cartoons. *(caricatura)*

center of interest The part of an artwork which attracts the viewer's eye. Usually the most important part of a work of art. *(foco de atención)*

color scheme A plan for selecting or organizing colors. *(gama de color)*

color wheel A circular chart made up of primary, secondary, and intermediate colors. *(círculo cromático)*

complementary colors *(com-ple-MEN-tah-ree)* Colors that are directly opposite each other on the color wheel, such as red and green, blue and orange, and violet and yellow. When complements are mixed together, they make a neutral brown or gray. When they are used next to each other in a work of art, they create strong contrasts. *(complementarios)*

concertina *(con-ser-TEE-nah)* A type of book made from a long strip of paper that is folded accordion-style to form the pages. *(concertina)*

continuity *(con-tin-OO-ih-tee)* To carry on, as a tradition or a custom. *(continuidad)*

contour line A line which shows or describes the edges, ridges, or outline of a shape or form. *(línea contorna)*

contrast A principle of design that refers to differences in elements such as color, texture, value, and shape. Contrasts usually add excitement, drama, and interest to artworks. *(contraste)*

crest In many North American communities, a grouping of totems used to show the identity of a tribe or family group. *(poste totémico)*

Cubism 1907–1914. An art history term for a style, developed by Pablo Picasso and Georges Braque, in which subject matter is broken up into geometric shapes and forms, and objects seem to be shown from many different points of view at once. *(cubismo)*

cultural meaning Meaning that only the members of a specific culture or cultural group can understand. *(significado cultural)*

cuneiform *(kew-NAY-i-form)* Early form of writing, developed in Mesopotamia ca. 3000 BCE, made up of wedge-shaped symbols pressed into clay. *(cuneiforme)*

document *(DOK-you-ment)* To make or keep a record of. *(documentar)*

earthwork Any work of art in which land and earth are important media. Often, large formations of moved earth, excavated by artists in the surface of the earth, and best viewed from a high vantage point. *(obras de tierra)*

elevation drawing A drawing that shows the external faces of a building. It can also be a side or front view of a structure, painted or drawn to reveal each story with equal detail. *(plano de alzado)*

emboss To create a mark or indentation by pressing objects into a soft surface, such as clay. *(grabar o tallar en relieve)*

emphasis Area in a work of art that catches and holds the viewer's attention. This area usually has contrasting sizes, shapes, colors or other distinctive features. *(acentuación)*

Expressionism 1890–1920. A style of art which began mostly in Germany but spread to other parts of Europe. The main idea in expressionist artworks is to show strong mood or feeling. *(expresionismo)*

fan A type of book whose pages—usually strips of paper—are loosely bound at one end. *(abanico)*

Fauves *(fohvz)* 1905–1907. A group of painters who used brilliant colors and bold exaggerations in surprising ways. *(fauvistas)*

fiber artist An artist who uses long, thin, thread-like materials to create artwork. *(artista de fibra)*

fields Large areas or shapes. *(campos)*

foreground In a scene or artwork, the part that seems closest to you. *(primer plano)*

form An element of design; any three-dimensional object such as a cube, sphere, pyramid, or cylinder. A form can be measured from top to bottom (height), side to side (width) and front to back (depth). Form is also a general term that means the structure or design of a work. *(forma)*

genre scene *(ZHAHN-ruh)* A scene or subject from everyday life. *(escena costumbrista)*

geometric shapes/forms Shapes and forms that are regular in outline. Geometric shapes include circles, squares, rectangles, triangles, and ellipses. Geometric forms include cones, cubes, cylinders, slabs, pyramids, and spheres. *(figures geométricas)*

Gothic art 1100–1400. A style of art in Europe that emphasized religious architecture and featured pointed arches, spires, and verticality. *(arte gótico)*

handscroll A long, horizontal painting. *(makemono)*

hanging scroll A long, vertical painting. *(kakemono)*

hieroglyph *(HAHY-er-uh-glif)* A picture or symbol used in writing instead of a word; the system was first used in ancient Egypt. *(símbolo jeroglífico)*

horizon line A level line where water or land seem to end and the sky begins. It is usually on the eye level of the observer. If the horizon cannot be seen, its location must be imagined. *(línea de horizonte)*

ideal A view of what the world and people would be like if they were perfect. *(ideal)*

identity The distinguishing traits or personality of a person or individual. *(identidad)*

illuminated manuscript A decorated or illustrated manuscript, popular during the medieval period, in which the pages are often painted with silver, gold and other rich colors. *(manuscrito iluminado)*

implied space The appearance of three-dimensional space in a two-dimensional artwork. *(espacio implícita)*

implied texture The way a surface appears to look, such as rough or smooth. *(textura implícita)*

Impressionism 1875–1900. A style of painting that began in France. It emphasized views of subjects at a particular moment and the effects of sunlight on color. *(impresionismo)*

installation art Art that is created for a particular site. *(arte de instalación)*

line A mark with length and direction, created by a point that moves across a surface. A line can vary in length, width, direction, curvature and color. Line can be two-dimensional (a pencil line on paper), three-dimensional (wire), or implied. *(línea)*

linear perspective *(lin-EE-er per-SPEK-tiv)* A technique used to show three-dimensional space on a two-dimensional surface. *(perspectiva lineal)*

maquette *(mah-KET)* A small-scale model of a larger sculpture. *(maqueta)*

media The material artists use to make their works. *(medios)*

middle ground Parts of an artwork that appear to be between objects in the foreground and the background. *(segundo plano)*

migration The movement of groups from one continent to another. *(emigró)*

model To shape clay by pinching and pulling. *(modelar)*

montage *(mahn-TAHZH)* A special kind of collage, made from pieces of photographs or other pictures. *(montaje)*

mosaic *(mo-ZAY-ik)* Artwork made by fitting together tiny pieces of colored glass or tiles, stones, paper or other materials. These small materials are called tesserae. *(mosaico)*

motif *(moh-TEEF)* A single or repeated design or part of a design or decoration that appears over and over again. *(motivo)*

mudras *(muh-DRA)* Symbolic hand gestures, often associated with Buddha in the Buddhist religion. *(mudra)*

mural *(MYOR-ul)* A large painting or artwork, usually designed for and created on the wall or ceiling of a public building. *(mural)*

narrative *(NAR-ah-tiv)* Depicting a story or idea. *(narrativa)*

negative shape/space The empty space surrounding shapes or solid forms in a work of art. *(forma o espacio negativo)*

Neoclassicism 1750–1875. A style of art based on interest in the ideals of ancient Greek and Roman art. These ideals were used to express ideas about beauty, courage, sacrifice, and love of country. *(neoclasicismo)*

nonobjective art A style of art that does not have a recognizable subject matter; the subject is the composition of the artwork. Nonobjective is often used as a general term for art that contains no recognizable subjects. Also known as non-representational art. *(arte no figurativo)*

organic shapes Shapes that are irregular in outline, such as things in nature. *(formas orgánicas)*

overlapping Covering part of one object by placing another object in front of it. Objects that overlap others seem closer than whatever is covered up. *(traslapar)*

patron *(PAY-trun)* A wealthy or influential person or group that supports artists. *(mecenas)*

pattern A choice of lines, colors or shapes, repeated over and over in a planned way. A pattern is also a model or guide for making something. *(patrón)*

perspective *(per-SPEK-tiv)* Techniques for creating a look of depth on a two-dimensional surface. *(perspectiva)*

porcelain *(POR-suh-len)* Fine white clay, made primarily of kaolin; also an object made of such clay. Porcelain may be decorated with mineral colorants under the glaze or with overglaze enamels. *(porcelana)*

positive shape/space The objects in a work of art, not the background or the space around them. *(forma o espacio positivo)*

Post-Impressionism 1880–1900. An art history term for a period of painting immediately following Impressionism in France. Various styles were explored, especially by Cézanne (basic structures), van Gogh (emotionally strong brushwork), and Gauguin (intense color and unusual themes). *(postimpresionismo)*

pre-Columbian art 7000 BCE to about 1500 CE. An art history term for art created in North and South America before the time of the Spanish conquests. *(arte precolombino)*

prehistoric people Those who lived before the time of written records. *(personas prehistóricas)*

proportion The relation of one object to another in size, amount, or number. Proportion is often used to describe the relationship between one part of the human figure and another. *(proporción)*

radial A kind of balance in which lines or shapes spread out from a center point. *(radial)*

Realism 1850–1900. A style of art that shows places, events, people, or objects as the eye sees them. Realist artists did not use the formulas of Neoclassicism or the drama of Romanticism. *(realismo)*

Realist Artist who thinks art should be about places and things they see every day. *(realista)*

relief print A print made by inking the raised surface of a block or plate. *(grabado en relieve)*

replica A copy of an item. *(replica)*

rhythm A type of visual or actual movement in an artwork. Rhythm is a principle of design created by repeating visual elements. Rhythms are often described as regular, alternating, flowing, progressive, or jazzy. *(ritmo)*

Rococo *(roh-coh-COH)* 1700–1800. A style of art that began in the luxurious homes of the French nobility and spread to the rest of Europe. It included delicate colors, delicate lines, and graceful movement. Favorite subjects included romance and the carefree life of the aristocracy. *(rococo)*

Romanesque *(roh-man-esk)* 1000–1200. A style of architecture and sculpture, influenced by Roman art, that developed in western Europe during the Middle Ages. Cathedrals had heavy walls, rounded arches, and sculptural decorations. *(románico)*

Romanticism *(ro-MAN-ti-sizm)* 1815–1875. A style of art that developed as a reaction against Neoclassicism. Themes focused on dramatic action, exotic settings, adventures, imaginary events, faraway places and strong feelings. *(romanticismo)*

round arch A curved architectural element that crosses over an opening. *(arco de medio punto)*

scale The size relationship between two sets of dimensions. For example, if a picture is drawn to scale, all its parts are equally smaller or larger than the parts in the original. *(escala)*

scroll A decorative motif made up of several spiral or convoluted forms, resembling the cross-section of a loosely rolled strip of paper; also, a curved ornamental molding common in medieval work. *(voluta)*

self-portrait Any work of art in which an artist shows himself or herself. *(autorretrato)*

shading A gradual change in value used to show the shift from light areas to dark ones. Shading is a way of making a picture appear more realistic and three-dimensional. *(sombreado)*

shape A flat figure created when actual or implied lines meet to surround a space. A change in color or shading can define a shape. Shapes can be divided into several types: geometric (square, triangle, circle) and organic (irregular in outline). *(forma)*

simplify To create less detail in certain objects or areas of an artwork in order to highlight other areas. To reduce the complex to its most basic elements. *(simplificar)*

spectrum *(SPEK-trum)* The entire range of colors created from white light. *(espectro)*

stele *(stee-lee)* An upright slab, bearing sculptured or painted designs or inscriptions. From the Greek for "standing block." *(estela)*

still life Art based on an arrangement of objects that are not alive and cannot move, such as fruit, flowers, or bottles. The items are often symbols for abstract ideas. A book, for example, may be a symbol for knowledge. A still life is usually shown in an indoor setting. *(naturaleza muerta)*

stupa *(STEW-pah)* A hemispherical or cylindrical mound or tower artificially constructed of earth, brick, or stone, surmounted by a spire or umprella, and containing a relic chamber. *(estupa)*

Surrealist An artist for whom dreams, fantasy, and the human mind are sources for ideas. *(surrealista)*

symbol Something that stands for something else; especially a letter, figure or sign that represents a real object or idea. A red heart shape is a common symbol for love. *(símbolo)*

symmetrical *(sim-MET-ri-kal)* A type of balance in which both sides of a center line are exactly or nearly the same, like a mirror image. For example, the wings of a butterfly are symmetrical. Also known as formal balance. *(simétrico)*

tesserae *(TESS-er-ah)* Small pieces of glass, tile, stone, paper, or other materials used to make a mosaic. *(teselas)*

texture The way a surface feels (actual texture) or how it may look (implied texture). Texture can be sensed by touch and sight. Textures are described by words such as rough, silky, pebbly. *(textura)*

tint A light value of pure color, usually made by adding a color to white. For example, pink is a tint of red. *(matiz claro)*

totem *(TOH-tem)* An object that serves as a symbol of a family, person, idea, or legend. *(tótem)*

totem pole A tall wooden structure with totems carved into it. *(poste tótemico)*

triptych *(TRIP-tick)* An altarpiece consisting of three panels joined together. Often, the two outer panels are hinged to close over the central panel. *(tríptico)*

unity A feeling that all parts of a design are working together as a team. *(unidad)*

value An element of art that means the darkness or lightness of a surface. Value depends on how much light a surface reflects. Tints are light values of pure colors. Shades are dark values of pure colors. Value can also be an important element in works of art in which there is little or no color (drawings, prints, photographs, most sculpture and architecture). *(valor)*

vanishing point In a perspective drawing, one or more points on the horizon where parallel lines that go back in space seem to meet. *(punto de fuga)*

variety The use of different lines, shapes, textures, colors, and other elements of design to create interest in a work of art. *(variedad)*

Index

Italicized page numbers refer to artworks.

Italicized page numbers refer to artworks.

Millet, Jean-François (France), *The Gleaners*, 181, *181*
model, 24
modeling, 24
Model of a Ball Game, 141
Monet, Claude (France)
 Grainstack (Sunset), 188, *189*
 Japanese Footbridge and the Water Lily Pond, Giverny, *xxix*
Moneylender and His Wife, The, Matsys, Quentin (Belgium), *108*
monoprint, 229, 303
montage, 234, 240. *See also* collage
mood, 8, 28, 96, 128, 163, 184, 190–191
Moran, Thomas (United States), *Grand Canyon*, 184, *209*
Morisot, Berthe (France), *Girl in a Boat with Geese*, *182*
mosaic, 38, 60
Mosan, *Stavelot Triptych*, *73*
Moses, Anna Mary Robertson, called Grandma Moses (United States), *Summer Party*, *xxi*
Mosque in Kuala Lumpur, Chen, Georgette (Singapore), *233*
motif, 10, 172
Mountain Landscape, *163*
movement, 136. *See also* principles of design
mudras, 81
murals, 67, 90
Murray, Elizabeth (United States), *Stirring Still*, 241, *241*
museum curator, 269
music, 118, 178, 208, 238
Myron of Athens, *Discobolus*, *34*

N
Nabageyo, Bruce (Australia), *The Rainbow Serpent at Gabari*, *172*
Nahl, Charles Christian (United States), *Saturday Night at the Mines*, *238*
Nalo, Joe (New Zealand), *The Legend of Leip Island*, 156, *157*
Narasimha: Lion Incarnation of Vishnu (India), *80*
narrative art, 6
Nataraja (Hindu god Siva), *82*
Native North American art, 50–53, 55. *See also* North American art
 Basket with rattlesnake design, *52*
 Eskofatshi, *53*
 Kwakiutl peoples, *34*
 Mask of a diving loon, *52*
 Northwest Coast artists, 35, 51
 Seed Jar, Anasazi people (United States), *50*
 Totem, Nuu-Chah-Nulth people (Canada), *51*
 Zuni Pueblo artists, 185
nature and natural world, 182–211
 color in, 188–191, 197
 earthwork, 246

inspiration from, 184–185, 193
Japanese art and, 200, 202
Latin American art and, 141
studio lessons, 187, 192–195, 199, 203, 204–207
as source of art materials, 186–187, 202
negative shape. *See* elements of art: shape
negative space, 158, 162
Neoclassicism, 166, 167, 180
Netherlands, 133, 137–138
Netsuke, 200, *201*
Nevelson, Louise (Russia)
 Dawn Shadows, *223*
 Sky Cathedral, *223*
New Guinea, *Hut of Spirits*, *171*
New Zealand. *See also* Polynesian art
Nin'ami Dohachi (Japan), *Footed Bowl*, 211, *211*
Niu Ailand People, Melanesia, *Memorial Pole*, *154*
Nok culture, Nigeria, *Terra cotta head from Rafin Fura*, *22*
Nolde, Emile (Germany), *Summer Flowers*, *300*
Noli me tangere and Crucifixion, *78*
nonobjective art, 228, 240
North Transept Rose and Lancet Windows(Melchizadek & Nebuchadnezzar, David & Saul, St. Anne, Solomon & Herod, Aaron & Pharoah, *71*
Northwest Coast native peoples, 35, 51, 55
Notre Dame Cathedral, 76, 88
Nuu-Chah-Nulth people (Canada), *Totem*, *51*

O
Oath of the Horatii, David, Jacques-Louis (France), *166*, *289*
Oceanic art, 170–173
oil pastels, 302
O'Keefe, Georgia (United States), *Oriental Poppies*, 215, *215*
Oldenburg, Claes (Sweden), *Spoonbridge and Cherry*, *291*. *See also* van Bruggen, Coosje
Olla, Zuni Pueblo, *185*
one-point perspective. *See* perspective
optical illusion. *See* illusion
Opulado Teeveona, Scharf, Kenny (United States), *258*
order and organization, 92–121
organic shape. *See* elements of art: shape
organization and order. *See* order and organization
Oriental Poppies, O'Keefe, Georgia (United States), *215*
Ortakales, Denise (United States), *Peacock*, *205*
Our Daily Bread, Leon, Ramon Frade (Puerto Rico), *143*

Outer coffin of Henettawy, Chantress of Amun at Thebes, *10*
overlapping, 94, 115, 158, 295

P
painting, 37, 109, 113, 132, 161, 191, 199, 229. *See also techniques*
 color schemes, 190
 mixing colors, 189, 191
 sculptural, 252
Pair of Vases, *111*
paper, as medium, 205. *See also* art medium/media, used in studio lessons
papier-mâché, 308
Papunya artists, 173
Park, Jae Hyun (Korea), *Toward Unknown Energy*, *262*
Parrots Live Forever, Flack, Audrey (United States), *133*
Passing a Summer Day Beneath Banana Palms, Ying, Ch'iu (China), *163*
Path, The, Haydon, Harold (United States), *68*
patron, 106
pattern. *See* principles of design
Peacock, Ortakales, Denise (United States), *205*
Peale, Charles Willson (United States), *The Peale Family*, *xxii*
Peale Family, The, Peale, Charles Willson Peale (United States), *xxii*
Peeters, Clara (Flanders), *Still Life of Fruit and Flowers*, 130, *131*, *283*
Pei, I. M. (United States), *Addition to the Louvre*, *xxxi*
Pelaez, Amelia (Cuba), *Still Life*, *140*
Penguin, Sewell, Leo (United States), *223*
Periods of Life, Friedrich, Caspar David (Germany), *159*
Persistence of Memory, The, Dalí, Salvador (Spain), 227, *291*
perspective, 93–97, 114–117, 158, 220. *See also* illusion: of space
 atmospheric, 107
 linear, 94, 107, 114–115, 158, 295
 one-point, 114, 116, 117, *159*, 295
 studio lessons, 114–117, 139
 two-point, 295
Perspective study for the staircase and horses (for the "Adoration of the Magi"), da Vinci, Leonardo (Italy), *107*
Peru art
 Poncho (Paracas), *141*
 Stirrup Vessel representing seated ruler with pampas cat, *145*
Philadelphia Museum of Art (Borie, Trumbauer, and Zantzinger), *55*
photography, 234–235, 239, 246, 298
Piazza della Minerva, Rome, Bernini, Gianlorenzo and Ercole Ferrara (Italy), *179*

Italicized page numbers refer to artworks.

Italicized page numbers refer to artworks.

V

value. *See* principles of design

van Brekelenkam, Quinringh Gerritsz (Netherlands), *The Tailor's Workshop*, 127

Vandenberge, Peter (United States), *Hostess*, 43

van Gogh, Vincent (Netherlands)
Irises, 198, 199
The Starry Night, xxviii

vanishing point, 94, 115, 120. *See also* perspective

van Rijn, Rembrandt (Netherlands), *View of Amsterdam*, 137

variety. *See* principles of design

Velázquez, Diego (Spain), *Las Meninas (The Maids of Honor)*, 136

Vermeer, Johannes (Netherlands), *The Milkmaid*, 122

vertical lines. *See* elements of art: line

View of Amsterdam, van Rijn, Rembrandt (Netherlands), 137

View on the Catskill, Early Autumn, Cole, Thomas (United States), xxix

View on the Stour near Dedham, Constable, John (England), 155

viewpoint, 127

visual culture, 21, 51, 81, 111, 141, 171, 201, 231, 261

Voisin, Charles and Chantilly manufactory (France), *Wall Clock*, 289

von Rydingsvard, Ursula (Germany), *Damski Czepek*, 245

W

Wajang purww shadow puppet: Bima, the Brave Giant, 232

Wall Clock, Voisin, Charles and Chantilly manufactory (France), 145, 289

Wallot, Paul (Germany), *Reichstag (Parliament)*, 242

watercolor, 300

Watler, Barbara (United States), *Cavern Gardens*, 180

Webb, Doug (United States), *Kitchenetic Energy*, 282

Wedding Ensemble, Qing Dynasty (China), xviii

Wedding Lover's Quilt No. 1, The, Ringgold, Faith (United States), xxx

Weekly market at the Great Mosque of Djénné, Traoré, Ismaila (Mali), 154

West façade of the Parthenon, Iktinos and Kallikrates (Greece), 47

West Side Story, 238

Whirligig Entitled "America", Memkus, Frank (United States), 36

Williams, Tennessee (United States), *The Glass Menagerie*, 148

William Tell Overture, Rossini (Italy), 208

Winchetty drub dreaming, Tjangala, Keith Kaapa (Australia), 172

Winged Genie, 9

Woman Grinding Maize (Rivera, Diego), 142

Woman's Sarong in batik canting technique, Matzelaar, L. (Indonesia), 231

wood, 186, 214

woodblock print, 304. *See also* printmaking

woodcut, 193, 202. *See also* printmaking

Woolworth Building From Ruckus Manhattan, The, Grooms, Red (United States), 250, *250*

words and writing, 64, 65

Wrapped Reichstag, Christo and Jeanne-Claude (Romania and Morrocco), 242

Wright, Frank Lloyd (United States)
Ennis-Brown House, 216
Fallingwater (Kaufmann House), 210

Writing the Written, Sikander, Shahzia (Pakistan), 262

Y

Yaure peoples, *Mask*, 214

Yetmgeta, Zerihun (Ethiopia), *Scale of Civilization*, 260

Ying, Ch'iu (China), *Passing a Summer Day Beneath Banana Palms*, 163

Yoruba artists, 23

Yoruba People, *Mabgo Headpiece for Oro Society*, 22, 23

Your Portrait—Chrysalis in a Cocoon, Kudo, Tetsumi (Japan), 158

Yup'ik, 52

Z

Zaga, Graves, Nancy (United States), 97

Zhi, Lu (China), *Pulling Oars Under Clearing Autumn Skies*, 112, 113

Zuni Pueblo artists, 185

Italicized page numbers refer to artworks.